Stubbs & the Horse

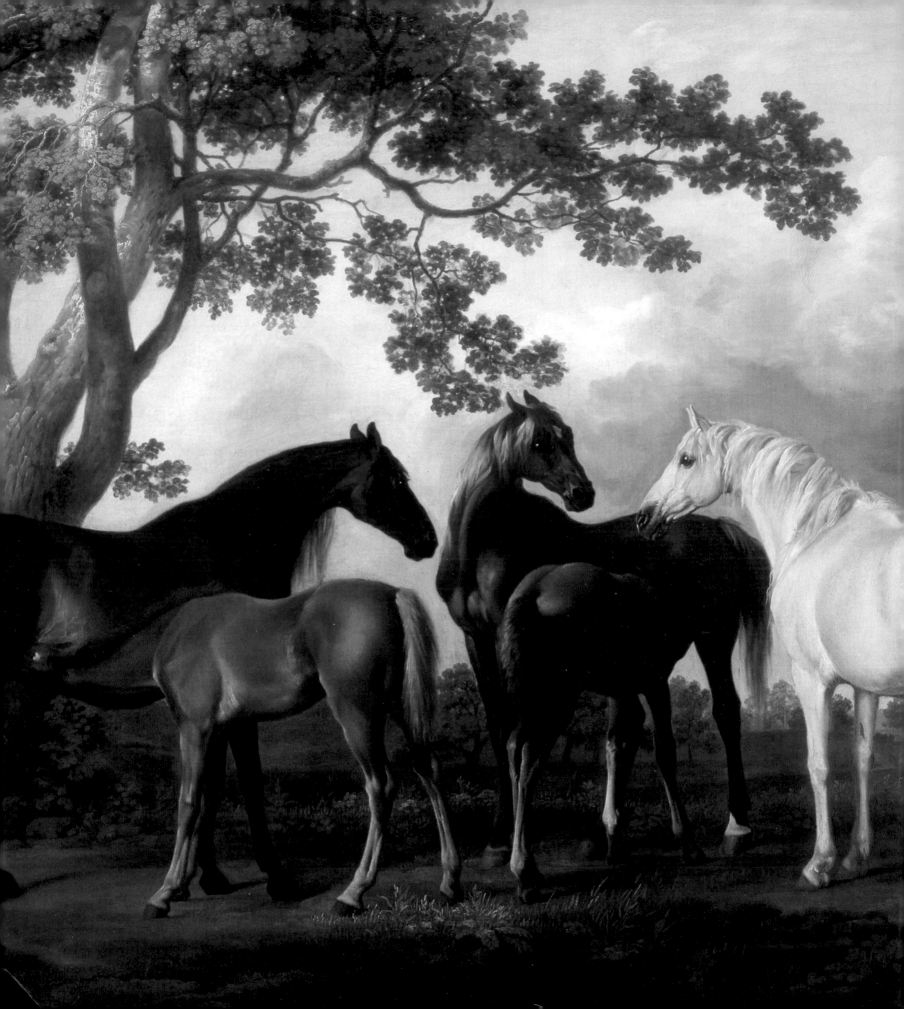

Stubbs & the Horse

Malcolm Warner
& Robin Blake

WITH AN ESSAY BY
Lance Mayer and Gay Myers

Yale University Press
New Haven and London

IN ASSOCIATION WITH
Kimbell Art Museum
Fort Worth

Published in conjunction with the exhibition
Stubbs and the Horse, organized by the Kimbell Art
Museum, Fort Worth, in association with the Walters
Art Museum, Baltimore, and the National Gallery,
London. The exhibition is supported by an indemnity
from the Federal Council on the Arts and the
Humanities.

KIMBELL ART MUSEUM, FORT WORTH
November 14, 2004—February 6, 2005

THE WALTERS ART MUSEUM, BALTIMORE
March 13—May 29, 2005

THE NATIONAL GALLERY, LONDON
June 29—September 25, 2005

Designed by Leslie Fitch
Set in Filosofia type by Leslie Fitch
Printed in Italy at Conti Tipocolor

A catalogue record for this book is available from the
British Library.

LIBRARY OF CONGRESS CATALOGING-IN-PUBLICATION DATA
Warner, Malcolm, 1953—
 Stubbs and the horse / Malcolm Warner and Robin
Blake ; with an essay by Lance Mayer and Gay Myers.
 p. cm.
"Catalog of an exhibition at the Kimbell Art Museum,
Fort Worth, Nov. 14, 2004—Feb. 6, 2005; the Walters Art
Museum, Baltimore, Mar. 13—May 29, 2005; and the
National Gallery, London, June 29—Sept. 25, 2005."
 Includes bibliographical references and index.
 ISBN 0-300-10472-3 (CLOTHBOUND : ALK. PAPER) —
 ISBN 0-912804-42-4 (PAPERBOUND : ALK. PAPER)
1. Stubbs, George, 1724—1806—Exhibitions. 2. Horses
in art—Exhibitions. I. Blake, Robin, 1948— II. Kimbell
Art Museum. III. Walters Art Museum (Baltimore,
Md.) IV. National Gallery (Great Britain) V. Title.
 ND497.S93A4 2004
 759.2—dc22 2004014451

The paper in this book meets the guidelines for
permanence and durability of the Committee on
Production Guidelines for Book Longevity of the
Council on Library Resources.

10 9 8 7 6 5 4 3 2 1

Page viii: Image of *Whistlejacket,* by George Stubbs,
projected on the outside of the National Gallery,
London, in 1998

Jacket/cover illustrations: *(front) Whistlejacket,* c. 1762
[see fig. 6]; *(back) Gimcrack on Newmarket Heath, with
a Trainer, a Stable-Lad, and a Jockey,* 1765 [see fig. 56]

Frontispieces: p. ii, detail of fig. 74; p. xviii, detail of
fig. 10; p. 18, detail of fig. 37; p. 42, detail of fig. 48;
p. 64, detail of fig. 73; p. 80, detail of fig. 84; p. 100,
detail of fig. 101; p. 122, detail of fig. 121; p. 140,
detail of fig. 131; pp. 160-61, detail of fig. 56

Contents

Principal support of this exhibition at
the Kimbell Art Museum is provided by
 JPMorganChase

Lenders to the Exhibition

Her Majesty Queen Elizabeth II 50, 74, 75

Syndics of the Fitzwilliam Museum, Cambridge 42

The Trustees of the Rt. Hon. Olive, Countess Fitzwilliam's
 Settlement, by permission of Lady Juliet Tadgell 36, 37, 38

The Trustees of the Goodwood Collection, Goodwood House,
 Chichester 33

The Earl of Halifax 76

Kimbell Art Museum, Fort Worth 49

McNay Art Museum, San Antonio 32

The National Gallery, London 39, 59, 67

National Gallery of Art, Washington 58

National Gallery of Scotland, Edinburgh 51

National Museums, Liverpool (The Walker) 62

National Portrait Gallery, London 66

Philadelphia Museum of Art 54

The Pierpont Morgan Library, New York 30

Private collection, courtesy of Hall & Knight 64

Royal Academy of Arts, London 1–29

Tate, London 41, 43, 52, 60

Tobin Foundation for Theatre Arts, courtesy of the McNay
 Art Museum, San Antonio 69, 72, 73

The Woolavington Collection 45

Yale Center for British Art, New Haven 31, 34, 40, 46, 63, 65,
 68, 70, 71, 77, 78

Yale University Art Gallery, New Haven 61

Anonymous lenders 35, 44, 47, 48, 53, 55, 56, 57

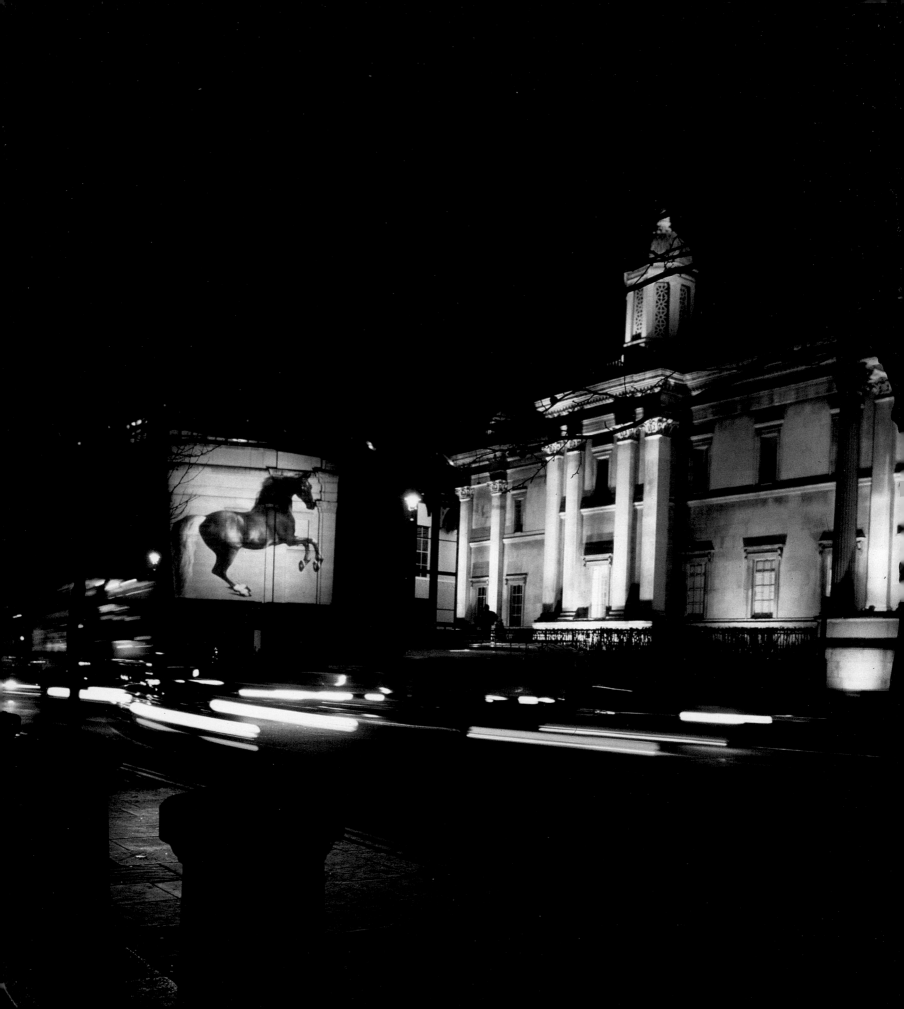

Directors' Foreword

GEORGE STUBBS was the greatest of all British horse painters and produced what is arguably the most significant and influential body of work on this theme by any European painter. Admiration and delight at his extraordinary facility in representing horses—whether tame or wild, at rest or in full gallop—were, however, long tinged with the condescending qualification that this was, after all, only "sporting art"—a view not discouraged by Joshua Reynolds's advocacy of the higher calling of history painting, and even portraiture. The reassessment of Stubbs's work as a painter of serious interest to the general history of art cannot be said to have taken firm hold until the publication of Basil Taylor's fine monograph on the artist in 1971.

It is a measure of how far the reengagement with Stubbs's achievement has come that in 1997, when the National Gallery, London, acquired his life-size portrait of the famous racehorse Whistlejacket, the artist was heralded as "one of the greatest, and certainly one of the most popular, British artists"—a judgment

borne out by the traffic-stopping effect of the rearing horse's image when projected on the outside of the Gallery in Trafalgar Square. In less than a decade this monumental work has become one of the most recognizable and admired icons of that collection, as well as its top-selling postcard.

Stubbs's reputation as a "mere" horse painter in fact masked his much more complex aspirations and record of achievement. Although renowned for his horses and other sporting pictures, Stubbs never abandoned the desire to be recognized also as a history painter. Despite his commercial and critical success, he remained an outsider to the London art establishment, his relationship with the newly founded Royal Academy being equivocal and often strained. Though working in a style that was broadly classical, he insisted on the priority of direct observation of nature over artistic paragons and produced work that speaks equally to Edmund Burke's aesthetic of the sublime and to the Romantic worship of nature's raw spirit. His horses look forward to Théodore Géricault and Eugène Delacroix as much as they hark back to classical sculpture. One aim of the exhibition is to give these ambivalences free rein and thereby to recognize the interesting complexities and tensions within Stubbs's approach to his art.

Previous exhibitions on Stubbs have represented general reviews of his work across all the subjects he treated. *Stubbs and the Horse* is the first to focus on the theme that looms largest in his oeuvre and has come to be seen as the truest measure of his achievement. Bringing together some thirty-four of his finest horse paintings, as well as examples of the anatomical drawings that first established his reputation in artistic and equestrian circles, it attempts to advance the appreciation of the works most central to his artistic aims and to widen understanding of the social, cultural, and intellectual environment in which he moved.

Most of Stubbs's horse paintings were commissioned by the English nobility and landed gentry, for whom horse racing, hunting, and riding were the defining leisure pursuits of their class. Stubbs's patrons were often more than just sporting enthusiasts, however; indeed some, like the second Marquess of Rockingham and the third Duke of Richmond, were among the most cultured and educated figures of English society and showed an active interest in the scientific and artistic aspects of contemporary Enlightenment culture. It is not surprising that commissions from patrons of such taste and intelligence each betrays a distinctive character in the choice of subjects and in their treatment—most strikingly in the use of a neutral background for *Whistlejacket* and other Rockingham works. By reuniting paintings from these commissions, in some cases for the first time, the exhibition allows us to see more clearly than before the productive interaction enjoyed between artist and patron.

Stubbs's incomparable facility in painting horses was based on an intimate knowledge of the animal's anatomy, a knowledge won not through books (which were then highly inadequate) or art but through an intensive study and dissection of equine cadavers during his early career. It is here that the comparison between Stubbs and Leonardo is more than hyperbole. Suspending carcasses from the ceiling to affect a natural stance, and injecting the veins to keep them visible, Stubbs would remove a specimen's muscles layer by layer over some six or seven weeks, making accurate drawings at every stage. The results of this malodorous exercise—surely one of the most unpleasant penances any artist ever paid for his craft—were published in *The Anatomy of the Horse* (1766), which was immediately hailed as the most accurate study of an animal's anatomy to date.

Stubbs's interest in anatomy—to which he returned

late in life in his unfinished project on the comparative anatomy of man, tiger, and the "common fowl"—was just one aspect of his empirical approach to art and the natural world in general. Undertaken to bring a proper scientific understanding of the animal into his art (as Burke put it, to "make the knife go with the pencil"), his dissections extended only to the musculature and skeleton; this was, as he explained, "as much as I thought necessary for the study of painting." Unsatisfied with the longevity of pigments in oil painting, he likewise looked to science for a remedy, experimenting with painting in enamel on copper and ceramic, and with mixtures of oils and wax on panel. Though these essays were not deemed successful in his lifetime (and have frustrated paintings conservators ever since), they bear testimony to his experimental and collaborative turn of mind. In no other painter of the day were the broader rationalist and scientific aspirations of the Enlightenment more thoroughly integrated into their ambitions and working method as an artist.

It is a great pleasure to acknowledge the extraordinary generosity with which both museums and private owners have supported this exhibition through the loan of their works. In some cases, this has allowed us to reassemble works carried out for the same patron or even deriving from a single commission—notably the three works from Lord Torrington's series of 1767 (cats. 54–56), which were last seen together in 1787. Perhaps most remarkably, the exhibition offers the first public display of *Brood Mares and Foals* (cat. 57) since 1768. This major painting entered a noble collection immediately after its creation and has resided with the same family ever since, unpublished except for a contemporary engraving; it can now be appreciated as one of Stubbs's most beautiful early works. Among the institutions that have been especially generous should be mentioned the Yale Center for British Art, New Haven; Tate Britain and the Royal Academy of Arts, London; and the Royal Collection. To all the owners of works in the exhibition, we extend our heartfelt thanks.

The exhibition has been conceived and curated by Malcolm Warner, senior curator at the Kimbell Art Museum. His connoisseurship and scholarship have contributed in equal measure to the selection of the works and to this catalogue, which is destined to be the starting point for future work in this area. We are grateful also to his principal coauthor, Robin Blake, who has brought into focus Stubbs's life and relationship with his principal patrons, and to Lance Mayer and Gay Myers for their insightful essay on his technique.

We are delighted that *Stubbs and the Horse* should be presented both in Stubbs's homeland and in the United States, the major repository of his works outside the United Kingdom. The artist would no doubt have been doubly pleased that it should be shown in two American cities—Fort Worth and Baltimore—that are also centers of horse breeding, racing, and horsemanship in its various manifestations. We feel confident that the sensation caused by Whistlejacket's arrival at the National Gallery will follow him to the land of Seabiscuit.

Timothy Potts
Kimbell Art Museum, Fort Worth

Charles Saumarez Smith
The National Gallery, London

Gary Vikan
The Walters Art Museum, Baltimore

Preface

THE HORSE was at once the mainstay of Stubbs's success and a problem for his reputation. In his lifetime he attracted much praise for his abilities as a painter of horses and, especially in the 1760s, an abundance of lucrative commissions from horse-loving British noblemen. But this won him little prestige in his profession. In the hierarchy of the genres that dominated eighteenth-century British attitudes to art, the highest rank was reserved for "history" subjects—myth, allegory, the Bible, historical events, and great literature—with portraiture and landscape considerably lower and animals lower still. Stubbs was keenly conscious of this. "I find Mr. S. repents much his having established a character for himself. I mean that of horse painter, & wishes to be considered as an history, & portrait painter," wrote his friend Josiah Wedgwood in 1780. "How far he will succeed in bringing about the change at this time of life I do not know." [1]

Certainly Stubbs produced a great deal of work that went beyond the portraiture of favorite racehorses and hunters that the term *horse painter* implied. He painted other animals, including dogs, farm animals, and such exotics as lions and tigers, the zebra, and the kangaroo. Moving up the hierarchy, he painted portraits that included horses but whose principal subjects were human. He made various kinds of animal history painting. But Wedgwood was right to doubt his ability to change the way he appeared in the eyes of the world. However he might introduce elements of the higher genres, the horse was—and, despite his aspirations, would remain—the central image of his art.

Stubbs's "low" subject matter continued to affect his reputation in posterity. Although the hierarchy of the genres broke down in the nineteenth century, there was a lingering belief among connoisseurs that paintings of horses were all very well as country-house decoration but could never be considered great works of art: sporting gentlemen had wanted accurate records of their horses and Stubbs had been their man, more a "facsimilist" (as the painter Henry Fuseli called him) than a true artist.[2]

The other side of the coin was that people who delighted in horses and country life remained as devoted to Stubbs as the young aristocrats who were his original patrons. The first study of him of any substance was by a sportsman, Sir Walter Gilbey, of Elsenham Hall, Essex. Gilbey was an avid collector of Stubbs's work and owned more of his paintings than anyone before Paul Mellon. He based his life of the artist largely on the manuscript memoir written by Ozias Humphry in the 1790s. Published in 1898, his book remains useful for its documentary appendixes, which include a list of works arranged by location (no fewer than thirty-four in the author's own collection)

and transcriptions of Stubbs's will and the catalogue of his posthumous sale.

In artistic circles Stubbs's reputation did not begin to rise until the middle years of the twentieth century. The poet and critic Geoffrey Grigson published the first considered appreciation of him from the artistic point of view in an essay of 1940. Admiring him *despite* the horses and the sport, the art historian Ellis Waterhouse wrote in 1953 of "that quality of strangeness which lifts many of Stubbs's pictures from the category of 'sporting art' into the realm of the poetry of creative observation."[3]

The first art historian to make a specialty of Stubbs, fully embracing his subject matter, was Basil Taylor. In *Animal Painting in England from Barlow to Landseer* (1955), Taylor presented a deeply unfashionable defense of animals and sport as subjects, and in 1957 he organized a Stubbs exhibition at the Whitechapel Art Gallery. In 1959 he met the American anglophile Paul Mellon, whom he soon began advising in the formation of a large collection of British art with an emphasis on animal and sporting subjects. Taylor continued to promote Stubbs's reputation through articles and exhibitions, and his much-admired monograph of 1971 made the most sustained critical argument for the artist to date.

Paul Mellon considered Stubbs his favorite British artist and collected more than forty of his paintings as well as many drawings and prints. "His horses are alive and beautiful because they were in his soul," he wrote of Stubbs; "he saw them as symbols of many life forces rather than as mere conveyances, necessities, implements."[4] As a keen equestrian, foxhunting man, and owner-breeder of racehorses, Mellon was a sporting collector like Gilbey. But with his impressive breadth of artistic interests and appreciation for Stubbs as more than a documenter of

sport, combined with his great wealth and philanthropy, he helped enormously in spreading the message articulated by Taylor. Most of his collection is now at the museum that he founded as a gift to his alma mater, the Yale Center for British Art, opened in 1977.

Since her exhibition *George Stubbs: Anatomist and Animal Painter* at the Tate in 1976, no one has done more to advance the understanding and appreciation of Stubbs than Judy Egerton. Among other contributions, she published a catalogue of the British sporting and animal paintings in Paul Mellon's collection in 1978 and organized the large Stubbs exhibition held at the Tate and the Yale Center for British Art in 1984–85. The exhibition was the most comprehensive survey of Stubbs's work ever; it greatly increased his popular reputation, and the catalogue remains a fund of information on the animals, people, and places he painted—with an accent on the elements of portraiture and landscape in his work. All those who have researched and written on Stubbs in the past twenty years, including the authors of this catalogue, owe Egerton a huge debt of gratitude. Though hard at work on her eagerly awaited Stubbs catalogue raisonné, she was generous with help and encouragement in the early stages of the present exhibition.

Recent scholars have looked at Stubbs from a variety of points of view. In *Sporting Art in Eighteenth-Century England* (1988), Stephen Deuchar put the condescension of earlier writers toward sporting subjects more firmly than ever in its place and paid serious attention to the meaning of Stubbs's works in his time. The catalogue of prints by and after Stubbs by Christopher Lennox-Boyd, Rob Dixon, and Tim Clayton (1989) contains invaluable information on the prints and, incidentally, almost every other aspect of Stubbs's work. Nicholas Hall's exhibition

Fearful Symmetry: George Stubbs, Painter of the English Enlightenment (2000) presented a convincing picture of Stubbs as an artist of intellect and ideas, and the accompanying catalogue made available for the first time a full transcription of Ozias Humphry's memoir. The authors of the present catalogue have relied on these publications in a number of ways.

Stubbs's misgivings about being called a horse painter are quite understandable in light of the artistic politics of his time. Today few people consider the stature of a work of art to be limited by its subject, and Stubbs's reputation as an artist is, in any case, beyond dispute. The time seems ripe, therefore, for a return to Stubbs the horse painter, focusing on his main theme and its significance in eighteenth-century Britain. The status and associations of the "noble horse" and the colorful world of its devotees, high and low, are not only fascinating topics in themselves; they are a setting in which the genius of this long-underrated artist emerges more vivid than ever.

The exhibition came into being through the kindness and cooperation of the lenders. We are especially grateful to Her Majesty Queen Elizabeth II for lending paintings from the group commissioned by the Prince of Wales in the early 1790s. Lady Juliet Tadgell has lent some outstandingly beautiful paintings commissioned by her ancestor the second Marquess of Rockingham. Among the institutional lenders, we owe a special debt to the Yale Center for British Art and its director, Amy Meyers, for lending three paintings and a number of works on paper from the Paul Mellon Collection; to the Tate, its director, Sir Nicholas Serota, and the director of Tate Britain, Stephen Deuchar, for four paintings; and to the Royal Academy of Arts and its president, Phillip King, for a group of the

anatomical drawings with which Stubbs began his career as an equine artist. We heartily thank these and all the other lenders to the exhibition, both private and public, for their generosity.

Some of the private owners of Stubbs's works not only agreed to lend to the exhibition but also welcomed emissaries of the project into their homes. Those of us who enjoyed their hospitality in the company of the Stubbses in their collections will be ever grateful for the experience. Further thanks are due to those who allowed and arranged for works of art in their collections to be specially photographed for the catalogue, in particular the Marquess of Londonderry.

We also acknowledge with thanks the crucial contribution of those who helped us trace the present whereabouts of works by Stubbs and establish contact with their owners. David Fuller of the British Sporting Art Trust, Max Deliss, Anthony Crichton-Stuart, Anthony Spink, David Ker, and Nicholas Hall all offered invaluable assistance in this respect. Thanks are also due to Francis Russell, Piers Davies, Margie Christian, Benjamin Dollar, Ben Hall, Johnny Van Haeften, Simon Dickinson, Adam Williams, Lowell Libson, Robert Holden, Richard Green, Rob Dixon, Andrew Rose, Michael Fullerlove, and Giles Waterfield.

We are grateful to the following curatorial colleagues for their help in showing us works by Stubbs and sharing information about them: Christopher Lloyd of the Royal Collection Trust; Angus Trumble, Scott Wilcox, Gillian Forrester, and Elisabeth Fairman of the Yale Center for British Art; Martin Myrone of the Tate; MaryAnne Stevens, Nick Savage, and Sasha Smith of the Royal Academy; Janie Munro of the Fitzwilliam Museum, Cambridge; Rosemary Baird of the Goodwood Collection; Derek Adlam of the Portland Collection; Franklin Kelly of the National Gallery of Art, Washington, D.C.; Joseph Rishel and Jennifer Thompson of the Philadelphia Museum of Art; John Bidwell of the Pierpont Morgan Library; Lyle Williams of the Marion Koogler McNay Art Museum, San Antonio; Malcolm Cormack of the Virginia Museum of Fine Arts, Richmond; Sona Johnston of the Baltimore Museum of Art; Martyn Anglesea and Eileen Black of the Ulster Museum, Belfast; Julian Treuherz and Alex Kidson of the National Museums Liverpool; Hilary Bracegirdle of the National Horseracing Museum, Newmarket; and Alastair Laing and Frances Bailey of the National Trust. For various similar kindnesses in connection with the organization of the exhibition, we thank Linda Farrington, T. P. Clarke, Debra Spink, and Victoria Bolton and, for help with obtaining photographs for the catalogue, Philip Ward-Jackson, Geoffrey Fisher, and Andrew Edmunds.

The experience of working with my fellow contributors to the catalogue has been delightful and instructive. It was my good fortune that, at just the right moment, Robin Blake should be engaged in a biography of Stubbs, and the conservators Lance Mayer and Gay Myers in a study of his techniques in connection with their work on paintings at the Yale Center for British Art. They have all been generous with their knowledge, and I have learned a great deal about the artist from them. My thanks also to Walter Liedtke of the Metropolitan Museum of Art, New York, who was kind enough to read over my catalogue essays and suggest improvements from the art-historical-cum-equestrian point of view. In connection with their catalogue essay, Lance Mayer and Gay Myers thank Theresa Fairbanks-Harris, Irène Aghion, Susan Brady, Ann Massing, and Rica Jones.

The paintings, drawings, prints, and rare books in the Paul Mellon Collection at the Yale Center for British Art, along with the publications of the Paul Mellon Centre for Studies in British Art, have been rich resources for all the contributors. My research was greatly enhanced by the important holdings in the literature of the horse in the Harry Ransom Humanities Research Center at the University of Texas at Austin. At the Kimbell the librarians Chia-Chun Shih and Steve Gassett have been models of helpfulness in finding and obtaining rare publications. For information on the pedigrees and performances of racehorses, I have benefited greatly from the Web sites Thoroughbred Heritage and the Thoroughbred Racehorse.

The colleagues at the Kimbell who have worked toward the realization of the exhibition and its catalogue are too many to mention individually. I am grateful to them all, and particularly to Samantha Sizemore, curatorial assistant, for her keen-eyed attention to every aspect of the exhibition's organization; to Wendy Gottlieb, manager of publications and public access, for tending so scrupulously to the nurture of the catalogue, assisted by Lindsay Elston Askins; and to Patty Decoster, registrar, assisted by Michelle Bennett, for organizing the assembly of the exhibition and its movements between venues.

It has been a pleasure in every respect to collaborate with our colleagues at the Walters Art Museum in Baltimore and the National Gallery in London. The exhibition was developed for the Walters as a venue by Eik Kahng, curator of eighteenth- and nineteenth-century art, and for the National Gallery by Susan Foister, head of curatorial department and curator of early Netherlandish, German, and British paintings. Mary Hersov, head of exhibitions at the National Gallery, and Joanna Kent, exhibitions organizer, were closely involved with the project throughout,

and from their special vantage point in London helped in a number of matters of diplomacy and organization.

The catalogue was brought together with flair and efficiency by Yale University Press, under the direction of Patricia Fidler, publisher of art and architecture. The press's expert team included assistant editor Michelle Komie, manuscript editor Laura Jones Dooley, production editor Margaret Otzel, designer Leslie Fitch, production manager Mary Mayer, and photo editor John Long.

M. W.

Notes

Epigraph: Peter Pindar (John Wolcot), Ode VII from "Lyric Odes to the Royal Academicians for M,DCC,LXXXII," Pindar 1794–1801, 1:32.

1. Josiah Wedgwood to Thomas Bentley, September 25, 1780, quoted in Tattersall 1974, 114.
2. From an entry on Stubbs for Matthew Pilkington's *Dictionary of Painters, a new edition, with considerable alterations . . . by Henry Fuseli* (1805), quoted in Grigson 1948, 19.
3. Waterhouse 1953/1962, 209.
4. Baskett 1980, 9.

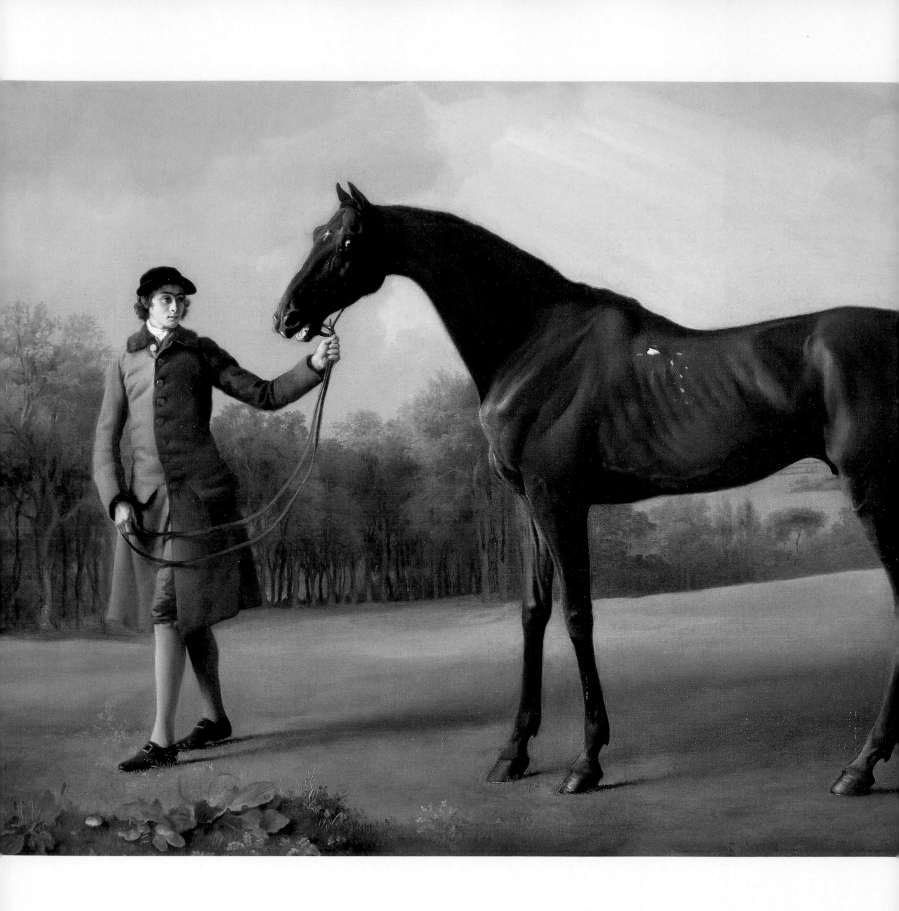

Ecce Equus

Stubbs and the Horse of Feeling

Malcolm Warner

THE FOUNDATION of Stubbs's career as a painter of horses was the study of equine anatomy. In 1756–58, living in a farmhouse in the northern English village of Horkstow, near Hull, he spent some eighteen months dissecting the bodies of horses and making elaborate notes and drawings of his findings. He was in his early thirties, and known in Liverpool, York, and Hull as a portraitist, lecturer on anatomy, and anatomical illustrator. The methods he used at Horkstow are described in the manuscript memoir of his life by his friend Ozias Humphry, written largely on the basis of the artist's own memories:

> The first subject that he procured, was a horse which was bled to death by the jugular vein; after which the arteries & veins were

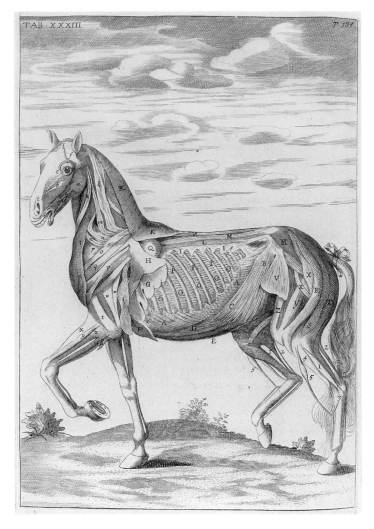

FIG. 1. Table 33 from Andrew Snape, *The Anatomy of an Horse . . .* , 1683. Engraving, plate: 10⅜ × 7¼ in. (26.5 × 18.4 cm). Yale Center for British Art, New Haven. Paul Mellon Collection

injected.—A Bar of Iron was then suspended from the ceiling of the room by a *Teagle* to which Iron Hooks of various sizes & lengths were fixed.—Under this bar a plank was swung about 18 inches wide for the horses feet to rest upon and the animal was suspended to the Iron Bar by the above mentioned Hooks which were fastened into the opposite off side of the horse to that which was intended to be designed; by passing the Hooks thro' the Ribs & fastening them under the Back bone . . . He first began by dissecting and designing the muscles of the abdomen proceeding thro' five different lay[er]s of muscles till he came to the *peritoricum* & the *pleura,* through which appeared the lungs & the intestines—afterwards, the Bowels were taken out, and cast away.—then he proceeded to dissect the Head by first stripping off the skin, & after having cleaned and prepared the muscles &c. for the drawing, he made careful design of them, & wrote the explanations which usually employed him a whole day.—He then took off another lay' of muscles, which he prepared, designed, & described in the same manner as is represented in the work.—and so he proceeded till he came to the skeleton. It must be noted that by means of the Injection, the Muscles, the Blood vessels and the nerves, retained their form to the last without undergoing any change.—In this manner he advanced his work by stripping off the skin & cleaning & preparing as much of the subject as he concluded would employ a whole day to prepare, design, and describe, till the whole subject was completed.[1]

Stubbs told the surgeon Henry Cline that he worked on one of the carcasses for as long as eleven weeks.[2] "So ardent was his thirst for acquiring experience by practical dissection," wrote his obituarist, "that he very frequently

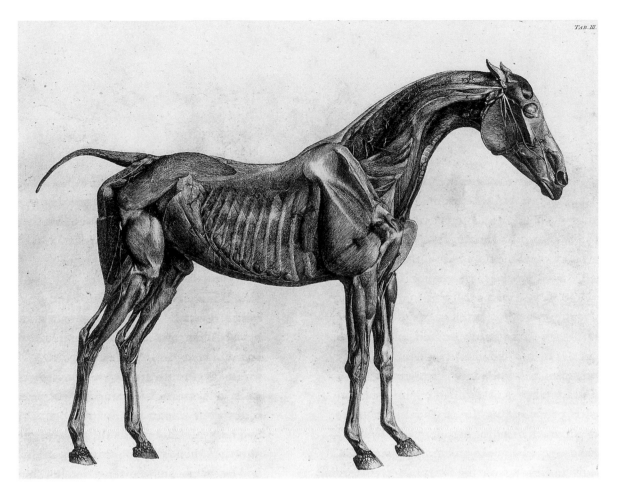

FIG. 2. George Stubbs, *Third Anatomical Table of the Muscles...*, from *The Anatomy of the Horse*, 1766. Etching, plate: 14⅞ × 18¾ in. (37.9 × 47.6 cm). The Pierpont Morgan Library, New York (cat. 30)

braved those dangers from putridity, &c. which would have appalled the most experienced practitioner."[3] Out of his gruesome, messy, and unhealthy labors in Horkstow came an impeccably ordered and beautiful book, *The Anatomy of the Horse,* published in London in 1766. It contained eighteen plates engraved by Stubbs from his own drawings and more than fifty thousand words of meticulous descriptive text.

The horse had been the subject of the first anatomical study devoted to a single animal other than the human being, Carlo Ruini's *Dell'anatomia et dell'infirmità del cavallo* (1598). But between Ruini and Stubbs the knowledge of horse anatomy advanced hardly at all. Rather than carrying out dissections and making anatomical illustrations of their own, the authors of books on horses merely had the woodcuts in Ruini copied. This was the case with the engravings in the leading English precedent for Stubbs's book, *The Anatomy of an Horse* (1683), by Andrew Snape, farrier to Charles II.[4] In the accuracy of his observations and the refinement of his illustrations, Stubbs raised his subject to a higher level (figs. 1, 2). His achievement parallels that of the great anatomist of the human body, Bernhard Siegfried Albinus, whose *Tables of the Skeleton and Muscles of the Human Body* appeared in English in 1749, and he was much indebted to Albinus's methods of presentation, in particular the use of separate key figures.[5]

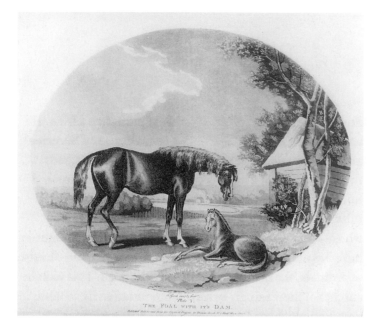

FIG. 3. Aquatints from the series *The Life and Death of a Race-Horse*, after Thomas Gooch, published 1792. Yale Center for British Art, New Haven. Paul Mellon Collection. (A) *The Foal with It's Dam*, plate: 11¼ × 13¼ in. (28.5 × 33.5 cm)

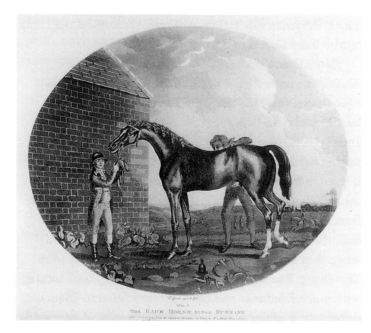

FIG. 3 (B). *The Race Horse after Running*, plate: 11½ × 13¼ in. (29.2 × 33.5 cm)

which their Skins were stripped and sold for what they were worth, and their Bodies left to be devoured by Dogs and Birds of Prey."[17] Thomas Gooch, a horse painter working under Stubbs's influence, elaborated on this basic story in a series of six paintings of scenes from the life of a racehorse, exhibited at the Royal Academy in 1783. They showed the horse as a foal with his dam; as a colt being broken; as a racehorse after winning a sweepstakes; as a hunter going out; as a hard-driven post chaise horse on the road; and finally as an ignominious carcass. Prints after the series were issued in book form in 1792 (fig. 3), with Hawkesworth's essay as accompanying text.[18] The lesser injuries visited on horses for the sake of fashion also came in for growing criticism: the docking of tails (which involved amputation of the tail bone), the nicking of tails to make them curve, the cropping of ears, and the slitting of nostrils. In such practices, remarked Richard Berenger, gentleman of the horse to George III, "we every day fly in the face of reason, nature, and humanity."[19]

Of course, the engagement of eighteenth-century British writers and artists with the issue of cruelty to animals attested to the fact of continuing cruelty; despite their pleas for greater understanding and kindness, others went on treating animals inhumanely. Still, they gave voice and encouragement to an important shift of attitude toward the "brute creation," fostering a sympathy and kinship feeling that hardly existed before, yet which was to become part of the modern sensibility. In *Man and the Natural World* (1983), the historian Keith Thomas has written of "the dethronement of man" in this period: a more objective study of nature led to the decay of the Tudor and Stuart worldview, in which God created the universe for humanity alone and the value of other living things lay entirely in their human uses. Instead, "the educated were now coming to believe that the natural world had

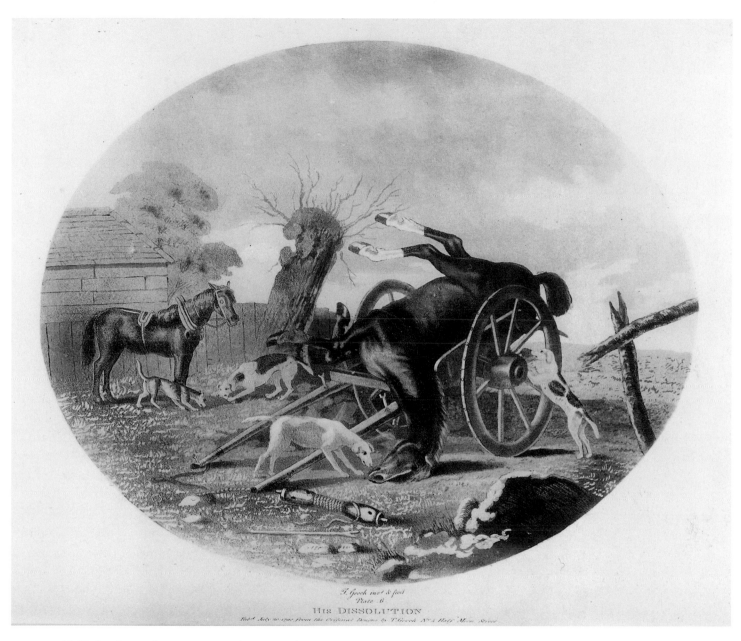

J. Gooch invt & fecit
Plate 6
HIS DISSOLUTION
Pub.d July 30 1700 from the Original Drawing by T. Gooch No 4 Half Moon Street

FIG. 3 (C). *His Dissolution*, plate: 11³⁄₈ × 13³⁄₈ in. (28.9 × 34 cm)

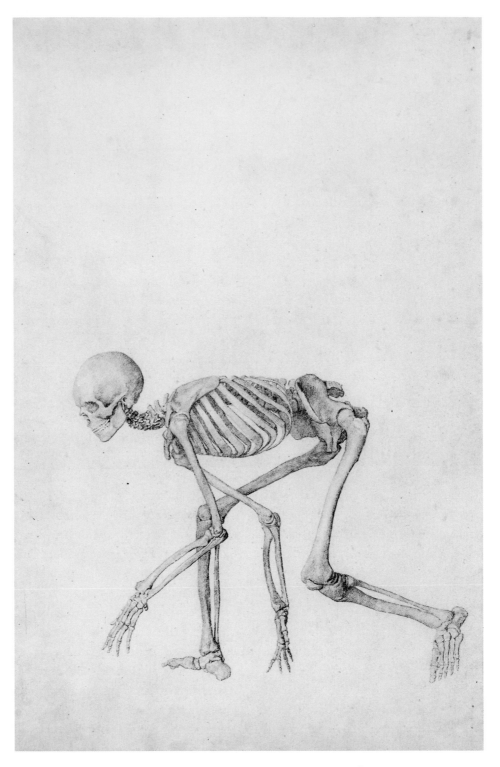

FIG. 4. George Stubbs, drawings for *A Comparative Anatomical Exposition of the Structure of the Human Body, with that of a Tiger and Common Fowl*, c. 1795–1806. Yale Center for British Art, New Haven. Paul Mellon Collection. (A) *Human Skeleton in Crouching Posture*. Graphite, 17 5/8 × 11 1/8 in. (44.8 × 28.3 cm)

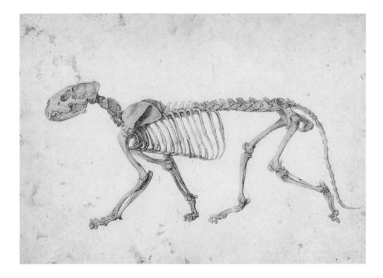

FIG. 4 (B). *Tiger Skeleton, Finished Study for Table 4*. Graphite, 16 × 21¼ in. (40.6 × 54 cm)

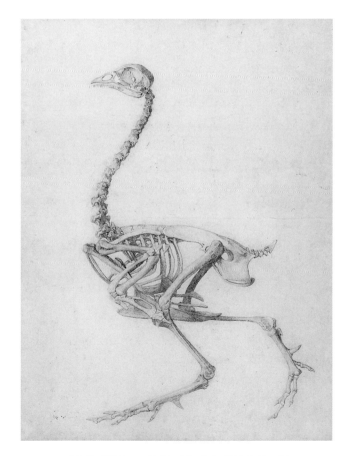

FIG. 4 (C). *Fowl Skeleton, Finished Study for Table 5*. Graphite, 21¼ × 16 in. (54 × 40.6 cm)

its own independent existence and was to be perceived accordingly."[20]

From the early eighteenth century, with the waning of anthropocentric attitudes, British writers more and more routinely embraced animals as "fellow-mortals," "fellow-brutes," "fellow-subjects," and so on. As the idea that animals were more like people developed, so did the corollary that people were more like animals. Stubbs's second and last great anatomical project was *A Comparative Anatomical Exposition of the Structure of the Human Body, with that of a Tiger and Common Fowl,* which he began in 1795 and left only partially published at his death in 1806. In this vast and ambitious work he pursued further than any previous anatomist the idea that seemingly disparate creatures were connected by fundamental physical similarities, that the human body was like that of a tiger or even a chicken (fig. 4). The superiority of man and his special place in Creation were still understood, but the differences between human and animal came to seem relative rather than absolute. *"The whole is one family of one parent,"* wrote the naturalist and poet Erasmus Darwin, grandfather of Charles, in 1794. "On this similitude is founded all rational analogy."[21]

In the course of Stubbs's lifetime the relationship of humankind to nature, to animals, and to horses was transformed. Andrew Snape noted that there were British farriers of the later seventeenth century who believed that horses had literally no brains.[22] By the end of the eighteenth century most people would have agreed that they had both brains and feelings, and some that they even had souls. In *A Philosophical and Practical Treatise on Horses* (1796–98), John Lawrence insisted on the individual horse as a distinct personality, leaving crude equations of temperament with color far behind: "The tempers

of Horses, like those of their masters, are various, endowed with a greater or less proportion of intelligence, sagacity, and feeling; and it is but too often, the beast evinces the greater degree of rationality."[23] As for the question of the soul, the issue was clear, Lawrence believed, when examined by the light of reason: "In pursuance of this philosophy, we will then say, that as the anatomical art evinces the strict analogy between the brute and human body, so the constant experience of the senses confirms the same, in respect to the mind and its qualities. The Horse is endowed with such as we are compelled to denominate qualities of mind; namely, perception, consciousness, memory, free-will; in these originate love, hatred, fear, fortitude, patience, generosity, obedience, a limited sense of justice. He reasons; he therefore possesses an immortal and imperishable soul."[24] From the heart of the country known as hell for horses, Lawrence claimed a heaven. John Wesley also espoused the idea of an afterlife for animals, promising them "happiness suited to their state, without alloy, without interruption, and without end."[25] He was the only important Christian leader to do so, and many would have considered such views outlandish. Yet the very fact that they could exist, even among a minority, said much about changing perspectives.

On his return to England, Swift's Gulliver bought some horses—to whom he could now speak using the Houyhnhnm language—and proceeded to treat them as equals: "I converse with them at least four Hours every Day. They are Strangers to Bridle or Saddle, they live in great Amity with me, and Friendship to each other."[26] In this Gulliver was ahead of his time, a forerunner of later eighteenth-century men of feeling who called for an emancipation of animals that would afford them something like the rights of man. Humphry Primatt drew a parallel between their condition and that of oppressed members of human society, particularly slaves:

> The white man, notwithstanding the barbarity of custom and prejudice, can have no right, by virtue of his colour, to enslave and tyrannise over a black man . . . For, whether a man is wise or foolish, white or black, fair or brown, tall or short, and I might add, rich or poor . . . such he is by God's appointment; and, abstractedly considered, is neither a subject for pride, nor an object of contempt. Now, if amongst men, the differences of their powers of the mind, and of their complexion, stature, and accidents of fortune, do not give any one man a right to abuse or insult any other man on account of these differences, for the same reason, a man can have no natural right to abuse and torment a beast, merely because a beast has not the mental powers of a man.[27]

Samuel Taylor Coleridge wrote his poem "To a Young Ass" (1794) in the same spirit:

> Poor little Foal of an oppressèd race!
> .
> I hail thee *Brother*—spite of the fool's scorn!
> And fain would take thee with me, in the Dell
> Of Peace and mild Equality to dwell.[28]

Again, though hardly mainstream, such views were a sign of the times. The fledgling animal rights movement in eighteenth-century Britain led eventually to legislation and organized action against abuse. "Martin's Act," which made cruelty toward the larger domestic animals a punishable offense for the first time, was passed in 1822. The Society (later Royal Society) for the Prevention of Cruelty to Animals was founded in 1824.

Whether well or poorly treated, the horse had long been the object of admiration, primarily for its tremendous energy and power. The lines of verse beneath the engraving of a stallion at the beginning of Snape's *Anatomy* are typical: "His Nostrills raise a Tempest when he blows; / His Feet produce an Earthquake when he goes." Under the old dispensation for animals, the power of the horse was understood as one of God's gifts to mankind, to control and use for his own purposes. The skillful rider on a mighty steed was an image of man's dominion over nature. It could also serve as an image of political authority. As the Duke of Newcastle observed, "What Prince or Monarch looks more Princely, or more Enthroned, than Upon a Beautiful *Horse*."[29] The ruler's horse suggested his power, and his horsemanship suggested his right and ability to command his fellow men. For this reason the most prominent role for horses in European art from the Renaissance onward was a supporting role in equestrian portraiture. In Peter Paul Rubens's portrait of the Duke of Buckingham (fig. 5), the duke's horse rears on command, showing his abilities as a horseman and, by implication, his leadership skills as lord high admiral of the navy. The equestrian portrait was especially apt for Buckingham since he was also master of the horse to Charles I, but by this date the use of horsemanship as an image of authority was a convention of European portraiture. The symbolism was still well understood in the eighteenth century. In 1770 an equestrian statue of George III in gilded lead, sculpted by Joseph Wilton, was erected at the Bowling Green in New York City; in 1776 it was pulled down and melted to make bullets for the American revolutionary army.[30]

It was as the basis for an equestrian portrait of George III that Stubbs painted *Whistlejacket* (fig. 6).[31] His most

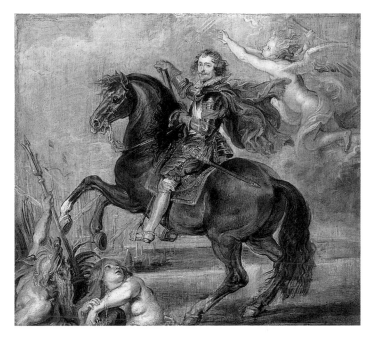

FIG. 5. Peter Paul Rubens, *George Villiers, First Duke of Buckingham*, 1625. Sketch for the large painting destroyed in 1949. Oil on panel, 18³⁄₈ × 20³⁄₈ in. (46.6 × 51.7 cm). Kimbell Art Museum, Fort Worth

important early patron, the Marquess of Rockingham, commissioned the work in about 1762 as a companion piece, identical in size, to an equestrian portrait of George II by the Swiss artist David Morier, which Rockingham already owned (fig. 7).[32] The two works were to hang together in the great hall at his country seat, Wentworth Woodhouse, in Yorkshire. The figure of the king and the background were to be added by other artists, unidentified except as the best in their particular fields of portraiture and landscape. Stubbs completed his part of the project, at which point Rockingham decided things should be left as they were, with Whistlejacket riderless against a plain background.

Rockingham decided to take the painting no further, Ozias Humphry noted, after hearing that Whistlejacket

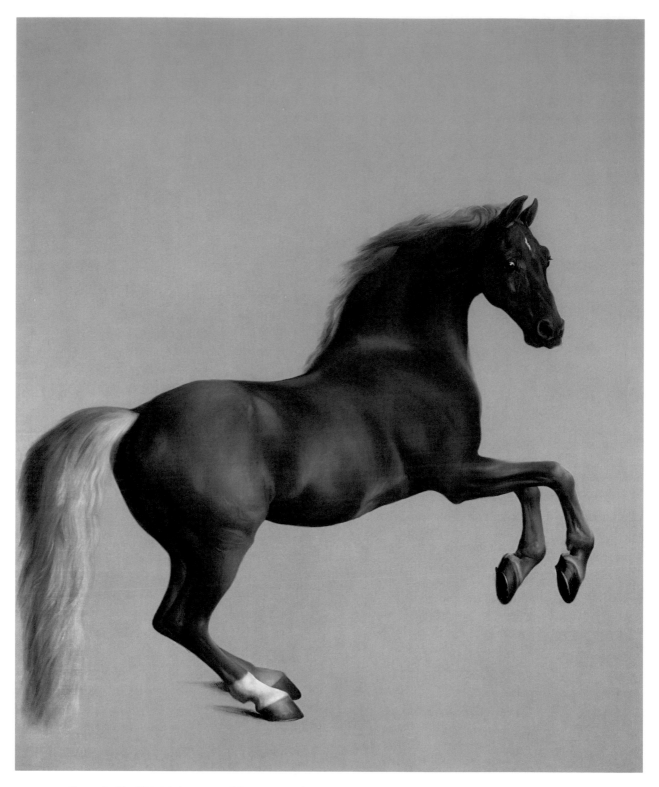

FIG. 6. George Stubbs, *Whistlejacket*, c. 1762. Oil on canvas, 115 × 97 in.
(292 × 246.4 cm). The National Gallery, London. Bought with the support
of the Heritage Lottery Fund, 1997 (cat. 39)

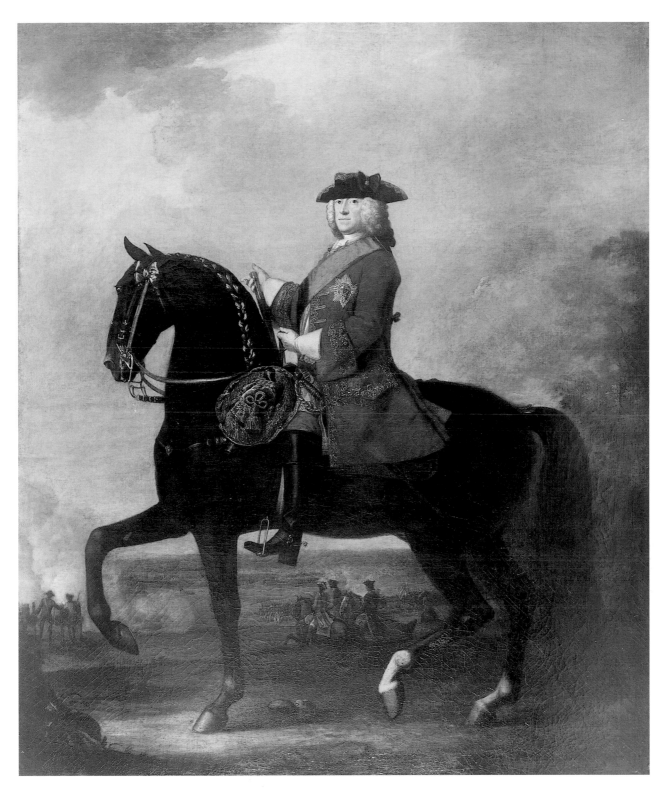

FIG. 7. David Morier, *George II*, c. 1745. Oil on canvas, 113½ × 94½ in.
(288.3 × 240 cm). The Royal Collection

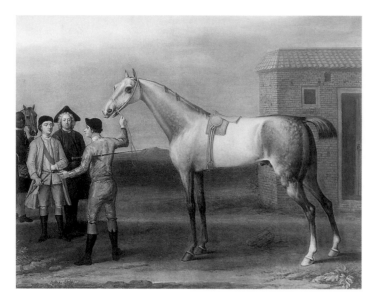

FIG. 8. John Wootton, *Lamprey at Newmarket*, 1723. Oil on canvas, 41 × 49½ in. (104 × 125.8 cm). Yale Center for British Art, New Haven. Paul Mellon Collection

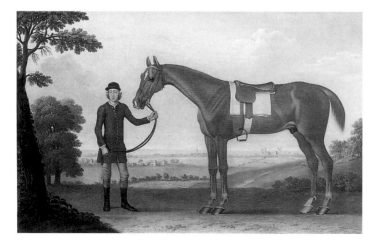

FIG. 9. James Seymour, *Chestnut Horse with a Groom, near Newmarket*, c. 1730–40. Oil on canvas, 26 × 41⅛ in. (66 × 104.5 cm). Tate, London. Bequeathed by Miss Agnes Clarke, 1978

himself had mistaken his image on the canvas for a real horse. Certainly the marquess may have seen that Whistlejacket's lifelike presence in the painting would overwhelm the Morier, making the idea of matching the works as companion pieces moot. Horace Walpole visited Wentworth Woodhouse in 1772 and recorded in his journal that Rockingham had abandoned the idea of the royal portrait on political grounds, as leader of the Whig opposition to the king's government.[33] Whatever the reasons for the decision, it was a bold and enlightened one—and a turning point in the history of the horse in art.

When the unfinished equestrian portrait of George III became *Whistlejacket*, the animal that was there for human purposes, to show the power and authority of the ruler, became himself the hero of the piece. As the mount of the king, Whistlejacket would have been rearing, like the Duke of Buckingham's horse, because commanded to do so; his action would have been seen by horsemen as an informal version of one of the highly controlled and artificial airs above the ground of *haute école* riding, the *levade*.[34] Now he reared naturally. Free of rider, saddle, and bridle, the sole figure in a work of art of monumental scale—without even a landscape setting to distract attention from him—he stood like an emblem of the animal as independent being, to be afforded a life of its own. In this way *Whistlejacket* introduced the tendency of Stubbs's work as a whole.

This is not to say that Stubbs was exceptionally tender-hearted toward animals. The horses he used for his early researches into equine anatomy were bled to death by the jugular vein for the purpose; clearly he valued the pursuit of scientific knowledge above the individual animal life. But throughout his paintings there are suggestions of the new respect and sympathy, especially for horses, that developed in his time. First, he paid them the homage of scrupulous attention to detail. Artists of the past, even

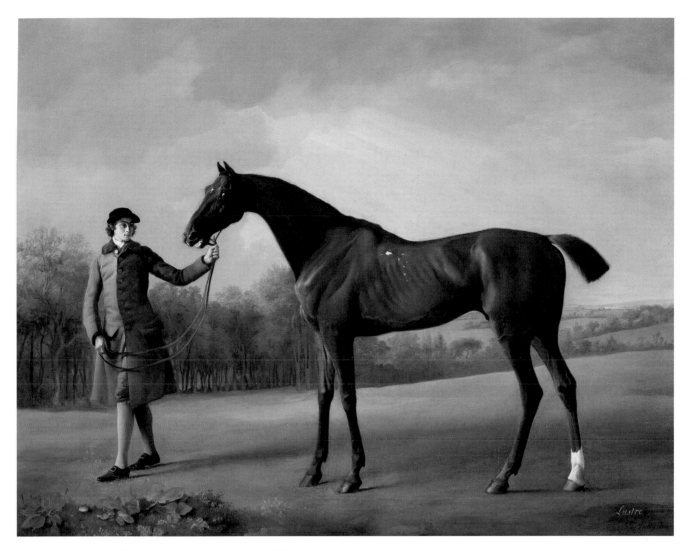

FIG. 10. George Stubbs, *Lustre, with a Groom*, 1761–62. Oil on canvas, 40⅛ × 50 in. (101.9 × 127 cm). Yale Center for British Art, New Haven. Paul Mellon Collection (cat. 34)

those whose treatment of the human figure was informed by considerable anatomical knowledge, sought little beyond a plausible general impression in their paintings of horses. Stubbs painted them as though the judges of his work would be horses themselves—as in the story of Whistlejacket, they occasionally were—and just as observant of errors as a human judge of the human figure. The British horse painters of earlier generations, chiefly John Wootton and James Seymour, relied largely on color, markings, and other obvious features to distinguish one horse from another. Stubbs used his trained eye and superior technical skill to paint whole-body portraits,

muscle by muscle, rivaling any human portraitist in his ability to suggest the living presence of an individual. "Previous to the professional emanations of this gentleman," observed one contemporary, "we were so barbarised as to regard with pleasure the works of Seymour."[35] After Stubbs, the work of the earlier horse painters, like that of the earlier anatomists, looked schematic and unconvincing (figs. 8–10).

Stubbs continued to paint the horse in leading roles for the rest of his career. The tradition of the racehorse portrait with jockeys, trainers, grooms, and stable-lads was well established thanks to Wootton and Seymour. But

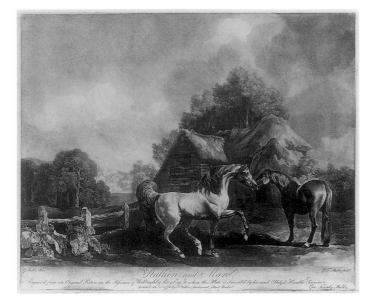

FIG. 11. George Townly Stubbs, after George Stubbs, *Stallion and Mare,* published 1776. Mezzotint, plate: 18¾ × 22¾ in. (47.6 × 57.8 cm). Yale Center for British Art, New Haven. Paul Mellon Collection

FIG. 12. George Townly Stubbs, after George Stubbs, *Horses Fighting,* published 1788. Mezzotint, second state, plate: 18⅞ × 23⅜ in. (48.3 × 59.5 cm). Yale Center for British Art, New Haven. Paul Mellon Collection (cat. 70)

in Stubbs, men and horses began to relate and communicate much more believably than before, like the groups in contemporary "conversation-piece" portraits. He deployed subtleties of body language to suggest understandings and negotiations, character to character, between horses and their human attendants. Generally he avoided the action and spectacle of the races in preference for quieter, almost intimate moments before and after, as though more interested in the horse's private life than its public performance. In Stubbs there is little of the rough-and-tumble of eighteenth-century racing—in which, for instance, a number of mounted spectators might ride in to the finish line with the racers (see fig. 139). The crowd is offstage, leaving the horse and its closest relationships at the center of attention. In the late masterpiece *Hambletonian, Rubbing Down* (see fig. 137), the attendants look out at us as though we were intruders on the exhausted horse's suffering.

Stubbs observed the relationships of horses with humans, fellow horses, and animals of other species. In his images of stallions, mares, and foals, he represented the workings of equine society at the stud farm: male desire and rivalry (figs. 11, 12), female conversation carried on through exchanges of looks. In his portraits of Dun-

gannon (see fig. 134) and the Godolphin Arabian (see fig. 96), he emphasized what the naturalist Gilbert White called the "wonderful spirit of sociability in the brute creation," showing the horses with the sheep and the cat that were their respective paddock mates and close companions.[36] Elsewhere he showed horses in wordless discussion and dispute with dogs. One of his paintings was published as an engraving with the title *Horse at Play*.[37] His scenes of mares with their foals and those of horses attacked by lions—idylls of peace and disasters of war—were perhaps Stubbs's most distinctive and original contribution to British painting. Again the theme was the horse in its own right—without saddle, bridle, or human presence—as a feeling creature. In them the artist touched extremes, on one hand maternal affection and the contentment of family life, on the other the survival instinct and the throes of mortal fear. In *Hambletonian,* painted in 1800, he presented the pained body of the horse with an almost sacramental solemnity, like the body of a martyr in an altarpiece. By the turn of the nineteenth century, the animal had become an individual personality, a feeling creature that deserved respect, even a subject for great art.

Notes

1. Humphry MS, 211.
2. Gilbey 1898, 22.
3. [Upcott?] 1806, 979.
4. See Snape 1683.
5. See Doherty 1974, 8.
6. Markham 1610/1695, 2.356.
7. The phrase appears with variations in a number of sources, including Robert Burton, *The Anatomy of Melancholy* (1621): "England is a paradise for women, and hell for horses: Italy a paradise for horses, hell for women," Burton 1621/1932, 3:265.
8. Markham 1610/1695, 1.8. Shakespeare played on the equine humors in the Dauphin's description of his horse in *Henry V:* "He is pure air and fire; and the dull elements of earth and water never appear in him, but only in patient stillness while his rider mounts him" (3.7.21–23).
9. Newcastle 1667, 28; Snape 1683, 2.
10. Gibson 1735, preface.
11. Gibson 1735, 2.2.
12. Bracken 1752, 1:3.
13. Hawkesworth 1753, 9.
14. Primatt 1776/1992, 23.
15. See John Gay, *Trivia* (1716): "Why vent ye on the gen'rous Steed your Rage?" (2.234), Gay 1974, 1:50; and William Blake, "Auguries of Innocence" (c. 1803): "A Horse misusd upon the Road / Calls to Heaven for Human blood" (ll. 11–12), Blake 1965, 481.
16. Granger 1773.
17. Swift 1726/2001, 222.
18. For a further example of the "horse's progress" narrative, see *The High Mettled Racer,* a series of four aquatints after Thomas Rowlandson, with verses by Charles Dibdin, published in 1789. The final lines of verse are as follows: "And now cold and lifeless exposed to the view, / In the very same cart, which he yesterday drew, / While a pitying croud, his sad relicks surround, / The high mettled Racer is sold for the hounds." Snelgrove 1981, 149.
19. Longrigg 1975, 88.
20. Thomas 1983, 91.
21. Darwin 1794, 1:1 (preface).
22. Snape 1683, 105.
23. Lawrence 1796–98, 1:174.
24. Lawrence 1796–98, 1:79.
25. From his sermon "Free Thoughts on the Brute Creation," first published 1782; Wesley 1876, 2:283. Wesley also campaigned against animal cruelty, and rode thousands of miles as an itinerant preacher using a slack rein to allow his horse to move its neck and mouth freely; see Kean 1998, 18–21.
26. Swift 1726/2001, 266.
27. Primatt 1776/1992, 22.
28. Lines 1, 26–28.
29. Newcastle 1667, 13.
30. Liedtke 1989, 321.
31. See Humphry MS, 205.
32. Millar 1963, 191, no. 591, pl. 200.
33. Walpole 1928, 71.
34. On the significance of the horse's various actions in equestrian portraiture, see Liedtke 1989.
35. John Williams ("Pasquin") in Gilbey 1898, 72.
36. Among other examples, White described the friendship between a horse and a hen; see his letter of August 15, 1775, in White 1789/1993, 164.
37. Lennox-Boyd, Dixon, and Clayton 1989, 266, no. 126.

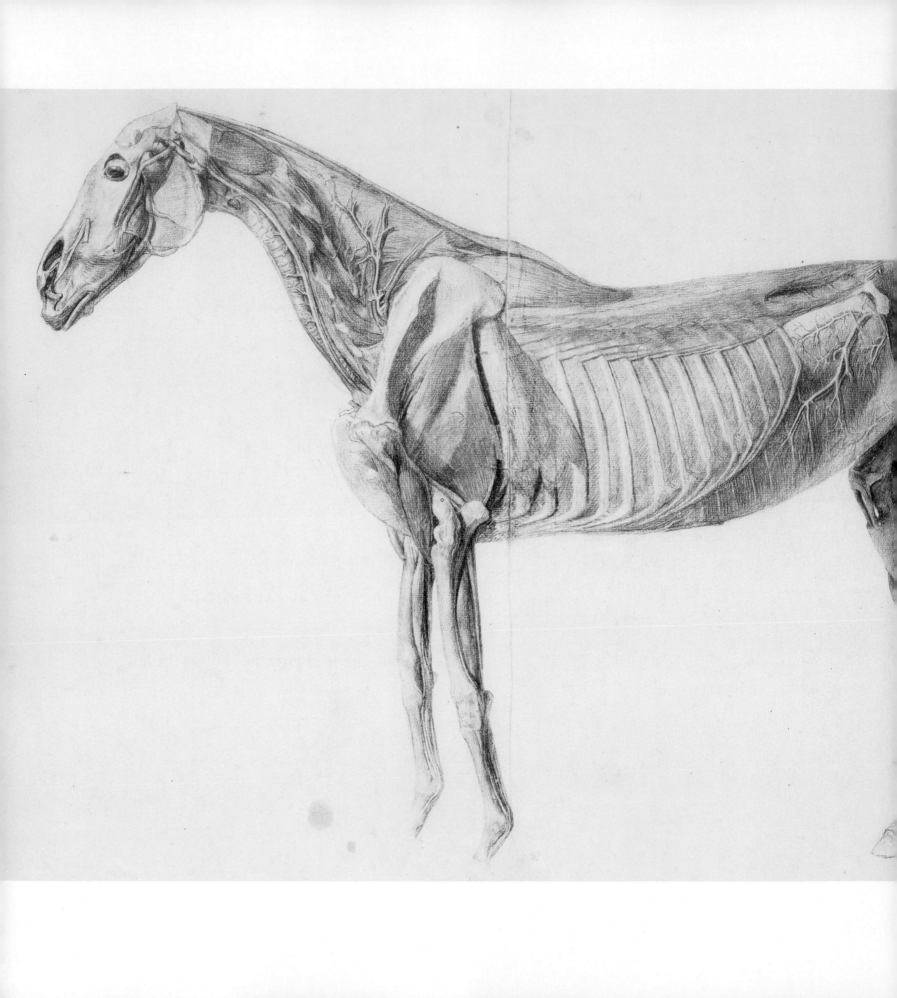

The Anatomy of the Horse

THIS SELECTION of anatomical drawings and etchings comprises working studies, some or all of which Stubbs made directly from the dissections he performed at Horkstow in 1756–58; finished studies from which he etched plates for his book *The Anatomy of the Horse;* and plates from the book itself, which he published in 1766. For further details of the project, see pages 162–72.

The drawings are from the group of forty-two bequeathed to the Royal Academy by Charles Landseer, R.A., in 1879.

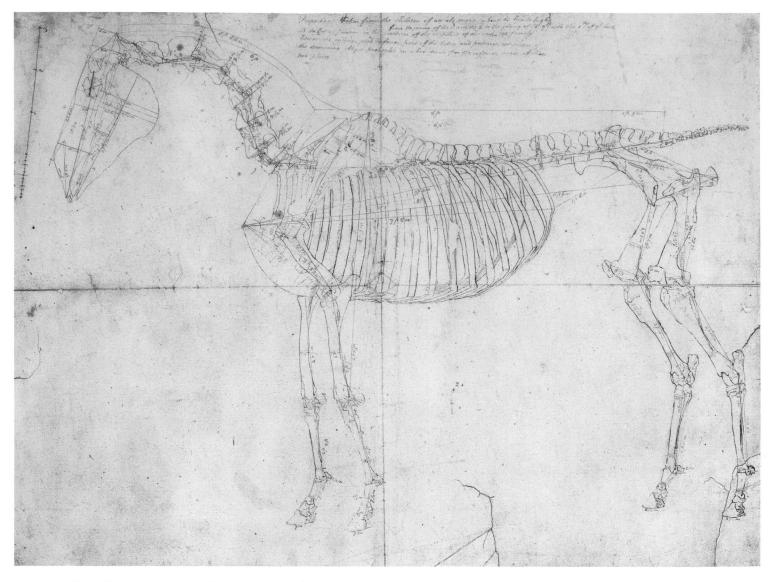

FIG. 13. George Stubbs, *Measured Study of the Skeleton (Lateral)*, 1756–58.
Brown ink, 14½ × 19⅞ in. (36.7 × 50.4 cm). Royal Academy of Arts,
London (cat. 1)

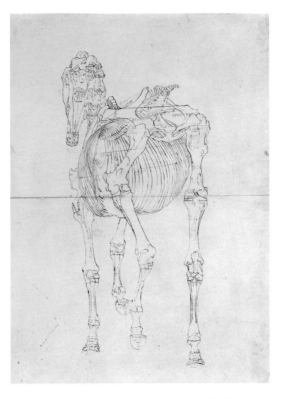

FIG. 14. George Stubbs, *Measured Study of the Skeleton (Posterior)*, 1756–58. Brown ink, 14¹⁄₄ × 9⁷⁄₈ in. (36.7 × 25 cm). Royal Academy of Arts, London (cat. 2)

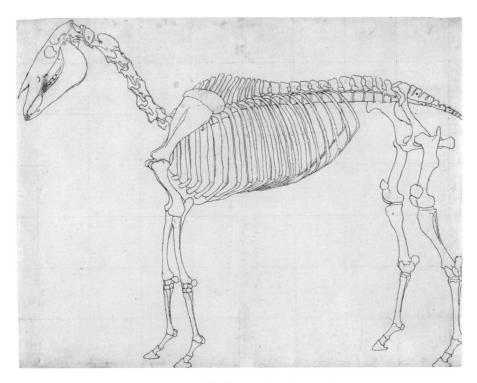

FIG. 15. George Stubbs, *Outline Study of the Skeleton (Lateral)*, 1756–58. Black and gray ink, with graphite, faintly squared for transfer, 18¾ × 23⁵⁄₈ in. (47.5 × 60 cm). Royal Academy of Arts, London (cat. 3)

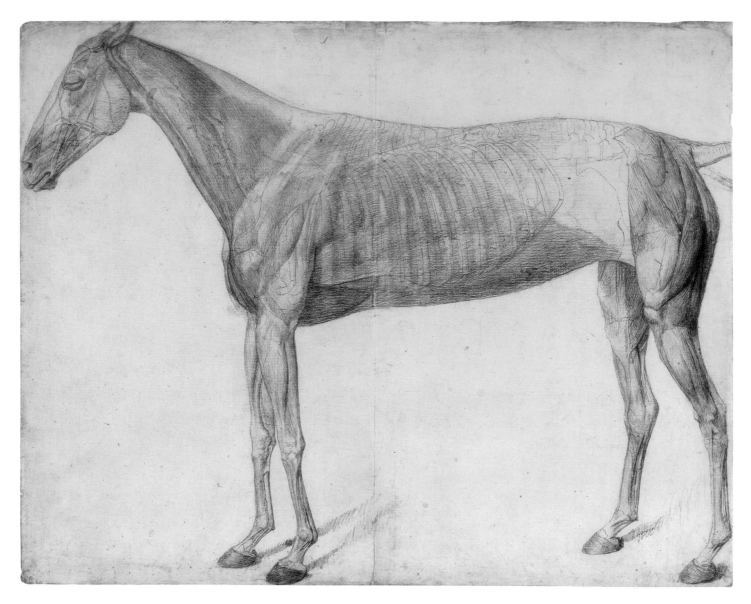

FIG. 16. George Stubbs, *Study of the Muscles (Lateral)*, 1756–58. Graphite, black
and red chalk, and brown ink, 18¾ × 23¾ in. (47.6 × 60.3 cm). Royal Academy
of Arts, London (cat. 4)

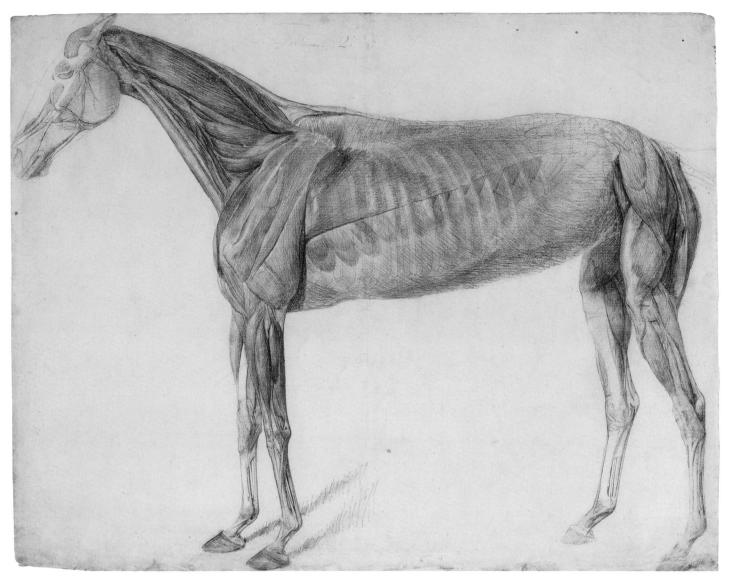

FIG. 17. George Stubbs, *Study of the Muscles (Lateral)*, 1756–58. Graphite, black and red chalk, and red-brown ink, 18¾ × 23¾ in. (47.6 × 60.3 cm). Royal Academy of Arts, London (cat. 5)

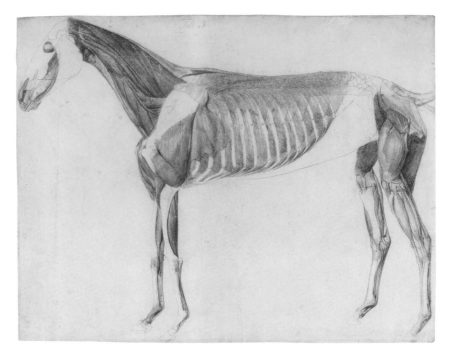

FIG. 18. George Stubbs, *Study of the Muscles (Lateral)*, 1756–58. Graphite, black and red chalk, and red-brown ink, 19 × 23⅞ in. (48.1 × 60.7 cm). Royal Academy of Arts, London (cat. 6)

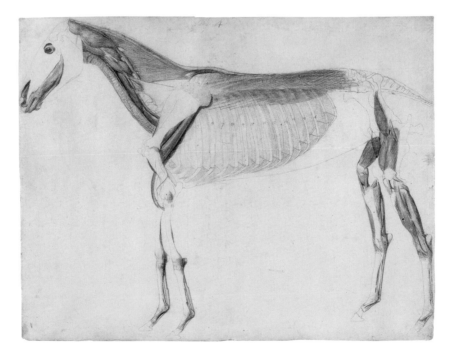

FIG. 19. George Stubbs, *Study of the Muscles (Lateral)*, 1756–58. Graphite, red chalk, and red-brown ink, 19¼ × 24 in. (48.9 × 61 cm). Royal Academy of Arts, London (cat. 7)

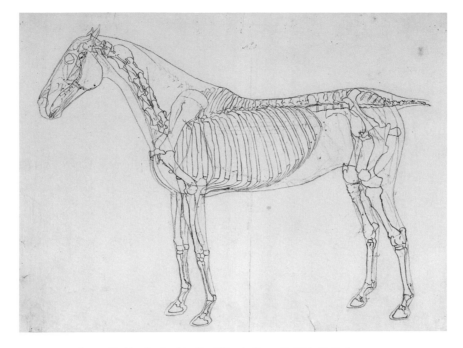

FIG. 20. George Stubbs, *Study of the Blood Vessels (Lateral)*, 1756–58. Red-brown ink, red chalk, and graphite, 14¼ × 19¾ in. (36.3 × 50.2 cm). Royal Academy of Arts, London (cat. 8)

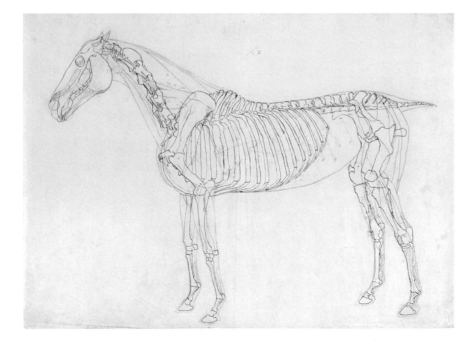

FIG. 21. George Stubbs, *Study of the Blood Vessels (Lateral)*, 1756–58. Orange and brown ink, red chalk, and graphite, 14½ × 19¾ in. (36.7 × 50.3 cm). Royal Academy of Arts, London (cat. 9)

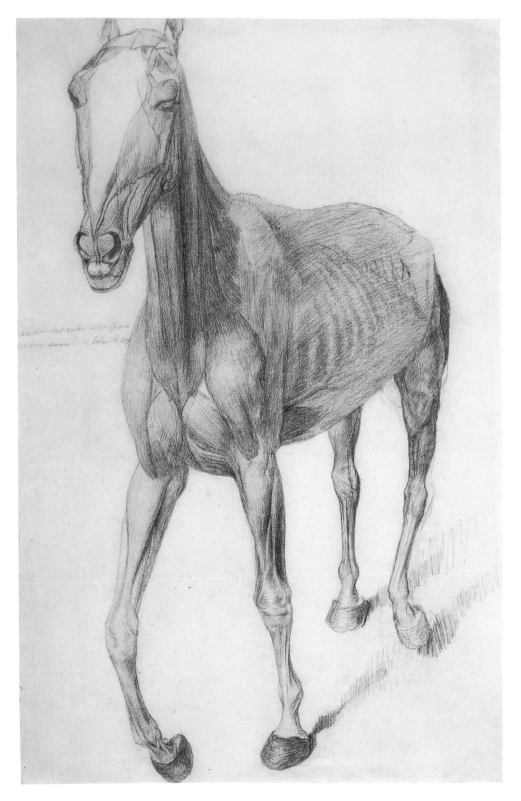

FIG. 22. George Stubbs, *Study of the Muscles (Anterior)*, 1756–58. Graphite and black and red chalk, 18½ × 11¾ in. (47 × 29.8 cm). Royal Academy of Arts, London (cat. 10)

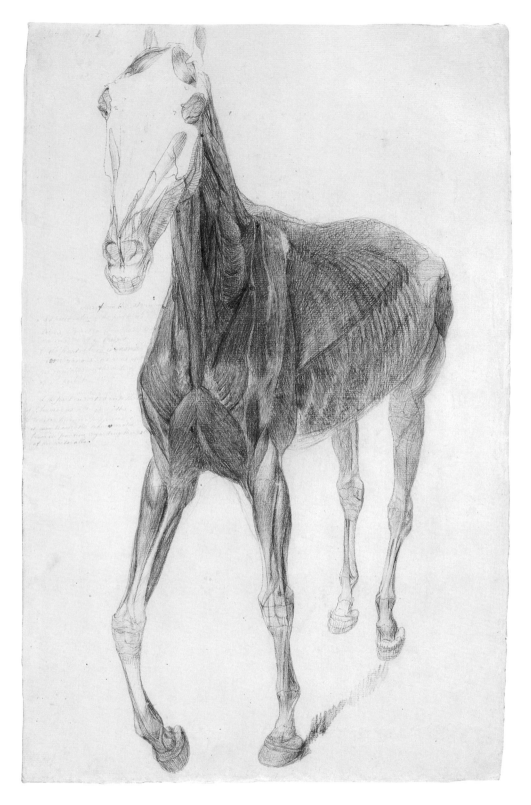

FIG. 23. George Stubbs, *Study of the Muscles (Anterior)*, 1756–58. Graphite, black and red chalk, and red-brown ink, 18⅞ × 12¼ in. (48 × 31.2 cm). Royal Academy of Arts, London (cat. 11)

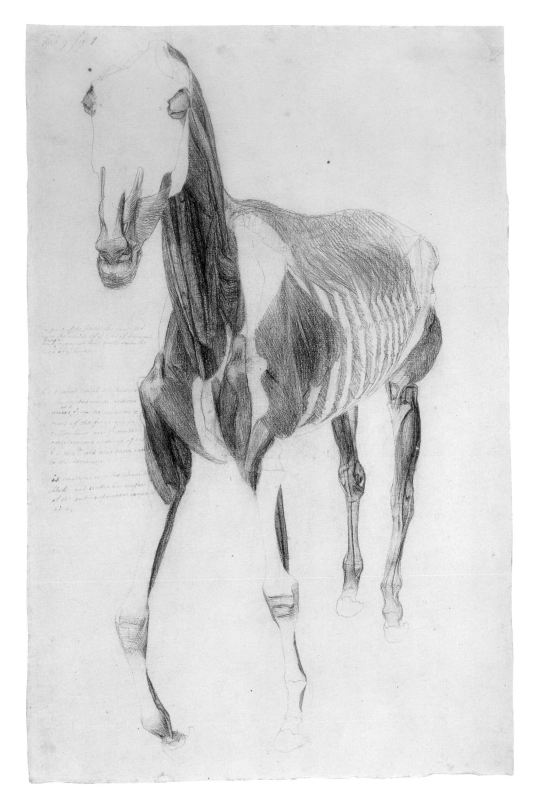

FIG. 24. George Stubbs, *Study of the Muscles (Anterior)*, 1756–58. Graphite,
black and red chalk, and red-brown ink, 18⅞ × 12 in. (48 × 30.5 cm).
Royal Academy of Arts, London (cat. 12)

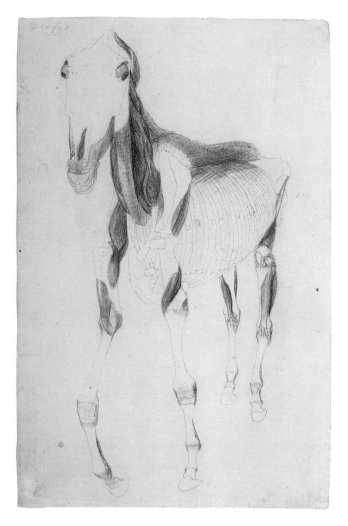

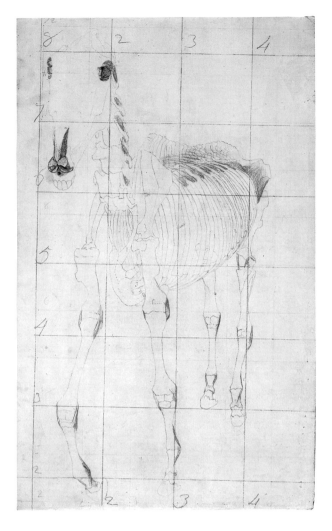

FIG. 25. George Stubbs, *Study of the Muscles (Anterior)*, 1756–58. Graphite, black chalk, and red-brown and gray-brown ink, 19¼ × 12¼ in. (48.8 × 31 cm). Royal Academy of Arts, London (cat. 13)

FIG. 26. George Stubbs, *Study of the Muscles (Anterior)*, 1756–58. Black chalk, gray-brown ink, and graphite, squared for transfer, 18½ × 11½ in. (47 × 29.2 cm). Royal Academy of Arts, London (cat. 14)

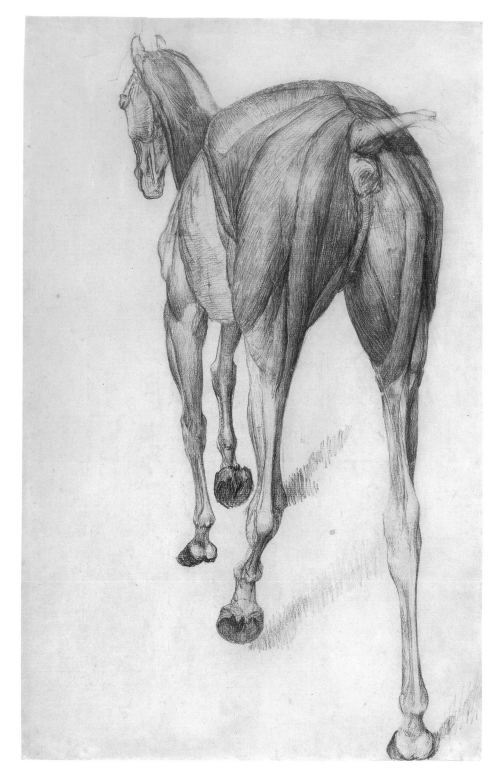

FIG. 27. George Stubbs, *Study of the Muscles (Posterior)*, 1756–58. Graphite and black and red chalk, 18¾ × 11⅝ in. (47.7 × 29.6 cm). Royal Academy of Arts, London (cat. 15)

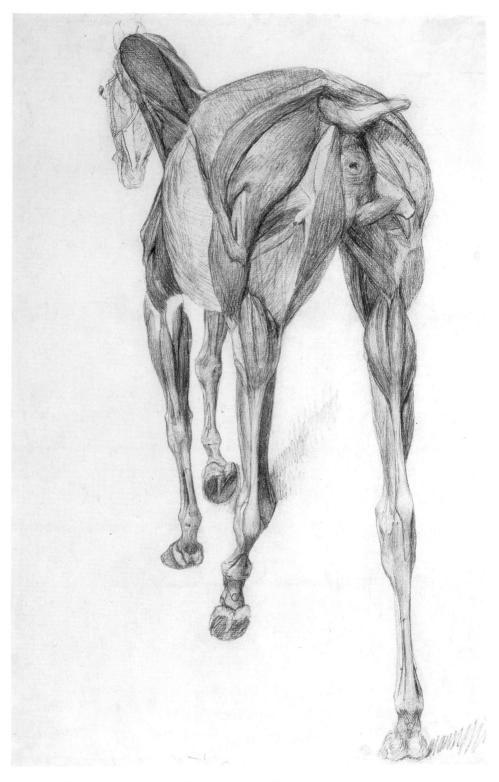

FIG. 28. George Stubbs, *Study of the Muscles (Posterior)*, 1756—58. Graphite and black and red chalk, 18½ × 11½ in. (47 × 29.2 cm). Royal Academy of Arts, London (cat. 16)

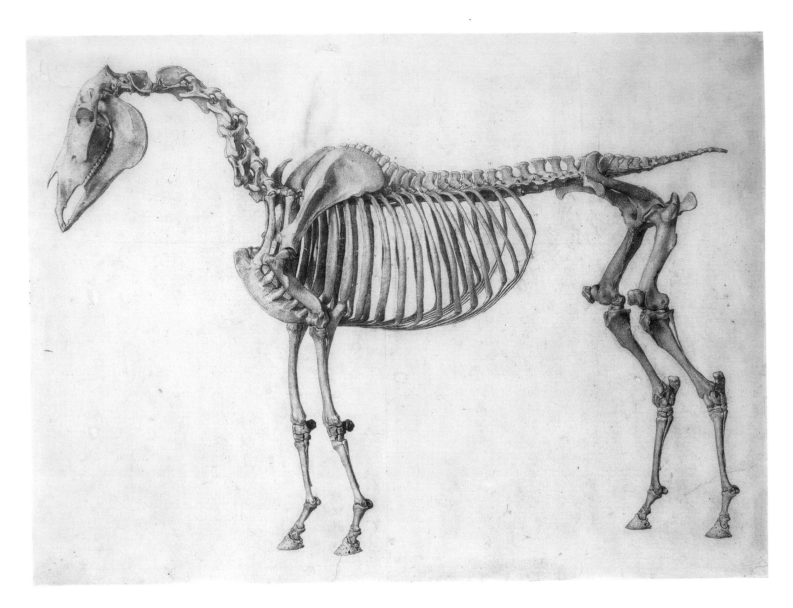

FIG. 32. George Stubbs, *Finished Study for the First Anatomical Table of the Skeleton . . .* , 1756–58. Black chalk, 14¼ × 19 in. (36.1 × 48.3 cm). Royal Academy of Arts, London (cat. 20)

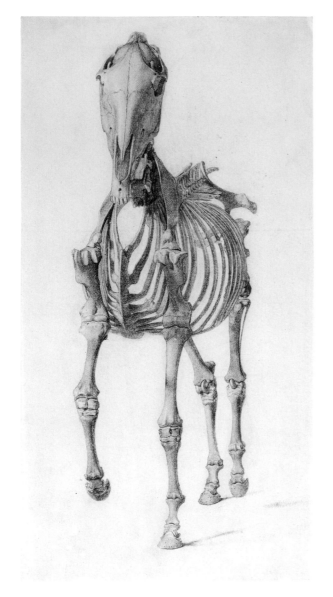

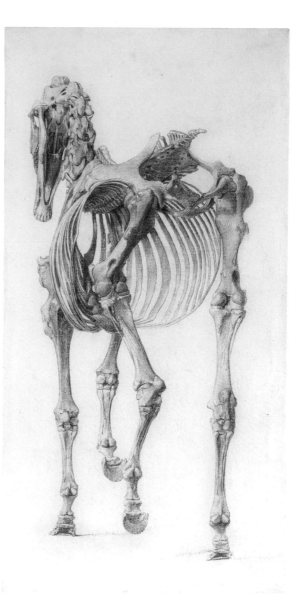

FIG. 33. George Stubbs, *Finished Study for the Second Anatomical Table of the Skeleton* . . . , 1756–58. Graphite and black chalk, 14 × 7¼ in. (35.6 × 18.4 cm). Royal Academy of Arts, London (cat. 21)

FIG. 34. George Stubbs, *Finished Study for the Third Anatomical Table of the Skeleton* 1756–58. Graphite and black chalk, 14 × 7⅛ in. (35.4 × 18 cm). Royal Academy of Arts, London (cat. 22)

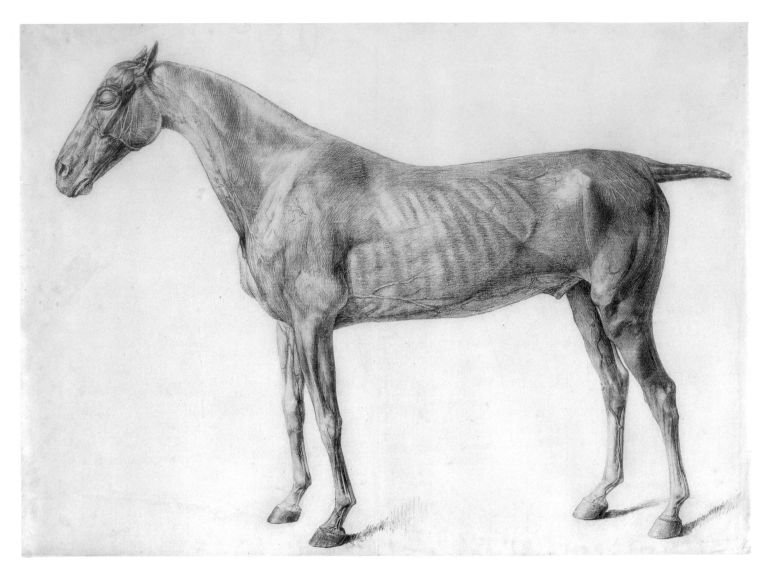

FIG. 35. George Stubbs, *Finished Study for the First Anatomical Table of the Muscles . . .*, 1756–58. Graphite and black chalk, 14½ × 19⅝ in. (36.7 × 49.9 cm). Royal Academy of Arts, London (cat. 23)

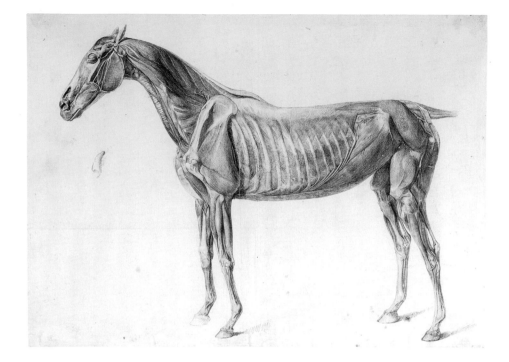

FIG. 36. George Stubbs, *Finished Study for the Third Anatomical Table of the Muscles . . .* , 1756–58. Graphite and black chalk, 14³⁄₈ × 19⁷⁄₈ in. (36.6 × 50.5 cm). Royal Academy of Arts, London (cat. 24)

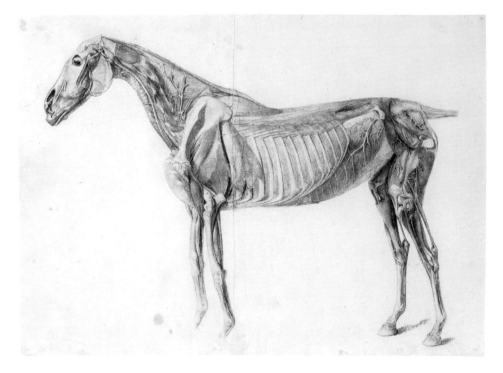

FIG. 37. George Stubbs, *Finished Study for the Fourth Anatomical Table of the Muscles . . .* , 1756–58. Black chalk, 14¹⁄₄ × 19¹⁄₂ in. (36.2 × 49.5 cm). Royal Academy of Arts, London (cat. 25)

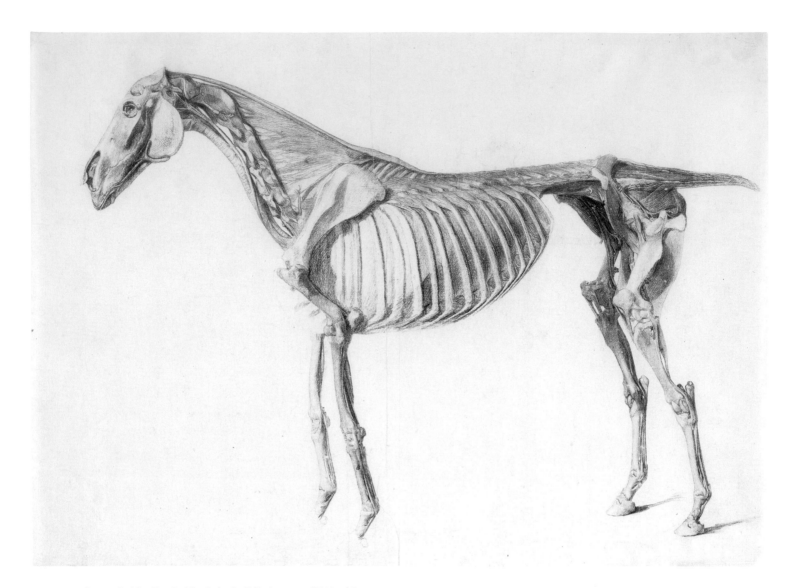

FIG. 38. George Stubbs, *Finished Study for the Fifth Anatomical Table of the Muscles . . .* , 1756–58. Black chalk, 14¼ × 20 in. (36.2 × 50.8 cm). Royal Academy of Arts, London (cat. 26)

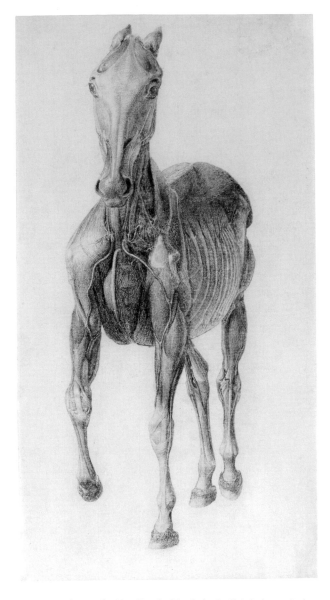

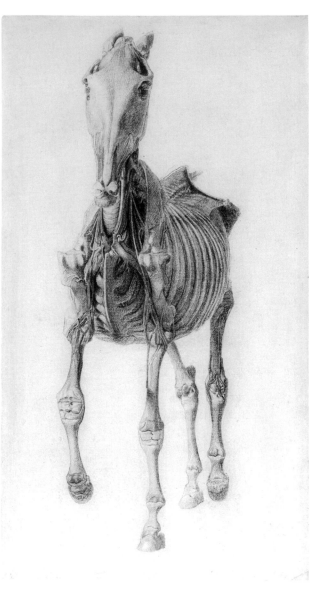

FIG. 39. George Stubbs, *Finished Study for the Eighth Anatomical Table of the Muscles . . .* , 1756–58. Graphite and black chalk, 14 × 7¼ in. (35.5 × 18.4 cm). Royal Academy of Arts, London (cat. 27)

FIG. 40. George Stubbs, *Finished Study for the Tenth Anatomical Table of the Muscles . . .* , 1756–58. Graphite and black chalk, 14 × 7⅝ in. (35.5 × 19.5 cm). Royal Academy of Arts, London (cat. 28)

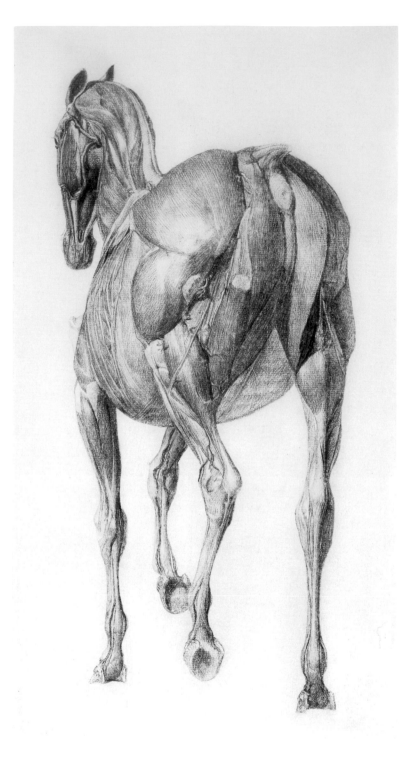

FIG. 41. George Stubbs, *Finished Study for the Thirteenth Anatomical Table of the Muscles . . .* , 1756–58. Graphite and black chalk, 14 × 7¼ in. (35.5 × 18.4 cm). Royal Academy of Arts, London (cat. 29)

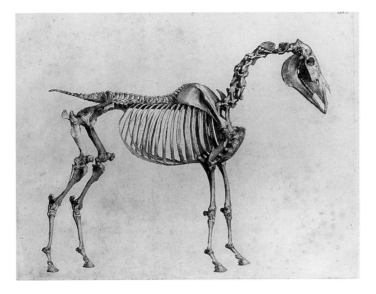

FIG. 42. George Stubbs, *First Anatomical Table of the Skeleton . . .* , from *The Anatomy of the Horse*, 1766, shown without the key figure, which is a separate plate. Etching; plate: 14¾ × 18⅝ in. (37.4 × 47.4 cm). The Pierpont Morgan Library, New York (cat. 30)

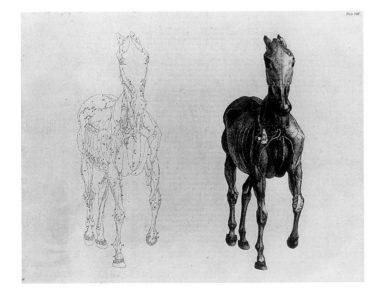

FIG. 43. George Stubbs, *Eighth Anatomical Table of the Muscles . . .* , from *The Anatomy of the Horse*, 1766. Etching; plate: 14⅞ × 18¾ in. (37.9 × 47.5 cm). The Pierpont Morgan Library, New York (cat. 30)

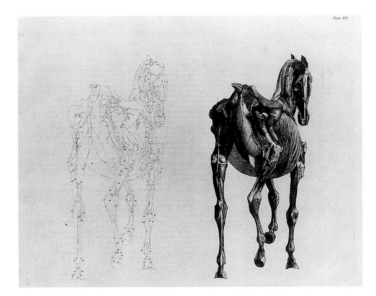

FIG. 44. George Stubbs, *Fourteenth Anatomical Table of the Muscles . . .* , from *The Anatomy of the Horse*, 1766. Etching; plate: 14¾ × 18½ in. (37.5 × 47.1 cm). The Pierpont Morgan Library, New York (cat. 30)

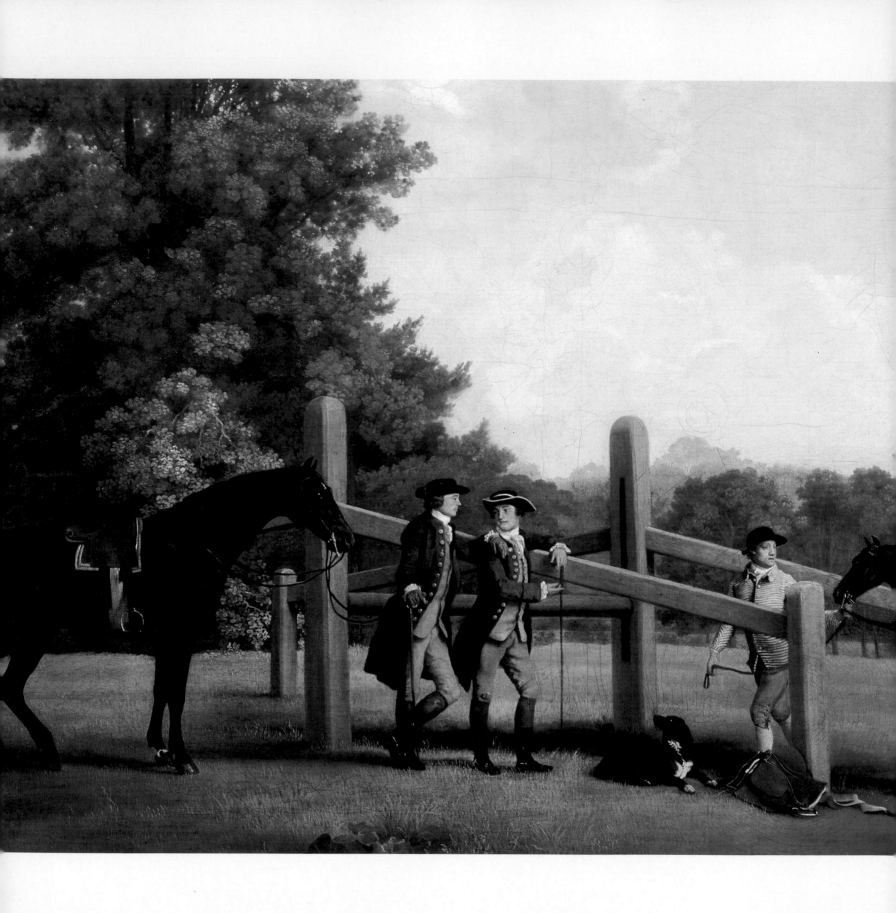

A Different Form of Art

STUBBS AND ROCKINGHAM'S YOUNG WHIGS IN THE 1760S

Robin Blake

UNTIL HE went up to London in 1758 or 1759, at the age of thirty-four, Stubbs had scratched a living as a portrait painter and anatomist in the north country. Despite his precocious and rapidly developing scientific expertise and a remarkable facility for portraiture, he had remained obscurely dependent on a few loyal but unglamorous patrons, such as the Nelthorpe family of Barton-on-Humber in Lincolnshire. His decision to go to the capital, as for so many people then and now, was born of the desire to make his mark and take control of his life.

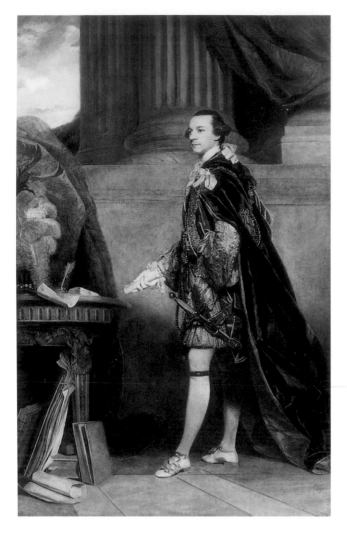

FIG. 45. Joshua Reynolds, *Charles Watson-Wentworth, Second Marquess of Rockingham*, 1766–68. Oil on canvas, 94⅛ × 58¼ in. (239 × 148 cm). The Trustees of the Rt. Hon. Olive, Countess Fitzwilliam's Chattels Settlement, by permission of Lady Juliet Tadgell

His personal circumstances at that time are difficult to construe. Although parish records in Liverpool, York, and Hull prove he had already fathered four children, there is no mention of this family, or even of the mother, in the memoir of his life written down by Ozias Humphry in the 1790s. It is clear that by the time Stubbs made his move to London, his wife (if that is what she was) must have died or been repudiated, but his relocation was probably a more direct consequence of his widowed mother's death two years earlier. This would have allowed Stubbs to sell his interest in the family's leather-dressing business and release much-needed funds. In any event, he did not go south immediately. He traveled instead to the Lincolnshire village of Horkstow, part of the Nelthorpes' estate, and set about a program of meticulous dissections and drawings for a mold-breaking book, *The Anatomy of the Horse,* with which he intended to gain entry to London patronage.

After eighteen laborious months Stubbs arrived in the capital with his drawings for *The Anatomy of the Horse.* Although the book itself would not be published for another seven or eight years, the brilliant preparatory drawings were eloquent enough. He had touted them around town searching for an acceptable engraver, before determining to do the job himself, but the sheets of "the Skeleton . . . Muscles, Fascias, Ligaments, Nerves, Arteries, Veins, Glands and Cartilages of the Horse . . . explained" must have been seen and admired in the meantime by a group of friends occupying a central position in British culture and politics. All coming of age during the 1750s, they were the rising generation of the old Whig landowning families: Richard Grosvenor, Viscounts Torrington and Bolingbroke, the Dukes of Richmond, Portland, and Grafton, John Spencer of Althorp (soon to be the first Earl) and the Marquess of Rockingham (fig. 45).

The encounter with these men was the fulcrum of Stubbs's career, and is paramount to our understanding of the work he produced over the next forty-five years. The Young Whigs had an insatiable desire for paintings of their outdoor activities, invariably involving horses. The anatomical drawings' unprecedented mastery of equine architecture, of the interplay between bones, muscles, blood vessels, hide, and hair, instantly revealed Stubbs's future usefulness. If his (as yet unproven) abilities in landscape matched up, the young men looking over his work in their clubs and coffeehouses knew they were on to a good thing.

ART, LAND, AND SCIENCE

Stubbs's new patrons were wealthy, youthful, and as much in love with art as they were with country life and their own (albeit civilized) aggrandizement. The marquess was their acknowledged leader (to the extent that they were generally known as "the Rockinghams") and he can be taken as epitomizing the group.[1] Like them, his birth and inclination had allotted him a leading role in national life. He had a sound classical education and a Grand Tour behind him. Having strolled among the tumbled remains of antiquity, and seen the manners of ancien régime Europe, he regarded himself as being free from Roman Catholic superstition, above puritan dourness, and the coming man. So did they all.

The call to leadership, whether in taste, science, sport, or politics, could not be answered without wealth, and Stubbs's young patrons had massive resources. In a time of extreme income differentials a vicar like James Woodforde was delighted to get £400 a year, and this was indeed an immense amount compared, for example, to a servant's annual wage of £5. Rockingham and his friends were not merely in another financial league from the servant, or even the parson: they were in a different universe. Grosvenor enjoyed at least £20,000 a year, Spencer £30,000, Richmond £35,000, and Rockingham £40,000. The richest of all was William Cavendish, fifth Duke of Devonshire, who at the age of sixteen came into an inheritance worth £60,000 per annum. These men were the multibillionaires of their age.[2]

But huge landed wealth was handled rather differently in preindustrial times. Its general object was to maintain its owner's aristocratic authority or "face." A noble was still a petty ruler over his extended family as well as his servants, estate workers, and tenants. He had to resolve disputes, punish crimes, give treats and feasts, and dispense charity, all at his own expense. In most cases several great establishments, in country and town, had to be governed in this way: Rockingham, for instance, held land in Yorkshire, Nottinghamshire, and Ireland, as well as a magnificent house at No. 4, Grosvenor Square, London. This was leased from his friend Richard Grosvenor, developer of Belgravia and himself lord over a huge swathe of Cheshire around Eaton Hall.

These houses, and even some of the outhouses, were in effect palaces, and repositories of much accumulated treasure, ranging from luxury goods, clothing, and jewelry to art, furnishings, a library, rare objects, and scientific curiosities. Their fashionably landscaped grounds were home to botanical gardens, glasshouses, exotic menageries, and breeding herds of the best livestock. The business of designing, decorating, and collecting, which entailed the continual employment of architects, artists, scholars, and skilled artisans, was constant. In the choice of these, the essential point was to discriminate. Taste and judgment were the true measures of worldly authority.

The excellence of Stubbs's anatomical drawings was self-evident to such men, and immediately commissions

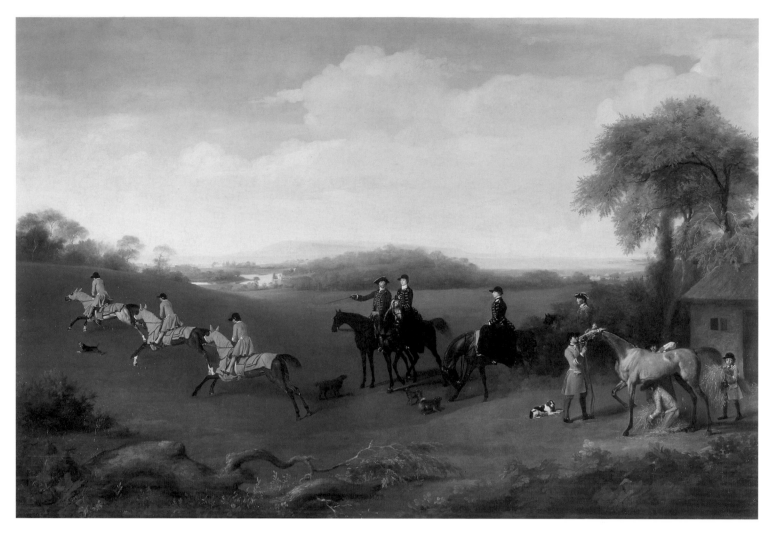

FIG. 46. George Stubbs, *The Duchess of Richmond and Lady Louisa Lennox Watching the Duke of Richmond's Racehorses at Exercise*, 1759–60. Oil on canvas, 55½ × 80½ in. (139.5 × 204.5 cm). Trustees of the Goodwood Collection, Goodwood House, Chichester (cat. 33)

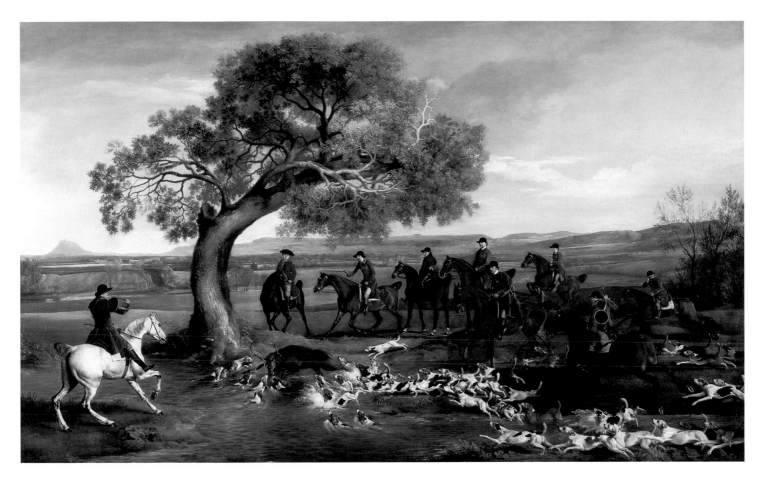

FIG. 47. George Stubbs, *The Grosvenor Hunt*, 1760–62. Oil on canvas,
59 × 95 in. (149 × 241 cm). Private collection

began to appear. In 1759 he was invited to the Duke of
Richmond's Goodwood, where, on Ozias Humphry's
account, he devoted no fewer than nine months to his
most ambitious painting project to date. The result was
three matched canvases: a soft, sweeping landscape with
the duke's string of racehorses exercising (fig. 46); a
sprightly view with Richmond and the hounds of his
Charlton Hunt (see fig. 53); and a shooting scene with
portraits of Lord Albemarle and the redoubtable politician
Henry Fox, later Lord Holland, with their mounts and
grooms. Immediately after completing these, Stubbs
traveled to Richard Grosvenor's Eaton Hall (close to his
own birthplace of Liverpool), where he painted a master-

piece on the dying tradition of stag hunting, *The Grosvenor
Hunt* (fig. 47), against a view of the estate.[3] In the Good-
wood "triptych," and the Grosvenor painting that followed,
we already see the range of work for which the young
Whigs most wanted Stubbs: the depiction of estate activi-
ties, incorporating portraits not only of racehorses, hunt-
ers, and dogs but of themselves, their families, friends,
and servants. As a final component, they expected the
inclusion of views of the English landscape, which was
their land.

As the great Stubbs scholar Basil Taylor commented,
"At no other period in English history were the economic
and social advantages of land possession and the creative

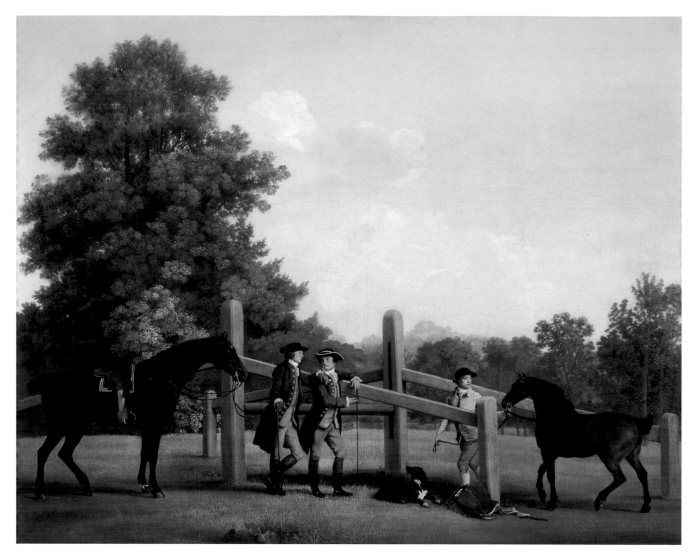

FIG. 48. George Stubbs, *William Henry Cavendish-Bentinck, Third Duke of Portland, and His Brother, Lord Edward Bentinck, with a Groom and Horses,* 1766–67. Oil on canvas, 39 × 49 in. (99.1 × 124.5 cm). Private collection (cat. 53)

satisfactions to be derived from it so intimately and constructively connected."[4] In fact, the magnates liked to treat their lands, shaped by the arts of Capability Brown, William Kent, or Humphry Repton, as living paintings, so that viewing the Claude Lorrain on one's wall and taking a walk in the park seamlessly merged. Repton described strenuous walks with the Duke of Portland on the Welbeck estate (figs. 48, 49): "He would often delight in following the tracks of deer or sheep, into the most sequestered haunts of the forest, and pause when any fresh scene of beauty or interest claimed particular attention, directing my eye to prototypes of Salvater or a Redinger."[5] Perhaps it was while walking (or riding) with the duke that Stubbs himself first visited Creswell Crags, which lay on Portland's land some four miles from Welbeck. This cave-punctured limestone ravine became the most pregnant landscape in

Stubbs's portfolio of backgrounds and settings, appearing again and again in horse portraits as well as in dramatic subject paintings tinged with Edmund Burke's theory of the sublime.

Science as well as art benefited from the magnates' estate improvements. Rockingham financed, and was closely involved with, controlled experiments in fertilizers, land drainage, plowing, and hoeing machinery—some of which he designed himself (fig. 50)—tile-making and brick-making, and, at what was later the site of the Rockingham pottery-works, ceramics. He was also an important early coal miner. With estates sitting on large deposits, he made extensive and pioneering inquiries into the properties of coal, apparently working with the metallurgist and chemist John Roebuck, F.R.S.[6] The tireless, muck-loving farmer and journalist Arthur Young

FIG. 49. *View of the Lake and Some of the Oaks at Welbeck,* without overlay, from Humphry Repton, *Sketches and Hints on the Theory and Practice of Landscape Gardening,* 1795. Colored aquatint, image (fold-out): 21 × 8¼ in. (53.5 × 20.5 cm). Yale Center for British Art, New Haven. Paul Mellon Collection

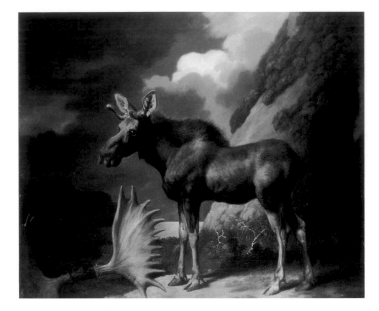

FIG. 52. George Stubbs, *The Duke of Richmond's First Bull Moose*, 1770. Oil on canvas, 24 × 27¾ in. (61 × 70.5 cm). Hunterian Art Gallery, University of Glasgow

humble fellow, Benjamin Wilson, a painter whose family Stubbs had known in Leeds during the 1740s. Rockingham employed Wilson as a family portraitist at Wentworth Woodhouse and went on to support his extensive electrical experiments to determine the correct shape for the tip of a lightning conductor.[11] Benjamin Franklin, one of the best minds of the time, was much occupied with the same question.

Among the sciences, only zoology rivaled anatomy in Stubbs's personal affections, and this, too, was an enthusiasm of the Young Whigs. Rockingham at Wentworth Woodhouse, Portland at Welbeck, Richmond at Goodwood, and Lord Upper-Ossory (a younger member of the circle) at Ampthill, Bedfordshire, all kept exotic menageries for scientific purposes. Twice, in 1770 and 1772, Stubbs was asked to Goodwood to make accurate drawings of bull moose sent from North America, the first of which he also painted (fig. 52).[12] These animals aroused widespread zoological interest, including that of the naturalist Gilbert White of Selborne, who rarely had the chance to see exotic species. White visited Goodwood in 1768 to study a cow moose acquired in the hope of breeding but was disap-

pointed to find only a stinking corpse, for the specimen had died.[13] Richmond's employment of Stubbs to record two of this animal's successors was indicative of how the Young Whigs valued an artist's scientific credentials. They were very far indeed from seeing him as an ordinary decorative or genre painter.

The same spirit of inquiry and experiment could extend to another essential country activity, the chase. The key development here was the rise of foxhunting and the search for a hound most scientifically suited to the job. When painting Richmond's Charlton Hunt in 1759 (fig. 53), Stubbs took the opportunity to develop a connoisseur's eye for the breed. Twenty foxhounds are seen in the foreground, each in a different movement, as if for the illustration of a treatise. A graphite sketch of one of these survives;[14] it may be a remnant from the series of kennel studies, presumably at least twenty, that Stubbs made from life in preparation for the painting. In 1788 he published a set of fine soft-ground etchings, one from the existing drawing, the others of four hounds in poses identical to individuals in the painting.[15] The prints suggest that the drawings had once had, and retained, a definitive quality in his mind, though the idea of publishing them may have been prompted by the completion in the previous year of magnificent centrally heated Palladian kennels at Goodwood, designed by James Wyatt and built at a cost of six thousand pounds.[16]

THE THOROUGHBRED PORTRAITS

A valuable horse was even more spoiled than a prize hound. Rockingham's new stables at Wentworth, begun in 1766, were "almost as impressive as the house itself," which is saying something.[17] Arthur Young described the stable complex after his visit in 1770: "It is to form a large quadrangle, inclosing [*sic*] a square of 190 feet, with a very elegant front to the park; there are to be 84 stalls,

FIG. 53. George Stubbs, *The Duke of Richmond with the Charlton Hunt*,
1759–60. Oil on canvas, 55 × 97½ in. (139.5 × 247.5 cm). Trustees of the
Goodwood Collection, Goodwood House, Chichester

with numerous apartments for the servants attending;
and spacious rooms for hay, corn, &c &c dispersed in such
a manner as to render the whole perfectly convenient."[18]
The complex was to house the marquess's domestic and
estate horses and his stud. Running horses were kept at
nearby Swinton, where Rockingham maintained an oval
circuit of a mile and three quarters for training purposes.
This was the training base for northern race meetings
only, and he had a second training establishment at
Newmarket.[19]

Racing may have been an intoxicating, raucous, highly
sociable, and in the eyes of many an irredeemably disrep-
utable activity—a natural magnet for hucksters, thieves,
confidence men, and whores, not to mention bookies. But
to men like Rockingham, Grafton, and Bolingbroke, it
had a serious purpose. The "racecourse test" was the sin-

gle yardstick of success in their joint selective breeding
enterprise, designed to produce the fastest possible
horse. To this end, data on breeding and racing were col-
lected with increasing detail, aided by the formation of
the Jockey Club around 1750, especially once the "Jockeys"
had engaged their keeper of the match book, James
Weatherby, in 1773. Under his supervision a comprehen-
sive set of breeding records and rules for racing speedily
evolved, and what is perhaps the longest-lasting scientific
experiment in history had begun. It continues today.

The brood-mares and foals painted so accurately by
Stubbs were part of the process of documentation. In
keeping with the high aesthetic value placed on science
in the Georgian period, they are also signally beautiful.
Those painted for Rockingham in about 1762 are what
might be called equine nudes, standing tranquil and free

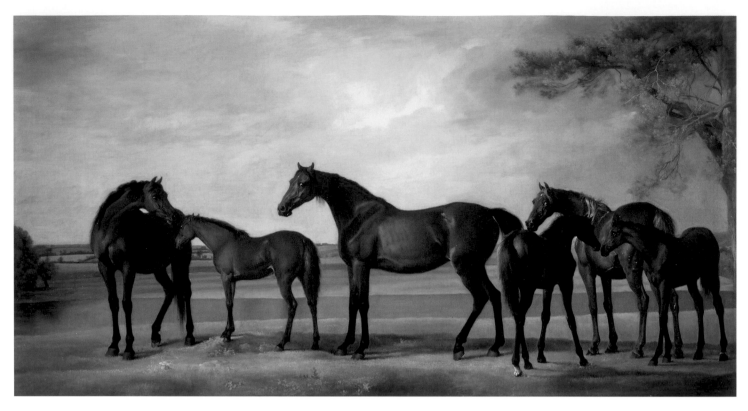

FIG. 54. George Stubbs, *A Brood of Mares*, 1761–62. Oil on canvas, 39 × 74 in. (99 × 187 cm). Private collection (cat. 35)

against a neutral, sand-colored background (see fig. 73). Members of Rockingham's circle placed six similar commissions with Stubbs—although in these cases, less radically, the mares are shown as figures in a landscape (fig. 54). Stallions do not generally appear in a state of nature; in this respect Rockingham's rearing, monumental *Whistlejacket* (see fig. 6) is an outstanding exception. Lord Bolingbroke's *Lustre, with a Groom* (see fig. 10) is more typical of the realistic and practical approach Stubbs settled for in his stallion portraits. The landscape is generalized and conventionally picturesque but nevertheless pays tribute to the patron's status as a true magnate and patriotic lover of the land.

At the races themselves, the hurly-burly of a meeting at Newmarket or York never interested Stubbs, at least not artistically—not in the way it was to interest Thomas Rowlandson, for instance (fig. 55; see also fig. 126). Stubbs's racing thoroughbreds are not wretched pawns in a game of dissipation but models of nobility. At first he placed them against generalized landscapes, like those of his mares

and foals. *The Marquess of Rockingham's Scrub, with John Singleton Up* (see fig. 80) and *Molly Long-Legs*, two of his earliest portrayals of racers as opposed to studhorses (indicated as such by the inclusion of a jockey in racing colors), stand in soft, idealized backgrounds.[20] A third, Grafton's *Antinous*, painted about 1763, has a distant view of what is surely Euston Hall, although here the landscape was done not by Stubbs but by his occasional collaborator and friend George Barret.[21]

From this time, however, there is a change in Stubbs's running horses. Now they are placed in the working environment of Newmarket Heath, a bare, windswept, and not at all picturesque space, with low horizons perfect for showing up the contours of the standing, profiled animal. One of the four rubbing-down houses (the subject of Stubbs's only known pure landscape paintings) was a favorite identifying element, and in the background, Newmarket's parish church of Saint Mary, the windmill, the Beacon Course's viewing boxes, and a running rail might also be shown. Conspicuously, there was no acknowledg-

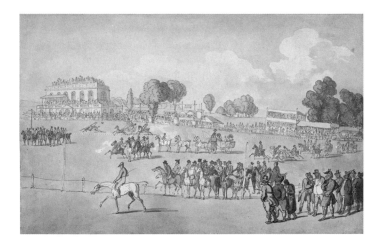

FIG. 55. Thomas Rowlandson, *York Races,* c. 1816. Pen and watercolor, sight: 9⅝ × 15 in. (24.4 × 38.1 cm). Museum of Fine Arts, Boston. Gift of John T. Spaulding

ment whatever of the horse's raffish appeal for the gambling public.

In the mid-1760s Stubbs created one of his most complex works in this mode, Bolingbroke's *Gimcrack on Newmarket Heath, with a Trainer, a Stable-Lad, and a Jockey* (fig. 56). The subject was an outstanding racer of his time, a diminutive but very courageous gray colt (he stood only 14.2 hands) who suffered one of his few defeats (though a "very easy" one) to Rockingham's durable Bay Malton—which, in another Rockingham commission, Stubbs also showed at full gallop (fig. 57). Gimcrack passed through the hands of six owners—Bolingbroke's tenure lasting for only a few months in 1765—and Stubbs painted him several times. This canvas commemorating one of his early victories is unique among Stubbs's known

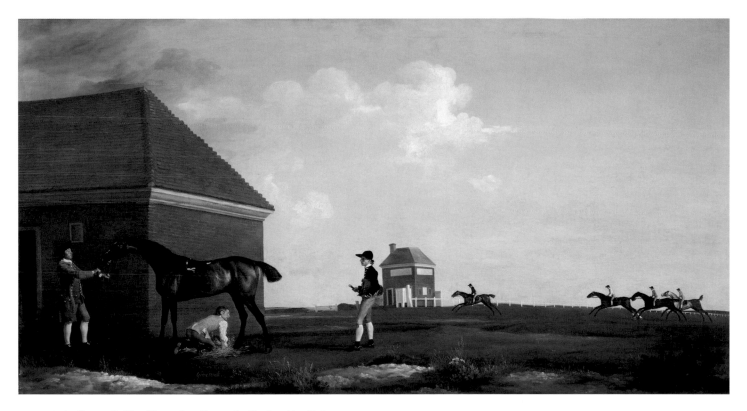

FIG. 56. George Stubbs, *Gimcrack on Newmarket Heath, with a Trainer, a Stable-Lad, and a Jockey,* 1765. Oil on canvas, 40 × 76 in. (101.6 × 193.2 cm). The Woolavington Collection (cat. 45)

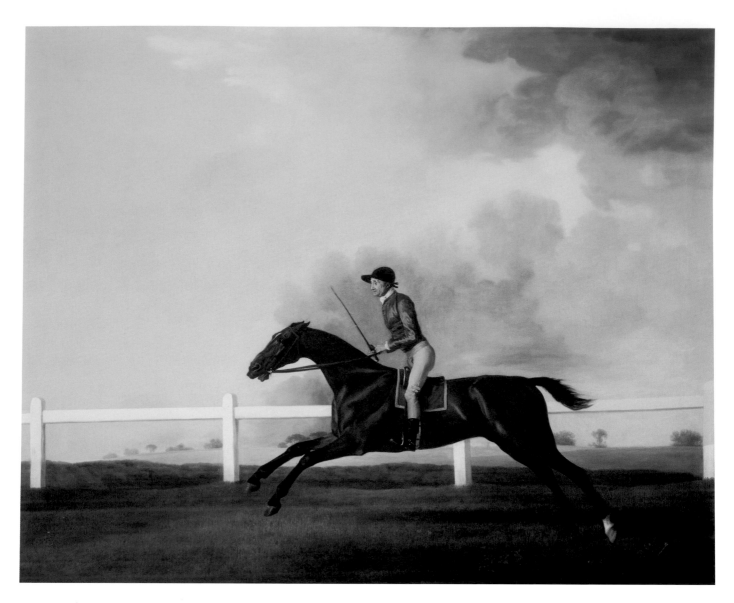

FIG. 57. George Stubbs, *Lord Rockingham's Bay Malton with John Singleton Up*, 1766. Oil on canvas, 40 × 50 in. (101.6 × 127 cm). Private collection

work: it is a double, or "time-shift," composition in which the colt is seen on one hand distantly galloping past the winning post well ahead of his field while, on the other, he stands in the foreground being rubbed down after the victory.

The race shown by Stubbs presents a puzzle. It is usually said to be Gimcrack's match for a thousand guineas against Sir James Lowther's Ascham on July 10, 1765. But a match implies only two participants, whereas the race

in progress shows four: the gray Gimcrack carrying black colors (Bolingbroke); a chestnut whose jockey wears Richard Vernon's white; and third and fourth horses, a brown or bay and a lighter gray, whose jockeys' jackets look similarly yellow, although one or both may originally have been the orange of Lowther.[22] The only four-horse race won by Gimcrack at Newmarket was on his debut at the course on April 9, 1765, when his owner is recorded as being William Wildman.[23] In that race the runner-up was

indeed a Vernon horse, the chestnut colt Prophet, while the third was Lowther's Treasure, a brown colt. But if this were the occasion of Stubbs's painting, why would Gimcrack not be shown carrying Wildman's red colors, as he does in *Gimcrack with John Pratt Up, at Newmarket* (see fig. 81)?[24] In addition, since the fourth horse in the race Gimcrack won on April 9 is recorded as a bay colt belonging to Sir John Moore (perhaps his South West), why would Stubbs show a light gray carrying not Moore's "darkest green" but the same colors as the horse in front of him? For reasons already given, historical accuracy was seen as an important part of sporting art, and at the present state of our knowledge, these questions have no obvious answer.[25]

Stubbs had such a quick eye that he could accurately reproduce the spray pattern of a water splash, as Basil Taylor showed by comparing the water under a leaping hound in *The Grosvenor Hunt* with a modern high-speed photograph of a splash.[26] Stubbs seems to have been aware that, for the galloping horse, it was incorrect to show four legs simultaneously extended; this is perhaps one reason why he preferred a standing pose where possible. No one grasped the true motion of galloping until Eadweard Muybridge published his sequential photographs in 1887 (fig. 58). Nevertheless it is remarkable how close Stubbs came, here and in other occasional examples, including *Lord Rockingham's Bay Malton with John Singleton Up*, to achieving a convincing arrangement. He realized, in particular, that the hind legs do not push off the ground together but quickly follow each other; he also understood the forward thrust of the head at the same moment.[27] This is the only part of the galloping cycle that the eye has a chance of getting even half right, which is why Stubbs, in common with most other horse painters, tended to show a field of runners stretching out identically, as if in formation, which would be impossible in reality.

FIG. 58. *Gallop: Thoroughbred Bay Mare (Annie G.)*, plate 626 from Eadweard Muybridge, *Animal Locomotion: An Electro-Photographic Investigation of the Phases of Animal Movements*, 1887. Harry Ransom Humanities Research Center, University of Texas at Austin

POLITICS AND PAINT

As Stubbs's involvement with the Rockinghams progressed, the magnates themselves became increasingly active as a party in politics, climaxing in mid-1765 with a brief stint in government, when Rockingham was prime minister. Their party line, and that of the members of Parliament who depended on their patronage and voted with them, was anticourt, pro-America, antitaxation, and latitudinarian, shading into a patrician form of liberalism that, as they saw it, guaranteed the interests of the free-born Englishman. They particularly disliked the influence of George III's friend the Scottish Earl of Bute and were determined to campaign against him. What can be said about Stubbs in relation to this world of politics? How far was he in any sense a party political artist?

It may seem a surprising question to ask about Stubbs, but in Yorkshire he had openly associated with men of highly political outlook, the Tories and Jacobites around the redoubtable Dr. John Burton of York, whose book he illustrated.[28] As he came into contact with the Rockinghams, his Jacobite connections were abandoned or buried, but he may not have entirely abandoned his

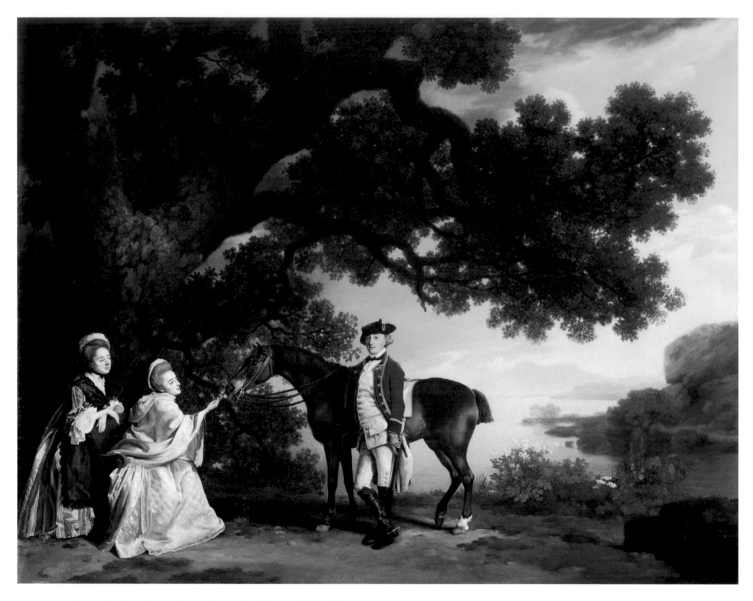

FIG. 61. George Stubbs, *Captain Samuel Sharpe Pocklington with His Wife, Pleasance, and Another Lady, Possibly His Sister Frances,* 1769. Oil on canvas, 39½ × 49⅞ in. (100.2 × 126.6 cm). National Gallery of Art, Washington, D.C. Gift of Mrs. Charles S. Carstairs in memory of her husband, Charles Stewart Carstairs (cat. 58)

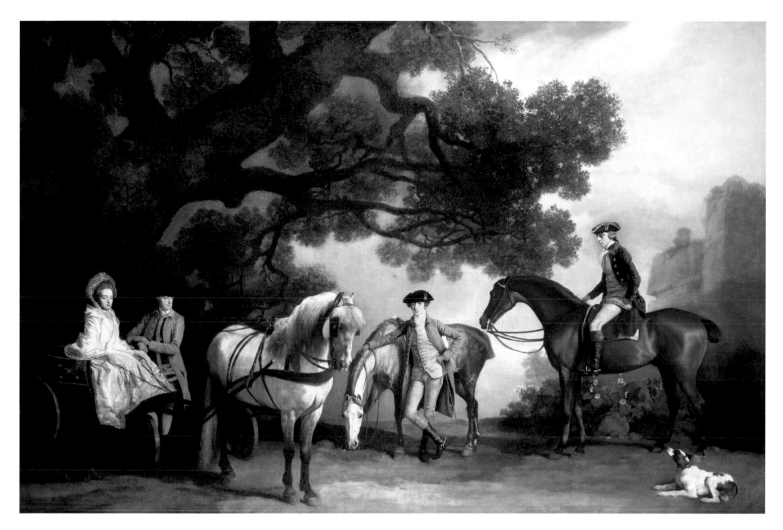

FIG. 62. George Stubbs, *Sir Peniston and Lady Lamb, Later Lord and Lady Melbourne, with Lady Lamb's Father, Sir Ralph Milbanke, and Her Brother John Milbanke (The Milbanke and Melbourne Families)*, 1769–70. Oil on canvas, 38¼ × 58 in. (97.2 × 147.3 cm). The National Gallery, London (cat. 59)

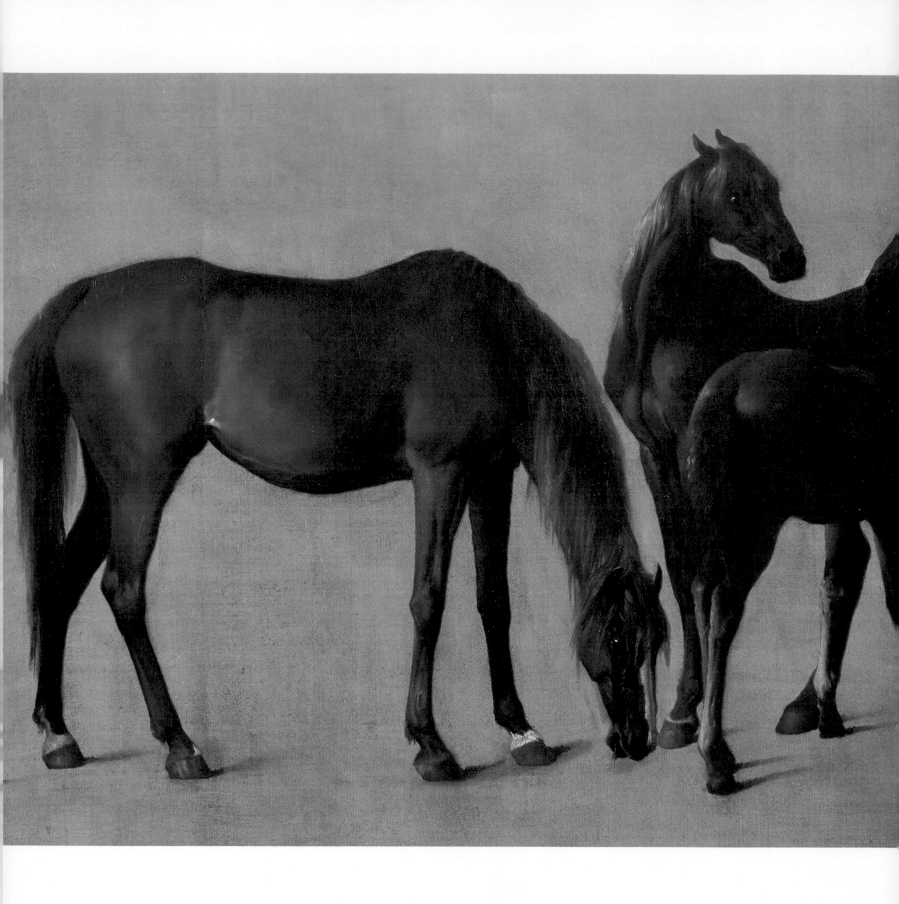

Stubbs's Classicism

Malcolm Warner

WHEN STUBBS mentioned the groups to whom he hoped *The Anatomy of the Horse* would be useful, he placed them in the following order: artists, farriers, anatomists, and "gentlemen who delight in horses."[1] Certainly he thought of the work as a contribution to science; as the primacy he gave the artists implied, however, he thought of it first as a contribution to art. Stubbs's predecessors in equine anatomy, Carlo Ruini and Andrew Snape, had the needs of farriers uppermost in their minds and dealt with the whole body of the horse, devoting their attention in large part to the bowels and other internal organs. Stubbs was more specialized, concentrating on the skeleton, muscles, and blood vessels. In 1771 the Dutch anatomist Petrus Camper wrote him a letter full of admiration for his work and asked whether he would be expanding it to cover the

internal organs and equine diseases. Stubbs replied: "What you have seen is all I meant to do, it being as much as I thought necessary for the study of Painting."[2] As he well knew, the anatomy of real importance to the painter was the skeleton for the basic proportions and the muscles for the contours of the skin.

Artists since the Renaissance had studied human anatomy to master the depiction of the figure, especially the nude. Introducing his later anatomical work, *A Comparative Anatomical Exposition of the Structure of the Human Body, with that of a Tiger and Common Fowl,* Stubbs wrote that a knowledge of anatomical proportions was as necessary to the painter or sculptor "as to the Physician or Surgeon," adding that "Leonardo da Vinci and Michael Angelo de Bonaroti were excellent Anatomists."[3] It was a sign of the importance placed on anatomy for artists that it was one of the four subjects, along with painting, perspective, and architecture, in which professorships were established at the Royal Academy on its foundation in 1768. The human skeleton and the body with the skin removed to reveal muscles (known as an *écorché,* or "flayed," figure) were standard drawing exercises for students, and artists commonly kept anatomical engravings in the studio for ready reference. To provide a reference collection of equine skeletons and écorchés, as Stubbs did in *The Anatomy of the Horse,* was to imply that the horse, like the human figure, deserved special attention; in this sense it was a manifesto for the horse as a subject for art.

The greater respect and sympathy for the "brute creation" that developed in the eighteenth century made people less apt to dismiss any species of animal as ugly, and many were painted that had never been painted before. In 1770, for the naturalist William Hunter, Stubbs tackled the Canadian moose (see fig. 52).[4] Still, the horse enjoyed a special position as a creature of beauty and, for

many, the most beautiful of all. In *The Analysis of Beauty* (1753), William Hogarth wrote: "This noble creature stands foremost amongst brutes; and it is but consistent with nature's propriety, that the most useful animal in the brute-creation, should be thus signalized also for the most beauty."[5] In the first chapter of his book, Hogarth used horses as examples of the importance of "fitness" (appropriateness) to beauty, drawing a parallel with famous classical sculptures: "Fitness of parts also constitutes and distinguishes in a great measure the characteristics of objects; as, for example, the race-horse differs as much in quality, or character, from the war-horse, as to its figure, as the Hercules from the Mercury. The race-horse, having all its parts of such dimension as best fit the purposes of speed, acquires on that account a consistent character of one sort of beauty."[6] The horse's movements, he argued, bore out his theory of the gently winding Line of Beauty: "Whoever has seen a fine Arabian war-horse, unback'd and at liberty, and in a wanton trot, cannot but remember what a large waving line his rising, and at the same time pressing forward, cuts through the air; the equal continuation of which, is varied by his curveting from side to side; whilst his long mane and tail play about in serpentine movements."[7]

For eighteenth-century writers on both aesthetic and equine matters, the beauty of the horse lay not only in its form and movement but also in the relative smoothness of its coat. Edmund Burke agreed with Hogarth that gradual variation in line and shape was an important property of beauty but considered smoothness more important still.[8] The idea of beautiful smoothness echoed through writings in praise of the horse from the midcentury on—as, for instance, in *A General History of Quadrupeds* (1790) by Thomas Bewick: "The various excellencies of this noble animal, the grandeur of his stature,

the elegance and proportion of his parts, the beautiful smoothness of his skin, the variety and gracefulness of his motions, and, above all, his utility, entitle him to a precedence in the history of the brute creation."[9] The smoothness of the horse's body, its muscles showing through in undulating relief, made its beauty almost human; in this respect the horse had an advantage over its generally hairier competitor for man's admiration, the dog. It was not implausible to compare equine beauty to that of the ideal figure in classical art: a warhorse was like the Hercules, a racehorse like the Mercury. Some horses were smoother than others, of course, and writers made a distinction between the true beauty of the Arabian or thoroughbred and the lower, "picturesque" appeal of the rougher forms of equine life. Among animals that were picturesque, wrote Uvedale Price: "The ass is eminently so, much more than the horse; and among horses it is the wild forester with his rough coat, his mane and tail ragged and uneven, or the worn out cart-horse with his staring bones. The sleek pampered steed with his high arched crest and flowing mane is frequently represented in painting, but his prevailing character either there or in reality is that of beauty."[10] The famous wit Sydney Smith put the same idea in terms of ecclesiastical class distinction: "The Vicar's horse is *beautiful,* but the Curate's is *picturesque.*"[11]

The idea of the horse as classically beautiful gained from the prominence of horses in the culture of ancient Greece and Rome. Writers on horses and horsemanship could, in a way that was central to eighteenth-century British thought as a whole, relate the modern to the ancient. This was the approach of Richard Berenger, gentleman of the horse to George III, in his book *The History and Art of Horsemanship* (1771). Berenger felt that, despite the teachings and writings of the Duke of Newcastle in the seventeenth century, great horsemanship was yet to flourish in Britain. His book, he hoped, would herald a golden age. Just as Joshua Reynolds insisted on the classical tradition in the discourses on art that he delivered to the students of the Royal Academy (1769–90), so Berenger endeavored "to trace the history of the equestrian art from its earliest appearance among men, but more *immediately* from its two great sources, *Greece* and *Rome.*"[12] The frontispiece to his first, more historical volume showed a statue of a centaur, half horse and half man, "the symbol of horsemanship."[13] Berenger introduced his subject with an erudite summary of references to horsemanship in ancient sources, largely Greek and Roman. The volume included an engraving of riders from the Parthenon frieze provided by the architect James "Athenian" Stuart, a translation of the treatise on horsemanship of the ancient Greek author Xenophon, and a scholarly "Dissertation on the Ancient Chariot" by Thomas Pownall. The frontispiece to the second volume, devoted to riding techniques, showed Minerva, goddess of wisdom, offering humanity her latest invention, the bridle (fig. 64).

The passages in classical literature featuring horses, much cited by Berenger, and in any case well known to the educated, lent the present-day horse an aura of antiquity. In addition to Xenophon, there was the discussion of the points of a good horse in the third of Virgil's *Georgics,* which were the model for a whole genre in eighteenth-century English poetry. There were also the horses—and centaurs—of Greek and Roman myth: the winged Pegasus, who was the mount of the heroes Bellerophon and Perseus;[14] the four horses that pulled the chariot of the sun and ran out of control when the sun god allowed his son Phaeton to take the reins; the wild, human-flesh-eating mares of King Diomedes, which were tamed by Hercules; the centaur Nessus, who tried to ravish Hercules's beloved

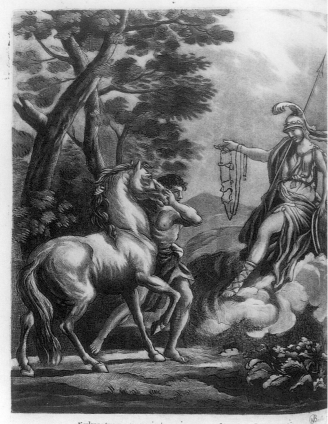

FIG. 64. William Baillie, frontispiece to vol. 2 of Richard Berenger, *The History and Art of Horsemanship*, 1771. Etching and mezzotint, plate: 9½ × 7¾ in. (24 × 19.7 cm). Yale Center for British Art, New Haven. Paul Mellon Collection

FIG. 65. D. P. Pariset, after Pierre Falconet, *G. Stubbs, Animalium Pictor*, published 1769. Roulette work, plate: 8½ × 5¾ in. (21.5 × 14.7 cm). National Portrait Gallery, London

Deianira and was killed by Hercules with his bow and arrow; and Chiron, another centaur, who was the wise and noble teacher of Achilles. The equine heroes of classical history included both Alexander the Great's Bucephalus and the horse of his adversary Darius, whose neighing at the right moment, when other claimants' horses were silent, had won his master the throne of Persia.

Like many British artists of his day, Stubbs self-consciously aspired to the prestige of "history painting" and no doubt pondered every classical story involving animals as a possible subject. As announced on an engraved portrait of him in neoclassical profile (fig. 65), he was no mere painter of animals but the *Animalium Pictor*. For his first essay in a subject from antiquity he chose the story of Phaeton; he showed versions at the exhibitions of the Society of Artists in 1762 and 1764, and painted another in 1775 (fig. 66).[15] Later he became interested in the stories of Hercules, presumably because so many of them involved animals, and may even have been working toward a Herculean series.[16] He showed *Hercules and Achelous*, in which the hero fights a rival suitor for Deianira who has taken the form of a bull, and *The Centaur, Nessus, and Dejanira* at the exhibitions of the Society of Artists in 1770 and 1772, respectively; he also painted *The Judgment of*

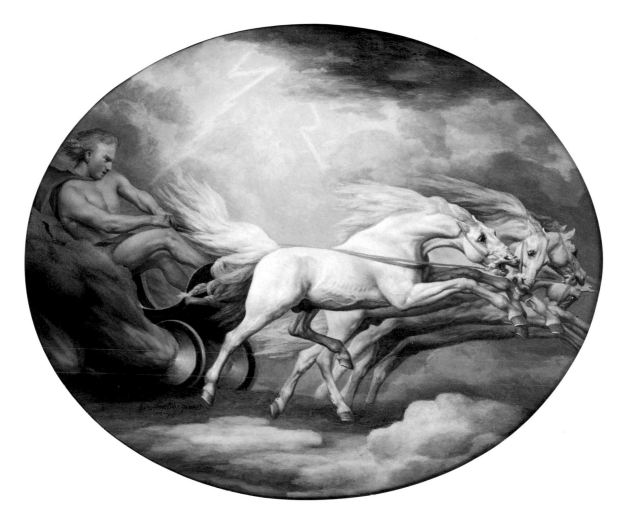

FIG. 66. George Stubbs, *Phaeton*, 1775. Enamel on copper, oval, 15 × 18 in.
(38.5 × 46 cm). Private collection, courtesy of Hall & Knight (cat. 64)

Hercules (unfortunately all three of these works are lost).[17] He was not the only artist engaged in classical animal subjects in the years around 1770. Sawrey Gilpin produced a huge *Darius Gaining the Persian Empire by the Neighing of His Horse* between 1769 and 1772,[18] and James Barry exhibited *The Education of Achilles,* featuring the centaur Chiron, at the Royal Academy in 1772 (fig. 67). Later, Benjamin Robert Haydon would paint Alexander and Bucephalus and refer to *The Anatomy of the Horse* for guidance.[19]

Stubbs looked to Greek and Roman art as well as myth and literature. In his Phaeton compositions, he followed the general appearance of the speeding *quadrigae* (chari-

ots drawn by four horses harnessed abreast) that are common in classical relief sculptures, cameos, gems, medals, and coins. Several examples were reproduced in Bernard de Montfaucon's compendium of classical images, a convenient source that was much consulted by British artists of the time, including Reynolds.[20] Ozias Humphry noted that, after seeing the first version of *Phaeton,* the neoclassical sculptor Johan Tobias Sergel "declared that the focus and expressions, as well as the fiery & animated motion of the animals placed them on a footing with the finest sculptures of the ancients."[21] Stubbs's compositions of horses attacked by lions derived, directly or indirectly,

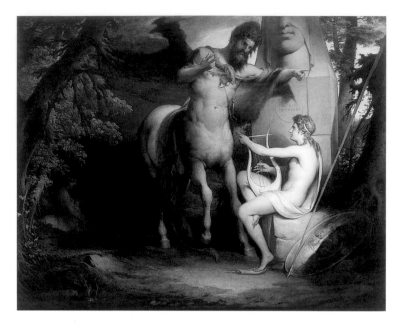

FIG. 67. James Barry, *The Education of Achilles,* c. 1771–72. Oil on canvas, 40½ × 50¾ in. (102.9 × 128.9 cm). Yale Center for British Art, New Haven. Paul Mellon Fund

FIG. 68. *Lion Attacking a Horse,* Hellenistic. Marble, height: approx. 55⅛ in. (140 cm). Musei Capitolini, Rome

from a well-known Hellenistic sculpture in the Palazzo dei Conservatori in Rome (fig. 68). In most of his variations on the theme he painted the horse's tail dragging on the ground and filling the space between its legs in a way that recalls the tree stumps and other support elements contrived by classical marble sculptors to help bear the weight of figures (fig. 69). Stubbs would certainly have been encouraged in his classicism by some of his early patrons who had undertaken the Grand Tour and formed their taste on the antiquities of Rome. Through them he had ready access to classical works in reproduction. The second Marquess of Rockingham commissioned a number of marble copies after the antique for Wentworth Woodhouse, and the third Duke of Richmond established a gallery of casts for the use of students at his house in Whitehall.[22]

The idea of painting that aspired to the condition of sculpture was integral to neoclassicism. In his technique Stubbs never strove for painterly flair—he delighted in the exquisite descriptive touch, not the stroke of bravura—and his surfaces shared the cool restraint associated with Greek and Roman marbles. He was drawn to wax painting in part by accounts of its use in antiquity and to enamel because it would make painting hard and durable like ancient sculpture in stone.[23] The idea of the "immortal" work of art (*ars longa, vita brevis*) was compelling. Writing of his attempts to perfect a large ceramic plaque on which Stubbs could paint in enamels, Josiah Wedgwood told his partner Thomas Bentley: "When you see Mr. Stubs [*sic*] pray tell him how hard I have been labouring to furnish him with the means of adding immortality to his very excellent pencil."[24] Erasmus Darwin, whose portrait Stubbs painted on a Wedgwood plaque, also touched on the idea of the Wedgwood ceramic as a work for the ages when he addressed the potter in his poem *The Botanic*

FIG. 69. George Stubbs, *A Lion Devouring a Horse*, 1769. Enamel on copper, octagonal, 9 9/16 × 11 1/8 in. (24.1 × 28.3 cm). Tate, London. Purchased with assistance from the Friends of the Tate Gallery, 1970 (cat. 60)

Garden (1791). For him Wedgwood's classically inspired ceramics looked to antiquity, modern times, and posterity alike:

> Whether, O Friend of Art! Your gems derive
> Fine forms from Greece, and fabled Gods revive;
> Or bid from modern life the Portrait breathe,
> And bind round Honour's brow the laurel wreath;
> Buoyant shall sail, with Fame's historic page,
> Each fair medallion o'er the wrecks of age.[25]

Stubbs painted classical subjects, responded to Greek and Roman sculpture, and shared some of the attitudes toward antiquity that defined the neoclassical movement in European art. It seemed fitting to regard the beauty of the horse in a classical light, and in his own ways, he did so. But his classicism was by no means straightforward or uncritical. On his one visit to Rome—like his aristocratic patrons, he spent some time there as a young man—he studied the monuments of antiquity in person and, according to the Humphry memoir, was unimpressed to the point of defiance: "It does not appear that whilst he resided in Rome he ever copied one picture or even designed one subject for an Historical Composition; nor did he make one drawing or model from the antique

sit this morning, & I write this by Mr. Stubs [*sic*] in the new stable, which is to be my study whilst he is painting there."[34]

In his memoir of the artist, Humphry related a story of Whistlejacket's last "sitting" for Stubbs at the stables at Wentworth Woodhouse. The animal suddenly became agitated on seeing his own portrait, presumably mistaking it for a real horse; he tried to attack the work until a stable-lad beat him on the face with a switch "& Stubbs likewise got up & frightened him with his palette and Mahl stick."[35] This is one of several stories of Stubbs's paintings being so lifelike as to cause an animal or person to believe they were seeing the real thing; since he must in some cases have been the source, the stories are a clue to how he wished his work to be understood. In the Humphry memoir, and the later annotations by the artist's companion Mary Spencer, there are accounts of an old hunter that "began to Neigh and seem very pleasantly agitated" at the sight of *The Grosvenor Hunt* (see fig. 47); real dogs that growled and bristled at painted ones, or cowered and urinated in fear on seeing a painted tiger; and a man who twice sprang out of the way to avoid a kick from the painted Hambletonian (see fig. 137).[36] These were variations on a form of story common in biographies of artists and originating in an anecdote told by the Roman writer Pliny. In a contest of skill, the Greek artist Zeuxis painted some grapes so well that birds came to peck at them; he then called on his rival, Parrhasius, who was to have painted the same subject, to draw back the curtain across his picture. When the curtain itself turned out to be painted, Zeuxis conceded defeat: he had fooled the birds but Parrhasius had fooled him.

Given heart, perhaps, by the fact that the great naturalistic painters of legend were Greek, Stubbs pursued neither naturalism nor classicism to the exclusion of the other but sought, in various ways, to bring them together. He seems to have discussed the relation of the natural to the classical with his friend Josiah Wedgwood. In 1780, after modeling a scene of a horse frightened by a lion for a Wedgwood relief plaque, he decided to model one of his Phaeton compositions as its companion piece (fig. 72). Wedgwood strongly disagreed with the choice, referring to the frightened horse composition as "a piece of natural history" and the Phaeton as "a piece of un-natural fiction."[37] His objection may have been as much that the subjects did not match well enough as that the Phaeton composition was inferior. Still, Stubbs must have been sensitive to talk of any of his works as unnatural. In the Phaeton compositions he tried to bring a classical story to life by modern means, including anatomical knowledge and, in the painted versions, color. No doubt he thought of them as correctives to, rather than mere imitations of, the representation of horses and chariots in classical art. Wedgwood was probably not alone, however, in finding them unnatural all the same.

Stubbs's efforts to be both classical and natural worked best when his classicism took a less literal, more abstract form. He may have believed "that nature was & is always superior to art whether Greek or Roman," but this by no means blinded him to the general qualities of balance and harmony that his contemporaries admired in classical art. Throughout his work, from the racehorse portraits to the mares-and-foals compositions, the scenes of park and farm life, the conversation pieces, and the horse-and-lion paintings, he showed a will to order and clarity rooted in the eighteenth-century idea of the classical. In his own way he followed the aesthetic principles summed up by Winckelmann in the famous phrase "noble simplicity and calm grandeur." He achieved these chiefly through composition, and behind his approach to

FIG. 72. George Stubbs, *Phaeton*, modeled 1780. Wedgwood plaque, white relief on a black basalt ground, 12 × 21 in. (30.5 × 53.3 cm). Private collection

FIG. 73. George Stubbs, *Mares and Foals*, 1762. Oil on canvas, 39 × 75 in. (99 × 190.5 cm). The Trustees of the Rt. Hon. Olive, Countess Fitzwilliam's Chattels Settlement, by permission of Lady Juliet Tadgell (cat. 37)

composition lay a particular form of classical art, the relief sculpture.

His interest in relief went beyond the actual relief plaques he modeled for Wedgwood. The relieflike composition, in which the principal subjects occupy a shallow space close to the picture plane, stand out emphatically from the background, and tend toward the profile, with little foreshortening, dominated his painting. The effect showed especially clearly in the early Rockingham mares-and-foals composition (fig. 73), in which a long, horizontal format gave the appearance of a frieze and the background was plain. But it pervaded later treatments of the theme in landscape settings (figs. 74, 75) and indeed paintings of all subjects throughout the rest of his career. The horse-and-lion subject derived from an antique sculpture in the round but in Stubbs's hands came to resemble a painted interpretation of a relief (see fig. 69). The change from the chestnut horse in his first ver-

sions to the gray in the later ones—from about 1769—made the gesture toward sculpture more pronounced in that its whiteness suggested marble.

The earlier British horse painters John Wootton and James Seymour also favored the profile view, which best displayed the characteristic form of the species and the identifying marks of an individual. With Stubbs, however, profiles were part of a distinctive mode of composition. He delighted in shape more than mass; though establishing them as objects in the round, he arranged animals, people, and things more in planes than in space. In most of the plates in *The Anatomy of the Horse*, he showed the horse from a viewpoint in front or behind, but in his paintings he confined himself almost entirely to the lateral view; the position varies from horse to horse, but rarely turns enough to give a strong projection forward or recession into depth. He unified his compositions on the principle of analogy rather than hierarchy—the principle

he followed as a comparative anatomist: the elements of the design do not build to the center but relate in a play of rhyming and near-rhyming outlines. All this was far from conventional. To one critic of the time the relation of figures to background in the *Haymakers* and *Reapers* (see figs. 91, 118) seemed even primitive, recalling art from before the Renaissance: "Undoubtedly the figures want taste in their disposition, and the arrangement has too Gothic an appearance."[38] On the whole, British taste was more attuned to figures and groupings that flowed gracefully in and out of depth: in his discourses Joshua Reynolds criticized the relieflike "dry manner" of the seventeenth-century painter Nicolas Poussin and commended him for changing "to one much softer and richer,

where there is a greater union between the figures and the ground."[39]

The sense of order that pervades Stubbs's work accords with the descriptions of his habits and personality. His obituarist noted that he always rose early in the morning, walked great distances for exercise, and "was remarkably abstemious; eating little food, and drinking only water, for the last forty years."[40] Another early biographer wrote of his belief "that the way to protract life was to avoid excesses of every description."[41] His greatest pleasure seems to have been work, in which he would engage for long hours. He was in his seventies and early eighties when he worked on his great study in comparative anatomy but, as his companion Mary Spencer

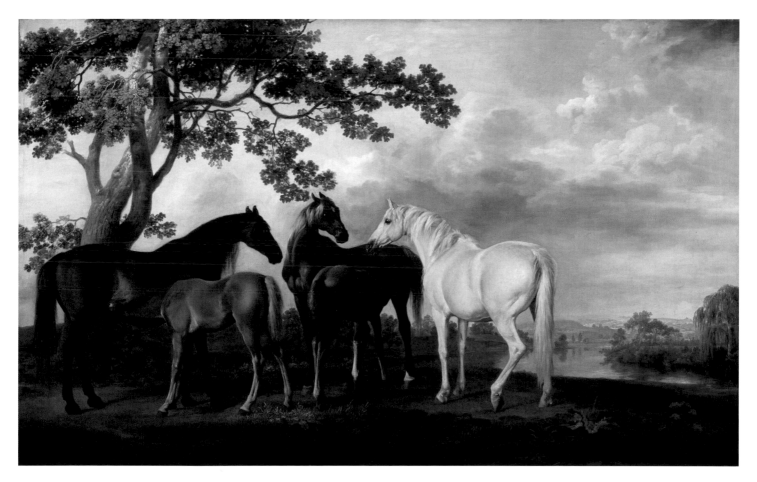

FIG. 74. George Stubbs, *Mares and Foals*, 1763–65. Oil on canvas, 40 × 63¾ in. (101.6 × 161.9 cm). Tate, London. Purchased with assistance from the Pilgrim Trust, 1959 (cat. 43)

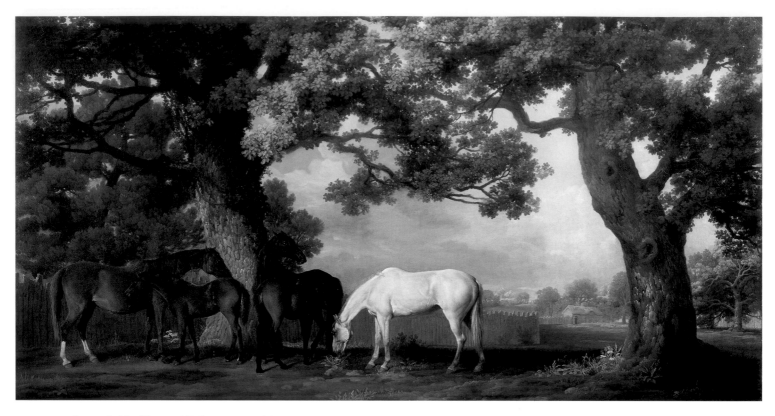

FIG. 75. George Stubbs, *Mares and Foals*, c. 1765–66. Oil on canvas, 39 × 74 in. (99 × 187 cm). Private collection (cat. 48)

recalled, retained the stamina of a much younger man, "often employing himself from the dawn of day in summer till midnight."[42] Some remarks he made on the last morning of his life, also recorded by Spencer, suggest a stoic tendency that had presumably been with him throughout: "I fear not death, I have no particular wish to live. I had indeed hoped to have finished my Comparative Anatomy eer I went, but for other things I have no anxiety."[43] Perhaps his devotion to work, a realm in which he had control and could achieve perfection, was a response to the messiness of his personal life, not least in his relationship with Spencer.

Intellectually, in his urge to observe and give rational structure to nature, Stubbs was an artist in tune with his time. His anatomical work on the horse, in which he distilled clear and clean images from a reality that must have been anything but clear and clean, set his course in this

respect as in others. In his paintings, the emphasis on composition, in which a multiplicity of details are brought to order within a strong overall design, parallels the emphasis on system in the work of contemporary naturalists.[44] The early years of his career saw, for instance, the general adoption of Linnaeus's system for naming plant species. Stubbs believed in scientific inquiry as a basis for art, but he was no realist, eager to reveal untidy or unpleasant truths. Some of his subjects would have lent themselves to this kind of treatment; horseracing was a world of crowds, confusion, and roguery, none of which come through in his paintings.[45] He was observant and at the same time selective, ordering and classicizing the world within his own version of ideal form, the relieflike composition. Ever a man of the Enlightenment, he looked to give form to reason and nature: reason in the design and nature in the details.

Notes

1. From his remarks "To the Reader"; for a reproduction of this page, see Egerton 1984a, 219.
2. Bibliothecaris der Rijksuniversiteit, Leiden, Netherlands, quoted in Egerton 1998a, 246, n. 1.
3. From the subscription proposal and the inside wrapper of the text; see Lennox-Boyd, Dixon, and Clayton 1989, 313.
4. Egerton 1984a, 118–19, no. 82.
5. Hogarth 1753/1997, 63.
6. Hogarth 1753/1997, 26. The Hercules and the Mercury were the Farnese Hercules in the Museo Nazionale, Naples, and the Mercury in the Uffizi, Florence.
7. Hogarth 1753/1997, 105. A satirist pointed out that, taken to its logical conclusion, Hogarth's theory of the Line of Beauty would mean that an animal was more beautiful if it had a hump: "The ugliest Camel then more Charms may claim, / Than e'er adorned th'Arabian Courser's Frame" (Hogarth 1753/1997, xliv).
8. Burke 1759/1958, 114–16.
9. Bewick 1807/1970, 1.
10. Price 1794, 58–59.
11. Hussey 1927/1967, 119.
12. Berenger 1771, 1:215.
13. Berenger 1771, 1:36. Shakespeare similarly likened the good horseman to a centaur, "incorps'd and demi-natur'd / With the brave beast" (Hamlet 4.7.86–87).
14. Pegasus had been represented commonly in European art since the Renaissance; see Brink and Hornbostel 1993.
15. In addition to his mythic Phaetons, Stubbs painted some of the modern high-speed carriages of the same name (see cats. 67, 74, and fig. 124). Antiquity was such a common source of names that contemporary subjects often came with their own classical allusions. Stubbs also painted racehorses named Romulus, Pyrrhus, Julius Caesar, and Antinous.

16. Nicholas Hall first suggested this possibility (Hall 2000, 138–39). For the stories of both Phaeton and Hercules, Stubbs would have consulted Ovid's Metamorphoses.
17. Hercules and Achelous was presumably one and the same as a large painting (59 × 95½ in.; 149.9 × 242.6 cm) in the collection of Sir Walter Gilbey in 1898, although Gilbey identified the subject as Hercules Capturing the Cretan Bull (Gilbey 1898, 150–51). For the other two Hercules subjects, see the artist's sale, May 27, 1807, lots 71 and 75 (Gilbey 1898, 204).
18. Gilpin exhibited a sketch at the Society of Artists in 1769 and a drawing of the composition in 1772. The painting itself (oil on canvas, 78 × 106¾ in.; 198.3 × 271 cm) is at York City Art Gallery; for a reproduction, see Morrison 1989, 176–77.
19. Diary entry, April 25, 1826, in Haydon 1963, 3:92. Haydon exhibited the painting, Alexander Returning with Bucephalus, at the Royal Academy in 1827; it is now at Petworth House (National Trust).
20. Montfaucon 1721–22, 3:pl. 51.
21. Humphry MS, 209.
22. On the Rockingham copies from the antique, see Penny 1991, 9–21.
23. On Stubbs's techniques and the ideas that inspired them, see the essay by Lance Mayer and Gay Myers in the present volume.
24. Josiah Wedgwood to Thomas Bentley, October 17, 1778, quoted in Tattersall 1974, 111.
25. Canto 2, ll. 341–46. Stubbs's portrait of Darwin, painted in 1783, is at the Wedgwood Museum, Barlaston.
26. Humphry MS, 202.
27. See Haskell and Penny 1981, 136–41, 179–80, 250–55. The centaur group is now in the Musée du Louvre, Paris.
28. Winckelmann 1764/1968, 1:242, 302.
29. See Camins 1981, 37–38, 66, 139.
30. Falconet 1808/1970, 3:80.
31. Humphry MS, 201.

32. Wedgwood to Bentley, August 7, 1780, quoted in Tattersall 1974, 113.
33. Humphry MS, 206.
34. Wedgwood to Bentley, August 21, 1780, quoted in Tattersall 1974, 114. The portrait of the Wedgwood family is now at the Wedgwood Museum, Barlaston.
35. Humphry MS, 205.
36. Humphry MS, 203, 208.
37. Wedgwood to Bentley, October 28, 1780, quoted in Tattersall 1974, 115.
38. Daily Universal Register, May 17, 1786, quoted in Myrone 2002, 65.
39. Reynolds 1797/1975, 87.
40. [Upcott?] 1806, 979.
41. T. N. 1809, 51–52.
42. From a note by Spencer, Humphry MS, 208.
43. Humphry MS, 208.
44. For a discussion of the analogy between pictorial order in Stubbs and the order of nature in eighteenth-century science, see Potts 1990.
45. Stephen Deuchar has described this mismatch of reality and image, arguing that Stubbs's orderly vision of sport held particular appeal to sportsmen at a time when they were developing a reputation for profligacy. Deuchar 1988, 107 ff.

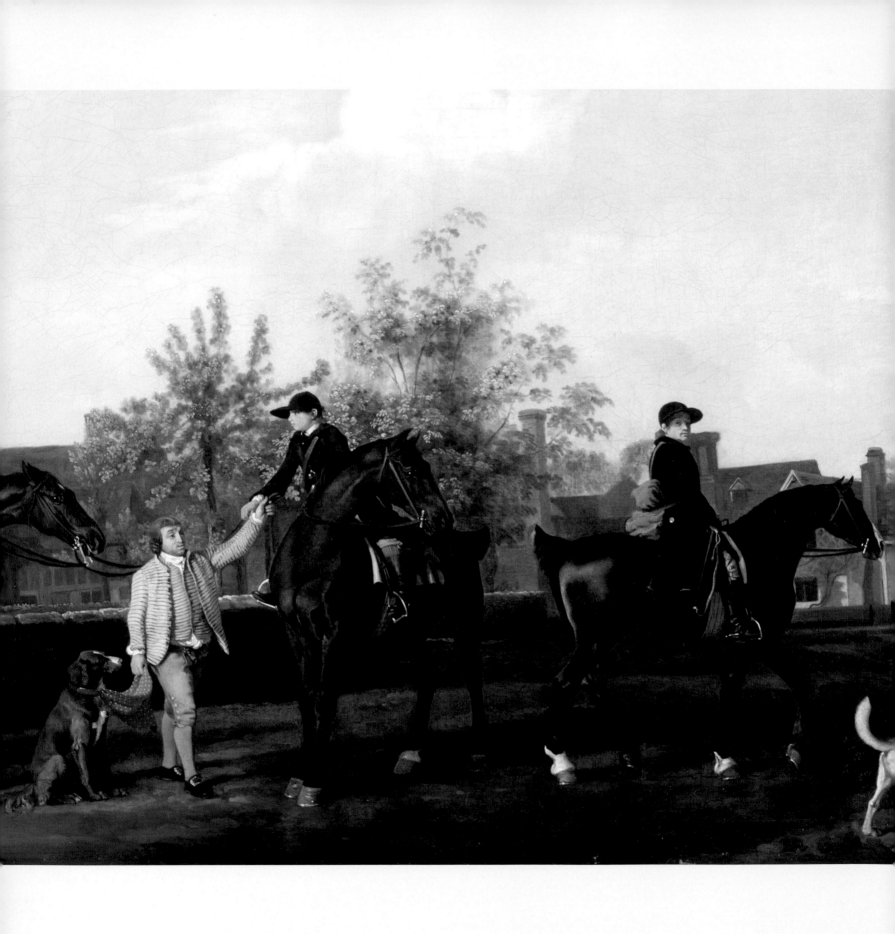

Fieldwork

STUBBS AND THE HUMBLER SORT

Robin Blake

FEW OF Stubbs's working drawings or sketches are known to have survived, but he was clearly a disciplined fieldworker and took great care to make accurate landscapes and true portraits of the figures, both human and animal, in his paintings. This is stressed more than once in Ozias Humphry's memoir, most explicitly in its account of the artist's procedure when working on *Lord Torrington's Bricklayers at Southill, Bedfordshire* (fig. 76): "Mr Stubbs was a long time loitering about considering the old men without observing in their occupation any thing that engaged them all, so as to furnish a fit subject for a picture, till at length they fell into a dispute about the manner of putting the Tail piece on to the Cart, and this dispute so favorable for his purpose agitated these

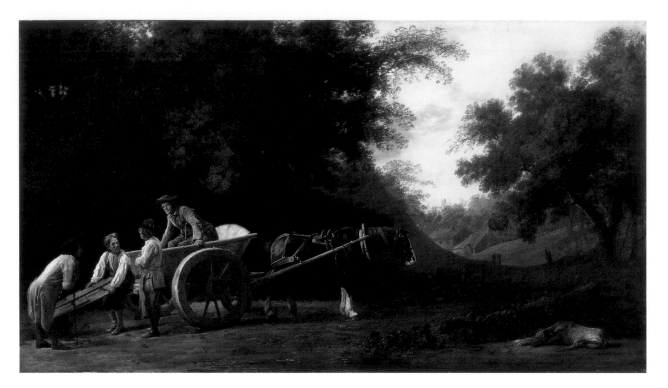

FIG. 76. George Stubbs, *Lord Torrington's Bricklayers at Southill, Bedfordshire*, 1767. Oil on canvas, 24 × 42 in. (61 × 106.7 cm). Philadelphia Museum of Art. John H. McFadden Collection (cat. 54)

Labourers & continued long enough to enable him to make a sketch of the men, Horse & Cart . . . [Then] he removed the Cart, Horse & men into a neighbouring Barn where they were kept well pleased & well fed till the picture was completed."[1]

The view of society underlying such work has been the subject of debate, but there is no doubting its seriousness.[2] England had never produced a more committed painter of the laboring class than Stubbs. His hunt servants, gamekeepers, stud-grooms, jockeys, stable-lads, tiger-boys, and farmworkers are neither patronized nor caricatured; they are studied presences, about whose features, clothing, and posture the artist has taken minute care. Few examples of Stubbs's earlier work as a jobbing portraitist in York and Liverpool are traceable today, but from those that are known it is obvious he had already developed a certain conscientiousness as a face painter. Portraits such as those of the shy old York draper George

Fothergill (dated 1747) and the pompous young James Stanley of Lancashire (1755), the fifth son of a minor gentry family, show people who fully inhabit the Georgian world yet seem near enough to touch us.[3] Exactly the same can be said of a magnificent work painted half a century later, *Hambletonian, Rubbing Down* (see fig. 137). Here the big-hatted trainer who holds Hambletonian's reins and the stable-boy who, braced against the exhausted horse's withers, pauses for breath in his energetic work of rubbing down, are portraits of equal probity. No label on the frame records the names of these vividly realized attendants. Yet Stubbs's humanistic treatment seems to invite us to ask who they were and what their lives were like.

SERVANTS IN CONTEXT

The lives of individual servants are difficult to research in detail. Few are in the *Dictionary of National Biography*, and we have no equivalents to the College of Heralds, or refer-

ence books like Burke's *Peerage and Baronetage* or *Landed Gentry*, to help us track their antecedents and successors. Antiquarians, forerunners of the social historian, have been largely indifferent to servants, at least until that servant-obsessed Victorian, Arthur Munby. Although their existences are preserved in the accounts and daybooks of many great houses, most are at best a bare name on a work roster or wages list.

Yet during Stubbs's lifetime there was an upsurge of educated interest in the moral life of the servant class. Servants now emerged from the mist, as writers and artists combined to make representations of them both common and acceptable. Samuel Richardson's sensationally successful novel *Pamela* (1740–41) is the story of Pamela Andrews, a servant girl fighting for her virtue in the house of a lecherous master. An "epidemical Phrenzy," as Henry Fielding called it, raged around this novel, to compare with the Harry Potter phenomenon 250 years later; like J. K. Rowling's books, *Pamela* spawned imitations and translations, not only into other languages but other media such as the stage, the print, and the oil painting.[4] Another phenomenon of the age was John Gay's *The Beggar's Opera* (1728), by far the most successful play written in eighteenth-century England. A multifaceted work, it was at the same time a morality play, a piece of urban mock-heroic, a low parody of pastoral romance, a savage political satire, and a musical entertainment, set among the staff and inmates of Newgate Gaol. The play's sheer vitality ensured that official attempts to stifle it—for unseemliness as much as the political content—never stood a chance. The narrative paintings and prints of William Hogarth, which included illustrations for *Pamela* and scenes from *The Beggar's Opera*, enjoyed similar popularity.

The trenchant morality of such further productions by Hogarth as *Industry and Idleness* or *A Harlot's Progress*

FIG. 77. William Hogarth, *The Artist's Servants*, c. 1750–55. Oil on canvas, 24¾ × 29¾ in. (63 × 75.5 cm). Tate, London. Purchased 1892

showed that art could preserve high ideals even when dealing with "low" subject matter. Quite unconnected with these morality tales, however, Hogarth also painted an innovative group portrait of his household's six servants (fig. 77) in which they are shown as an arrangements of heads, each particularized in such a way, as art historian David Piper remarked, that "no king could hope for such sympathy, combined with such veracity."[5] It is noticeable, too, that Hogarth makes no attempt to associate the images of these servants with their functions in the house, and the Hogarth scholar Ronald Paulson's suggestion that they are a coachman, a valet, a housekeeper, two maids, and an all-purpose boy cannot be guessed from their appearance.[6]

Most of Hogarth's educated contemporaries would think it pointless to commission a servant portrait that did not indicate the servant's role. But if this absence of

FIG. 78. George Stubbs, *Thomas Smith the Banksman,* c. 1765. Oil on canvas, 28 × 24¼ in. (71.1 × 61.5 cm). Private collection

occupational context sets Hogarth apart in the history of servant portraiture, there is a remarkably similar instance in Stubbs's half-length of *Thomas Smith the Banksman,* which he painted for his patron, and Smith's employer, Lord Rockingham (fig. 78). Hogarth, Stubbs, and even Rockingham were capable of realizing that *who* these people were may be as important as *what* they were, and conceivably even more so.

RACING LIVES

Henry Fielding's first full-length novel, *Joseph Andrews* (1742), a parody and critique of Richardson's moralizing *Pamela,* purports to be the biography of Pamela's younger brother. Joseph's early career, before he goes on the road with the charming but simple-minded Parson Adams, follows that of a representative Georgian country boy. Bound apprentice at ten years old to the local landowner, Sir Thomas Booby, he begins as a bird-scarer. "His voice being so extremely musical that it rather allured birds than terrified them," however, he is transferred to the kennels, where he becomes "whipper-in" under the huntsman. Here again his dulcet voice is his downfall: it charms the hounds, and the huntsman jealously denounces Joseph to their master as a bad influence on the pack, with the result that he is moved to the stable:

> Here he soon gave Proofs of Strength and Agility, beyond his Years, and constantly rode the most spirited and vicious Horses to water with an Intrepidity which surprised every one. While he was in this Station, he rode several Races for Sir *Thomas,* and this with such Expertness and Success, that the neighbouring Gentlemen frequently solicited the Knight to permit little *Joey* (for so he was called) to ride their

Matches. The best Gamesters, before they laid their Money, always enquired which Horse little *Joey* was to ride, and the betts were rather proportioned by the Rider than by the Horse himself; especially after he had scornfully refused a considerable Bribe to play booty [i.e., cheat] on such an Occasion.[7]

Many a jockey painted by Stubbs must have been given his first chance as a race rider in a similar way. Some, then as now, were the sons of horsemen and as firmly bred to the game as the horses they cared for and rode. But others came into racing from outside, excited by its glamour, color, and carnival excitement. Of course, for every one who showed skill at jockeyship like Joseph Andrews, there were hundreds of hardworking lads who did not make the grade. One of these left a detailed memoir of a stable-lad's life in Newmarket at the very time Stubbs first went there, to paint Jenison Shafto's stallion Snap.[8]

Thomas Holcroft, born in 1745, was the son of a shoe-maker of Nottingham. His father's shop failed, possibly as a result of gambling on horses, and Holcroft Senior became an itinerant peddler. But the change in fortune does not seem to have put him off racing: his son caught the bug in 1757 or 1758 when his father took him to see a race between a Nottingham-bred speed horse called Careless and the Duke of Devonshire's unbeaten champion, Atlas.[9] The Nottingham horse lost, but Holcroft was infused with excitement and at fourteen went to Newmarket determined to work in racing.

He found a job in the stables of John Watson, trainer to the notable owner Captain Richard Vernon. His memoirs are probably unique as a firsthand account of life in a Georgian racing stable:

All the boys rise at the same hour, from half-past two in spring, to between four and five in the depth of winter. The horses hear them when they awaken each other, and neigh, to denote their eagerness to be fed. Being dressed, the boy begins with carefully clearing out the manger, and giving a feed of oats, which he is obliged no less carefully to sift. He then proceeds to dress the litter; that is, to shake the bed on which the horse has been lying, remove whatever is wet or unclean, and keep the remaining straw in the stable for another time. The whole stables are then thoroughly swept, the few places for fresh air are kept thoroughly open, the great heat of the stable gradually cooled, and the horse, having ended his first feed, is roughly cleaned and dressed. In about half an hour after they begin or a little better, the horses have been rubbed down, and reclothed, saddled, each turned in his stall, then bridled, mounted, and the whole string goes out to morning exercise; he that leads being first: for each boy knows his place.[10]

Holcroft, who grew up to be a radical journalist as well as a playwright and novelist, did not think this a hard life compared to the poverty he had earlier endured. "I was warmly clothed, nay, gorgeously, for I was proud of my new livery and never suspected that there was disgrace in it; I fed voluptuously, not a prince on earth perhaps with half the appetite, and never-failing relish; and instead of being obliged to drag through the dirt after the most sluggish, obstinate and despised among our animals, I was mounted on the noblest that the earth contains, had him under my care, and was borne by him over hill and dale, far outstripping the wings of the wind."[11]

In Holcroft's memory John Watson was a decent and

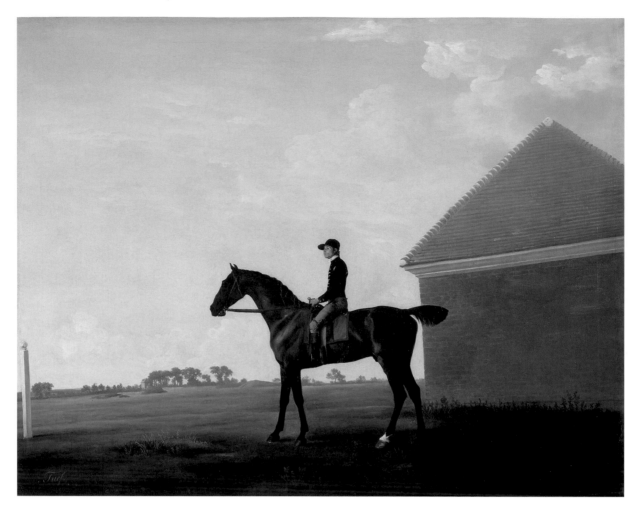

FIG. 79. George Stubbs, *Turf, with Jockey Up, at Newmarket*, 1765–66. Oil on canvas, 38 × 49 in. (96.5 × 124.5 cm). Yale Center for British Art, New Haven. Paul Mellon Collection (cat. 46)

humane master. Other stable regimes must have been meaner and harsher, but essentially this was the life of the boys we see in Stubbs's paintings, from the lad kneeling beneath the horse in *Gimcrack on Newmarket Heath, with a Trainer, a Stable-Lad, and a Jockey* (see fig. 56) to the waifs attending Hyena and Pumpkin, and the lumpish teenager with the fistful of rag in *Hambletonian, Rubbing Down*.[12] To be a jockey, like the young fellow wearing Bolingbroke silks on Turf (fig. 79) or the one strolling back to be weighed in after a victory on Gimcrack, was their hope. Gazed on with envy and awe by the kneeling boy who scrabbles for a handful of straw to rub the horse

down, Gimcrack's jockey is clearly a figure of consequence and glamour. As Holcroft says, "every boy knew his place," but that did not stop them dreaming.

John Singleton, Rockingham's man, was the kind of jockey a talented, intelligent, honest, and hardworking boy could become if he also happened to be very lucky. Singleton was born in 1715 at Pocklington, Yorkshire, and his first master was a gentleman trainer, Wilberforce Read. Singleton's equestrian skills attracted attention locally, and Rockingham invited him to Wentworth Wood-house, where he became a fixture not only as rider but as a confidential servant, entrusted with money and the

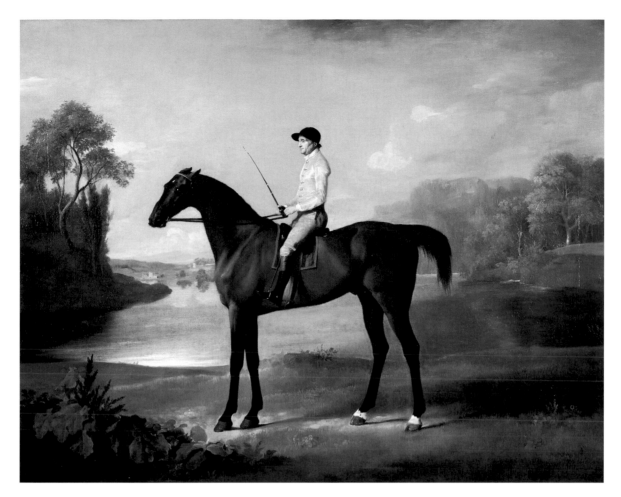

FIG. 80. George Stubbs, *The Marquess of Rockingham's Scrub, with John Singleton Up*, 1762. Oil on canvas, 40 × 50 in. (101.5 × 127 cm). The Trustees of the Rt. Hon. Olive, Countess Fitzwilliam's Chattels Settlement, by permission of Lady Juliet Tadgell (cat. 36)

training of racehorses.[13] He rode all Rockingham's best racers in the 1750s and 1760s, including Bay Malton, Scrub (fig. 80), and Whistlejacket, and gained a national reputation as a highly dependable jockey. He had retired by 1780 but lived on into a comfortable and vigorous old age, alongside old Scrub, who was given to him to care for in their joint retirements.

The job of principal jockey was then apportioned between two men who were already riding winners for Rockingham. One was another John Singleton, the old man's nephew, who was born in 1736 (possibly in Kendal) and initially rode on the northeastern circuit.[14] Singleton

the Younger rode Rockingham's filly Alabaculia to glory in the first St. Leger run at Doncaster in 1776.[15] He was even longer-lived than his uncle but less fortunate in retirement. He became a horse breaker and farrier in Chester but was ruined by medical bills run up for his sick wife and ended his days, aged ninety-three, in the Chester workhouse. The other jockey working for Rockingham was Christopher Scaife (born 1745), another experienced Yorkshireman who was taken on in 1774 on the recommendation of John Pratt. Scaife retired from the saddle after a riding accident in 1793 but continued to train until his death at age sixty-three in 1808.[16] The Wentworth

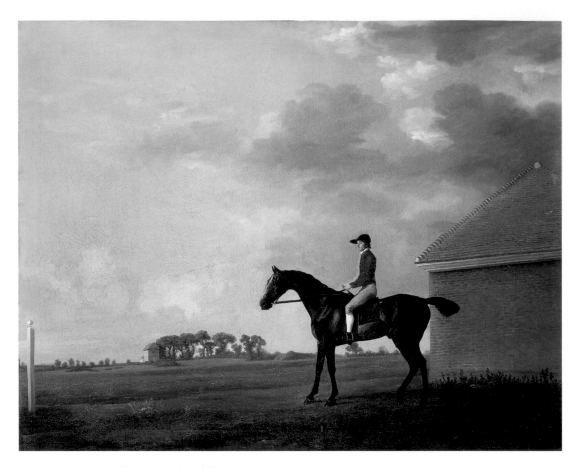

FIG. 81. George Stubbs, *Gimcrack, with John Pratt Up, at Newmarket,*
c. 1765. Oil on canvas, 39½ × 50 in. (100.4 × 127 cm). Fitzwilliam
Museum, Cambridge

estate produced one successful homebred jockey, William
Clift, born in 1763. Rockingham noticed the boy, son of
one of his shepherds, at an informal pony race held in the
park, in which he bested young Cobb, the stud-groom's
son. Clift became a successful professional jockey who
rode much for Rockingham's heir, Lord Fitzwilliam.[17]

There were "gentleman jockeys" such as John Larkin
and the aforementioned John Pratt, both of whom Stubbs
painted mounted and in silks (fig. 81).[18] But a jockey in
the 1760s was usually still a servant even when he was, like
the Singletons or Scaife, quite a superior one. The earliest
jockey to become truly famous, the first in a long line of
turf stars, was Sam Chifney. In 1790 the Prince of Wales
engaged him for the generous salary of two hundred
guineas. With his dandy's wardrobe and his long love-locks

(clearly visible in his Stubbs portrait atop the prince's
Baronet), Chifney was a highly confident man, never
afraid of self-advertisement.[19] He had an individual style,
riding his horses "off the bridle" even in the early part
of a race and yet always aiming to hold them up before
unleashing his famous last-furlong "rush" to snatch vic-
tory at the post.[20]

Chifney was at the center of the sensational Escape
affair of 1791, when he was accused of cheating in a race
in which he rode the hot favorite, the prince's Escape.[21]
Allegedly the jockey and/or the Prince of Wales had backed
Escape to lose, which he duly did (fig. 82). But in a second
race the next day, opposing two of the same horses, and at
odds of five-to-one against, Escape romped home. This
time Chifney had backed himself to win. The circum-

stances provoked a Jockey Club inquiry and a warning to the prince that, if he continued to employ Chifney, "no gentleman would start against him." The prince refused indignantly to abandon his jockey and instead deserted the turf, continuing to pay his two hundred guineas' retainer to Chifney. "Sam Chifney," he said when the two met a decade later in Brighton, "there's never been a proper apology made; they used me and you very ill. They are bad people—I'll not set foot on the ground more."[22] Chifney, now effectively "warned off" by the Jockey Club, defended his actions in a best-selling book, *Genius Genuine* (1804), an early example of the celebrity sportsman's (and royal servant's) egregious memoir—the kind that today would certainly be serialized for a large sum in a Sunday tabloid. Chifney's son became a successful jockey, but his own career was over. Outraged by the book's indiscretion, the prince finally broke with Chifney, who died in the Fleet prison for debtors in 1807.

No jockey is represented in *Hambletonian, Rubbing Down* (see fig. 137), though we know that Sir Harry Vane-Tempest's horse was ridden in the match against Diamond (see fig. 139) by the next dominant jockey to appear after Chifney, Frank Buckle. The horse's trainer does appear, standing tensely in his great coat and holding Hambletonian's head. He has not been positively identified, but there are two possibilities. Vane-Tempest's usual trainer-jockey was Tom Fields, born at Pocklington, Yorkshire, in 1751. Along with another called Mangles, Fields had been the best north-country jockey riding in the 1780s. He rode for the stable of one of the north's leading trainers, Charles Dawson, but later got a yard of his own, from where he both trained and rode many horses, including Hambletonian. By 1799 Fields was forty-eight, and in a contest on which so much was at stake, Vane-Tempest may have judged him too old to take on

FIG. 82. Thomas Rowlandson, *How to Escape Winning*. Etching, 10¾ × 14⅝ in. (27.3 × 37.3 cm), with publisher's watercolor, published 1791. Andrew Edmunds, London

Diamond's partner, the expert Dennis Fitzpatrick, then at the top of his form. The result was that Fields was "jocked off" and Buckle, the best rider in the country and Fitzpatrick's great rival, was engaged instead.[23]

This maneuver, as well as the horse's final preparation for the contest, was attended by ructions in the Vane-Tempest camp. With three thousand guineas on the match, several times that amount staked by Sir Harry in bets, and a vast crowd expected to see the race on Newmarket Heath, Vane-Tempest was racked by nerves. He was uncertain whether Fields had got the horse right and asked a man regarded as the north's best judge of horseflesh, John Hutchinson, to take a look. Hutchinson reported that Hambletonian was short of work and needed one last gallop to put him right. Fields, understandably resenting Hutchinson's imputation, "flew into a rage and, giving him the key of the stable, told him that he and the horse 'might go to the devil.' Mr Hutchinson

FIG. 83. George Stubbs, *Whistlejacket and Two Other Stallions, with the Groom Simon Cobb*, 1762. Oil on canvas, 39 × 74 in. (99 × 187 cm). The Trustees of the Rt. Hon. Olive, Countess Fitzwilliam's Chattels Settlement, by permission of Lady Juliet Tadgell (cat. 38)

took the key and two days before running, gave the horse an additional sweat at an easy pace, though heavily clothed; and it has always been affirmed, from his management, he was instrumental (through his perfect knowledge of the animal's constitution) in the horse gaining the contest."[24]

On this evidence, Fields had resigned and John Hutchinson had temporary charge of Hambletonian for the match. Hutchinson was at this time sixty-four, and he is certainly not the figure at the horse's head in Stubbs's painting. It may be Armstrong, Hutchinson's chief groom. Armstrong was regarded as almost as talented a horse handler as his master: "At one period in his life [he] was possessed of a very respectable property; unfortunately, in after life, habits of dissipation wasted his substance and he eventually died of indigence in the Malton work-

house."[25] On balance, however, it seems more likely that the man holding Hambletonian is Tom Fields after all—that he had the sense to swallow his pride and return to duty. Hambletonian had to be hard ridden by Buckle for his narrow victory, and with neither whip nor spurs being spared, the great horse was hurting and exhausted. There is a look of mute suffering on the trainer's face, as if, having reclaimed his stable star, he can only despair at what has been done to him.

THE ESTATE, THE STUD, AND THE FARM

Simon Cobb, the richly liveried stud-groom who proudly embraces Rockingham's Whistlejacket in Stubbs's painting of three stallions without a background (fig. 83), was a senior member of Lord Rockingham's outdoor staff at Wentworth Woodhouse. Rockingham employed at least

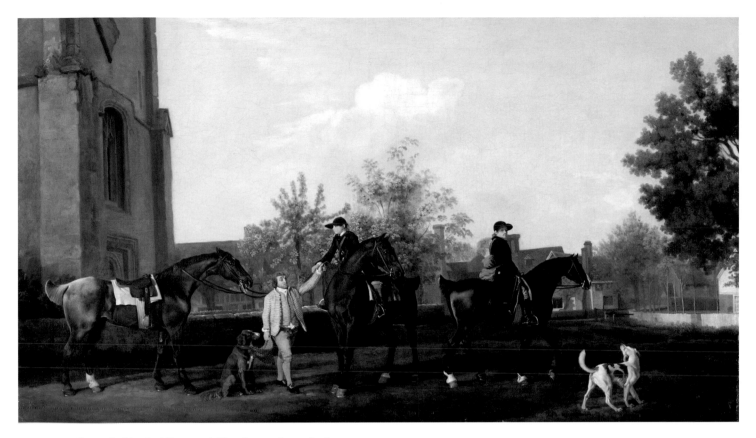

FIG. 84. George Stubbs, *Lord Torrington's Hunt Servants Setting Out from Southill, Bedfordshire*, 1767. Oil on canvas, 24 × 41½ in. (61 × 105.5 cm). Private collection (cat. 56)

three generations of the family. Joshua Cobb (probably Simon's son) had started as a personal hunting groom to the marquess in 1740, when both were still boys. By the mid-1760s, Joshua was head gamekeeper on a generous wage of forty pounds a year.[26] He may have been promoted to stud-groom on Simon's death, perhaps holding both posts simultaneously; on February 14, 1771, Rockingham mentioned in a letter to the Duke of Portland that "Cobb, my old stud groom and Park Keeper," had died and that his son Joshua was now in his father's place.[27] The latter is the lad who failed to beat young Clift in the Wentworth Park pony race mentioned above.

Long, semidynastic service was common. At Goodwood, Stubbs probably portrayed several members of the Budd family in 1759–60, in both *Henry Fox and the Earl of Albemarle Shooting* and *The Duke of Richmond with the Charlton Hunt* (see fig. 53).[28] The two gamekeepers, Henry and William Budd, may be those shown in the painting of Fox and Albemarle, one acting as loader, the other mounted. Christopher Budd was the Charlton's huntsman, an important man in his own right and possibly the liveried figure resaddling a gray hunter in the painting of Richmond.[29] At Viscount Torrington's Southill estate in Bedfordshire, Stubbs was employed specifically to paint the outdoor servants going about their work. The pair of hunt grooms setting off to deliver a saddled horse to their master at the meet—presumably of the Southill Harriers— might easily be father and son, while the man organizing their departure wears what looks like indoor livery (fig. 84).

More is known about Joseph Mann, the gamekeeper trudging behind the mounted steward in another of the

FIG. 85. George Stubbs, *Lord Torrington's Steward and Gamekeeper with Their Dogs, at Southill, Bedfordshire*, 1767. Oil on canvas, 23½ × 41½ in. (59.7 × 105.4 cm). Private collection (cat. 55)

paintings commissioned by Lord Torrington (fig. 85). Born at the turn of the eighteenth century, he was not local to Southill but had come from Hertfordshire in 1733. At this stage he already looked middle-aged, with hair that had turned gray during a serious illness in his late teens. Perhaps his premature gravitas helped him land the job of huntsman, but he also doubled as head gamekeeper. Mann is said to have been

> a perfect adept in Shooting, Hare hunting and in the Arts of preserving Game. Domesticated so long in the same Family, and attentive to the same sports, he was looked upon by the neighbours as a Prodigy . . . and was called by all the county people Daddy. He was in constant, strong morning Exercise; he went to bed always betimes; but never till his skin was filled with ale. This he said "would do no harm to an early riser" (he was ever up at daybreak) "and to a man who pur-

sued Field sports." At 78 years of age he began to decline, and then lingered for three years. His Gun was ever upon his Arm; he still crept about, not destitute of the hope of fresh Diversion.[30]

As gamekeeper Mann had the job of enforcing the unfair and widely flouted Game Laws, which made poachers of anyone caught taking game, even on common land, who did not have an estate worth one hundred pounds per annum. Many keepers abused their position, taking bribes or a cut of the poachers' profits. Others were draconian, opening fire on trespassers and sowing the forests with vicious mantraps. Mann's general popularity in the county suggests that he exercised his jurisdiction with paternal care, but perhaps not too strictly.

A comparable commission, this time from Charles Anderson-Pelham of Brocklesby in Lincolnshire, came to Stubbs in 1776. Pelham's pack of foxhounds, largely

homebred, was reputed to be the most advanced in the country, and its huntsmanship was virtually a hereditary office, passing through four generations of the Smith family. Stubbs shows Thomas Smith the Elder riding behind his son, also Thomas (fig. 86). The old man had held the office of huntsman until he retired in 1761, when he yielded it to his son. Thomas the Younger continued in the post until 1816, when he in turn was succeeded by his son, William. It is thanks to William Smith's essay *Thoughts on Hunting* (1830) that we know the names of the horses his father and grandfather ride in the painting: a hack called Brilliant, which had been bought for Mrs. Pelham's use but proved unsuitable, and an ex-racer called Cigg. We also know that the scene represents the two men riding to covert "at foot's pace" in the cold early morning, for old Thomas is seen warming his left hand in his riding coat's pocket, as his grandson says he invariably did on such occasions.[31] The old foxhunting practice of drawing covert in the very early morning, when the scent was pronounced and the fox torpid after feeding, would soon go out of fashion. As faster and stronger hounds were developed—not least by the Brocklesby—a better or at least a longer chase was to be had by drawing in midmorning, when the fox was fitter to run and the scent less keen.[32] The pack's ability to run all day meant that many of the horses became exhausted and required changing midway through the hunt. This may be what the Prince of Wales's hack-groom William Anderson is doing in Stubbs's painting of 1793 (see fig. 130). Moving at a spanking trot and in the fine, rather cumbersome royal coaching livery, he appears to be leading a fresh saddled mount to the field.

Stubbs's stallion portraits of the 1760s almost invariably include a stud-groom. In prints based on some of them, these figures are omitted—as in a mezzotint of *Lord Grosvenor's Arabian* published in 1771 by William Wynne

FIG. 86. George Stubbs, *Thomas Smith, Huntsman of the Brocklesby Hounds, and His Father, Thomas Smith, Former Huntsman*, 1776. Oil on panel, 32¼ × 39½ in. (77 × 100.3 cm). The Earl of Yarborough

Ryland.[33] The excision radically changes Stubbs's prime compositional idea, and an important narrative element in the scene is lost. As any stud manager will testify, the bond between a stallion and his handler is close. In the Grosvenor painting (see fig. 97) the groom stands eyeball to eyeball with his charge, exerting calm but total authority. The stallion is young, jumpy; his man, by contrast, is experienced and fully in control, using a handling pole rather than a leading rein with, so it seems, an almost hypnotic gaze to charm the animal. There is something peculiarly rustic about the groom. His coat is plain and hardly new, and among all Stubbs's horsemen his hat is uniquely floppy and unofficial. The whole ensemble is nothing like the Grosvenor livery worn by the groom holding Bandy in Stubbs's painting of 1763.[34] It suggests a free man rather than a liveried servant. Perhaps he was

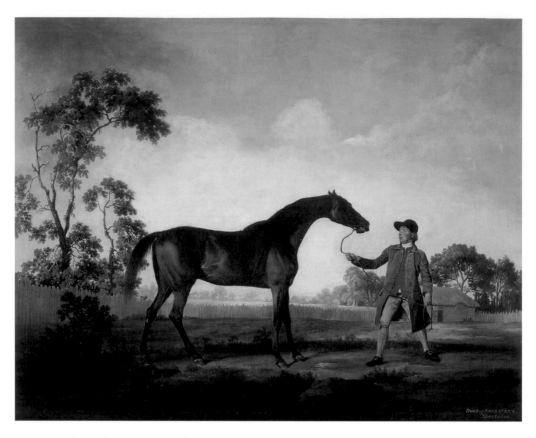

FIG. 87. George Stubbs, *The Duke of Ancaster's Stallion Spectator, with a Groom*, c. 1765–66. Oil on canvas, 39½ × 50⅛ in. (100.4 × 127.2 cm). Private collection (cat. 47)

a professional horse handler employed to deal with a newly arrived, high-mettled animal.

The posture, or body language, of Stubbs's grooms is always to be noted in these paintings. In *The Duke of Ancaster's Stallion Spectator, with a Groom* (fig. 87) the groom fixes the horse with an apprehensive gaze, his legs exaggeratedly braced and the rein loosened, as if he expected Spectator to give a sudden upward jerk of his head. *The Duke of Ancaster's Stallion Blank, with a Groom* (fig. 88) suggests a similar unease between horse and attendant. *Lustre, with a Groom* (see fig. 10), by contrast, shows no such moment of imbalance or tension. The young man checks his horse fondly, with a graceful (almost a dancer's) twist of the waist and hips. Lustre's body is also slightly canted, a visual hint of the bond that has grown up between himself and his attendant. The

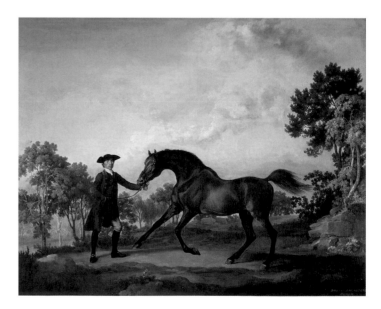

FIG. 88. George Stubbs, *The Duke of Ancaster's Stallion Blank, with a Groom*, c. 1765–66. Oil on canvas, 39½ × 49½ in. (100.4 × 125.8 cm). Private collection

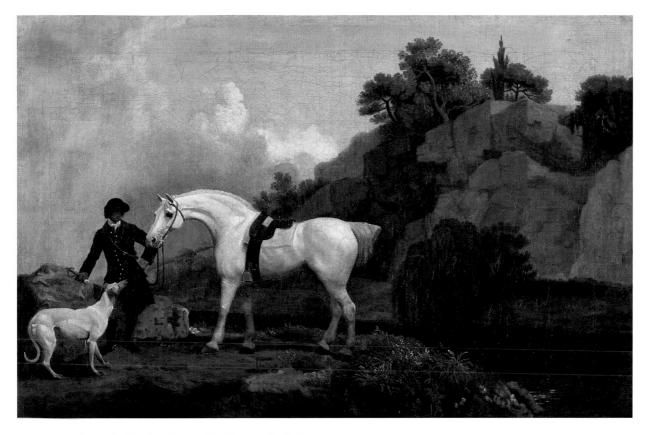

FIG. 89. George Stubbs, *Gray Hunter with a Groom and a Greyhound*,
c. 1766. Oil on canvas, 17½ × 26¾ in. (44.5 × 67.9 cm). Tate, London.
Purchased 1895 (cat. 52)

relationship between groom and his charge is at its most
relaxed in *Gray Hunter with a Groom and a Greyhound* (fig.
89). Here, against a looming, rocky landscape, the liveried
servant stands in a classic pose, his body's S-curve con-
forming closely to what Hogarth called the Line of Beauty.

In the early 1780s, when Stubbs was increasingly in-
volved with experiments in printmaking and enamel work
(and for three years submitted nothing for exhibition), he
made new farming studies that, in time, produced works
in various media on the theme of haymaking and harvest-
ing—a new direction for him (figs. 91–93). With his
penchant for producing linked paintings, he may have in-
tended to complete a Four Seasons series, reflecting the
continuing popularity of James Thomson's Virgilian poem
The Seasons. If so the scheme was truncated, since in the
end only Summer (haymaking) and Autumn (reaping)

subjects were developed. When two of the paintings
appeared at the Royal Academy exhibition of 1786, they
were criticized for being in an antiquated style, perhaps
because they seemed reminiscent of works by Pieter
Bruegel the Elder (fig. 90).[35]

At first sight, Bruegel's higher viewpoint, deeper land-
scape, and richer palette of colors contrast with Stubbs's
lower eye and flatter composition. But there are also
strong affinities. Stubbs had begun to paint on wooden
panels, which Bruegel had invariably done but which had
been rare among professional artists for at least a century.
Painting on wood was in line with Stubbs's concern to
achieve a smooth, hard surface for his pictures, which he
also sought through enamel work and his trials with bees-
wax as a paint medium, and it is notable that *Haymakers*
and *Reapers* later became the bases for some of his most

FIG. 90. Pieter Bruegel the Elder, *Haymaking*, c. 1565. Oil on panel, 46⅛ × 63⅜ in. (117 × 161 cm). Lobkowicz Collections, Nelahozeves Castle, Czech Republic

FIG. 91. George Stubbs, *Haymakers*, 1785. Oil (possibly with additives such as beeswax or resin) on panel, 35¼ × 53¼ in. (89.5 × 135.2 cm). Tate, London. Purchased with assistance from the Friends of the Tate Gallery, the National Art Collections Fund, the Pilgrim Trust, and subscribers, 1977

successful enamels. The Humphry manuscript tells us that, when commissioned to paint the Southill bricklayers (see fig. 76 and the related print, fig. 94), Stubbs had been specifically asked by Torrington to strive for a Flemish effect, and it is easy to see why this instruction would please the artist. Like Bruegel's, Stubbs's works are documentary in the sense that they deal with agricultural tasks as they are performed, without sentiment or narrative framework. Indeed, as Christopher Lennox-Boyd observed, *Reapers* "contains step-by-step instruction on how to cut and bind a sheaf of corn."[36] At a more aesthetic level, the Flemish painter would have struck sonorous chords in Stubbs with his habit of arranging figures rhythmically in pairs and threes.

Stubbs's later paintings of horses and servants show no diminution of interest in the servants. *Hambletonian, Rubbing Down* has already been discussed. Three commissions for the Prince of Wales—*William Anderson with Two Saddle Horses, The Prince of Wales's Phaeton, with the Coachman Samuel Thomas and a Tiger-Boy,* and *Soldiers of the Tenth Light Dragoons* (see figs. 130–32), all painted in 1793—constitute elements of a new series comparable to the Torrington commissions, paintings in which private servants and private soldiers are in roles more important than the mere supporters to a horse portrait. The prince's state-coachman Samuel Thomas, waiting to hitch up two magnificent carriage horses to a new "high-flyer" phaeton, certainly has more than a little Dickensian afflatus about him, but on examination he must be accepted as a figure of authority in his sphere. The tiger-boy, who turns his back to us just as emphatically as Thomas pushes out his belly, waits alertly for the order from the senior man to proceed. Thomas in his turn is looking outside the picture field, also waiting to receive orders. Neither man is his own master.

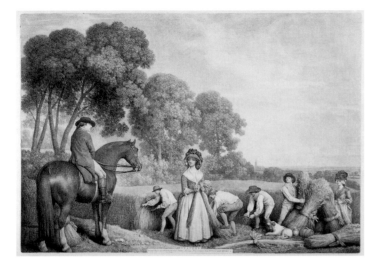

FIG. 92. George Stubbs, *Reapers*, published 1791. Stipple and roulette work, first state, plate: 19 × 26⅞ in. (48.3 × 68.3 cm). Tobin Foundation for Theatre Arts, courtesy of the McNay Art Museum, San Antonio (cat. 72)

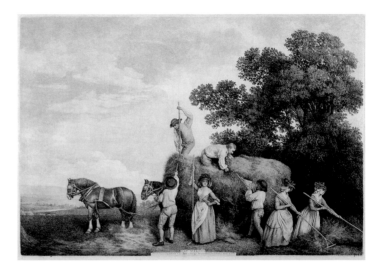

FIG. 93. George Stubbs, *Hay-Makers*, published 1791. Stipple with roulette work, first state, stamped "proof," plate: 19 × 26⅞ in. (48.3 × 68.3 cm). Tobin Foundation for Theatre Arts, courtesy of the McNay Art Museum, San Antonio (cat. 73)

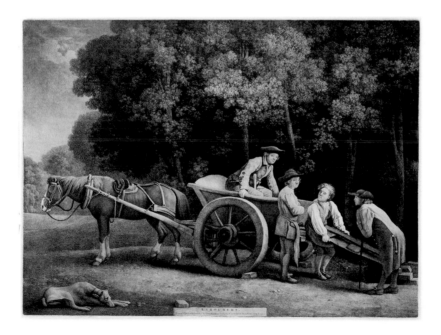

FIG. 94. George Stubbs, *Labourers*, published 1789. Etching, stipple, roulette, and rocker work, second state, plate: 20⁹⁄₁₆ × 27⅜ in. (52.3 × 69.5 cm). Yale Center for British Art, New Haven. Paul Mellon Collection (cat. 71)

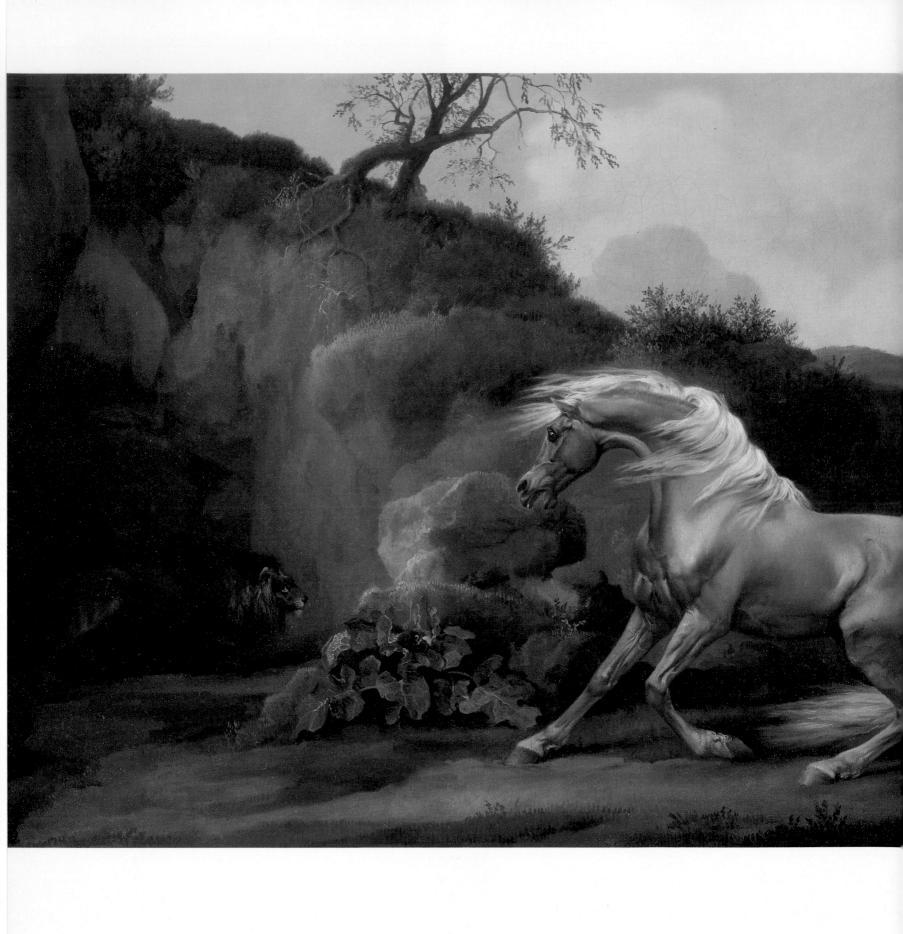

6

Stubbs and the Origins of the Thoroughbred

Malcolm Warner

THE GLORY of the eighteenth-century equine world was the creation of the English thoroughbred. Between 1680 and 1750, the athletic prowess and breeding consistency of British horses were improved, to a degree that seemed almost miraculous, by infusions of foreign blood. The progenitors of the race were stallions imported by successive generations of British breeders from the Middle East and North Africa; although most were called Arabian, Turk, or Barb (from Barbary, the old name for the western part of North Africa), their provenance was often obscure. The diarist John Evelyn captured the delight and admiration with which the British looked on these exotic animals after some new arrivals were displayed for Charles II and his court in St. James's Park: "They trotted like Does, as if they did not feele the Ground . . . in all

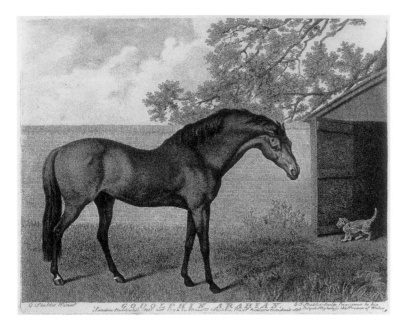

FIG. 96. George Townly Stubbs, after George Stubbs, *Godolphin Arabian*, published 1794. Stipple with etching, plate: 7⅞ × 9⅞ in. (20 × 25 cm). British Museum, London

reguards beautifull & proportion'd to admiration, spirituous & prowd, nimble, making halt, turning with that sweiftness & in so small a compase as was incomparable, with all this so gentle & tractable."[1] Breeders mated the foreign stallions with selected British-born mares whose ancestry was also, thanks to earlier importations, in large part foreign. Though not good racers themselves, the stallions sired a breed of horse better equipped for racing than any the world had known—in the words of the poet and critic Geoffrey Grigson, "a creature of mettle and elegance, a pasha of the Levant, a Bedouin of Arabia nourished upon English grass."[2] The most important of the stallions were, in chronological order, the Byerley Turk, the Darley Arabian, and the Godolphin Arabian, whose posthumous portrait Stubbs painted (fig. 96); these were the "foundation sires," from whom all modern thoroughbreds descend in the male line.

The development of the thoroughbred gave a huge impetus to racing. As faster horses were bred, racing became ever more exciting. Horses raced at a younger age over shorter distances and carried lighter weights, a trend that shifted the emphasis of the sport from stamina to speed. By midcentury, with more and more at stake for owners and gamblers alike, it was clear that the free-wheeling informality of the sport needed controls. From the time of its establishment in Newmarket in 1752, the Jockey Club gradually took on the role of a regulating body, setting and publishing rules, keeping records of horses' names and pedigrees, owners' colors, and race results. With the institution of some of the classic races—the St. Leger (1776), the Oaks (1779), and the Derby (1780)—the second half of the eighteenth century was the golden age of British racing. The thoroughbred also contributed to the flourishing state of hunting in this period; in the more prestigious hunts, the thoroughbred, seven-eighths-bred or three-parts-bred hunter was, by the mid-1770s, a common sight.[3]

Stubbs's racehorse portraits and stud-farm scenes, commissioned or bought from him by wealthy owner-breeders, paid homage to the British racing world. Sometimes in direct and practical ways, they were part of the workings of that world. The portrait of a horse was an expression of pride in ownership, a celebration of racing success, the record of a winning horse's appearance in its prime; it could even be an advertisement for its pedigree and services at stud. In 1775 a print after one of Stubbs's portraits of the great Gimcrack was published with the inscription: "Gimcrack, (now the property of Lord Grosvenor) was got by Cripple his Dam by Grieswood's Partner his Grandam by old Spot, his great Grandam by the Chestnut white leg'd Lowther Barb, out of the Old Vintner Mare. Gimcrack covers at Oxcroft Farm near Balsham and West Wratting, Cambridgeshire, at thirty Guineas a Mare and five Shillings the Groom."[4]

With his aspirations to the status of the "history painter," however, Stubbs hoped that his art might be seen as transcending the down-to-earth realities of sport, even when sport was its subject. The Turf Gallery that he opened in 1794 to display a series of portraits of outstanding racehorses of the past half century—a thoroughbred Hall of Fame, beginning with the Godolphin Arabian—was broadly modeled on the Shakespeare Gallery, a permanent exhibition of paintings by various artists of scenes from Shakespeare's plays (see fig. 133). One of the objects of the Shakespeare Gallery, founded by the print publisher John Boydell in the 1780s, was to encourage the growth of a British school of history painting. Stubbs would have liked the idea of his racehorse portraits as essays in modern history painting, or at least comparable to portraits of great and famous men and women. He was certainly conscious of the comparison he invited, in setting up his gallery, between the characters and dramas of the turf and those of Shakespeare. He remarked that his project might surprise the public in that "the chief merit consists in the actions, and not in the language, of the HEROES and HEROINES it proposes to record, and with whom, possibly, LITERATURE, may exclaim, 'She neither desires connection or allows utility.'" He wrote this only partly in jest. Great racehorses were, after all, heroic; their heroism was beyond the playwright, perhaps, but not the artist. Why not take it as seriously as any other artistic subject?

Horses were useful, generally benevolent in character, agreed to be beautiful, and as such the animals that people most readily imagined as possessed of high human qualities. By the beginning of the eighteenth century, and more and more with the flourishing of the thoroughbred, the epithet most commonly applied to them—soon almost invariably—was "noble." The special status they enjoyed would be written into natural history. Following the lead

of the great *Histoire naturelle* of Georges-Louis Leclerc, comte de Buffon (1749 onward), Thomas Pennant began his *British Zoology* (1768–70) with a discussion of the horse before all other animals, representing the species with a print after Stubbs's portrait of Lord Grosvenor's Arabian (fig. 97). Thomas Bewick also gave the horse pride of place in *A General History of Quadrupeds* (1790). The order in which these writers arranged the "brute creation" depended on the relationship of each species to man; domestic animals took precedence over wild ones and horses over all, the nobility of the animal kingdom.

The idea of the noble horse—indeed, that of the *foreign* noble horse—had its apotheosis in the fourth part of *Gulliver's Travels* (1726), "A Voyage to the Country of the Houyhnhnms." The Houyhnhnms (pronounced as a whinnying sound) are a superior race of equines who have their own language—in which their name means "a *Horse, and in its Etymology, the Perfection of Nature*." Gulliver becomes a servant to one of the first he meets, a gray. He discovers that the Houyhnhnms live together in harmony, free of all the evil and injustice with which he is familiar at home, and guided in everything by nature and reason. He describes life in England to them with some difficulty even after learning their language, since it contains no words for power, government, war, law, punishment, pride, lying, "and a Thousand other Things." The Houyhnhnms know nothing of bridles and saddles, and wearing clothes does not occur to them since they are unashamed of the bodies that nature has provided. "They preserve *Decency* and *Civility* in the highest Degrees, but are altogether ignorant of *Ceremony*," Gulliver observes. They educate their colts and foals with great care and show the same affection toward their neighbors' offspring as toward their own: "They will have it that *Nature* teaches them to love the whole Species, and it is *Reason* only that maketh a

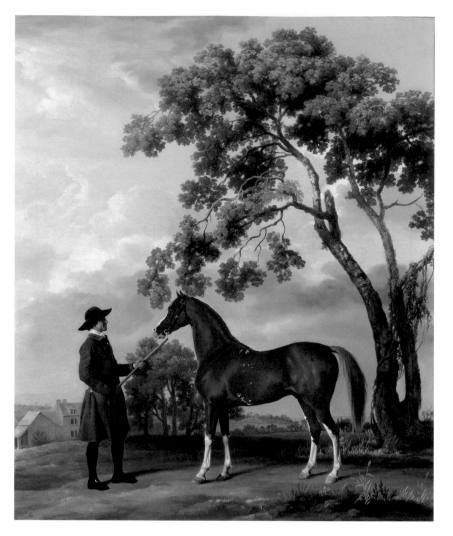

FIG. 97. George Stubbs, *Lord Grosvenor's Arabian Stallion, with a Groom*, 1766–70. Oil on canvas, 39⅛ × 32⅞ in. (99.3 × 83.5 cm). Kimbell Art Museum, Fort Worth (cat. 49)

Distinction of Persons, where there is a superior Degree of Virtue."[8]

Whereas the Houyhnhnms show civilization in its highest form, the other creatures that inhabit their country and serve them as beasts of burden, the filthy, hairy Yahoos, plumb the depths of barbarism. The Yahoos resemble humans, which leads the Houyhnhnms to take Gulliver, much to his dismay, for a more advanced version of the same species. In the moral scheme of the novel, the wise, noble Houyhnhnms and the bestial Yahoos are poles between which Gulliver, as a man, occupies a middle position. Of course, Jonathan Swift did not invent the equine utopia of the Houyhnhnms to glorify horses; it was a device by which to highlight the vices and follies of

eighteenth-century British society. Yet, among all the animals he might have chosen for the part of the noble, rational, civilized being that man was not, he did choose the horse.[9] (Perhaps thinking of the Houyhnhnms, William Blake was also to use the horse as the animal of reason, although for him true wisdom lay in the deep impulses of passion: "The tygers of wrath are wiser than the horses of instruction.")[10] *Gulliver's Travels* was immensely popular from the time it was published. It was a natural source for a horse painter in search of narrative subjects, and in 1768–72 Stubbs's younger contemporary Sawrey Gilpin painted scenes of Gulliver encountering the Houyhnhnms for the first time, describing war to them, and leaving their country (figs. 98–100)—with

FIG. 98. Sawrey Gilpin, *Gulliver Addressing the Houyhnhnms, Supposing Them to Be Conjurers*, c. 1768. Oil on canvas, 41 × 55 in. (104 × 139.8 cm). Yale Center for British Art, New Haven. Paul Mellon Collection

FIG. 99. Sawrey Gilpin, *Gulliver Taking His Final Leave of His Master, the Sorrel Nag, etc., and the Land of the Houyhnhnms*, c. 1771. Oil on canvas, 41 × 55 in. (104 × 139.8 cm). Yale Center for British Art, New Haven. Paul Mellon Collection

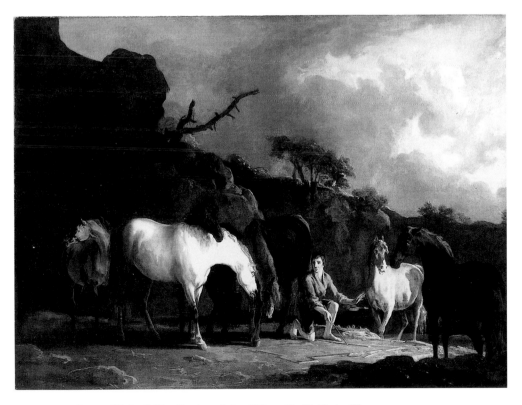

FIG. 100. Sawrey Gilpin, *Gulliver Reprimanded and Silenced by His Master, When Describing the Horrors of War*, c. 1772. Oil on canvas, 41 × 55 in. (104 × 140 cm). York Museums Trust (York Art Gallery)

groupings of horses that strongly recall Stubbs's mares-and-foals compositions.[11]

Although he never painted a Houyhnhnm subject himself, Stubbs was clearly interested in the elevation of animal painting through narrative. The most clearly "historical" of his works in this sense were his mythological paintings showing scenes from the stories of Hercules and Phaeton. It was in keeping that Joshua Reynolds, the champion of history painting in Britain, should have owned the first version of *Phaeton* (see cat. 64). Though not dealing with such established narratives, Stubbs's horse-and-lion compositions were also readily understood as a raising of the animal subject above its normal station. One of these belonged to Benjamin West, another artist associated with the cause of history painting and Reynolds's successor as president of the Royal Academy.[12] They not only derived from a well-known classical model; they seemed to verge on myth or allegory, even to share some of the grandeur admired by men such as Reynolds and West in the art of antiquity and the Renaissance. They were a translation of great images of human struggle—the famous classical sculpture of Laocoön and his sons attacked by serpents, for instance, or figures from a Rape of the Sabine Women or Last Judgment—into animal terms.

Stubbs's horse-and-lion paintings were his response to a much-discussed idea in eighteenth-century art theory, the idea that high art could deal in the terrible as well as the beautiful. This was the topic of Edmund Burke's *Philosophical Enquiry into the Origin of our Ideas of the Sublime and Beautiful* (1759). Like Hogarth in *The Analysis of Beauty* (1753), Burke used horses to illustrate some of his points. Discussing the role of power in the sublime, he argued that the sense of great power about a horse became truly sublime only when combined with an element of fear—as with the horse in the Book of Job, "whose neck is clothed with thunder, the glory of whose nostrils is terrible." The sublime seldom arose from everyday circumstances, even from a sight as impressive as that of a powerful horse, Burke maintained, but "comes upon us in the gloomy forest, and in the howling wilderness, in the form of the lion, the tiger, the panther, or rhinoceros."[13]

In some of his variations on the horse-and-lion theme Stubbs showed the horse pulling back in horror on first seeing the lion (fig. 101, for instance). One of these moved Horace Walpole to write a descriptive poem, "On seeing the celebrated Startled Horse, painted by the inimitable Mr. Stubbs," published in the *Public Advertiser* on November 4, 1763:

> —And Picture snatch the Palm from Life.
> How weak are words the passions to display,
> How artificial sounds are thrown away!
> When startled nature rushes through the eyes,
> In all the force of terror and surprize!
> Look there, proud Sage, thy learned spleen repress,
> Look there convinc'd—th'extorted truth confess;
> Convinc'd, transfix'd, repress thy learned spleen,
> Is that an engine! that a meer machine!
> Did ever terror through the senses look
> With more astonish'd force!—fling down thy book,
> Vain Man! Read nature there, by reason taught;
> Nature and reason are together fraught
> In that sublime essay—my blood runs back,
> My fibres tremble, and my sinews slack;
> I feel his feelings: how he stands transfix'd!
> How all the passions in his mien are mix'd!
> How apprehension, horror, hatred, fear,
> In one expression, are concenter'd there!
> How pois'd betwixt the love of life and dread,
> With yielding joints, with wild distended head,

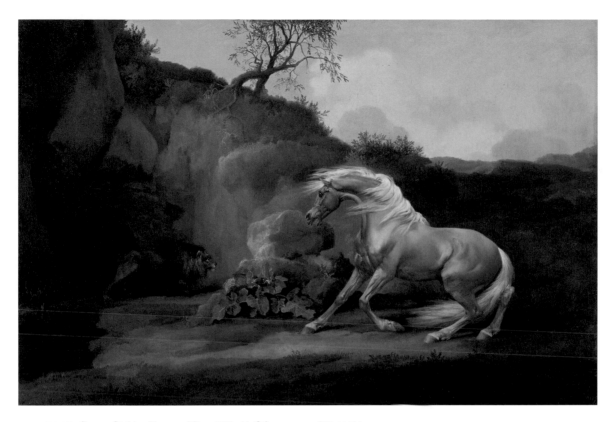

FIG. 101. George Stubbs, *Horse and Lion*, 1762–68. Oil on canvas, 27¾ × 41 in. (70.5 × 104.1 cm). Yale Center for British Art, New Haven. Paul Mellon Collection (cat. 40)

With ears shot forward, with stiff projected mane,
That all the workings of his soul explain,
He trembling stands! and on the lyon nigh,
With frighted visage and with fasten'd eye,
He stares bereft, unable to retire!
The furious beast with fascinating fire
Dissolves his faculties; he's rooted there.
How elegant, how tender, is his air;
His beauteous frame, in such convuls'd distress,
Must all the anguish of his heart express:
In terms pathetic we peruse his pain,
And read his pang through each transparent vein.
Through that stretch'd nostril see each feeling fly,
And Garrick's self might study close that eye;
Holland and he with ardor here may dwell,
And copy nature, if they can, so well.

Thy pencil, Stubbs, no rival need to fear;
Not mimic art, but life itself is here.[14]

Walpole, whose wildly fantastic and emotional story *The Castle of Otranto* (1764) was to launch the Gothic novel as a literary genre, was a devotee of the sublime. His verses on Stubbs's painting, though obviously no poetic master-piece, stand among the most valuable commentaries on the artist's work by a contemporary. Stubbs must have been delighted at the repeated references to his truthful-ness to nature—the painting was "Not mimic art, but life itself"—and the empathy he had managed to inspire be-tween poet and horse. In the horse's body and face Wal-pole felt "all the workings of his soul," a world of passions into which he could enter as fully as if the protagonist were human. "I feel his feelings," he declared, voicing

both the intense emotional engagement demanded by the sublime and the new sense of kinship with animals developing in Britain at this time.

Like most of the more ambitious artists of the age, Stubbs studied not only anatomy but also physiognomy. At the time of his death he owned twenty-three "coloured Prints of the Passions" by artists unknown, as well as nineteen of the famous engravings of heads expressing various emotions after the French artist Charles Lebrun, first published in 1698.[15] He himself sculpted models of four expressive heads, presumably to keep in the studio; reproductive prints of them were published in 1800 as *Views of the Passions: Laughter, Crying, Tranquility,* and *Terror or Fright* (fig. 102).[16] They differ from Lebrun's heads, and those of Lebrun's many imitators, in that they are *écorchés,* showing the anatomy of each expression as it would appear without skin; in this they resemble Stubbs's dissection-based anatomical drawings and etchings of horses. In his horse-and-lion compositions Stubbs challenged himself to capture the anatomy of the horse under extremes of emotion, creating equine versions of the full-blown heads of terror in Lebrun's series or his own model.[17] In the process he was again drawn toward the écorché: with the bulging of the muscles and veins, the body and face of the terrified horse almost appear flayed.

Stubbs would have seen the primary artistic source for his horse-and-lion paintings, the Hellenistic sculpture of the same subject in the garden of the Palazzo dei Conservatori (see fig. 68), during his youthful visit to Rome in 1754; it featured in the standard guidebooks, which noted that Michelangelo himself had admired it.[18] The group had been the basis for a number of modern interpretations—they varied in material, size, the position of the horse's head, and other aspects of the design—and Stubbs would have known at least some of these, too. They

FIG. 102. George Townly Stubbs, *Terror or Fright,* after a model by George Stubbs, first published 1800. Stipple with roulette work, second state (published 1815), plate: 13 × 9⅜ in. (32.9 × 23.8 cm). Wellcome Library, London

included an early-seventeenth-century bronze version after Giambologna (fig. 103), casts of which he may have seen in British collections of small Italian bronzes, even that of his patron Lord Rockingham.[19] An eighteenth-century Italian marble version seems also to have been in a British collection;[20] and a large version in Portland stone by Peter Scheemakers was installed in the gardens at Rousham, Oxfordshire, in about 1741.

According to an article in the *Sporting Magazine* of May 1808, however, Stubbs was inspired to undertake his series of horse-and-lion paintings by memories of seeing a horse actually stalked and killed by a lion in Morocco—part of old Barbary—where he stopped for a brief visit while on his way home by sea from Rome:

During his passage he became acquainted with a gentleman, a native of Africa, whose tastes and pursuits

in life were similar to his own. This gentleman had been to Rome, and was returning to his family: he was liberally educated, and spoke the English language with accuracy. His information made him a delightful companion to Stubbs, who had often expressed how much it would add to his gratification if he could but behold the lion in its wild state, or any other wild beast.—His friend, on one occasion, gave him an invitation to the paternal mansion he was about to visit. The offer was accepted with pleasure, and Stubbs landed with his friend at the fortress of Ceuta. They had not been on shore many days, when a circumstance occurred most favourable to the wishes of our painter. The town where his friend resided was surrounded by a lofty wall and a moat. Nearly level with the wall a capacious platform extended, on which the inhabitants occasionally refreshed themselves with the breeze after sun-set. One evening, while Stubbs and his friend were viewing the delightful scenery, and a thousand beautiful objects, from this elevation, which the brilliancy of the moon rendered more interesting, a lion was observed at some distance, directing his way with a slow pace, towards a white Barbary horse, which appeared grazing not more than two hundred yards distant from the moat. Mr. Stubbs was reminded of the gratification he had so often wished for. The orb of night was perfectly clear, and the horison serene. The lion did not make towards the horse by a regular approach, but performed many curvatures, still drawing nearer towards the devoted animal, till the lion, by the shelter of a rocky situation, came suddenly upon his prey. The affrighted barb beheld his enemy, and, as if conscious of his fate, threw himself into an attitude highly interesting to the painter. The noble creature then appeared fasc-

inated, and the lion, finding him within his power, sprang in a moment, like a cat, on the back of the defenceless horse, threw him down, and instantly tore out his bowels.[21]

With the antique sculpture of the horse attacked by a lion fresh in his mind, Stubbs would have felt this experience of nature imitating art keenly; and the fact that the victim of the attack was a Barbary horse would have given it greater resonance still since the Barb, as any Englishman knew, was an ancestor of the thoroughbred.

Stubbs painted probably the first and certainly the largest of his horse-and-lion paintings (fig. 104) for Lord Rockingham, for whom he also painted *Whistlejacket* (see fig. 6). Painted around the same time, these two grand canvases show horses of similar color on the same large scale. They were not literally companion pieces; they hung in different houses, *Whistlejacket* at Wentworth Woodhouse and the *Horse and Lion* in Rockingham's London residence at No. 4, Grosvenor Square. On an imaginative level, however, they were complementary. The story that connected them, one that could hardly have been closer to Rockingham's heart as an avid owner-breeder of racehorses, was that of the origins and progress of the English thoroughbred. Whistlejacket was a paragon of thoroughbred beauty. He was also of impeccable lineage: his grandsire was the Godolphin Arabian—whom some believed, despite his name, to have been in fact a Barb.[22] While painting him Stubbs may have thought of his experience in Morocco, told Rockingham, and with his patron formed the idea of painting Whistlejacket's counterpart in the wild, a similarly beautiful creature who might be an ancestor, shown as he lived and died in a faraway place and time. Rockingham would have the modern marvel of the English thoroughbred on one hand and its prehistory

FIG. 103. Antonio Susini or Giovanni Francesco Susini, after Giambologna, *Lion Attacking a Horse,* first quarter of the seventeenth century. Bronze; height: 9½ in. (24.1 cm). The J. Paul Getty Museum, Los Angeles

on the other. As a pendant to the *Horse and Lion* in Rockingham's house on Grosvenor Square, Stubbs painted a lion attacking a stag on the same large scale.[23] But the horse-and-lion subject clearly interested him more; it was a theme to which he would return, using various techniques of painting, printmaking, and relief modeling, in numerous smaller works over the following twenty-five years (see figs. 69, 101, 108–10, 112, 113).

By Stubbs's time it was common for horse-painters to allude to the origins of Arabians, Turks, and Barbs in their portraits of them. John Wootton showed the Byerley Turk and others among classical ruins and attended by dark-skinned, mustachioed grooms dressed *à la turque,* presumably to give an idea of Mediterranean lands once under the Greeks or Romans and now part of the Ottoman Empire; sometimes he introduced pyramids or palms to

enhance the effect. Stubbs's approach to suggesting the ancestral homeland of the thoroughbred was more complicated. His *Gray Arabian with a Groom* and *The Marquess of Rockingham's Arabian Stallion* show different Arabian horses that belonged to different owners (figs. 105, 106). Whereas one groom is in Turkish costume in the manner of Wootton—probably to match earlier horse portraits belonging to the patron who commissioned the work, the Duke of Ancaster—the other is clearly British. Yet the landscape settings are almost identical, showing the same piece of rocky terrain. This is identifiable as Creswell Crags, near Welbeck Abbey, the seat of another of Stubbs's patrons, the Duke of Portland.

Stubbs's scenes from the world of breeding comprised both stallion portraits and mares-and-foals groups, and the great *Brood Mares and Foals* (fig. 107) also has a looming Creswell Crags setting. But it was probably as a background for his horse-and-lion paintings that he first became interested in the place. Although the large *Horse and Lion* that he painted for Rockingham included palms, he soon abandoned such props—perhaps in part because he had little chance to study their appearance from nature—and in his many variations on the theme used and reused sites among the Crags (fig. 108). The attraction, as the Stubbs scholar Judy Egerton has pointed out, was the aura of the primitive.[24] The place was rough, inhospitable, and dramatic. In the aesthetic language of the time, it was neither beautiful nor picturesque but sublime. When the caves at the Crags were excavated in the later nineteenth century they were found to contain the remains of prehistoric animals, including horses and cave lions, in fairly shallow soil. Perhaps Stubbs came across these and used his knowledge of anatomy to form some idea of what they were. As a setting for his paintings, the Crags were a sublime wilderness—an image for Barbary

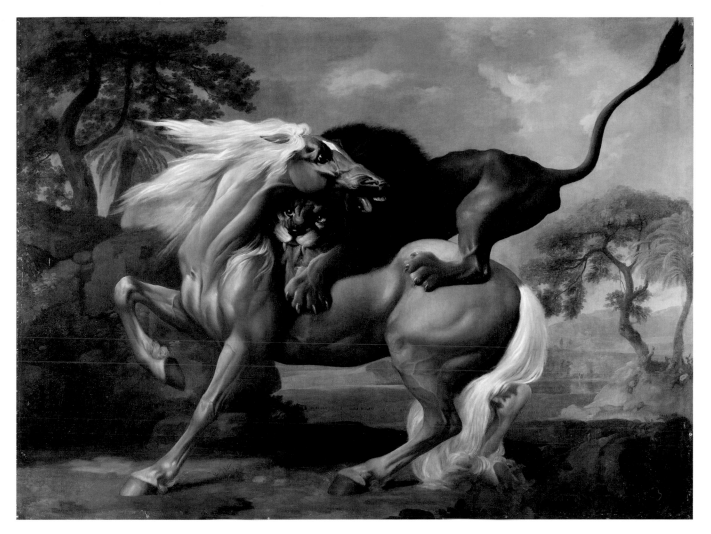

FIG. 104. George Stubbs, *Horse and Lion*, 1762. Oil on canvas, 96 × 131 in. (243.7 × 333 cm). Yale Center for British Art, New Haven. Paul Mellon Collection

and the barbaric world from which the thoroughbred had emerged.

The thoroughbred's Middle Eastern and North African background was a topic of some fascination to British horse enthusiasts. They marveled at the quality of horses bred in such harsh climates and terrain, as well as at the skill of the breeders. "They have raised and refined the species," wrote Richard Berenger, "and led it up to a pitch of perfection, beyond what mere nature perhaps could have attained, though assisted by the advantages of a better country." Horses and horsemanship flourished, he added, because owners in the region treated their horses

fondly, "and perfect good will and harmony subsists between them."[25] In his *British Zoology*, Thomas Pennant digressed at length on the subject, suggesting finally that the horse described in the Book of Job—and mentioned by Burke as an example of the sublime—must have been an Arabian:

> The *Arabs* place their chief delight in this animal; it is to them as dear as their family, and is indeed part of it: men, women, children, mares, and foals all lie in one common tent . . . This constant intercourse produces a familiarity that could not otherwise be

FIG. 105. George Stubbs, *Gray Arabian with a Groom*, c. 1765–66. Oil on canvas, 35 ½ × 44 in. (90.2 × 111.8 cm). Private collection

FIG. 106. George Stubbs, *The Marquess of Rockingham's Arabian Stallion,*
with a Groom, 1766. Oil on canvas, 38½ × 48½ in. (97.8 × 123.2 cm).
National Gallery of Scotland, Edinburgh (cat. 51)

Painting in an Age of Innovation

Stubbs's Experiments in Enamel and Wax

Lance Mayer and Gay Myers

"There is a picture at the exhibition in which Stubbs has invented enamelling oil paintings, and it looks as if he would succeed—not that our painters will adopt it. They are as obstinate as mules or farmers. Would they deign to employ the encaustic that Müntz revived in this house?"—Horace Walpole

WHEN THE author, tastemaker, and inveterate letter-writer Horace Walpole saw Stubbs's enamel painting *Horses Fighting* (fig. 114) at the Royal Academy exhibition in 1781, he elevated Stubbs to a rank above the other "obstinate," mulelike artists who were reluctant to embrace innovative painting techniques. In fact, Stubbs was even more of an innovator than Walpole probably realized. We now know that Stubbs actually *had* deigned to employ versions of the encaustic (wax painting) that Walpole and the peripatetic Swiss painter

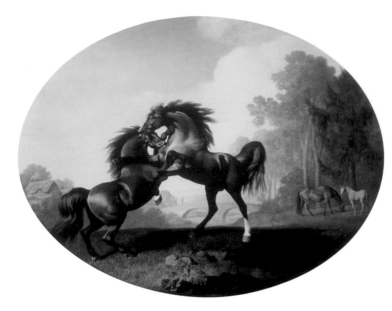

FIG. 114. George Stubbs, *Horses Fighting*, 1781. Enamel on Wedgwood earthenware, oval, 29 × 37 in. (73.7 × 94 cm). Private collection

Johann Heinrich Müntz had promoted two decades earlier. The experiments that Stubbs carried out in enameling and wax painting are now well known; his innovations in enamel painting are particularly admired and have received a great deal of scholarly attention.[1] Perhaps less well known is the context out of which these technical innovations grew.

Stubbs's career coincided with the period of greatest change and experimentation in painting techniques since the Renaissance. Artists all over Europe looked to the classical past for inspiration, tried out new methods, and often wrote down the results of their investigations. This essay discusses Stubbs's enamel painting and wax painting in the context of published and manuscript accounts of painting techniques, which grew enormously in number during Stubbs's lifetime. In this way we can clarify the distinctive nature of Stubbs's contributions, and (since Stubbs himself is silent about his innovations and his reasons for them) the possible motivations of Stubbs and other artists in undertaking such experiments. Some gaps

in our knowledge of the techniques and motivations of artists working in London can be supplied by accounts from North American painters, who began to travel to London in increasing numbers beginning in the 1760s and, eager to learn, took notes on all they saw.

The first question one might ask is why Stubbs's experiments with enameling and wax took place when they did—beginning at the end of the 1760s and coming to fruition in the 1770s. These decades were a time of crisis for British painters, and one cause for anxiety was the belief that knowledge of painting techniques was woefully lacking in Britain. Thomas Bardwell's treatise on painting, first published in 1756, lamented that British painters lacked "certain knowledge" even of the techniques of such painters as Peter Paul Rubens and Anthony Van Dyck, who had worked in Britain during the previous century.[2] By the 1760s this was leading some, especially those who traveled to Italy, to search ever more enthusiastically for the "secret" recipes of earlier painters. Stubbs's friend James Barry wrote about the "magilphs and mysteries" that British painters sought in Italy ("magilph" or megilp is a concoction added to oil paint to improve its working qualities).[3] Stubbs's friend and biographer Ozias Humphry, who also studied in Italy, became a compulsive researcher in this area, compiling information about seventeenth-century painters' techniques as well as soliciting recipes from his contemporaries.[4]

By the 1760s there were more painters in London than ever before and more opportunities to exhibit, and there are hints that some artists thought that technical innovations or "secrets" might give them a leg up on the competition. Benjamin West, who had invented his technique in Italy, was described by the young American Charles Willson Peale in 1767 as painting "in a Differrent Manner from Common Oil Paint:g which gives great luster & Strength to the Coulering—a method or art no Painter

here Else knows any thing of."[5] (This would not be the last time that West would be said to have an exclusive technical "secret" that put his competitors at a disadvantage.)[6] It is perhaps no coincidence that at almost exactly this time Joshua Reynolds began to keep notes in his ledger books describing in quasi-Italian his own experiments with various media.[7] It is very much in the spirit of the times that in the late 1760s a painter like Stubbs, who had employed a rather conservative, straightforward oil painting technique up until then but who had ambitions to be seen as much more than an animal painter, might have felt that new techniques could give him an advantage.

One might ask why Stubbs chose to experiment simultaneously with two media—enamel and wax—that at first seem so different. Some of the connections between the two are obvious. Both enameling and some forms of wax painting involve the application of heat. Both media were also claimed to have a classical pedigree: Pliny's account of the use of encaustic by the ancient Greeks had sometimes been interpreted in the eighteenth century as meaning enameling.[8]

Another connection between wax painting and enamel painting was the equivalency that they were given, alongside oil painting, in period literature. This is particularly noticeable in the important and widely circulated British treatise on painting technique, *The Handmaid to the Arts*, by Robert Dossie (first edition, 1758).[9] Dossie's book was one of many compendia of practical knowledge that now began to appear all over Europe, of which Denis Diderot's encyclopedia is only the most famous. The second edition of *The Handmaid to the Arts*, which appeared in 1764 (fig. 115), treats painting in enamel and painting in wax as if they were equal, alternative media that an artist might choose, like oil or watercolor. Charles Willson Peale, who had purchased a copy of Dossie's book in Philadelphia, even felt constrained to explain that during

FIG. 115. Title page to Robert Dossie, *The Handmaid to the Arts*, 2d ed., 1764

his stay in London between 1767 and 1769 he "was not contented with knowing how to paint in one way, but engaged in the whole circle of arts, except at painting in enamel."[10] Further proof of the connection between wax and enamel painting is that two of the early pioneers of wax painting, Jean-Jacques Bachelier and Benjamin Calau, working in France and Germany, respectively, were said also to have done paintings in enamel.[11]

Interest in the possibilities of enameling had been building in Britain during the decades before Stubbs began his experiments, although the technique was still

FIG. 116. George Stubbs, *Self-Portrait,* 1781. Enamel on Wedgwood earthenware, oval, 27 × 20 in. (68.6 × 50.8 cm). National Portrait Gallery, London (cat. 66)

associated mostly with modest decorative functions. A precedent for an ambitious attempt to connect enameling and the fine arts was the short-lived Battersea enamel works (1753–56), which produced colored enamel portraits of royalty and copies after works by such painters as Antoine Watteau and François Boucher.[12] It is against the background of the failure of Battersea that Dossie's pleas for the encouragement of British enameling, which he described as being "of late introduction among us," must be seen.[13] The sheer number and variety of enamel colors described by Dossie (forty-eight in the 1764 edition) show that British enameling was poised for greater things several years before Stubbs tried it.[14] The Society for the Encouragement of Arts, Manufactures and Commerce (Society of Artists) also tried to promote innovations in enameling, offering a premium of fifty pounds in 1765 for a white enamel equal to the product from Venice, which dominated the market.[15]

Stubbs began enameling on copper about 1769 (see cat. 60), but by 1775 he was working in partnership with Josiah Wedgwood to develop enamels on ceramic tablets on a much larger scale, eventually succeeding in 1778 (see, for example, figs. 63, 111, 114, 116, 117, 119, 128). Although no one approached Stubbs in the size and sophistication of his enamel paintings, he was not alone in using enamels innovatively at this time. There is evidence that Wedgwood encouraged one Edward Stringer in enamel painting on ceramic plaques during the 1770s,[16] and there are hints in Wedgwood's correspondence that Joseph Wright of Derby may have intended to try his hand at enameling in 1778 or 1779.[17] In 1785 the Society of Arts awarded two prizes for innovations in enameling, including one for some paintings in enamel "in a manner nearly resembling the method of painting in oil, which blends and unites the colours."[18]

The technical literature of the time can help explain the greatest mystery of all connected with Stubbs's enamel paintings: how he blended his colors so successfully that—as Walpole noted—they looked like oil paintings. Enamel colors are powders made from glass (or mixtures of glassy materials) plus coloring matter, similar to, but with a lower melting point than, ceramic glazes. The powdered enamel colors are mixed with a liquid so that they can be applied to a metal or ceramic substrate, and when they are fired in a kiln the glassy portion melts and serves as a binder.

Some of the difficulty in understanding Stubbs's enameling process may have arisen because today we are most familiar with modern ceramic glazes, which have a water base and dry quickly to a powdery, pastel-like surface, in which it is difficult to discern what has been applied. Eighteenth-century sources make it clear that enamel technique at that time involved the use of a "secondary vehicle"—a slow-evaporating, oily liquid that would give the painter considerable time to see the colors "wetted up" while they were being applied. Dossie recommended oil of spike for this purpose, because it had an "unctuous" character but evaporated in the kiln. Dossie said that some practitioners added linseed oil or olive oil, and other sources recommended vehicles that had been thickened by boiling or by standing for three or four years.[19] These less volatile additives would give the artist even more time to spread and blend the colors. Dossie warned, however, that linseed oil or olive oil would leave blackish deposits on firing.[20] It has been previously pointed out that some of Stubbs's early enamels have a pattern of small black spots,[21] and some of the later ones do as well, including *Reapers* (fig. 117). It is possible that Stubbs, who was pushing the enamel medium to new limits, might have used one of these nonvolatile additives to

FIG. 117. George Stubbs, *Reapers*, 1795. Enamel on Wedgwood earthenware, oval, 30¼ × 40½ in. (76.8 × 102.9 cm). Yale Center for British Art, New Haven. Paul Mellon Collection

get more working time, with the results that we now see in the form of black spots, exactly as Dossie predicted.

Ozias Humphry reported that Stubbs initially spent two years perfecting nineteen "tints" for use in enameling.[22] The word "tint" was used in the eighteenth century to indicate mixtures of pigments prepared in advance by the artist.[23] Stubbs did not need to invent new chemical compounds for enameling; many already existed. His challenge was rather to make mixtures of existing enamel colors that stayed true on firing and could be blended imperceptibly with other tints to represent all the colors of nature without a "paint-by-number" appearance. A French treatise on enameling of 1721, which Stubbs probably owned, spelled out the steps that an enamel painter should take to mix tints and try them out by firing.[24] The painter was advised carefully to label small pots with the weights of the various components in the trial mixtures

and finally to fire a plaque painted with samples of all of the tints (applied both thinly and thickly) to keep in front of him for reference while working.[25] It is extraordinary that Stubbs succeeded so well in making and using these kinds of mixtures; when we look at an enamel painting like *Reapers*, the spots of blue sky that punctuate the foliage of the trees are somewhat schematized compared to the version painted on a wooden panel (fig. 118), but the subtle shading in the deep brown colors perfectly captures the texture of the horseman's jacket and the sheen of his horse's coat. This kind of sophisticated painting is evidence not only of Stubbs's success in developing tints that could be blended with one another but also of the use of a secondary vehicle that gave him enough working time and allowed him to see what he was doing.

It has been suggested that Stubbs applied his enamel colors in multiple firings.[26] Enamels on metal were tradi-

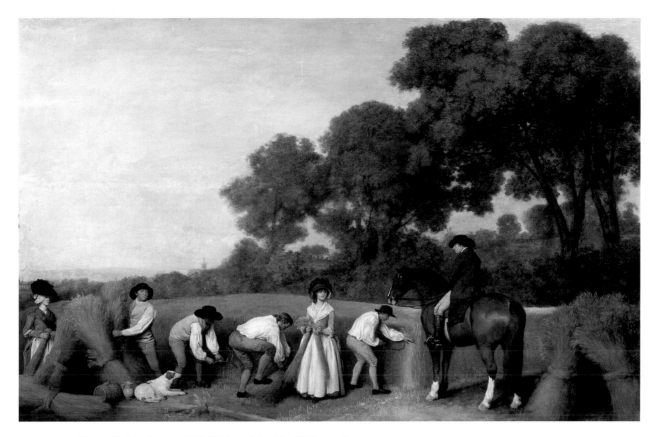

FIG. 118. George Stubbs, *Reapers*, 1785. Oil (possibly with additives such as beeswax or resin) on oak panel, 35½ × 53⅞ in. (90 × 137 cm). Tate, London. Purchased with assistance from the Friends of the Tate Gallery, the National Art Collections Fund, the Pilgrim Trust, and subscribers, 1977

tionally done this way—first a white underlayer was applied and fired, then the layers containing coloring were applied (usually quite thinly), and last a transparent, glassy layer was applied. Each layer needed to have a successively lower melting temperature so that it did not melt into and spoil the layer below. This was probably the procedure that Stubbs followed in his enamels on metal supports.

But the paintings on ceramic tablets are quite different, showing no white underlayer and no glossy final coating. The enamel colors that Stubbs applied to ceramic tablets are very similar to the matte "encaustic" enamels on Wedgwood's imitations of Greek pots, which show crisp brushstrokes that retain their texture and do not melt into a pool on firing. Stubbs's portrait of Hospey Walker (fig. 119) is an interesting and revealing case. Examination shows that the piece developed a flaw during

production—part of the thick enamel is missing in the area of the sitter's forehead—and the artist then applied an additional thick layer of enamel and refired the piece. What is striking is that both the first and second layers of enamel have remained intact—they are firmly attached but have not flowed together (fig. 120). The thickness of layers implies that Stubbs *could* have painted major parts of his enamel paintings thickly, *alla prima* (blended wet-into-wet), in one firing. An unctuous secondary vehicle could have helped him to blend his colors, and the nature of the glazes was such that the thickness and to some degree the individual brushstrokes would be preserved. In painting alla prima, Stubbs's simple, straightforward oil-painting technique would have served him well (as opposed, for instance, to Reynolds's technique of multiple translucent glazes). But the example of *Hospey Walker* also indicates that the nature of Stubbs's enamel colors allowed him to

FIG. 119. George Stubbs, *Hospey Walker*, 1783. Enamel on Wedgwood earthenware, oval, 18 × 14½ in. (45.7 × 36.8 cm). Yale Center for British Art, New Haven. Paul Mellon Bequest

FIG. 120. *Hospey Walker*, detail of refired area

apply enamel a second time and refire a piece without endangering his first application of enamel.

Stubbs's experiments with wax are less well known than his innovations in enameling, and not as well documented, because we lack the benefit of a letter-writer involved in the project as Josiah Wedgwood was involved in the enamels. Analysis of paintings at the National Gallery in London, however, has established that Stubbs used mixtures of beeswax and resin (with no oil) on some paintings during the 1770s and early 1780s. Paintings made after this, such as *Gentleman Driving a Lady in a Phaeton* (fig. 121), were found to contain mixtures of beeswax and resin *plus* oil. Unusual ingredients like nondrying oils or fats also appear to be present in some of Stubbs's paintings.[27]

In his use of wax, Stubbs was part of a movement that fascinated the European art world during the second half of the eighteenth century. Wax painting was the perfect pursuit for the neoclassical age—there was an ancient source for it in Pliny, but his account was so vague that there was plenty of room for experimentation and invention in the spirit of the Enlightenment. It helped that the techniques being revived were those of the ancient Greeks rather than the Romans (hence supposedly more perfect), although it was recognized that there was no guarantee that Pliny the Roman knew any more about the methods of Polygnotus than Reynolds knew about those of Titian.[28] Experimentation with wax soon took on a life of its own; in his *Encaustic, or Count Caylus's Method of Painting in the Manner of the Ancients* (1760), J. H. Müntz wrote of wax painting: "Any discovery that tends towards improvement of arts and sciences is valuable . . . Therefore it matters not if the ancients did so or not."[29] This modern-sounding confidence in progress and willingness *not* to be strictly constrained by the past might have appealed to Stubbs—

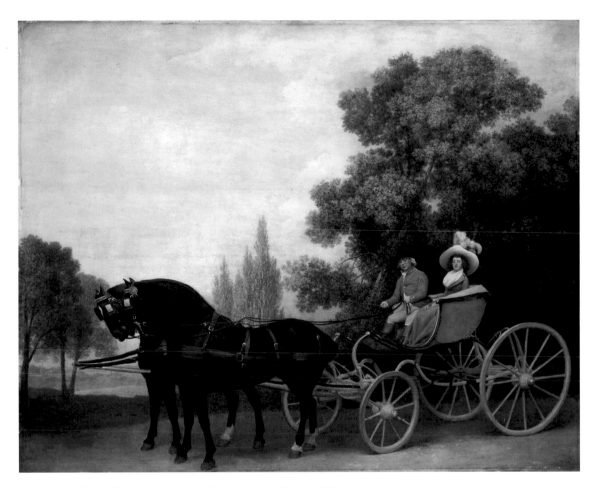

FIG. 121. George Stubbs, *Gentleman Driving a Lady in a Phaeton*, 1787.
Oil, wax, and resin on oak panel, 32½ × 40 in. (82.5 × 101.6 cm). The
National Gallery, London (cat. 67)

contrary to usual practice, Stubbs allegedly did not copy
old paintings or draw from the antique while he was in
Italy because he felt he could learn more by observing
nature.[30]

The complex trail of experiments and theories about
wax painting began in mid-eighteenth-century France,
and soon spread as far as Scandinavia and Russia.[31] The
most important early publication was the *Mémoire sur la
peinture à l'encaustique et sur la peinture à la cire* (1755) by
the famous antiquarian Count Caylus, written in collabo-
ration with a physician named Majault. Caylus proposed
a variety of techniques, including some involving heat
("true" encaustic), as well as other processes that involved
mixing wax with resin to make a cold solution that could

be applied more or less like oil paint.[32] He sent emissaries
to Italy to propagate his theories, and British artists may
have encountered Caylus's ideas there.[33] French researches
into wax painting were certainly known in England by
1756.[34] By 1758, Müntz was carrying out his own experiments
at Strawberry Hill under Walpole's patronage. Müntz
quarreled with Walpole and published his book—which
is a partial translation and interpretation of Caylus—inde-
pendently, in 1760.[35] Dossie's otherwise comprehensive
Handmaid to the Arts had nothing to say about wax painting
in 1758, but the 1764 edition quoted at length from Müntz's
book and described wax painting as being "of practical
importance."[36] Peale reported that by 1767 Müntz's book
had grown so popular that a pirated edition existed.[37] Given

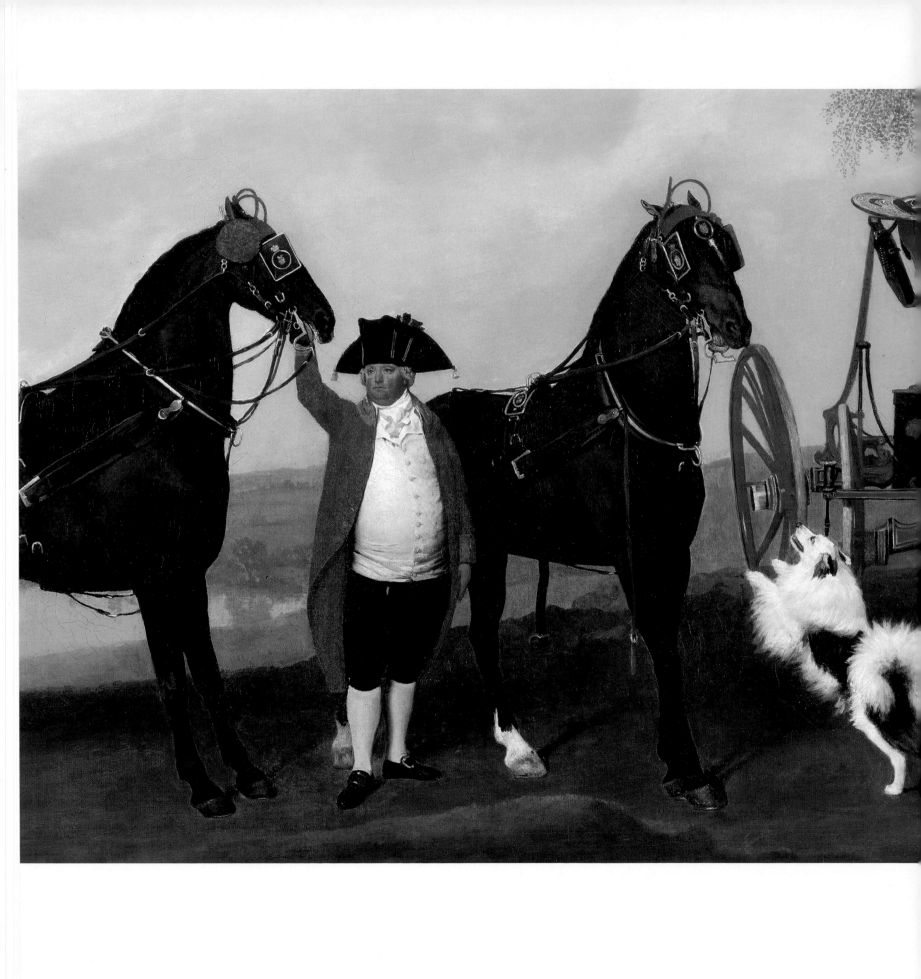

Stubbs, the Macaroni, and the Prince of Wales

Robin Blake

UNDER THE patronage of Lord Rockingham and his Whig followers, Stubbs found himself recognized as an artist-scientist of national renown and importance. He might then have expected to attract the interest of the royal court, the most important source of patronage on the arts scene. Yet for the next twenty years he remained significantly outside the magic circle of royal patronage, a situation to which he probably did not object. Gleanings from his obscure family background contain a few telling indications—in his grandfather Richard Stubbs's time, when the Protestant Glorious Revolution displaced the Catholic James II and his heirs—of nonjuring, not to say Jacobite, sympathies.[1] As a young adult in York, Stubbs himself mixed chiefly with Catholics, nonjurors, and Jacobites—and later, in London, his adherence to the opposition Whigs, loyalty to the

FIG. 125. George Stubbs, *The Prince of Wales on Horseback*, 1791. Oil on canvas, 40⅜ × 50¼ in. (102.5 × 127.6 cm). The Royal Collection

FIG. 126. Thomas Rowlandson, *The Betting Post*, c. 1789. Ink and color washes, 5½ × 8 in. (14 × 20.3 cm). Victoria and Albert Museum, London. The Prince of Wales with fellow devotees of the turf

Society of Artists, and dislike of the Royal Academy all give the same impression of an anticourt stance. No personal writings by Stubbs survive, and nothing of his religious or political temper emerges from the small stock of reminiscences by friends and acquaintances. It is impossible, then, to be sure if, or in what way, he articulated anti-Hanoverian views. What is certain is that his avoidance of royal patronage, or its avoidance of him, continued (with the apparent exception of one commission in 1782) until 1790—when suddenly there was a rush of fourteen commissions over three years.[2]

The change came with the arrival of a new royal patron. In 1783 George, Prince of Wales (fig. 125), who later became Prince Regent and King George IV, had come of age. He was in a particular hurry to make his way as a sportsman, an art collector, and a scapegrace. By the time he came to a serious appreciation of Stubbs, he had already traveled some distance down all three paths.

PRINCE OF TASTE AND DISSIPATION

The Prince of Wales was a young man who seemed deliberately to cultivate contradiction. He was good looking, intelligent, and well-read and could be excellent company. He had wit, his mimicry was extremely funny, and he sang in a strong, accurate tenor voice; he played the piano passably and the cello with skill. Above all, he was developing a great love and knowledge of architecture and the fine and decorative arts. His father, trying to ensure that George would become a disciplined and dutiful son and heir, had imposed an isolated education and an oppressive moral regimen on his son; predictably, it had the opposite of the desired effect. Though King George III and Queen Charlotte were devoted to each other, they were cold and unresponsive parents; they had difficulties with all their seven sons, though none was so disobedient as the Prince of Wales.

FIG. 127. Attributed to George Townly Stubbs, *His Highness in Fitz*, published 1786. Etching with engraving, partly stippled, 6⅞ × 9⅞ in. (17.5 × 25 cm). Andrew Edmunds, London

George's extreme behavior quickly became the talk of the town. In early adulthood he frequently got his way by throwing tantrums. He drank heavily and was a glutton and lecher, as well as an extraordinary spendthrift—using not his own money, of course, but the taxpayer's—and a plunging gambler (fig. 126). In his twenties his filial impiety grew so great that he took the foolhardy step of marrying the twice-widowed Catholic gentlewoman Mrs. Maria Fitzherbert in a secret ceremony. This action offended against everything the king expected of his heir: propriety, Protestantism, and (for dynastic reasons) the transparency of royal marriage.[3] Not surprisingly, the prince's conduct was the butt of much satire, including some anonymous prints attributed to Stubbs's son George Townly Stubbs (fig. 127).

From the age of eighteen the prince lobbied the king for an independent household and income. After prolonged negotiation (and plenty of tears before bedtime) the king reluctantly gave his son the use of Carlton House,

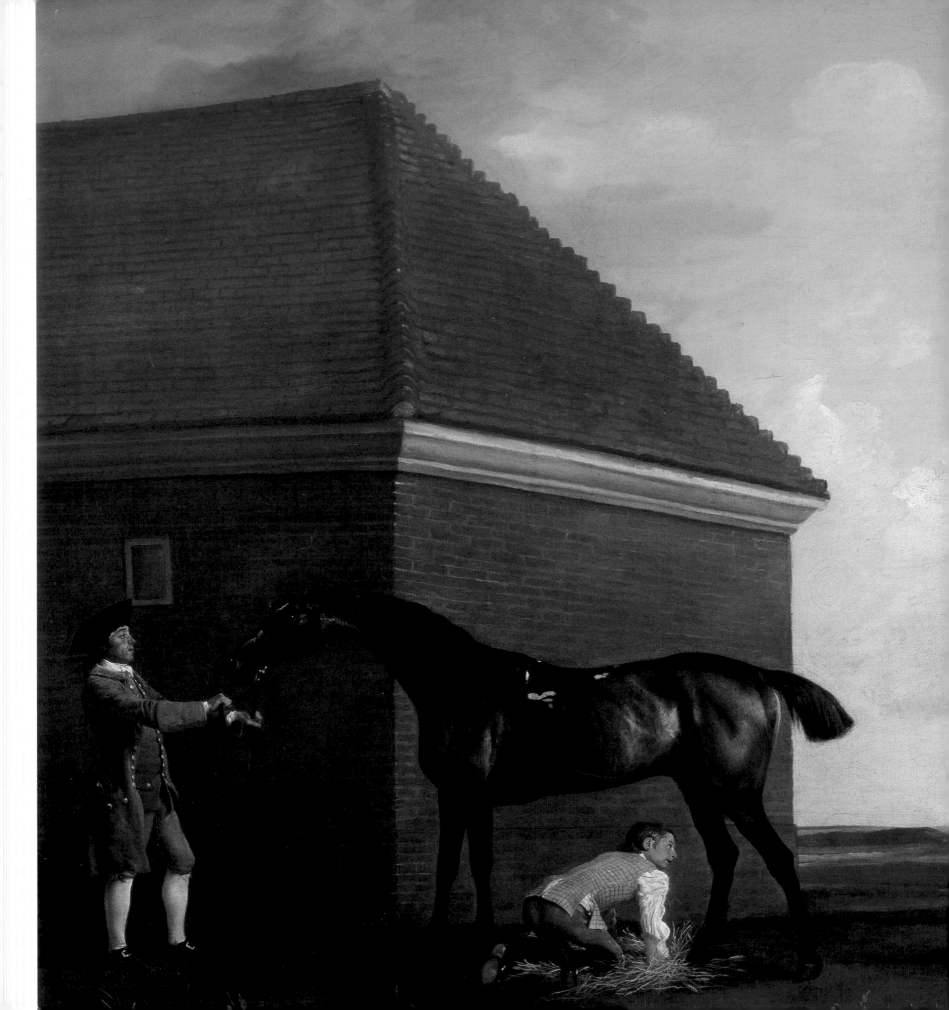

Catalogue

1–32
Anatomical Works

Literature: Humphry MS, 202–3; Mayer 1879, 12–19; Gilbey 1898, 14–29; Doherty 1974, 5–11, 37–110, 319–43; Egerton 1976; Taylor 1976; Egerton 1984a, 31–49, 218–21; Taylor 1987; Lennox-Boyd, Dixon, and Clayton 1989, 295–312, 368, nos. 165–88, 587–627; Savage 2002

Stubbs's interest in anatomy bloomed between 1746 and 1752, when he lived in York. There he associated with medical men at the county hospital and studied anatomy with the surgeon Charles Atkinson. He also knew Dr. John Burton and provided etched anatomical illustrations for Burton's *Essay towards a Complete New System of Midwifry* (1751). In 1756 Stubbs embarked on a serious study of equine anatomy—a far less advanced branch of the science than its human counterpart—and spent some eighteen months dissecting and drawing horses at a farmhouse in the village of Horkstow, across the Humber estuary from Hull, probably with the support of his early patrons the Nelthorpe family of nearby Barton-on-Humber. The house has been speculatively identified as the Manor House, built about 1700 and still standing.[1] Stubbs was assisted by Mary Spencer, a young woman some seventeen years his junior who became his lifetime companion. In his memoir Ozias Humphry identified her as Stubbs's niece; later writers have assumed her to have been his common-law wife.

Humphry wrote about Stubbs's work in Horkstow at some length:

> Mr Stubbs went from Liverpool to execute commissions which he had long received, even before he went to Rome, from Lady Nelthorpe of various portraits. In this neighbourhood it was that he resolved to carry on and complete what he had long since determined upon by the advice of his young chirurgical friends with whom he had formerly been connected at York, which was to publish the Anatomy of the Horse; and for this purpose he engaged a Farm House at Horkstow in Lincolnshire, that he might without inconvenience to others, have dead horses in his apartment and other subjects adapted to his purposes. In this retirement he continued with unremitting diligence to dissect for eighteen months (he was then in his 32nd year) and here also it was that he completed the Drawings & descriptions for his publication of the Anatomy of the Horse with no other companion or assistance than his female relation and friend Miss Spencer, his niece, who was born near him at Liverpool and had in that Town shewn particular pleasure in observing from time to time the experiments he there made.[2]

Stubbs would first bleed a horse to death, inject its blood vessels with warm tallow, and suspend the carcass from the ceiling. He would then perform his dissections, removing the skin and layer after layer of muscle down to the skeleton, making detailed notes and drawings. He discarded the organs and bowels, concentrating on the muscles, bones, blood vessels, and nerves. He later mentioned to the

surgeon Henry Cline that he worked on one horse, "which he had injected for the blood vessels," for as long as eleven weeks, although the average time was probably less.[3] For Humphry's more detailed account of the methods Stubbs used to prepare and dissect the horses, see above, pages 1–2.

Forty-two of Stubbs's equine anatomical drawings have survived; twenty-nine are included in the present catalogue. The drawings fall broadly into two types: working studies, some with measurements and annotations (cats. 1–19), and finished studies for tables in the book (cats. 20–29). They are arranged here within each type, with the skeleton drawings first (like the skeleton tables in the book) and the others in sequences according to viewpoint— lateral, anterior, and posterior—and then stages of dissection. Both the working and the finished studies are on larger sheets for lateral views and smaller sheets for anterior and posterior views. The working studies are in black chalk, red-brown ink, and other materials on a robust, heavy-weight Whatman paper; most sheets measure roughly 19 by 24 inches, or half that size, 19 by 12 inches. The finished studies are in black chalk and graphite on a finer, lightweight paper—suitable for tracing purposes—that came from a different manufacturer, Durham of Gloucestershire; the sheets measure roughly 14½ by 20 inches and 14 by 7¼ inches.[4] The basic forms of the horse's body repeat themselves so exactly through sequences of drawings, within both the working and the finished studies, that it seems clear that Stubbs used tracing, probably with a skeleton drawing as a template, to establish the outlines in each case.[5] Some of the studies are squared, also presumably to facilitate the image-transfer that was essential to the mechanics of showing a body through successive stages of dissection. All the known drawings take in the full extent of the body. In the memoir Humphry mentioned studies of such parts as ears, noses, and limbs (see below), but these are not extant.

Stubbs brought his anatomical drawings with him when he moved to London and used them with considerable success to help attract commissions for horse paintings. For some time he sought a professional to engrave the plates for the projected book, but eventually he undertook the work himself. The Humphry memoir continues:

> Upon his arrival in town in 1758 or 59 he made application to many of the engravers; viz: Mr Grignion, Mr Pond & others; but when his designs were shewn to them, they rather excited ridicule than applause—for many of the drawings were of entire figures—but others were of parts only, such as Ears, Noses & Limbs; so that the engravers, who had been unaccustomed to such studies, & not understanding them were fearful of being bewildered & therefore rather wished to decline undertaking his commissions. This compelled him to engrave the whole of his designs himself.— The work was advertized to be published by subscription, which, indeed he considered as one & the best methods of making himself known; & this more than any other thing tended to throw him into Horse Painting, & indeed to this he ascribes entirely his being a Horse Painter.
>
> It must be here recorded that in all these Tasks, his daily occupations in painting, which were generally Horses, were in no wise interrupted; for the etchings of the plates were made early in the morning, in the evening, and oftentimes very late at night.—In about six years they were brought to a state for publication as they now appear.—This was in the year 1766.[6]

The Anatomy of the Horse was published in March 1766, having been printed "for the Author" by J. Purser in London (cats. 30–32); the price was four guineas to subscribers and five to nonsubscribers. In his preface Stubbs wrote of the audiences to which he hoped the work would appeal: "When I first resolved to apply myself to the present work, I was flattered with the idea, that it might prove particularly useful to those of my own profession; and those to whose care and skill the horse is usually entrusted, whenever medicine or surgery becomes necessary to him; I thought it might be a desirable addition to what is usually collected for the study of comparative anatomy; and by no means unacceptable to those gentlemen who delight in horses, and who either breed or keep any considerable number of them."

In addition to the eighteen tables, each with its own key figure, The Anatomy of the

Horse contained some fifty thousand words of dense technical commentary. Raising the study of equine anatomy to a higher level, Stubbs's book was compared to the works in human anatomy of the renowned Dutch professor Bernhard Siegfried Albinus—to whose methods the artist was, indeed, much indebted. It received a warm welcome from critics, horse enthusiasts, and fellow anatomists at home and abroad; its tables were to be much consulted by artists, and widely copied and imitated. As the authors of the catalogue of Stubbs's prints point out, "It is likely that the book was being produced on demand throughout Stubbs's lifetime and for many years after his death."[7] It was reprinted a number of times in the first half of the nineteenth century, with Stubbs's original copper plates used for the tables and the publication date of 1766 still on the title page; the reprints are on various papers, some with dated watermarks. The last time the plates were used appears to have been for Henry Bohn's edition of 1853, which was in a smaller format, with new letterpress and the tables folded. In the editions that have appeared since, the tables have been facsimiles.

All of Stubbs's surviving drawings for the project are in the collection of the Royal Academy of Arts, London. Following the artist's death they passed to Mary Spencer. Her executors offered them at auction after her death in 1817, and the dealer Colnaghi bought them. Edwin Landseer, Britain's leading animal painter of the nineteenth century, bought them from Colnaghi. On Landseer's death in 1873, his elder brother Charles acquired them. Charles Landseer, long-serving keeper of the Royal Academy Schools, died in 1879 and the drawings came to the Royal Academy by his bequest. There they were in use for many years as aids in the teaching of equine anatomy to students.

Because of their fragility, a number of the drawings could not be shown at all three venues of this exhibition.

Notes

1. Taylor 1987.
2. Humphry MS, 202.
3. Gilbey 1898, 22.
4. For notes on the materials and the recent conservation of the drawings, see Catherine Rickman, "A Conservator's View," in Savage 2002 (unpaginated).
5. See Doherty 1974, 9–10.
6. Humphry MS, 202–3.
7. Lennox-Boyd, Dixon, and Clayton 1989, 297.

1

Measured Study of the Skeleton (Lateral), 1756–58

Brown ink

14½ × 19⅞ in. (36.7 × 50.4 cm)

Royal Academy of Arts, London (R.A. no. 36)

Literature: Doherty 1974, 39, no. III.19

National Gallery only

ACROSS THE top of the sheet Stubbs made a pencil annotation that begins, "Proportions taken from the skeleton of an old mare about 13 hands high" and continues with details concerning the horse's vertebrae. This, the following skeleton study (cat. 2), and two studies of blood vessels (cats. 8, 9) depart from the usual sheet sizes for the working studies.

2

Measured Study of the Skeleton (Posterior), 1756–58

Brown ink

14½ × 9⅞ in. (36.7 × 25 cm)

Royal Academy of Arts, London (R.A. no. 34)

Literature: Doherty 1974, 39, no. III.21

Kimbell and Walters only

3

Outline Study of the Skeleton (Lateral), 1756–58

Black and gray ink, with graphite, faintly squared for transfer

18¾ × 23⅝ in. (47.5 × 60 cm)

Royal Academy of Arts, London (R.A. no. 37)

Literature: Doherty 1974, 39, no. III.22

Kimbell and Walters only

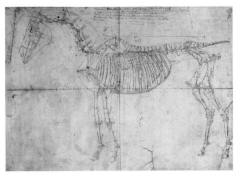

1 (FIG. 13)

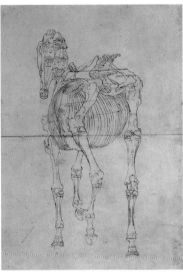

2 (FIG. 14)

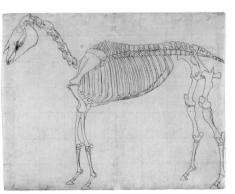

3 (FIG. 15)

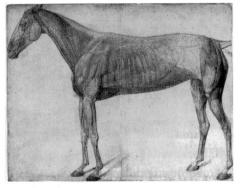

4 (FIG. 16)

4

Study of the Muscles (Lateral), 1756–58

Graphite, black and red chalk, and brown ink

18¾ × 23¾ in. (47.6 × 60.3 cm)

Royal Academy of Arts, London (R.A. no. 26)

Literature: Doherty 1974, 39–40, no. III.23

National Gallery only

IN THIS sequence of four lateral views (cats. 4–7), Stubbs clearly drew the muscles over a skeleton outline, in each case having traced the skeleton to establish a standard size and position for the horse's body. This seems to have been his usual practice.

5

Study of the Muscles (Lateral),
1756–58

Graphite, black and red chalk, and red-brown
 ink
18¾ × 23¾ in. (47.6 × 60.3 cm)
Royal Academy of Arts, London (R.A. no. 31)

Literature: Doherty 1974, 40, no. III.24;
 Egerton 1984a, 40, no. 12

Walters only

6

Study of the Muscles (Lateral),
1756–58

Graphite, black and red chalk, and red-brown
 ink
19 × 23⅞ in. (48.1 × 60.7 cm)
Royal Academy of Arts, London (R.A. no. 27)

Literature: Doherty 1974, 40, no. III.25;
 Egerton 1984a, 39, no. 11

Kimbell only

7

Study of the Muscles (Lateral),
1756–58

Graphite, red chalk, and red-brown ink
19¼ × 24 in. (48.9 × 61 cm)
Royal Academy of Arts, London (R.A. no. 32)

Literature: Doherty 1974, 40, no. III.26

Kimbell only

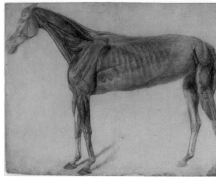

5 (FIG. 17)

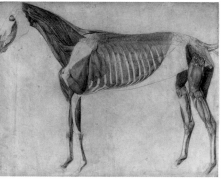

6 (FIG. 18)

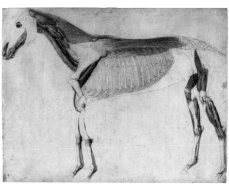

7 (FIG. 19)

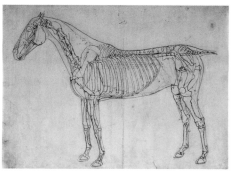

8 (FIG. 20)

8

Study of the Blood Vessels (Lateral),
1756–58

Red-brown ink, red chalk, and graphite
14¼ × 19¾ in. (36.3 × 50.2 cm)
Royal Academy of Arts, London (R.A. no. 40)

Literature: Doherty 1974, 40, no. III.28

National Gallery only

As WITH his studies of the muscles, Stubbs
seems to have begun this and the following
study of blood vessels (cat. 9) by tracing
a skeleton to establish a standard size and
position for the horse's body. Like two of
the skeleton studies above (cats. 1, 2), they
are on sheets that depart from the usual
sizes for the working studies.

9

Study of the Blood Vessels (Lateral),
1756–58

Orange and brown ink, red chalk, and
 graphite
14½ × 19¾ in. (36.7 × 50.3 cm)
Royal Academy of Arts, London (R.A. no. 38)

Literature: Doherty 1974, 40, no. III.29

Kimbell and Walters only

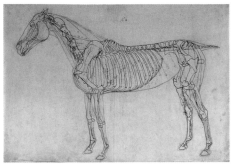

9 (FIG. 21)

10

Study of the Muscles (Anterior),
1756–58

Graphite and black and red chalk
18½ × 11¾ in. (47 × 29.8 cm)
Royal Academy of Arts, London (R.A. no. 6)

Literature: Doherty 1974, 41, no. III.33

In the working studies both the anterior
and posterior views are from a closer posi-
tion and a slightly different angle from
those in the finished studies and etchings.

11

Study of the Muscles (Anterior),
1756–58

Graphite, black and red chalk, and red-brown
 ink
18⅞ × 12¼ in. (48 × 31.2 cm)
Royal Academy of Arts, London (R.A. no. 19)

Literature: Doherty 1974, 41, no. III.34

Walters only

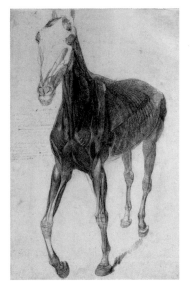

11 (FIG. 23)

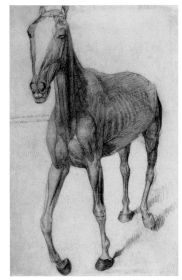

10 (FIG. 22)

12

Study of the Muscles (Anterior),
1756–58

Graphite, black and red chalk, and red-brown
 ink
18⅞ × 12 in. (48 × 30.5 cm)
Royal Academy of Arts, London (R.A. no. 20)

Literature: Doherty 1974, 41, no. III.35;
 Egerton 1984a, 32–33, no. 6

National Gallery only

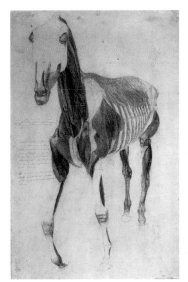

12 (FIG. 24)

13
Study of the Muscles (Anterior),
1756–58
Graphite, black chalk, and red-brown and
 gray-brown ink
19¼ × 12¼ in. (48.8 × 31 cm)
Royal Academy of Arts, London (R.A. no. 21)

Literature: Doherty 1974, 41, no. III.36

Kimbell only

14
Study of the Muscles (Anterior),
1756–58
Black chalk, gray-brown ink, and graphite,
 squared for transfer
18½ × 11½ in. (47 × 29.2 cm)
Royal Academy of Arts, London (R.A. no. 22)

Literature: Doherty 1974, 41, no. III.37

National Gallery only

15
Study of the Muscles (Posterior),
1756–58
Graphite and black and red chalk
18¾ × 11⅝ in. (47.7 × 29.6 cm)
Royal Academy of Arts, London (R.A. no. 1)

Literature: Egerton 1984a, 38–39, no. 10

16
Study of the Muscles (Posterior),
1756–58
Graphite and black and red chalk
18½ × 11½ in. (47 × 29.2 cm)
Royal Academy of Arts, London (R.A. no. 2)

Literature: Doherty 1974, 41, no. III.38;
 Egerton 1984a, 34–35, no. 7

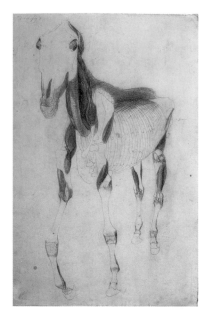

13 (FIG. 25)

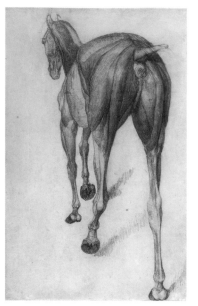

15 (FIG. 27)

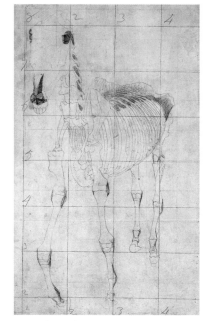

14 (FIG. 26)

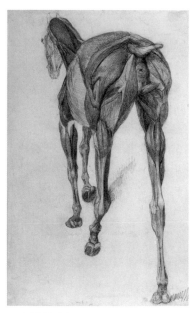

16 (FIG. 28)

17

Study of the Muscles (Posterior),
1756–58

Graphite, black and red chalk, and red-brown
 ink

18⅞ × 11½ in. (48 × 29.3 cm)

Royal Academy of Arts, London (R.A. no. 23)

Literature: Doherty 1974, 41–42, no. III.39;
 Egerton 1984a, 35–36, no. 8

Walters only

18

Study of the Muscles (Posterior),
1756–58

Black chalk and red-brown ink

19⅛ × 12¼ in. (48.5 × 31 cm)

Royal Academy of Arts, London (R.A. no. 24)

Literature: Doherty 1974, 42, no. III.40;
 Egerton 1984a, 35, 37, no. 9

Kimbell only

19

Study of the Muscles (Posterior),
1756–58

Black chalk and red-brown ink

18⅞ × 12 in. (48 × 30.5 cm)

Royal Academy of Arts, London (R.A. no. 25)

Literature: Doherty 1974, 42, no. III.41

National Gallery only

20

**Finished Study for the
First Anatomical Table of
the Skeleton . . . ,**
1756–58

Black chalk

14¼ × 19 in. (36.1 × 48.3 cm)

Royal Academy of Arts, London (R.A. no. 5)

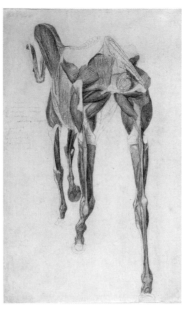

17 (FIG. 29)

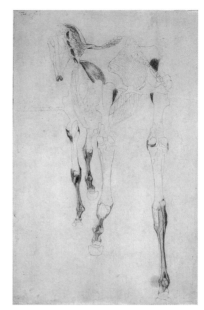

19 (FIG. 31)

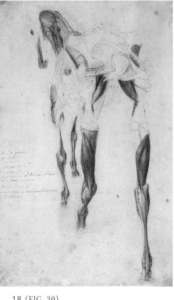

18 (FIG. 30)

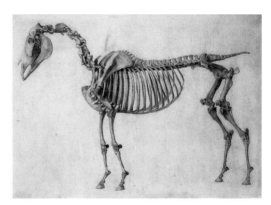

20 (FIG. 32)

Literature: Doherty 1974, 37, no. III.1; Egerton
 1984a, 44, no. 16

Stubbs followed the finished studies
closely in his etchings for the book. He
etched them without changing the orien-
tation, and the images were reversed in
the printing.

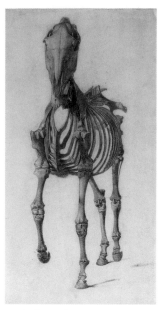

21 (FIG. 33)

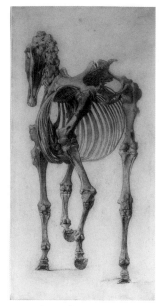

22 (FIG. 34)

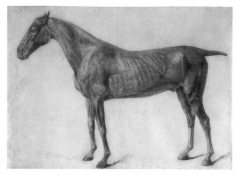

23 (FIG. 35)

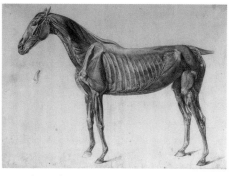

24 (FIG. 36)

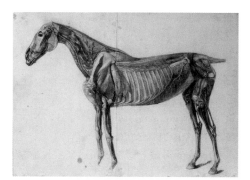

25 (FIG. 37)

21

Finished Study for the Second Anatomical Table of the Skeleton . . . ,
1756–58
Graphite and black chalk
14 × 7¼ in. (35.6 × 18.4 cm)
Royal Academy of Arts, London (R.A. no. 10)

Literature: Taylor 1971, 205, pl. 5; Doherty 1974, 37, no. III.2; Egerton 1984a, 47, no. 21

22

Finished Study for the Third Anatomical Table of the Skeleton . . . , 1756–58
Graphite and black chalk
14 × 7⅛ in. (35.4 × 18 cm)
Royal Academy of Arts, London (R.A. no. 18)

Literature: Doherty 1974, 37, no. III.3; Egerton 1984a, 49, no. 25

23

Finished Study for the First Anatomical Table of the Muscles . . . ,
1756–58
Graphite and black chalk
14½ × 19⅝ in. (36.7 × 49.9 cm)
Royal Academy of Arts, London (R.A. no. 4)

Literature: Doherty 1974, 37, no. III.4

24

Finished Study for the Third Anatomical Table of the Muscles . . . ,
1756–58
Graphite and black chalk
14⅜× 19⅞ in. (36.6 × 50.5 cm)
Royal Academy of Arts, London (R.A. no. 28)

Literature: Taylor 1971, 205, pl. 6; Doherty 1974, 38, no. III.6

25

Finished Study for the Fourth Anatomical Table of the Muscles . . . , 1756–58
Black chalk
14¼ × 19½ in. (36.2 × 49.5 cm)
Royal Academy of Arts, London (R.A. no. 29)

Literature: Doherty 1974, 38, no. III.7; Egerton 1984a, 42, no. 14

National Gallery only

26

Finished Study for the Fifth Anatomical Table of the Muscles . . . , 1756–58

Black chalk

14¼ × 20 in. (36.2 × 50.8 cm)

Royal Academy of Arts, London (R.A. no. 30)

Literature: Doherty 1974, 38, no. III.8; Egerton 1984a, 43, no. 15

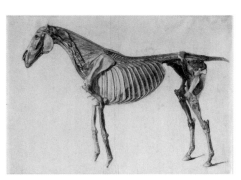

26 (FIG. 38)

27

Finished Study for the Eighth Anatomical Table of the Muscles . . . , 1756–58

Graphite and black chalk

14 × 7¼ in. (35.5 × 18.4 cm)

Royal Academy of Arts, London (R.A. no. 9)

Literature: Doherty 1974, 38, no. III.11; Egerton 1984a, 46, no. 18

28

Finished Study for the Tenth Anatomical Table of the Muscles . . . , 1756–58

Graphite and black chalk

14 × 7⅝ in. (35.5 × 19.5 cm)

Royal Academy of Arts, London (R.A. no. 17)

Literature: Doherty 1974, 38, no. III.13; Egerton 1984a, 47, no. 20

29

Finished Study for the Thirteenth Anatomical Table of the Muscles . . . , 1756–58

Graphite and black chalk

14 × 7¼ in. (35.5 × 18.4 cm)

Royal Academy of Arts, London (R.A. no. 7)

Literature: Doherty 1974, 39, no. III.16; Egerton 1984a, 48, no. 22

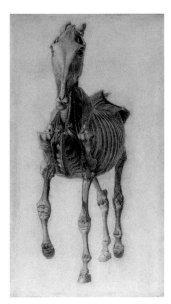

28 (FIG. 40)

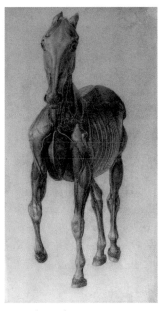

27 (FIG. 39)

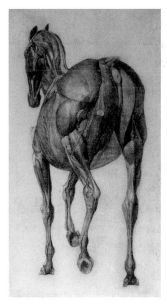

29 (FIG. 41)

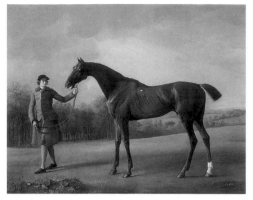

34 (FIG. 10)

34

Lustre, with a Groom, 1761–62

Oil on canvas

40⅛ × 50 in. (101.9 × 127 cm)

Commissioned by Frederick St. John,
second Viscount Bolingbroke

Yale Center for British Art, New Haven.
Paul Mellon Collection

Literature: Taylor 1971, 214, pl. 118 (det.);
Egerton 1978, 68, no. 68; Egerton 1984a,
68, no. 40

FOALED IN 1754, Lustre was a son of the Duke of Ancaster's Blank (fig. 88) and a grandson of the Godolphin Arabian (fig. 96). By 1760 he belonged to the second Viscount Bolingbroke, for whom he raced successfully in 1760–61. Bolingbroke probably commissioned the present portrait after retiring him to stud.

Known to his friends as "Bully," Bolingbroke was a famous figure in the world of horse breeding and racing, both as an owner and as a reckless gambler. He was a member and for a time a steward of the prestigious Jockey Club and owned some of the most successful horses of the age, including the illustrious Gimcrack. Along with his friends the Duke of Richmond and the Marquess of Rockingham, Bolingbroke was among Stubbs's most im-

portant early patrons. He commissioned one of the mares-and-foals compositions (cat. 35) and at least eight racehorse portraits, including the present work, *Gimcrack on Newmarket Heath, with a Trainer, a Stable-Lad, and a Jockey* (cat. 45), and *Turf, with Jockey Up, at Newmarket* (cat. 46).

Lustre, with a Groom was among the first of the Bolingbroke racehorse portraits, along with portraits of Tristram Shandy—who is shown held by a groom in the same livery, presumably Bolingbroke's—and Molly Long-Legs.[1] In color and handling these relate closely to one another, and also to the Bolingbroke mares-and-foals painting. All four works clearly belong to a separate, earlier campaign of work from the Newmarket paintings. Basil Taylor suggested that the setting of the mares-and-foals painting may be the park at Bolingbroke's estate, Lydiard Tregoze, in Wiltshire.[2] If this is correct, the similar landscapes in *Lustre, with a Groom* and the portraits of Tristram Shandy and Molly Long-Legs may also represent views there.

Notes

1. The portrait of Tristram Shandy, exhibited at the Society of Artists in 1762, was sold at Christie's, London, on June 14, 2000, lot 4; that of Molly Long-Legs, dated 1762 and shown at the same exhibition, described as *Its Compan-*

ion, is at the Walker Art Gallery, Liverpool (see Egerton 1984a, 64, no. 37).
2. Taylor 1971, 206–7.

35

A Brood of Mares, 1761–62

Oil on canvas

39 × 74 in. (99 × 187 cm)

Commissioned by Frederick St. John, second
Viscount Bolingbroke

Private collection

Literature: Taylor 1971, 206–7, pl. 21; Gaunt
1977, pl. 12

THIS MAY be the earliest of Stubbs's compositions showing groups of mares and foals at stud farms. He was to paint probably a dozen or more variations on the same theme (see also cats. 37, 43, 48, 57).[1]

The background may represent Lord Bolingbroke's park at Lydiard Tregoze, in Wiltshire.[2] Similar in style, and showing what could be another stretch of the same green landscape, the three horse portraits *Lustre, with a Groom, Tristram Shandy,* and *Molly Long-Legs* must have been commissioned by Bolingbroke at about the same time (see cat. 34). The portraits of Tristram Shandy and Molly Long-Legs were shown as companions at the exhibition of the Society of Artists in 1762, and the pres-

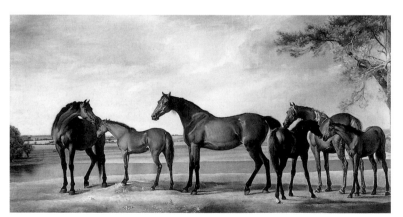

35 (FIG. 54)

ent work was likely the painting shown in the same exhibition under the title *A Brood of Mares.*

There is little evidence of how Stubbs's patrons displayed his works in their houses, but often he seems to have designed commissions carried out for a particular patron to form an ensemble. In a group of horse portraits in his usual 40-by-50-inch format, of which Bolingbroke owned several, *A Brood of Mares* would certainly have been a natural centerpiece.

Notes

1. For a useful collection of reproductions of ten of the mares-and-foals compositions, see Parker 1971, 57.
2. This was first suggested by Basil Taylor in Taylor 1971, 206–7.

36
The Marquess of Rockingham's Scrub, with John Singleton Up,
1762

Oil on canvas

40 × 50 in. (101.5 × 127 cm)

Commissioned by Charles Watson-Wentworth, second Marquess of Rockingham

The Trustees of the Rt. Hon. Olive, Countess Fitzwilliam's Chattels Settlement, by permission of Lady Juliet Tadgell

Literature: Humphry MS, 205–6; Mayer 1879, 32; Egerton 1984a, 62, no. 35

FOALED AT Lord Rockingham's stud at Wentworth Woodhouse in Yorkshire in 1751, Scrub was a son of Blaze, before whom his ancestors in the male line were the great Flying Childers and the Darley Arabian. He raced at Newmarket and York from 1755. When Stubbs painted him he was at the end of his racing career, after which he returned to Rockingham's stud as a stallion. The setting of the present

portrait may be intended to suggest the park at Wentworth.

The Yorkshireman John Singleton (1715–1799) was Rockingham's favorite jockey, riding for him from the early 1760s until his retirement in 1780. In the portrait he wears the marquess's racing colors. His observation on the present portrait was "that Lord Rockingham had mounted him upon many a *good* horse and many a *bad* one, but now he had mounted him upon a Scrubb for ever."[1] Singleton

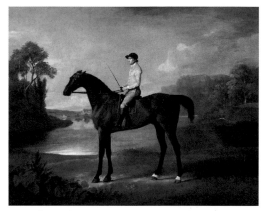

36 (FIG. 80)

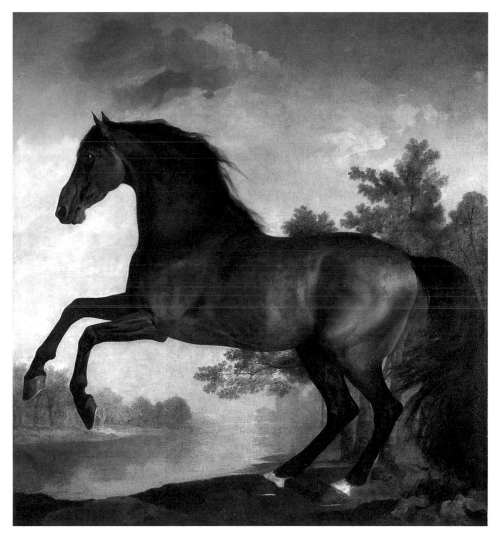

FIG. 1. George Stubbs, *Scrub,* c. 1762–63. Oil on canvas, 102½ × 95 in. (260.4 × 241.3 cm). The Earl of Halifax

was one of the first jockeys to enjoy a national reputation. He was to win his most famous victories on Bay Malton, whom Stubbs painted for Rockingham, again with Singleton up, in 1766 (fig. 57). Eventually Singleton received Scrub as a gift from Rockingham, and the horse spent the rest of his life in his possession in Yorkshire.

The Marquess of Rockingham's Scrub, with John Singleton Up can be identified among the five paintings for which Rockingham paid Stubbs the sum of 185 guineas on August 15, 1762 (see cat. 37).

Later Stubbs painted another, much larger portrait of Scrub (fig. 1). Ozias Humphry states that, having decided not to proceed with *Whistlejacket* (cat. 39) as an equestrian portrait of George III, Rockingham decided to have another horse painted as the king's mount: "His Lordship accordingly ordered Mr S to begin a fresh picture & fixed upon Scrubb, a dark Bay Horse with a black Mane & Tail."[2] Like *Whistlejacket*, however, the portrait of Scrub was never to have the king, or any other rider, added. To Humphry's account Mary Spencer added the note: "Upon some dispute with Lord Rockingham Mr Stubbs brought it away afterwards and sold it to Mr Ryland, who sent it to India with other pictures which were never landed but returned to England, and it was so much Injured by the voyage that Mr Stubbs took it back, in part of payment, new lined and repaired it, and it was finally disposed of at his sale."[3]

Notes
1. Humphry MS, 206.
2. Humphry MS, 205.
3. Humphry MS, 205.

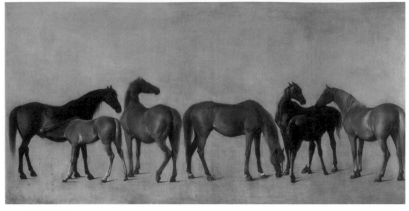

37 (FIG. 73)

37

Mares and Foals, 1762

Oil on canvas

39 × 75 in. (99 × 190.5 cm)

Commissioned by Charles Watson-Wentworth, second Marquess of Rockingham

The Trustees of the Rt. Hon. Olive, Countess Fitzwilliam's Chattels Settlement, by permission of Lady Juliet Tadgell

Literature: Taylor 1971, 206, pls. 20, 27; Egerton 1984a, 126, no. 88

THE SECOND Marquess of Rockingham, for whom Stubbs painted this work and several others (see cats. 36, 38, 39, 51, and figs. 57, 104), was a prominent figure in British politics, leading the Whig opposition to George III's Tory ministers and supporting independence for the American colonies; for brief periods in 1765–66 and 1782 he was prime minister. He was also an enthusiastic owner-breeder of racehorses, maintaining a large stud farm at his country house, the grand Wentworth Woodhouse in Yorkshire. He was one of Stubbs's most important patrons, commissioning paintings both for Wentworth Woodhouse—where he pursued an extensive program of refurbishing and improvement—and for his London residence at No. 4, Grosvenor Square. Among the rich, mostly young aristocrats for whom Stubbs worked in the 1760s, Rockingham seems to have been the most adventurous artistically, and it was for the Green Room at the Grosvenor Square house that the artist painted the largest and apparently the first of his horse-and-lion paintings (fig. 104), along with its pendant of a lion attacking a stag.[1]

The device of setting horses against plain backgrounds of more or less flat color—with only short shadows at their feet, as in some of the anatomical drawings, to suggest a surface on which they stand—also seems to have originated in Rockingham commissions. Stubbs used it in the present work, *Whistlejacket and Two Other Stallions, with the Groom Simon Cobb* (cat. 38), and *Whistlejacket* (cat. 39). It is probable that all three of these were to have had settings added by a landscape specialist rather than Stubbs himself and that Rockingham decided they would be better left as they were—the explanation Ozias Humphry offered for the plain background of *Whistlejacket*.

The two long, horizontal paintings, complementary images of female and male

life at the stud farm, were presumably conceived as a pair and hung as such at Wentworth Woodhouse. After the idea of a pairing with Morier's portrait of George II had been abandoned, *Whistlejacket* may well have been hung with them to form an ensemble, although the different directions of the fall of light (from the left in the long paintings and the right in *Whistlejacket*) suggest that they were not designed for the same wall.[2]

Stubbs signed a receipt acknowledging his having been paid for five paintings, including cats. 36–38, on August 15, 1762: "Recd of the Most Honble ye Marquis of Rockingham, the sum of one Hundred and ninety four pounds five shillings [185 guineas] in full for a picture of five brood-Mares and two foles one picture of three Stallions and one figure and one picture of a figure on Horseback."[3]

The present work is the same size as the earlier mares-and-foals composition painted for Lord Bolingbroke (cat. 35), as well as later essays in this type of subject (see cats. 48, 57). The positions of the mare and foal on the left and the two mares and foal on the right are repeated in the later example in the collection of the Tate (cat. 43).

Notes
1. On Stubbs and Rockingham, see Egerton 1998a, 242–46, and Egerton 1998b. For a useful reconstruction of the decoration of the Green Room, see Fordham 2003. Both of the large Stubbs paintings executed for the Green Room are at the Yale Center for British Art, New Haven.
2. The original arrangement of the paintings is unknown. The Whistlejacket Room at Wentworth Woodhouse, in which *Whistlejacket* was the only Stubbs, was the creation of the marquess's nephew and heir after his death.
3. Constantine 1953, 236–37. Of the further works mentioned in the receipt, one was a painting of foxhounds (Egerton 1984a, 63, no. 36) and the other is unidentifiable.

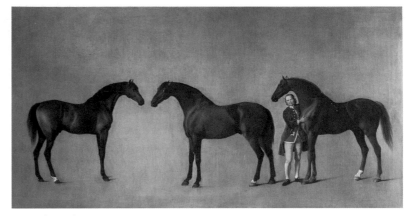

38 (FIG. 83)

38
Whistlejacket and Two Other Stallions, with the Groom Simon Cobb, 1762

Oil on canvas

39 × 74 in. (99 × 187 cm)

Commissioned by Charles Watson-Wentworth, second Marquess of Rockingham

The Trustees of the Rt. Hon. Olive, Countess Fitzwilliam's Chattels Settlement, by permission of Lady Juliet Tadgell

Literature: Egerton 1984a, 59, no. 33

THIS AND the preceding work (cat. 37) represent different groups within the equine society of the stud farm, mares and foals on one hand and stallions on the other. Both show the artist's tendency toward a relieflike mode of design, but the mares and foals are disposed to create flowing, varied lines, whereas the stallions stand in a stiffer, staccato arrangement, playing up the contrast of female and male. In both paintings the horses' body language—the positions of the ears, for instance—suggests subtleties of mood and social interaction.

Simon Cobb (d. 1770 or 1771), the man in livery standing beside Whistlejacket, served Lord Rockingham as stud-groom and park-keeper. One Joshua Cobb, probably the son of Simon, also worked on the estate: by the mid-1760s he was head gamekeeper, and on Simon's death he inherited his old positions.[1] For a brief biography of Whistlejacket, see cat. 39.

Whistlejacket and Two Other Stallions, with the Groom Simon Cobb can be identified among the five paintings for which Rockingham paid Stubbs the sum of 185 guineas on August 15, 1762 (see cat. 37).

Note
1. Bloy 1986, 97.

39

Whistlejacket, c. 1762

Oil on canvas

115 × 97 in. (292 × 246.4 cm)

Commissioned by Charles Watson-Wentworth, second Marquess of Rockingham

The National Gallery, London. Bought with the support of the Heritage Lottery Fund, 1997

Literature: Humphry MS, 205; Mayer 1879, 30–31; Gilbey 1898, 31–32, 168; Taylor 1971, 29, 205–6, pl. 10; Egerton 1984a, 60–61, no. 34; Lennox-Boyd, Dixon, and Clayton 1989, 175, no. 61; Egerton 1998a, 240–47

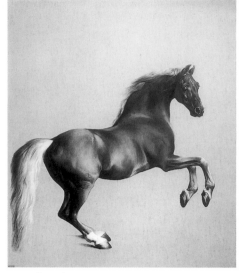

39 (FIG. 6)

WHISTLEJACKET was the largest of the group of works commissioned from Stubbs by the second Marquess of Rockingham for Wentworth Woodhouse. Though commonly regarded as an equine portrait, it began life as an equestrian one: a portrait of George III in which Whistlejacket was to be merely the model for the king's mount. Ozias Humphry described its history:

> In oil, Mr Stubbs painted for the Marquis of Rockingham two portraits of horses the size of life; one of them was called Whistle Jacket, upon which it was intended that his present majesty should have been represented by the best portrait painter, and the Landscape back ground by the best artist in that branch of painting; hoping by an union of talents to possess a picture of the highest excellence as a companion to one of a similar subject of the late King by Moriere, to hang in the great Hall at Wentworth House, the Marquis's seat in Yorkshire.—
>
> A very extraordinary incident occurred whilst the picture of Whistle Jacket was executing.—On the last day this Horse stood, which was so remarkably unmanageable that it was dangerous for any one but the person accustomed to feed him [perhaps Simon Cobb; see cat. 38], to lead him from the stable, & to this man only that task was entrusted.—The picture was advanced to such a state that Mr S expected to have finished the last sitting, or rather standing, at a given hour; when his feeder was desired to attend & take the Horse back to his stall; but it so happened that it was completed before the appointed time, & the boy who held the horse for Mr Stubbs to paint from was leading it up and down a long range of stables.—In the mean while, Stubbs had placed the picture advantageously against the wall to view the effect of it, & was scumbling and glazing it here [and] there, when the Boy, cried out, "Look, Look, Sir, look at the Horse!" He immediately turned around, and saw Whistle Jacket stare & look wildly at the picture, endeavouring to get at it, in order to attack it.—the boy pulling him back & checking him, till at length the horse reared up his head and lifted the boy quite up from the ground; upon which he began beating him over the face with a switch stick, & Stubbs likewise got up and frightened him with his palette and Mahl stick till the animal, whose tail was with an intent to kick at it, but being then baffled and his attention taken off, by this time turned towards the picture, became confused, & suffered himself to be led quietly away.—

The Marquis came shortly after to see what progress had been made, & learning the circumstance, was so pleased with such proof of the excellence of the picture that he determined nothing more should be done to it, tho' it was on the bare canvas without a back ground.[1]

According to Horace Walpole, Rockingham's reasons for discontinuing the painting as an equestrian portrait of George III were political: "It was to have had a figure of George 3d until Lord Rockingham went into opposition."[2] The Stubbs scholar Judy Egerton has suggested that the story of the work's genesis as a portrait of the king was a legend that arose because "contemporaries were so astonished that a single horse should command such a huge canvas."[3] But to the present author the story rings true, especially given the painting's close correspondence in size to the David Morier portrait mentioned by Humphry as its prospective pendant (fig. 7).

Bred at Sir William Middleton's stud at Belsay Castle, Northumberland, Whistlejacket was foaled in 1749. His sire was Mogul and his grandsire the Godolphin Arabian (fig. 96). Racing for Middleton at Newmarket in 1756, he was narrowly beaten for the Jockey Club Plate by the Duke of Ancaster's Spectator (cat. 47). Middleton afterward sold him to Rockingham. His most celebrated race was his last, a match against Brutus over four miles at Newmarket, in August 1759, for two thousand guineas. He won by a length, ridden by Rockingham's favorite jockey, John Singleton (see cat. 36). After this Rockingham retired him to stud. He also features in *Whistlejacket and Two Other Stallions, with the Groom Simon Cobb* (cat. 38). Where Rockingham hung *Whistlejacket* at Wentworth Woodhouse is unknown; the impos-

ing Whistlejacket Room there was created after his death by his nephew and heir.[4]

Benjamin Killingbeck, a minor artist associated with Rockingham, made an etched and stippled print after the painting some time after 1780, adding a landscape setting with a view of Wentworth Woodhouse.[5]

Notes

1. Humphry MS, 205. The second of the two large horse paintings that Humphry mentioned at the beginning of his account was *Scrub* (cat. 36, fig. 1).
2. Walpole 1928, 71.
3. Egerton 1998a, 245.
4. For a photograph of the room with *Whistlejacket* in situ, see Parker 1971, 66.
5. Lennox-Boyd, Dixon, and Clayton 1989, 175, no. 61.

40 (FIG. 101)

40
Horse and Lion, 1762–68

Oil on canvas

27¾ × 41 in. (70.5 × 104.1 cm)

Yale Center for British Art, New Haven.
Paul Mellon Collection

Literature: Egerton 1978, 74, no. 73; Cormack et al. 1999, 45, no. 25

IN HIS scenes of horses being stalked and attacked by lions Stubbs raised the painting of animals above portraiture and genre to the higher artistic category of history painting. Essays in the "sublime," they suggest a primeval state in which horses

were prey to barbaric violence in the wild, long before being embraced into human civilization. In particular they relate to the prehistory of the English thoroughbred in North Africa and the Middle East. The horse owners, breeders, and admirers who were Stubbs's main patrons were deeply concerned with matters of pedigree and fascinated by the exotic origins of the thoroughbred. In the horse-and-lion compositions Stubbs offered them imaginary scenes from the lives and deaths of their own horses' ancestors.

His inspiration seems to have come from both art and nature. On his visit to Rome in 1754 he would have seen the well-known antique sculpture of a horse attacked by a lion at the Palazzo dei Conservatori (fig. 68); versions and copies of this were available in Britain. According to an article on the artist published in 1808, however, the source of the subject was his witnessing a lion stalk and kill a horse in Morocco, where he stayed on his way back from Rome to England.[1] Although Basil Taylor and Judy Egerton have doubted this story, it seems to this author more likely than not to be true. If false, it would certainly have been a bold fabrication, published within two years of the artist's death, when there were still friends and relatives around to refute it.

Stubbs painted the largest and probably the first of his horse-and-lion compositions for the second Marquess of Rockingham in 1762 (fig. 104). Ozias Humphry noted that, in preparation, he made many studies of a lion at Lord Shelburne's menagerie on Hounslow Heath.[2] After the large Rockingham painting he produced a number of further, smaller works that were variations on the same general theme. Some show the horse with the lion on its back as in the Rockingham painting;

some show it starting in terror at the sight of the lion stalking it. The core group consists of paintings—in both oil and enamel—that are datable between 1762 and 1770 (cats. 40, 41, 60, 61, 62). Stubbs showed some of these at the annual exhibitions of the Society of Artists, and some were reproduced as prints—both by professional engravers and by Stubbs himself (cats. 68, 69). There is also a Wedgwood relief of the stalking subject that was modeled by Stubbs in 1780, probably using one of his own prints as a basis.[3]

Though previously dated as late as the 1790s, the present work seems to this author to belong among the earliest of Stubbs's horse-and-lion paintings—in which the horse is chestnut with a light mane and tail as in the large Rockingham painting. (In the later paintings, datable to 1769–70, it is usually white.) In composition it resembles three other paintings that also show the horse frightened by the approach of its enemy rather than under attack. Its closest relative is an untraced painting reproduced in a mezzotint by Benjamin Green: *The Horse and Lion*, published in 1767 (fig. 1).[4] The others are a painting in the collection of the Tate and another untraced painting reproduced in an etching by Stubbs himself: *A Horse Affrighted by a Lion*, published in 1777.[5] The chief differences between these lie in the landscape; the positions of the animals remain the same, presumably duplicated by the artist by means of a cartoon of some kind. At the exhibition of the Society of Artists in 1763 Stubbs showed a painting under the title of *A Horse and a Lion*; this could have been the present work or any of the other three stalking pictures mentioned above, although the one reproduced in the Green mezzotint seems the most likely candidate. Stubbs showed a

FIG. 1. Benjamin Green, after George Stubbs, *The Horse and Lion*, published 1767. Mezzotint, first state, plate: 17⁷/₈ × 22 in. (45.5 × 55.8 cm). Fitzwilliam Museum, Cambridge

presumably different stalking scene, entitled *A Horse Frightened by a Lion,* at the Society of Artists in 1768; this is also impossible to identify with certainty, and may, again, have been the present work or any of the other three versions of the subject discussed above.

Horace Walpole visited the 1763 exhibition and made a note beside the title of Stubbs's painting in the catalogue: "The horse rising up, greatly frightened."[6] He so admired the work that he was inspired to write a descriptive poem.[7] The Stubbs painting listed immediately after *A Horse and a Lion* in the catalogue appeared simply as *It's [sic] companion.* In another catalogue belonging to Walpole, the collector John Sheepshanks noted that this was "A stag and hound."[8] Shown as a pair, the two works would presumably have read as complementary scenes of hunting, wild and civilized. The stag-and-hound painting in question was probably the *Hound*

Coursing a Stag at the Philadelphia Museum of Art.[9]

As the authors of the catalogue of Stubbs's prints have pointed out, the scene of the horse frightened as the lion approaches was disseminated more widely in print form than the scene of the attack; indeed, it was "the image by which, above all others, Stubbs was to be known to his contemporaries."[10]

Notes

1. The account of the episode is quoted in full above, 108–9.
2. Humphry MS, 206. The artist's sale in 1807 included "One Book with 22 Lions and Stags in black lead" and "One Book with 14 Lions in black chalk" (see Gilbey 1898, 202).
3. See Tattersall 1974, 78–79, no. 23, and note 5, below.
4. Lennox-Boyd, Dixon, and Clayton 1989, 72–73, no. 4.
5. For the Tate painting, see Egerton 1984a, 94, no. 62. For the etching, see Lennox-Boyd, Dixon, and Clayton, 170–72, no. 59; this was probably the basis for the relief of 1780.
6. Graves 1907, 249.
7. For the poem, see above, 106–7. Unfortunately, it contains no clues as to exactly which version of the subject Walpole had seen.
8. Walpole 1939, 78.
9. See Dorment 1986, 382–84, no. 107. The Philadelphia painting is larger and more upright in its proportions than either the present work or the stalking scene at the Tate. The size of the untraced painting in the Green mezzotint is unknown, but it did have the same proportions as the Philadelphia painting (roughly four to five) and would therefore have been a more suitable "companion" to the latter, supporting the possibility that it was indeed the version of the subject exhibited in 1763.
10. Lennox-Boyd, Dixon, and Clayton 1989, 72.

41

A Lion Seizing a Horse, 1763–64

Oil on canvas

27¼ × 40¾ in. (69.2 × 103.5 cm)

Tate, London. Purchased 1976

Literature: Gilbey 1898, 156; Taylor 1971, fig. 17; Egerton 1978, 72, no. 70; Egerton 1984a, 95, no. 63

41 (FIG. 108)

THIS PAINTING of the attack scene in the horse-and-lion encounter is unique in showing the horse's legs collapsed under its body—as they are in the sculpture in Rome that was part of Stubbs's original inspiration to treat the subject. This fact and the chestnut color of the horse seem to place the work among the earliest of the horse-and-lion paintings. Stubbs showed a number of his horse-and-lion paintings in the annual exhibitions of the Society of Artists but only one in oil—rather than enamel—that dealt with the attack rather than the stalking scene: *A Lion Seizing a Horse,* shown in 1764.[1] This is likely to have been the present work.

The landscape background is one of the first that Stubbs based on Creswell Crags, which are blocky limestone cliffs on either side of the River Wellow, near the Nottinghamshire-Derbyshire border. The crags are about twenty miles from Wentworth Woodhouse, the seat of Stubbs's most important early patron, the Marquess of Rockingham, and it was probably thanks to Rockingham that he first discovered them, probably in 1762; they are only about three miles from Welbeck Abbey, the home of another patron, the Duke of Portland, but Portland's patronage came later, in 1766–67. Clearly Stubbs regarded the crags as a suitably wild, "sublime" setting for his primeval scenes of combat between horses and lions, making them considerably more imposing in his paintings than they were in reality. The early stalking scene in the collection of the Tate, which Judy Egerton has plausibly suggested as a pendant to the present work, also shows a landscape readily identifiable as the crags.[2] Egerton has speculated that Stubbs may have known about the prehistoric remains in the caves there.[3] He also used the crags as a setting for the occasional horse portrait (cat. 51 and fig. 105)—hinting at the state of nature in which horses lived before becoming the animal most closely associated with human civilization—and to add an atavistic touch to the first of his *Shooting Series,* exhibited in 1767.[4] They also appear in one of his later mares-and-foals compositions (cat. 57).

Notes

1. In his copy of the exhibition catalogue, Horace Walpole wrote "bad" alongside the title (Walpole 1939, 79).
2. Egerton 1984a, 94, no. 62.
3. Egerton 1984a, 102; Egerton 1984b.
4. Yale Center for British Art, New Haven, Paul Mellon Collection; see Egerton 1984a, 108, no. 73.

42

Joseph Smyth, Lieutenant of Whittlebury Forest, Northamptonshire, 1763–64

Oil on canvas

25¼ × 30¼ in. (64.2 × 76.8 cm)

Probably commissioned by Augustus Henry FitzRoy, third Duke of Grafton

Fitzwilliam Museum, Cambridge

Literature: Egerton 1984a, 58, no. 32

JOSEPH SMYTH (1710–1799) was lieutenant of Whittlebury (or Whittlewood) Forest for fifty-two years. He and his staff managed the forest, which spanned more than five thousand acres to the south of Northampton, for the third Duke of Grafton. Since the early eighteenth century the dukes of Grafton had been hereditary wardens of the forest, the rights in which they shared with the Crown; their principal seat was at Euston Hall, in Norfolk. As Grafton's lieutenant for the forest, Smyth was responsible, among other duties, for administering supplies of timber to the Crown and venison to the royal household. In his portrait he wears a coat of the traditional green of officers in charge of vert (deer forest) and venison. The countryside stretching far into the distance hints at the large area of

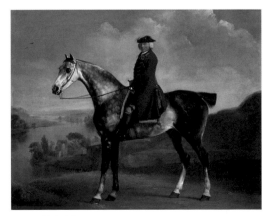

42 (FIG. 51)

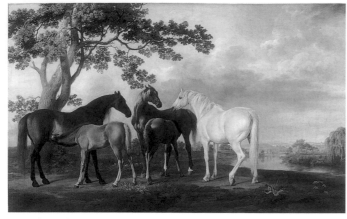

43 (FIG. 74)

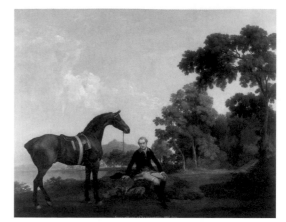

44 (FIG. 60)

land under his management, over which he presumably ranged on his dappled gray horse.

Although Stubbs may have painted the portrait for Smyth himself, it seems more likely to have been for his employer, the third Duke of Grafton. The duke certainly commissioned other works from Stubbs: a portrait of his prized racehorse Antinous and a mares-and-foals composition that included Antinous's dam, both exhibited at the Society of Artists in 1764.[1]

Note
1. See, respectively, Egerton 1984a, 71, no. 43, and Taylor 1971, 206, pl. 18.

43

Mares and Foals, 1763–65

Oil on canvas

40 × 63¾ in. (101.6 × 161.9 cm)

Tate, London. Purchased with assistance from the Pilgrim Trust, 1959

Literature: Taylor 1971, 207, pl. 24; Egerton 1984a, 127, no. 89

STUBBS SEEMS to have painted his first compositions of mares and foals for Lords Bolingbroke and Rockingham in 1761–62

(cats. 35, 37). As in his horse-and-lion compositions, he sometimes repeated successful poses and groupings. Those in the present work are quoted from the friezelike Rockingham painting but without the two mares in the center. The correspondence is close enough to suggest the use of a full-scale cartoon of some kind to establish the outlines; unfortunately, hardly any of Stubbs's drawings have survived, and no such work is known. The chief variations from the original lie in the color of the mare on the far right, which changes from chestnut to gray, and the position of one of the same mare's hind legs. In both works the tenor of the composition is neoclassical, and here the disposition of the equine figures seems gently to echo the geometry of columns and pediment in a temple front.

Before its acquisition by the Tate, the painting descended in the family of the earls of Midleton. It was likely commissioned or purchased from Stubbs by the third Viscount Midleton, of Peper Harrow, in Surrey—who died young in 1765 and was succeeded by his ten-year-old son—although there remains the possibility that it was acquired by his son in later life or by another member of the family.

44

Portrait of a Hunter (James Hamilton, Second Earl of Clanbrassill, with His Horse Mowbray), 1764–65

Oil on canvas

40 × 50½ in. (101.6 × 128.3 cm)

Commissioned by the sitter

Private collection

JAMES HAMILTON, second Earl of Clanbrassill (1730–1798), was an Irish peer and at the time of this portrait a thirty-four-year-old bachelor. His father, the first earl, is remembered for the large part he played in the redevelopment of Dundalk in the early eighteenth century. The second earl succeeded to the title on his father's death in 1758. He took his seat in the Irish Parliament, and from 1768 to 1774 represented Helston (Cornwall) at Westminster. In 1774 he married Grace Foley; she was the daughter of Thomas Foley, who later became Baron Foley of Kidderminster. The literary hostess Mary Delany met Clanbransill at the time of his wedding and described him as "old of his age (having lost all his fore teeth), but . . . tall, genteel, and very well bred."[1] He served as governor of County Louth; in

1783 the king nominated him a knight companion of the newly created Order of St. Patrick, and in 1785 he was one of the founding members of the Royal Irish Academy. On his mother's side he was a cousin of one of Stubbs's most important patrons, the third Duke of Portland (see cat. 53). He had no children, and at his death the earldom became extinct.

Stubbs showed the portrait at the annual exhibition of the Society of Artists in 1765, under the title *Portrait of a Hunter*. Presumably he chose the title to refer playfully both to Clanbrassill—who wears hunting dress that is probably the livery of a particular hunt—and to his horse Mowbray. Horace Walpole visited the exhibition and noted in his catalogue: "bad. Lord Clanbrazil."[2]

Notes
1. Namier and Brooke 1964, 2:569.
2. Walpole 1939, 79.

45

Gimcrack on Newmarket Heath, with a Trainer, a Stable-Lad, and a Jockey, 1765

Oil on canvas
40 × 76 in. (101.6 × 193.2 cm)
Commissioned by Frederick St. John, second
 Viscount Bolingbroke
The Woolavington Collection

Literature: Taylor 1971, 207, pls. 30–32, 35–36; Egerton 1982; Egerton 1984a, 84–85, no. 55

GIMCRACK was one of the most popular and admired of all eighteenth-century racehorses. His name lives on today in the Gimcrack Club and the Gimcrack Stakes, both at York. A grandson of the Godolphin

45 (FIG. 56)

Arabian (fig. 96), he was bred by Gideon Elliot in Hampshire and foaled in 1760. He was unusually small, though possessed of great stamina and courage. He won twenty-eight out of his thirty-six races, and was unplaced only once. After an un beaten first year in 1764, he made his New-market debut on April 9, 1765, in the first spring meet. His owner then was William Wildman, who commissioned Stubbs to paint a portrait of him with the jockey John Pratt up, wearing Wildman's colors, against a Newmarket background (fig. 81).[1] At the same meet at Newmarket, Wildman sold him to the second Viscount Boling-broke, for whom he won matches for a thousand guineas against Rocket and Ascham in the second spring meet. The betting on the match against Ascham, which took place on July 10, reputedly exceeded one hundred thousand pounds. It was presumably about this time that Bolingbroke, who had been a patron of Stubbs since the early 1760s (see cats. 34, 35), commissioned the present work.

Gimcrack belonged to Bolingbroke for only about six months. In October 1765 he had his first loss, to Lord Rockingham's Bay Malton (fig. 57), after which Boling-broke sold him to the Comte de Laura-

guais. Much to the disgust of the British racing world, Lauraguais subjected him to a punishing twenty-two-and-one-half-mile race against the clock in France, which he "won" by coming in under an hour. In 1768 Lauraguais sold him to Sir Charles Bunbury, president of the Jockey Club, who sold him to Lord Grosvenor in the following year. He raced for the last time in 1771, now an eleven-year-old, and was retired by Grosvenor to his stud at Oxcroft, near Newmarket. Grosvenor commissioned Stubbs to paint a portrait of him at stud, his dark gray coat by this time turning white with age.[2]

In the present work Stubbs adopted the archaic device of conflating two scenes in the same image: Gimcrack winning a race by lengths in the right background and a stable-lad rubbing him down, attended by his trainer and jockey, in the left fore-ground. In the background scene the jock-eys wear different colors, which indicates racing rather than exercising, but there is a strange absence of spectators, and the stand at the finishing line is closed up.[3] "As always with Stubbs," Judy Egerton has remarked, "there is no crowd: the victory is almost a private affair between the horse, his jockey, his trainer and the stable-lad."[4]

Stubbs shows the racers' legs in the impossible "flying gallop" position; for a brief discussion of this, see the Goodwood painting showing racehorses at exercise (cat. 33).

Egerton suggested that Bolingbroke commissioned the painting to celebrate Gimcrack's win against Ascham. As Robin Blake has pointed out, however, this was a two-horse match; the four-horse race depicted in the painting more likely represents Gimcrack's first race at Newmarket on April 9, 1765—although his jockey on that occasion wore William Wildman's colors, not Bolingbroke's as here.[5] In all likelihood Stubbs's idea was to put the horse's racing prowess across in a general way, alluding to a particular victory, perhaps, but without recording the details literally. The fact that Bolingbroke commissioned the work must have been a strong argument for dressing the jockey in his colors whether this was accurate or not.

The scene of the rubbing down echoes the Goodwood painting mentioned above and looks forward to the great portrait of Hambletonian (fig. 137). Here and elsewhere Stubbs seems to have painted the rubbing-down house from oil sketches that he may have made on the spot. The building appears from a different angle in the portrait of Turf (cat. 46), another Bolingbroke commission, and from the same angle, along with the spectators' stand in the distance, in the portrait of Hambletonian.

One of the most remarkable aspects of the painting is its composition, the race scene occupying exactly one half of the canvas and the rubbing-down scene the other. This could well have led to disjointedness. The figures of the trainer and stable-lad halt and balance the otherwise dominant movement from right to left, however, and the restrained simplicity of Stubbs's relieflike mode of design lends coherence and authority to the whole.

Stubbs painted a replica of the work that he put on display in his Turf Gallery in June 1794 (see cat. 76). It seems to have been commissioned or bought by Lord Grosvenor and is now in the collection of the Jockey Club, Newmarket.

Notes

1. Egerton 1984a, 86, no. 56. This was one of the first of Stubbs's works to be published as a print, a mezzotint by William Pether, published in 1766; Lennox-Boyd, Dixon, and Clayton 1989, 66–67, no. 2.
2. Private collection. George Townly Stubbs published a mezzotint after the work in 1775 (Lennox-Boyd, Dixon, and Clayton 1989, 152, no. 44). A second version, painted by Stubbs for the Turf Gallery in the 1790s, is in the collection of the Earl of Halifax.
3. For a journalistic image of a finish at Newmarket, see fig. 139.
4. Egerton 1984a, 84.
5. Robin Blake discusses the issue more fully above, 56–57.

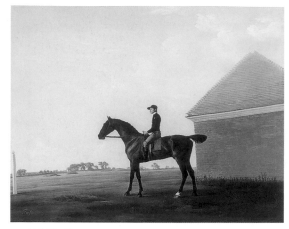

46 (FIG. 79)

46

Turf, with Jockey Up, at Newmarket, 1765—66

Oil on canvas

38 × 49 in. (96.5 × 124.5 cm)

Commissioned by Frederick St. John, second Viscount Bolingbroke

Yale Center for British Art, New Haven. Paul Mellon Collection

Literature: Egerton 1978, 78–79, no. 76a; Egerton 1984a, 87, no. 57

LORD BOLINGBROKE's Turf was foaled in 1760. His sire was Matchem, his grandsire Cade, and his great-grandsire the Godolphin Arabian (fig. 96); his dam was the Duke of Ancaster's Starling mare. He raced mostly at Newmarket, and the high point of his career was beating King Herod in a match for a thousand guineas over the Beacon Course on April 4, 1766. He was retired to stud, lame, in 1767. One of his daughters produced Messenger, who became an important sire in America. The identity of the nonchalant-looking jockey is unknown; he wears Bolingbroke's colors of a black jacket and cap with buff breeches.

The brick building to the right is a rubbing-down house. This was a shed for

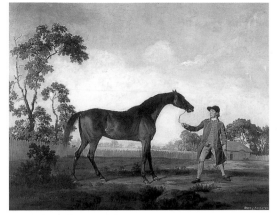

47 (FIG. 87)

storing equipment, in or near which stable-lads would wipe off the horses' sweat with straw and cloths after exercise or a race. There were four rubbing-down houses at Newmarket, and the one in the painting seems to have been reserved for horses belonging to royal owners and members of the Jockey Club such as Bolingbroke. Stubbs painted a pair of oil sketches of different views at Newmarket in which it features prominently, the only known works by him without animal or human figures.[1] He used the sketches repeatedly as the basis for backgrounds to his racehorse portraits. One of them, now at the Yale Center for British Art, clearly served for the present work and for a portrait of the great Gimcrack when he belonged to William Wildman (fig. 81).[2] The other, now at the Tate, served for *Gimcrack on Newmarket Heath, with a Trainer, a Stable-Lad, and a Jockey* (cat. 45), commissioned by Bolingbroke after buying Gimcrack from Wildman in 1765, and for *Hambletonian, Rubbing Down* (fig. 137).

Notes

1. Egerton 1984a, 82–83, nos. 52–53.
2. Egerton 1984a, 86, no. 56.

47

The Duke of Ancaster's Stallion Spectator, with a Groom,

c. 1765–66

Oil on canvas
39½ × 50⅛ in. (100.4 × 127.2 cm)
Commissioned by Peregrine Bertie, third
 Duke of Ancaster
Private collection

Literature: Egerton 1984a, 73, no. 45

FOALED IN 1749, Spectator was bred by Thomas Panton at Newmarket. His ancestors on his dam's side included both the Darley Arabian and the Byerley Turk. He raced for Panton with some success at Newmarket, winning the Jockey Club Plate in 1756 (beating Whistlejacket) and placing second in the following year. Probably soon after this Panton sold him to the third Duke of Ancaster. The relationship between Panton and Ancaster went beyond horses: in 1750 the duke had married Panton's daughter Mary as his second wife, and she brought him a fortune of sixty thousand pounds. After his retirement from racing, Spectator stood at Ancaster's stud at Grimsthorpe Castle, Lincolnshire, and sired some outstanding

broodmares. He died in 1772. In his portrait the position of his ears hints at a restless mood, while the groom braces himself as though expecting trouble.

Like most of Stubbs's important early patrons, Ancaster was devoted to horses, breeding, and racing. He officiated as lord great chamberlain at the coronation of George III in 1760, and was the king's master of the horse from 1766 until his death in 1778. In addition to the portrait of Spectator, he commissioned Stubbs to paint his star stallion Blank (fig. 88) and an Arabian with an oriental groom in the landscape of Creswell Crags (fig. 105). Showing Arabians with oriental grooms had long been a fashion in horse portraiture, notably in the work of John Wootton. Stubbs presumably painted his variation on the theme to match with the several examples already at Grimsthorpe.

Although the setting must notionally represent Ancaster's stud farm, the exact repetition of the background building in the *Mares and Foals* probably commissioned by Lord Grosvenor (cat. 48) indicates that Stubbs was not always topographically specific in such works.

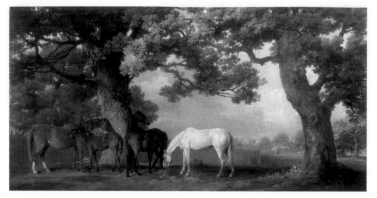

48 (FIG. 75)

48

Mares and Foals,

c. 1765–66

Oil on canvas

39 × 74 in. (99 × 187 cm)

Probably commissioned by Lord Grosvenor,
 later first Earl Grosvenor

Private collection

Literature: Gilbey 1898, 34, 130; Taylor 1971,
 207, pl. 23; Egerton 1979; Egerton 1984a,
 128–29, no. 90

National Gallery only

LIKE OTHER mares-and-foals compositions, this work was commissioned or bought from Stubbs by one of the wealthy owner-breeders of racehorses who supported him in the 1760s. Richard Grosvenor of Eaton Hall, Cheshire, was one of the richest men in England, owning large estates in both Cheshire and London. He was born the son of a baronet, whom he succeeded in 1755, but was raised to the peerage as Baron Grosvenor in 1761 and created first Earl Grosvenor in 1784. Breeding and racing horses were his passions, and he spent huge sums on his stud farms, at both Eaton and Oxcroft, in Cambridgeshire, and on his racing stables at

Newmarket. In the 1780s and 1790s horses owned by him won the Oaks five times and the Derby three times. Grosvenor was also an enthusiastic patron of contemporary artists, above all Stubbs. According to a note by the artist's companion Mary Spencer, Stubbs came to Eaton in 1760 and stayed for "many months," painting a portrait of Grosvenor's stallion Bandy as well as *The Grosvenor Hunt* (fig. 47).[1] Grosvenor went on to commission at least nine further works from him, all portraits of horses and scenes of stud-farm life like the present work, including the portrait of a prized Arabian stallion (cat. 49). The commissions dried up after 1779, when Grosvenor's lavish spending landed him in financial difficulties.

The setting of the present work has been said to represent the stud farm at Eaton. Walter Gilbey identified the oak trees as "Eaton oaks" like the one in *The Grosvenor Hunt.*[2] On the other hand, the building in the background is exactly the same as the one in Stubbs's portrait of the Duke of Ancaster's stallion Spectator (cat. 47), suggesting that the resemblance to any particular place may be partial at most.

The painting corresponds in size to the mares-and-foals compositions that

Stubbs painted earlier for Lords Bolingbroke and Rockingham (cats. 35, 37). It almost certainly dates from the mid-1760s, when Stubbs showed mares-and-foals compositions regularly at the exhibitions of the Society of Artists. In 1764 he showed the smallest of the group, *Brood Mares and Foals,* which was commissioned or purchased by the third Duke of Grafton.[3] In 1765 he showed *Brood Mares,* a composition of mares without foals that belonged to the Duke of Cumberland.[4] The Grosvenor painting, if shown at all, may have been the otherwise unidentified *Brood Mares* at the exhibition of 1766.

In about 1770 John Wesson published a reproductive print by Richard Brookshaw showing the gray horse in the painting above the title *Lord Grosvenor's Arabian.*[5]

Notes

1. Humphry MS, 203. Though presumably begun in 1760 or 1761, *The Grosvenor Hunt* is dated 1762.
2. Gilbey 1898, 34.
3. Duke of Grafton, Euston Hall, Norfolk; see Taylor 1971, 206, pl. 18.
4. See Walpole 1939, 79; the painting is now at Ascott, Wing, Bedfordshire (National Trust).
5. Lennox-Boyd, Dixon, and Clayton 1989, 107, no. 18.

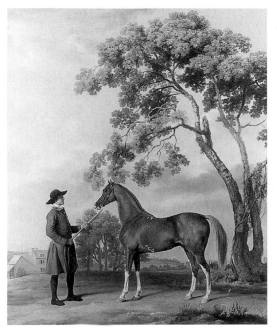

49 (FIG. 97)

49
Lord Grosvenor's Arabian Stallion, with a Groom, 1766–70

Oil on canvas

39 1/8 × 32 7/8 in. (99.3 × 83.5 cm)

Commissioned by Lord Grosvenor, later first
 Earl Grosvenor

Kimbell Art Museum, Fort Worth

Literature: Taylor 1971, 208, pl. 38; Egerton
 1979, 1892; Egerton 1984a, 78, no. 49;
 Lennox-Boyd, Dixon, and Clayton 1989,
 112–13, 126–27, 269, 347, nos. 21, 30, 130,
 313–16

THIS CHESTNUT Arabian with Sabino
markings—tall white stockings, a broad
blaze, and white spots—covered mares at
Lord Grosvenor's stud farm at Eaton Hall,
Cheshire, from about 1766. In 1770 Thomas
Pennant used an engraved vignette based
on Stubbs's painting to illustrate the horse
as a species in the supplementary fourth
volume, "Illustrated by Plates and Brief
Explanations," of his *British Zoology.* "The
representative of this species," he wrote,
"is a native of *Yemine,* in *Arabia felix;* the
property of Lord *Grosvenour,* taken from a
picture in possession of his Lordship,
painted by Mr. *Stubbs,* an artist not less
happy in representing animals in their
stiller moments, than when agitated by
their furious passions; his matchless
paintings of horses will be lasting monu-
ments of the one, and that of the lion and
panther of the other. This horse, by its
long residence among us, may be said to
be naturalized, therefore we hope to be
excused for introducing it here, not-
withstanding its foreign descent. From its
great beauty it may be presumed that it
derives its lineage from *Monaki Shadubi,
of the pure race of horses, purer than milk.*"[1]
Pennant went on to admire Arabian horses
in general, and the training and breeding
methods of the Arabs.

The engraver of the vignette in
Pennant's book was Peter Mazell, who
also made a reproductive engraving of the
whole painting (cat. 50). This shows a
more extensive landscape to the left,
indicating that the original canvas was at
some time cut down; the missing portion
was a little more than a third of the whole.
A small oil copy by John Nost Sartorius
(1759–1828), apparently made from
Stubbs's painting in its cut-down state,
and omitting the figure of the groom, is
on loan from a private collection to the
National Horseracing Museum in
Newmarket.

Just as the large Grosvenor mares-
and-foals painting (cat. 48) may have been
the *Brood Mares* that Stubbs showed at the
Society of Artists exhibition in 1766, so
the present painting may have been *An
Arabian Horse* at the same exhibition.[2]

Notes
1. Pennant 1768–70, 4:42–43.
2. The portraits of Arabians that Stubbs painted
 for the Duke of Ancaster (fig. 105) and the
 Marquess of Rockingham (cat. 51) are also
 candidates.

50

Peter Mazell, after George Stubbs
Lord Grosvenor's Arabian,
1770–72
Engraving with etching, second state
plate: 16⅜ × 19⅛ in. (41.5 × 48.7 cm)
The Royal Collection

Literature: Lennox-Boyd, Dixon, and Clayton
1989, 126–27, no. 30

PETER MAZELL was a zoological illustrator who worked for the celebrated naturalist Thomas Pennant. He engraved a vignette from Stubbs's painting to represent the horse as a species in the fourth volume of Pennant's *British Zoology,* published in 1770 (see cat. 49). The vignette was probably the basis for an anonymous mezzotint of the Arabian in a set of three portraits of Grosvenor horses published by William Wynne Ryland in 1771, although the orientation is reversed.[1]

Lennox-Boyd, Dixon, and Clayton suggest that the present work, which presumably corresponds closely to the appearance of Stubbs's painting before it was cut down, may have been a private plate executed for Lord Grosvenor. An impression was exhibited at the Society of Artists in 1772.

Note

1. Lennox-Boyd, Dixon, and Clayton 1989, 112–13, no. 21.

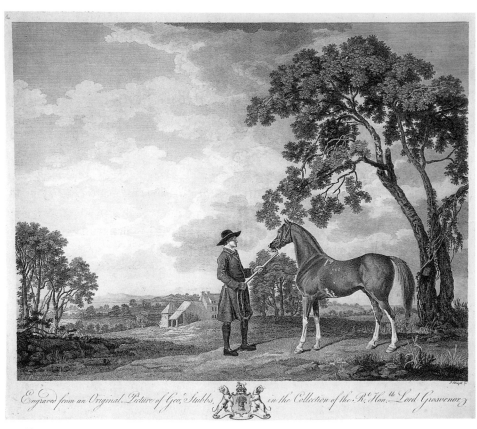

50

51 (FIG. 106)

51

The Marquess of Rockingham's Arabian Stallion, with a Groom,
1766
Oil on canvas
38½ × 48½ in. (97.8 × 123.2 cm)
Commissioned by Charles Watson-
 Wentworth, second Marquess of
 Rockingham
National Gallery of Scotland, Edinburgh

Literature: Constantine 1953, 237; Egerton
 1984a, 106–7, no. 72

STUBBS USED the rough landscape of Creswell Crags as a sympathetic environment in which to set his scenes of equine life in the wild—with horses falling prey to lions—and, by extension, to suggest the wild origins of now-civilized horses, especially Arabians. The present work shows the same stretch of crags and weeping willow that appear in *Gray Arabian with a Groom* (fig. 105) and *Gray Hunter with a Groom and a Greyhound* (cat. 52). Stubbs gives these features broadly the same forms but varies the details considerably from painting to painting.

The work can be identified as the "Picture of an Arabian" for which the Marquess of Rockingham paid Stubbs forty guineas on August 7, 1766.[1] It may also have been the painting Stubbs showed at the exhibition of the Society of Artists in

the spring of that year under the title *An Arabian Horse*, although this may equally have been one of the portraits of Arabians he painted for the Duke of Ancaster (fig. 105) and Lord Grosvenor (cat. 49).

Note
1. Constantine 1953, 237.

52 (FIG. 89)

52

Gray Hunter with a Groom and a Greyhound, c. 1766

Oil on canvas
17½ × 26¾ in. (44.5 × 67.9 cm)
Tate, London. Purchased 1895

Literature: Egerton 1984a, 103, no. 70

THE IDENTITY of the gentleman or nobleman who owned the hunter, and whose livery the groom presumably wears, is unknown. As Judy Egerton has suggested, the presence of the greyhound probably means that it was a hunter used for hare coursing. Typically, Stubbs takes the opportunity to suggest communication between the animals, as in a human "conversation piece." He carefully introduces affinities of line and pose from horse to hound to man, as though setting up a casual study in comparative anatomy. The setting is Creswell Crags (see also cats. 41, 51, 57, and fig. 105).

When bought by the National Gallery in 1895, this became the first painting by Stubbs to enter a British national collection. It was transferred to the Tate shortly afterward.

53

William Henry Cavendish-Bentinck, Third Duke of Portland, and His Brother, Lord Edward Bentinck, with a Groom and Horses, 1766–67

Oil on canvas
39 × 49 in. (99.1 × 124.5 cm)
Commissioned by William Henry Cavendish-Bentinck, third Duke of Portland
Private collection

Literature: Gilbey 1898, 143, 211; Taylor 1971, 208, pl. 37

National Gallery only

THE THIRD Duke of Portland (1738–1809), who succeeded to the title on the death of his father in 1762, was another patron of Stubbs who belonged to the circle of young, horse-loving Whig noblemen around the Marquess of Rockingham. He was one of the leading political figures of his time, occupying a series of high offices. In Rockingham's short-lived ministries of 1765–66 and 1782 he was respectively lord chamberlain and lord lieutenant of Ireland. On Rockingham's death in the latter year he became leader of the Whigs and for a period in 1783 was prime minister. In 1794 he and his Whig faction formed an alliance with the Tory William Pitt, and he served as Pitt's home secretary until 1801. In 1807–9 he was once again prime minister. From the time of his marriage to the daughter of the fourth Duke of Devonshire in November 1766, Portland lived at Welbeck Abbey in Nottinghamshire. Although he did not own Welbeck until the death of his mother in 1785, he

ran the estate, undertook an extensive program of improvements, and from 1789 employed the renowned landscape gardener Humphry Repton.

In the portrait Stubbs shows Portland at Welbeck, watching a groom in livery lead a riding horse toward a jump or "leaping bar" and leaning on the shoulder of his younger brother, Lord Edward Bentinck (1744–1819). Portland was fond of his brother, allowing him unlimited credit despite a tendency to extravagance—a tendency that Portland himself shared. Nicknamed "Jolly Heart," Lord Edward also had a career in politics—he was elected member of Parliament for Lewes in 1766, and later represented Carlisle, County Nottingham, and Clitheroe—but this was entirely thanks to Portland's influence; he showed little liking or aptitude for public life. His contemporaries regarded him as amiable but idle and careless.

There was a tradition of equestrianism at Welbeck going back to William Cavendish, Duke of Newcastle, who did much to introduce his countrymen to the Continental art of horsemanship and built the Riding House there in 1623.[1] As Portland's guest, Stubbs would have seen the series of twelve large, primitive paintings of horses

53 (FIG. 48)

that Newcastle seems to have commissioned for this building; they originally alternated with portraits of Roman emperors in a decorative scheme probably based on that of the Sala dei Cavalli at the Palazzo del Te in Mantua.[2]

Stubbs painted two portraits for Portland in 1766—67, the present work and another in the same size showing the duke in front of the Riding House on a gray horse, with a stable-lad leading another horse, saddled, behind him; perhaps the second horse would have been for Lord Edward Bentinck.[3] The latter portrait appeared at the exhibition of the Society of Artists in 1767. In the same exhibition Stubbs showed the first of the four paintings in his *Shooting Series*.[4] In the catalogue the shooting scene was described as showing a view of Creswell Crags "taken on the spot," and it seems likely that Stubbs would have drawn or painted the crags while staying at Welbeck, which is only three miles away, to paint the Portland portraits. He had painted the crags as a background before (see cat. 41), but perhaps the visit to Welbeck renewed his interest in them: they appear not only in the shooting scene but also in other works datable to about the same time (see cats. 51, 52, 57, and fig. 105).

Notes

1. Newcastle wrote and published his celebrated manual on horsemanship while in exile in Antwerp; it was published in English in 1667 (see Newcastle 1667).
2. From information about Welbeck and its contents kindly supplied by Derek Adlam, curator of the Portland collection. For a reproduction of one of the Welbeck horse paintings, see Taylor 1955, pl. 7.
3. See Parker 1971, 169.
4. Yale Center for British Art; Egerton 1984a, 108, no. 73.

54
Lord Torrington's Bricklayers at Southill, Bedfordshire, 1767

Oil on canvas
24 × 42 in. (61 × 106.7 cm)
Commissioned by George Byng, fourth
 Viscount Torrington
Philadelphia Museum of Art. John H.
 McFadden Collection

Literature: Humphry MS, 204; Mayer 1879, 29—30; Gilbey 1898, 175, 207; Russell 1980; Egerton 1984a, 76, no. 47; Dorment 1986, 384—87, no. 108; Lennox-Boyd, Dixon, and Clayton 1989, 210—13, nos. 86—87

STUBBS PAINTED this and the following two paintings (cats. 55, 56) for the fourth Viscount Torrington; they form a series showing various outdoor servants going about their work at Southill, Torrington's estate in Bedfordshire. In the present exhibition the series is shown together for the first time since 1787.[1]

Ozias Humphry gave an account of the origins of the bricklayers subject in his memoir of the artist:

> At Southile, the seat of Lord Viscount Torrington, Mr Stubbs painted the celebrated picture of the Bricklayers & Labourers, loading Bricks into a Cart.—This commission he received from the noble Lord in London, who had often seen them at their Labours appearing like a Flemish subject and therefore he desired to have them thus represented. He arrived at Southile a little before Dinner, where he found with Lord Torrington, the Duke of Portland with other noblemen and gentlemen—During dinner the old men were ordered to prepare themselves for their Labours with a little cart drawn by Lord Torrington's favorite old Hunter, which was used only for these easy tasks; for this being the first horse his Lordship ever rode, furnished the ostensible motive for ordering the picture.

54 (FIG. 76)

> Mr Stubbs was a long time loitering about considering the old men without observing in their occupation any thing that engaged them all, so as to furnish a fit subject for a picture, till at length, they fell into a dispute about the manner of putting the Tail piece on to the Cart, and this dispute so favorable for his purpose agitated these Labourers & continued long enough to enable him to make a sketch of the men, Horse & Cart, as they have been represented. Thus having settled the design as time & opportunity served, he removed the Cart, Horse & men into a neighbouring Barn where they were kept well pleased & well fed till the picture was completed.

According to a note added by Mary Spencer, the dog in the lower right corner was "Lord Torrington's favourite Old Dog."[2]

Humphry's account reveals much about Torrington's and Stubbs's intentions. The "ostensible motive" was to record the appearance of Torrington's old hunter, the first horse he ever rode, who was by then in service as a carthorse on his estate. Thus the painting connects to the common narrative of the "horse's progress" (see pages 5—6, above), although in this case— by contrast with most—the horse's old age was an easy and pleasant one. The work was to be both a portrait of a horse to which Torrington was sentimentally attached, and a genre scene, "like a Flemish subject," that included portraits of some of his old estate workers. Stubbs had to observe them for some time before the

right subject presented itself, and it is clear from Humphry's account that this meant a humorous subject—in the tradition of Flemish peasant genre painting, familiar chiefly in the work of Pieter Bruegel (fig. 90) and David Teniers.

Torrington was associated with the group of noblemen who had employed Stubbs since the beginning of the 1760s. According to Humphry, he was entertaining the Duke of Portland to dinner when the artist arrived at Southill, and it may well have been Portland who recommended his services (see cat. 53). Torrington had a considerable collection of paintings at Southill, including some Dutch and Flemish works.[3] In 1778, forced to give up Southill, he sold no fewer than 144 works at auction at Christie's. They included cats. 54–56 and three paintings in which Stubbs painted the figures and animals and the landscapist George Barret added the settings: a portrait of Lady Torrington at Roche Abbey and two portraits of horses.[4]

In 1779 Stubbs painted a larger version of the present work in oil on panel, showing it at the Royal Academy exhibition of that year under the generalized title of *Labourers*.[5] In 1781 he painted a further version in enamel on a Wedgwood earthenware plaque (fig. 63). According to Humphry, "Another repetition was sold to Thomson West, Esq, in which was given the portrait of that Gentleman's favorite horse, himself seated on it, looking at the workmen & enjoying their dispute."[6] Perhaps Stubbs based the versions on the initial sketch of the men, horse, and cart that Humphry mentioned his having made at Southill; this certainly remained in his studio.[7]

Originally the right side of the background of the present painting included a view of the new Palladian lodge on the Southill estate, which the men in the

FIG. 1. X-radiograph of a section of the right side of the painting. Conservation department, Philadelphia Museum of Art

foreground had presumably built (see X-radiograph, fig. 1). At some time between 1787 and 1789 the then owner of the painting, Andrews Harrison, employed the minor landscapist Amos Green to alter its landscape setting, most conspicuously by overpainting the lodge with picturesque rustic buildings; one can gain some idea of the extent of the changes by comparing the work to the enamel version. Stubbs himself truncated the composition to omit the lodge in the print of the subject that he published on January 1, 1789, again with the title of *Labourers* (cat. 71); he may have based the print on any of the painted versions or on the initial sketch. No doubt both Harrison in his alterations to the painting and Stubbs in his print wished to make the image less specific, changing a scene of life at Southill in particular into a scene of country life in general. Harrison also owned the painting of Torrington's steward and gamekeeper (cat. 55), in which he similarly employed Green to alter the landscape. On January 2 and March 25, 1790, respectively, Benjamin

Beale Evans published reproductive mezzotints showing Harrison's paintings in their altered state with the titles of *Labourers* and *Game Keepers* and the inscription "Painted by George Stubbs . . . Landscape by Amos Green."[8]

The artist Joseph Farington expressed the common opinion of posterity on the Green interventions after seeing the paintings in 1814: "Walked to the house of the late Mr. Harrison, and saw two pictures by Stubbs (the animals & figures) the landscape by the late Mr. Green of Bath painted over that which was executed by Stubbs, but very unworthy of the admirably painted animals."[9]

Notes

1. The paintings were in Lord Torrington's sale, Christie's, January 23–24, 1778, all bought by William Wildman. Following Wildman's death in 1784, they were sold and separated at Christie's, January 20, 1787.

2. Humphry MS, 204.

3. For further details of the collection, see Russell 1980, 253.

4. The present whereabouts of these three works are unknown. For Lord Torrington's sale, see note 1, above.

5. Bearsted Collection, Upton House (National Trust), Warwickshire.

6. Humphry MS, 204.

7. It was in his posthumous sale in 1807: "the original design for the Painting of Men loading a Cart, being a Scene from nature in Lord Torrington's Garden" (Gilbey 1898, 197); its present whereabouts are unknown.

8. Lennox-Boyd, Dixon, and Clayton 1989, 212–15, nos. 87–88. The engraver of the prints is given as Henry Birche; according to Lennox-Boyd et al., this was probably a pseudonym for Robert Laurie and Richard Earlom.

9. Farington 1978–84, 13:4458, entry for February 28, 1814.

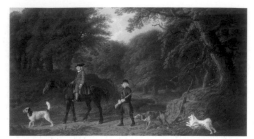

55 (FIG. 85)

55

Lord Torrington's Steward and Gamekeeper with Their Dogs, at Southill, Bedfordshire, 1767

Oil on canvas

23½ × 41½ in. (59.7 × 105.4 cm)

Commissioned by George Byng, fourth
 Viscount Torrington

Private collection

Literature: Humphry MS, 204; Gilbey 1898,
 175, 209; Russell 1980; Lennox-Boyd,
 Dixon, and Clayton 1989, 214–15, no. 88;
 Russell 2003, ix–x, 6, no. 13

THIS IS one of the series of three paintings that Stubbs carried out for Viscount Torrington (cats. 54–56). Ozias Humphry described its subject as "an old man, his Steward, on an aged horse with the Game Keeper, followed by a Pomeranian dog."[1] Although a steward outranked a gamekeeper in the world of the country estate, the name of Lord Torrington's steward has not come down and that of his gamekeeper has. He was Joseph Mann, known generally as Old Joe, who worked as both gamekeeper and huntsman at Southill from 1733 to 1777; for a description of him, see pages 91–92, above. As in the painting of Torrington's bricklayers, Stubbs portrays the men with gentle humor. They look out at the viewer with apparent disdain and suspicion, and the steward's superior-looking hound and Mann's keen, alert

setter seem to express aspects of their masters' personalities, both in contrast to the frisky Pomeranian.

Like the bricklayers painting, the work belonged to Andrews Harrison by the late 1780s and was overpainted at his request by Amos Green. Since there is no image of the work before Green's alterations, it is difficult to assess their extent. Judging from the alterations in the bricklayers painting, however, they presumably removed features that gave the sense of a specific place and made the landscape look more emphatically rough and irregular, in line with contemporary ideas of the picturesque.

On March 25, 1790, Benjamin Beale Evans published a mezzotint after the painting in its altered state with the title of *Game Keepers.*[2] Clearly in the interests of making the image more appealing to a general audience, the engraver made the men's expressions friendlier, and the publisher provided a title that simplified their identities, glossing over the distinction between their occupations and status.

Notes

1. Humphry MS, 204.
2. Lennox-Boyd, Dixon, and Clayton 1989, 214–15, no. 88; see also cat. 54, note 8.

56

Lord Torrington's Hunt Servants Setting Out from Southill, Bedfordshire, 1767

Oil on canvas

24 × 41½ in. (61 × 105.5 cm)

Commissioned by George Byng, fourth
 Viscount Torrington

Private collection

Literature: Humphry MS, 204; Mayer 1879, 30;
 Taylor 1971, 208, pls. 41–42; Russell 1980;
 Egerton 1984a, 74–75, no. 46

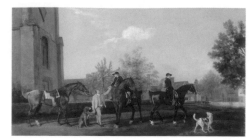

56 (FIG. 84)

ANOTHER OF the three paintings of about the same size that Stubbs executed for Viscount Torrington (cats. 54–56), this work was described by Humphry as "a hunting scene [in which] were introduced his Lordship's Coachman, Grooms, Hunters, a few dogs and his Whipper in.— The village of Southile forming the background of the picture."[1] It was separated from the other paintings when the series was sold at auction in 1787; it never belonged to Andrews Harrison and escaped the overpainting to which the others were subjected.

Judy Egerton has noted that maps and an early-eighteenth-century view of the village of Southill reveal that Stubbs painted the place exactly as it was. The west tower of the church of All Saints appears on the left, and the servants are represented as though they had just come out of the east gates of Southill Park.[2]

Notes

1. Humphry MS, 204.
2. Egerton 1984a, 74.

57

Brood Mares and Foals, 1767–68

Oil on canvas
39¼ × 74¼ in. (99.7 × 188.6 cm)
Private collection

Literature: Gilbey 1898, 169; Egerton 1984a, 109

Kimbell and National Gallery only

STUBBS HAD painted compositions of mares and foals since the early 1760s (see cats. 35, 37, 43, 48), and most were commissioned or bought from him by noblemen who bred horses. The subject paid tribute to the peaceable realm of the stud farm and the extraordinary achievement of British breeders in creating the thoroughbred racehorse. In the groupings and body language of the horses, Stubbs took the opportunity to suggest interactions and relationships, the workings of equine family and community life.

In the present work, the rocky outcrops in the background are recognizable as Creswell Crags, which Stubbs used as a setting in a number of other paintings, though none with this type of subject (see cats. 41, 51, 52, fig. 105). What is clearly the same steep formation appears in the first of his series showing men on a day's shooting, exhibited at the Society of Artists in 1767.[1] The stone walls and view along the river are also common to both paintings—although a thatched watermill in the shooting scene here becomes a stable or shed. Stubbs associated the crags with the idea of the wild, most obviously in scenes of horses attacked by lions but also in portraits of Arabians, in which they suggest the subjects' origin in supposedly uncivilized lands. In the present, unique scene of mares and foals against the crags, he may have meant to give a similar hint of the primeval: the noble horse has

emerged, through breeding, from raw and savage nature.

The first owner of the painting was a soldier, Colonel George Lane Parker, of Woodbury, Cambridgeshire, brother of the third Earl of Macclesfield. Whether Parker bred horses and whether he commissioned or simply purchased the painting from the artist are unknown. In 1798 an illustration showing the mare on the right of the group (in reverse, and with a different background) appeared in a drawing manual with the title *A Brood Mare belonging to Mr. Shafto*.[2] Mr. Shafto was the well-known breeder and gambler Jenison Shafto, of West Wratting, near Cambridge and Newmarket. Stubbs painted a portrait of Shafto's horse Snap for him in the early 1760s, and may well have used a mare—and possibly other horses—from the stud farm at West Wratting in the present painting.[3] Perhaps there was also a connection between Parker and Shafto: among the other paintings by Stubbs apparently acquired by Parker was a double-portrait of Snap with another Shafto horse, Goldfinder.[4]

Stubbs showed the painting at the

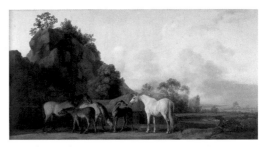

57 (FIG. 107)

exhibition of the Society of Artists in the spring of 1768, and again on September 30 the same year in a special exhibition to honor a visit by the king of Denmark, in both cases with the title *Brood Mares and Foals*.[5] Between that time and the present exhibition it appears never to have been shown in public.

The exhibition of spring 1768 also included a proof of Benjamin Green's mezzotint after the work (fig. 1), which was published as *Brood-Mares* on May 10, while the exhibition was still in progress; the inscription identified Parker as the painting's owner.[6] The mezzotint shows the composition in reverse and truncated to omit most of the view along the river into the distance, which makes for a more

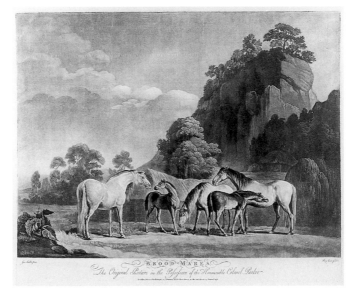

FIG. 1. Benjamin Green, after George Stubbs, *Brood-Mares*, published 1768. Mezzotint, third state, plate: 17¾ × 21¹¹/₁₆ in. (45.1 × 55.1 cm). Yale Center for British Art, New Haven. Paul Mellon Collection

closed setting and more conventional proportions. Stubbs had a liking for the unusually long, emphatically horizontal format of the painting, and indeed for canvases of exactly this size (see also cats. 35, 37, 38, 45, 48).

Stubbs repeated the group of mares and foals, against a different landscape background, in what seems to have been his largest essay in this type of subject, dated by Basil Taylor to 1769.[7] In 1773 he painted a further variation on the mares-and-foals theme in oil on panel for Lord Grosvenor—the second such subject for this patron (see cat. 48)—and in 1774 another, also in oil on panel, for Jenison Shafto's brother Robert Shafto.[8] He showed an unidentified painting entitled *Mares and Foals* at the Royal Academy exhibition in 1776, and in 1777 he painted a composition with mares only, again in oil on panel, for John Musters of Colwick Hall.[9]

Notes

1. Yale Center for British Art; Egerton 1984a, 108, no. 73. The four paintings in the *Shooting Series* appeared in successive exhibitions from 1767 to 1770.
2. Lennox-Boyd, Dixon, and Clayton 1989, 269, no. 129.
3. On Stubbs and Shafto, see Egerton 1984a, 68–69, no. 41.
4. Parker had presumably owned the six Stubbses later recorded in the collection of his relative the seventh Earl of Macclesfield (Gilbey 1898, 170). In addition to the present painting and the portrait of Snap and Goldfinder, they included *Hyena, with a Groom, on Newmarket Heath*, now at the Virginia Museum of Fine Arts, Richmond; see Cormack et al. 1999, 26, no. 9.
5. See Graves 1907, 249, 319–20.
6. Lennox-Boyd, Dixon, and Clayton 1989, 74–77, no. 5. Green later used two groups of a mare and a foal from the composition (probably copied from the print and re-reversed, ending in the same orientation as in the painting) as the basis for illustrations in a drawing manual; see Lennox-Boyd, Dixon, and Clayton 1989,

147–48, nos. 39–40. The illustration of 1798 showing the mare that stands slightly apart from the rest of the group (see note 2, above) was made for a similar purpose.
7. Private collection, United States; see Taylor 1971, 207, pl. 25.
8. Private collections; see Egerton 1984a, 130–31, nos. 91–92.
9. Private collection; see Parker 1971, 69, and Egerton 1978, 89–90.

58

Captain Samuel Sharpe Pocklington with His Wife, Pleasance, and Another Lady, Possibly His Sister Frances, 1769

Oil on canvas
39½ × 49⅞ in. (100.2 × 126.6 cm)
Probably commissioned by Captain Pocklington
National Gallery of Art, Washington, D.C. Gift of Mrs. Charles S. Carstairs in memory of her husband, Charles Stewart Carstairs

Literature: Taylor 1971, 209, pls. 57–59; Egerton 1984a, 146–47, no. 107; Hayes 1992, 258–61

THE IDENTITIES and histories of the main sitters in this portrait were established by Judy Egerton in 1984.[1] The captain was born Samuel Sharpe, the son of a surgeon. He seems to have joined the regiment of the Third Foot Guards, whose uniform he wears, in 1760. He and his wife were married in 1769, the year in which the portrait was painted. She was born Pleasance Pykarell but had changed her name to Pocklington as a condition of inheriting the manor of Chelsworth in Suffolk from her cousin Robert Pocklington. On marrying her, the captain added the Pocklington name to his own. The couple lived at Chelsworth and had two sons, the elder of whom had a distinguished career in the

58 (FIG. 61)

Fifteenth Light Dragoons. By 1771 the captain seems to have retired from the army. His wife died in 1774 and he in 1781. The lady to the left of Pleasance Pocklington in the portrait is impossible to identify with confidence. The captain had three sisters, and Egerton speculated that this might be the only unmarried one, whose name was Frances.

This and the following painting (cat. 59) are Stubbs's most important essays in the genre of the "conversation piece," a relatively informal group portrait in which family members or friends commune through looks and activities. In both cases the human sitters seem to come together mainly through their horses. Here, in a portrait that must have been commissioned to celebrate their marriage, the captain and his bride share intimacies with his horse rather than each other: he leans his arm affectionately on its back; she offers it a posy of flowers. The animal appears almost as a member of the family, embraced into the human world from nature.

Stubbs repeated the oak tree almost branch for branch in cat. 59, perhaps using the same drawing from nature as a basis, perhaps some form of cartoon.

Note

1. Egerton 1984a, 146–47.

59

Sir Peniston and Lady Lamb, Later Lord and Lady Melbourne, with Lady Lamb's Father, Sir Ralph Milbanke, and Her Brother John Milbanke (The Milbanke and Melbourne Families), 1769–70

Oil on canvas

38¼ × 58 in. (97.2 × 147.3 cm)

Probably commissioned by Sir Peniston
 Lamb, second Baronet

The National Gallery, London

Literature: Taylor 1971, 209, pl. 55; Egerton
 1984a, 150–51, no. 110; Egerton 1998a,
 pp. 248–55

SIR PENISTON LAMB (1745–1828) of Brocket Hall, Hertfordshire, was the son and heir of a wealthy attorney who advised and lent money to many of the nobility. He presumably commissioned this group portrait or "conversation piece" to commemorate his recent marriage and the union between his family and his wife's, a union of new money and county respectability. Lamb appears on horseback on the right of the composition, and his wife, born Elizabeth Milbanke (1752–1818), occupies a ladylike light carriage, or "park phaeton," on the left. They were married on April 13, 1769, and when Lady Lamb sat for the portrait she was probably pregnant; she gave birth to a son, named Peniston after his father, on May 3, 1770. Standing by Lady Lamb's carriage is her father, Sir Ralph Milbanke of Halnaby Hall in Yorkshire (?1721–1798), by this time a widower; and leaning on his horse near the center of the composition is her brother John Milbanke (d. 1780). The landscape setting seems to have been an invention: the large oak tree roughly duplicates the one in the earlier portrait of Captain Samuel Sharpe Pocklington and his wife (cat. 58), and the rocks on the right are based on Creswell Crags. As else-

59 (FIG. 62)

where (see cat. 51 and fig. 105), Stubbs may have incorporated the crags to allude to the "savage" origins of the Arabian horse, of which Lamb's mount is a handsome specimen.

This was probably the painting Stubbs showed under the title of *A Conversation* at the exhibition of the Society of Artists in the spring of 1770. The same exhibition included *A Lion Devouring a Horse* (cat. 60), which Sir Peniston Lamb bought for a hundred guineas. He was an enlightened patron of British artists and in 1769–70 also bought important works by Joseph Wright of Derby, as well as commissioning a portrait of his wife and child from Joshua Reynolds and decorative works for Brocket Hall from John Hamilton Mortimer.[1]

On June 8, 1770, while the Society of Artists exhibition was in progress, Lamb was raised to the Irish peerage and took the title of Lord Melbourne. As Lady Melbourne, his strong-minded, ambitious wife was to become a famous figure of her time. She was the mistress of a number of eminent men, including Lord Egremont and the Prince of Wales, and in later life the confidante of Lord Byron. Her son William (fathered, it was generally assumed, by Egremont) became the second Lord Melbourne and a prominent politician; he was prime minister at the accession of the young Queen Victoria, who looked to him as her mentor in public affairs.

Note

1. See Egerton 1998a, 251–53.

60

A Lion Devouring a Horse, 1769

Enamel on copper, octagonal,

9⁹⁄₁₆ × 11⅛ in. (24.1 × 28.3 cm)

Tate, London. Purchased with assistance
 from the Friends of the Tate Gallery, 1970

Literature: Humphry MS, 205; Egerton 1984a,
 96, no. 64

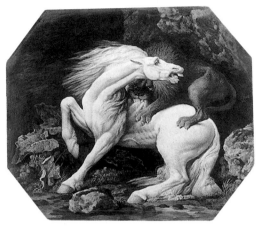

60 (FIG. 69)

THIS AND the following works (cats. 61, 62) are from Stubbs's later group of horse-and-lion paintings, datable to 1769–70. In the scenes of the attack, the horse has not collapsed, as in the earlier oil version of the subject also in the Tate's collection (cat. 41), but remains standing, as in the large Rockingham painting that seems to have been the prototype for the horse-and-lion compositions as a whole (fig. 104). The positions of the horse and the lion are virtually identical in cats. 60, 61, and three other works of about the same time: an untraced painting reproduced as a mezzotint by Benjamin Green, *The Lion and Horse,* published in 1769; a painting in oil on canvas at the National Gallery of Victoria, Melbourne; and a painting in oil on panel in the Paul Mellon Collection.[1] Where there are compositional differences, they lie in the scope and the details of the landscape setting.

A distinctive feature of the later group of horse-and-lion paintings, including ones showing the lion stalking the horse as well as those showing the attack, is that the horse is white—whereas the paintings of the earlier group, including the large Rockingham painting and smaller oils datable to 1762–64, all show a chestnut. The exception to the rule is the untraced enamel on which Stubbs based the soft-ground etching of the attack subject published in 1788 (cat. 69), which apparently showed the same chestnut horse as the large Rockingham painting.

The present painting, dated 1769, is one of Stubbs's earliest works in enamel and the first to be exhibited. He painted his first enamels on copper supports; another example is the *Phaeton* of 1775 (cat. 64). Apparently frustrated by the limitations of scale inherent in copper, from 1777 he began to experiment with the potter Josiah Wedgwood on paintings in enamel on earthenware (see cat. 66).

Stubbs showed the work at the exhibition of the Society of Artists in 1770 under the title *A Lion Devouring a Horse, Painted in Enamel*. Horace Walpole annotated catalogues of the exhibition with the comments "Very pretty" and "singularly large piece of enamel, & fine."[2] The artist sold the work to Sir Peniston Lamb, later Lord Melbourne. Ozias Humphry noted: "an octagon within a circle of 12 inches upon Copper of a Lyon devouring a Horse was sold to Lord Melbourne for 100 Guineas being the first picture in Enamel that our author sold."[3] Stubbs painted Lamb in a group portrait with his wife and members of her family (cat. 59), and this was probably the work shown under the title of *A Conversation* in the same exhibition as the enamel.

In 1770 Stubbs painted an enamel of similar shape and size showing the stalking scene.[4] He showed this at the Society of Artists exhibition in the following year as *A Horse and Lion; in Enamel*.[5]

Notes

1. See, respectively, Lennox-Boyd, Dixon, and Clayton 1989, 80–83, no. 7; Taylor 1965a, 86, fig. 37, and Parker 1971, opp. 80; and Egerton 1984a, 97, no. 65. An enlarged copy of the mezzotint in oil on canvas is in the collection of the Musée du Louvre, Paris. It has been identified as a painting that appeared in Eugène Delacroix's sale in 1864 as the work of Théodore Géricault; this attribution was not accepted by Germain Bazin (see Bazin 1987, 2:463, no. 395).
2. Graves 1907, 250; Walpole 1939, 79.
3. Humphry MS, 205.
4. Private collection; see Taylor 1965a, 86, fig. 35.
5. When Horace Walpole noted "exhibited last year" in his catalogue (Walpole 1939, 79), he was presumably mistaking the work for the present painting, which he had indeed seen in 1770.

61

Horse and Lion, 1770

Oil on canvas
40⅛ × 50¼ in. (101.9 × 127.6 cm)
Yale University Art Gallery, New Haven.
 Gift of the Yale University Art Gallery
 Associates

Literature: Gilbey 1898, 157; Wark 1955; Taylor 1971, 209, pl. 61; Egerton 1984a, 99, no. 67

IN THIS variation on the theme of the horse attacked by a lion, Stubbs set the encounter in a landscape more extensive than elsewhere. It shares this feature with the following painting from the Walker Art Gallery, Liverpool (cat. 62), which shows the moment before the attack, with the horse terrified at the sight of its approaching enemy. The paintings are roughly the same size and clearly con-

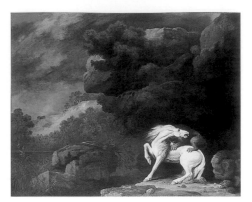

61 (FIG. 109)

ceived as pendants; both are dated 1770. The breadth and inhospitality of the settings, which recall Creswell Crags (see cat. 41), suggest the idea of the horse's violent death as part of the wildness of nature as a whole. In the stalking scene the sky is largely clear; as the lion consummates the hunt in the present work, storm clouds thicken and darkness descends like a pall.

Stubbs pursued the idea of matching stalking and attack scenes in the same year, 1770, when he painted an enamel of the stalking scene to match the 1769 enamel of the attack (see cat. 60). Like the Yale-Liverpool pair, these have not remained together and may well have been bought separately from the artist. The untraced enamels of horse-and-lion subjects that Stubbs reproduced in his etchings of 1788 (cats. 68, 69)—the originals also presumably dating from about 1770—were, similarly, a pair showing the stalking and attack scenes.

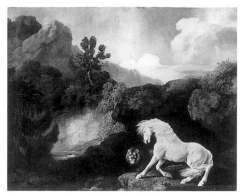

62 (FIG. 110)

62

Horse and Lion, 1770

Oil on canvas

40 × 50¼ in. (101.6 × 127.6 cm)

National Museums Liverpool (The Walker)

Literature: Gilbey 1898, 156–57; Wark 1955;
Taylor 1971, 209, pls. 62, 65; Egerton
1984a, 98, no. 66

STUBBS PAINTED this scene of a horse
stalked by a lion in a menacingly "sublime"
landscape as a pendant to the Yale University Art Gallery painting of the attack (cat.
61). Two further pairs of complementary
stalking and attack subjects, both in
enamel, are datable to about the same time
(see cats. 60, 61). Other related treatments
of the stalking subject include the following: a mezzotint by the artist's son George
Townly Stubbs, published in 1770 as *The
Horse & Lion,* which reproduces an untraced painting or possibly a detail from
the present work; and a mezzotint by
Benjamin Green, published in 1774, which
reproduces an apparently unique painting
of the frightened horse with a recumbent
lioness.[1]

In the present work and all the later
stalking scenes (except the one with the
lioness), the lion appears to the side of the
horse rather than in front as in the earlier
versions of the subject (for example, cat.

40). In addition, the horse—always white
rather than chestnut—starts back in a
different position, with the front leg closer
to the viewer extended forward and the
other bent back rather than vice versa.

According to Humphry, the model
Stubbs used for the white horse starting
back in fear in these works was one from
the Royal Mews, to which he gained access
thanks to the architect James Paine, a
prominent fellow member of the Society of
Artists: "The white Horse frightened at
the Lion was painted from one of the Kings
Horses in the Mews which Mr Payne the
architect procured for him. The expression of Terror was produced repeatedly,
from time to time by pushing a brush upon
the ground towards him, and this, aided by
his anatomical skill, enabled him to give
the sentiment of expression & apprehension to the animal which the picture
represents."[2]

Notes

1. Lennox-Boyd, Dixon, and Clayton 1989, 104–5,
 142–43, nos. 16, 37.
2. Humphry MS, 209.

63

Thomas Burke, after George Stubbs

Eclipse, published 1772

Mezzotint, third state

plate: 18⅛ × 22¼ in. (46 × 56.5 cm)

Yale Center for British Art, New Haven.
Paul Mellon Collection

Literature: Lennox-Boyd, Dixon, and Clayton
1989, 130–31, 341–42, nos. 32, 251–59;
Cormack et al. 1999, 29, no. 12

MANY CONSIDER Eclipse to have been the
greatest thoroughbred racehorse of all
time. He was a son of Marske and a greatgreat-grandson of the Darley Arabian.
Bred by the Duke of Cumberland at Wind-

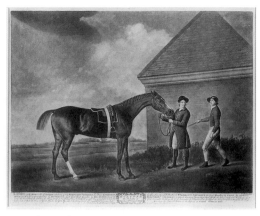

63 (FIG. 95)

sor, he was foaled during a solar eclipse
on April 1, 1764. After the duke's death in
the following year, he was sold to William
Wildman, who had made his fortune as a
Smithfield meat salesman. This remarkable self-made man also owned another
great horse of the age, Gimcrack (see cat.
45). Eclipse raced for Wildman for the first
time, as a five-year-old, at Epsom on May
3, 1769. It was a race of heats, and before
the second of them, the Irish gambler
Dennis O'Kelly made his now-famous bet
on the placings: "Eclipse first, the rest
nowhere" (that is, the rest too far behind
officially to be placed at all). O'Kelly not
only won the bet but bought the horse,
paying Wildman 650 guineas for a halfshare initially and buying him out for a
further 1,100 guineas in April 1770.

Eclipse raced for only two seasons,
1769 and 1770, running eighteen races and
winning them all with ease. Then O'Kelly
retired him to his Clay Hill Stud, near
Epsom, where he was also a spectacular
success as a stallion, siring 334 winners.
One of his many outstanding offspring was
Dungannon (cats. 76, 77). His influence on
the breed has been enormous and continues to this day: the direct tail-male line
of 95 percent of modern thoroughbreds
can be traced back to him, and more than

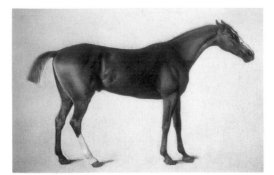

FIG. 1. George Stubbs, *Eclipse*, 1769–70. Oil on canvas, 25½ × 30¾ in. (64.7 × 78 cm). The Royal Veterinary College, London

a hundred of his descendants have won the Derby. When Eclipse died in 1789, Charles Vial de Sainbel dissected his body; his *Elements of the Veterinary Art* contains "An Essay on the Proportions of the Celebrated Eclipse" with an analysis of the motion of the horse's legs while galloping.[1]

The present mezzotint print reproduces a painting of 1770.[2] The painting shows the colors worn by the jockey as William Wildman's red and black—as in Stubbs's portrait of Gimcrack with John Pratt up (fig. 81). This suggests that it was Wildman—probably Stubbs's most important commoner patron—who commissioned the work, presumably before O'Kelly bought him out in April 1770. The jockey was identified in the catalogue to Stubbs's Turf Gallery (1794) as Samuel Merritt.[3] The brick building in the background is the same Newmarket rubbing-down house that appears in several other racehorse portraits (see cats. 45, 46, fig. 137).

Stubbs also painted a portrait of Eclipse on a smaller canvas against a plain background (fig. 1), probably as a study for the painting shown in the mezzotint: the figure of the horse is identical in pose and size, the chief differences being that in the painting shown in the mezzotint he

acquires a saddle, a bridle, and braids in his mane. Stubbs did not normally make studies in oil for horse portraits, and he may have done so in the case of this unusually famous subject because he expected to make repetitions. Eclipse appears in exactly the same pose and size again—with saddle, bridle, and braids—in another portrait of about the same date that shows him with William Wildman and his two sons in a park setting.[4]

When Dennis O'Kelly bought out Wildman and became the sole owner of Eclipse, he appears also to have bought the painting shown in the mezzotint; the inscription below describes both horse and painting as his property. The painting appeared at the exhibition of the Society of Artists in 1771, presumably lent by O'Kelly, with the title *A Portrait of the Famous Horse, Eclipse*. Robert Sayer published the mezzotint on October 1, 1772, although in impressions of the third state (as here), the year was changed to 1773. Perhaps for reasons of marketability, or perhaps because the artist wished to be known for other types of subject, relatively few such prints after Stubbs's horse portraits were published before the Turf Gallery project of the 1790s (see cats. 76–78).

To represent Eclipse in the Turf Gallery, Stubbs painted a replica of the painting shown in the mezzotint.[5] His son George Townly Stubbs made two prints from the replica for the *Review of the Turf* series, and they were published in about 1796.[6]

Notes

1. Vial de Sainbel 1797; see Podeschi 1981, 82–85, no. 74.
2. Sold at Christie's, London, November 20, 1987, lot 24.
3. See Gilbey 1898, 186.
4. William Woodward Collection of Sporting Art, Baltimore Museum of Art; see Walker 1972, 102, pl. 56.
5. Jockey Club, Newmarket; Egerton 1984a, 83, no. 54.
6. Lennox-Boyd, Dixon, and Clayton 1989, 264–65, nos. 124–25.

64

Phaeton, 1775
Enamel on copper
oval, 15 × 18 in. (38.5 × 46 cm)
Private collection, courtesy of Hall & Knight

Literature: Taylor 1971, 212, pl. 94; Tattersall 1974, 64–65, no. 16; Hall 2000, 126–29, no. 27

National Gallery only

THE ROMAN poet Ovid relates the myth of Phaeton (sometimes Phaethon) in book 2 of his *Metamorphoses*. Phaeton is told by his mortal mother that he is the son of the sun god Phoebus (also identified as Apollo or Helios). He begs the god for a sign that this is true, and Phoebus fondly but rashly promises to grant him any wish. Despite his father's warnings of the danger involved, especially in controlling the horses, Phaeton insists that he be allowed to drive the chariot of the sun for a day. His father's worst fears are realized when the horses bolt and the chariot hurtles out of control, passing too close to the earth and causing catastrophic destruction. The earth goddess appeals to Jupiter to put a stop to the boy's wild ride, which he does by hurling down a thunderbolt; it kills Phaeton instantly and smashes the chariot to pieces. As the horses break free, Phaeton's charred body falls through the air like a shooting star and lands in the great river Eridanus.

In his painting Stubbs shows the moment before the thunderbolt strikes. The horses spring forward furiously (here the "flying gallop" seems appropriate to the subject) as Phaeton tries ineffectually to restrain them. The chariot has wheel rims of gold and spokes of silver as Ovid describes, and solar fire spews from its hubs in plumes of flame and smoke.

For Stubbs the appeal of Phaeton's story was that it was a classical subject involving horses, and as such a means of showing that the animal painter could also be a "history painter." Like his other essays in elevated and dramatic types of subject, notably the horse-and-lion paintings, his *Phaeton* addresses the theme of natural violence: without proper control, even the noble horse falls prey to wild and savage impulses.

The present work appears to be Stubbs's third painting of the subject. Ozias Humphry gave an account of the first version in his memoir of the artist: "The Fall of Phaeton with the roan horses was painted for himself upon speculation but afterwards purchased by Sir J. Reynolds.— the Horses that furnished the subject were a set of coach horses belonging to Lord Grosvenor."[1] In this first version, the horses, the chariot—which has a distinctive footboard in the form of a shell—and the figure of Phaeton differ considerably from those in the present one. Stubbs exhibited the work at the Society of Artists in 1762 as *Phaeton*. Joshua Reynolds may have bought it as Humphry states—it would certainly have been fitting for the great champion of history painting in Britain to have taken an interest in such a work—although he may in fact have been acting on behalf of his friend John Parker of Saltram, Devon. The painting

was passed down in Parker's family and remains at Saltram.[2] A mezzotint after the work by Benjamin Green, with the composition reversed and the title given as *Phaëthon,* was published in about 1765–66.[3]

The mezzotint is inscribed with some of the relevant lines from Ovid in both Latin and English, the English adapted from Joseph Addison's translation of 1717:

> The Horses flying through the Plains above,
> Ran uncontroul'd where-e'er their Fury drove,
> And now above, and now below they flew,
> And near the Earth the burning Chariot drew.
> With dreadful Thund'rings thus th'almighty Sire
> Suppress'd the Raging of the Fires with Fire.[4]

Stubbs showed his second *Phaeton* at the Society of Artists in 1764, and it, too, was published as a mezzotint by Benjamin Green—in 1770.[5] In this version the design of the chariot's footboard changes from a shell to a stylized flame, and the horses and the figure of Phaeton appear much as they are in the present work. Humphry wrote of the second version after his account of the first: "And that with white horses which was afterwards purchased by Col Thornton, & which was superlatively beautiful, & much superior to the former, was painted from one of his own coach horses & this picture Mr Seriel the celebrated sculptor of the King of Sweden when he saw it (upon the visit he made to London on his return from Rome to his native country) declared that the focus and expressions, as well as the fiery & animated motion of the animals placed them on a footing with the finest sculptures

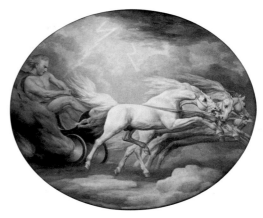

64 (FIG. 66)

of the ancients."[6] The buyer mentioned by Humphry has been identified by Judy Egerton as Colonel William Thornton.[7] "Mr Seriel" was the German neoclassical sculptor Johan Tobias Sergel, who was active mainly in Sweden. Humphry's statement that Stubbs painted the white horses from a coach horse of his own is supported by Walter Gilbey's description of his new house on Somerset Street as having "an excellent coach-house and a four-horse stable."[8] From about 1769 onward he was also to use white horses in most of his horse-and-lion compositions.

The present painting, dated 1775, has the distinction of being the largest work in enamel on copper that Stubbs produced. Humphry referred to the work briefly after his account of the other two versions: "The same subject has been repeated in enamel, upon a copper plate of the size of 18 inches by 15 with great success."[9] It is in large part a translation into a different technique of the second version, the oil painting exhibited in 1764; it differs in its oval format and the less ornate design of the chariot. In this latter feature Stubbs was perhaps responding to the practical analysis of chariot construction in Thomas Pownall's "Dissertation on the Ancient Chariot,"

published in Richard Berenger's book *The History and Art of Horsemanship* (1771). As Nicholas Hall has pointed out, Stubbs certainly seems to have referred to classical sources, especially the many representations of four-horse chariots, or *quadrigae*, in antique relief sculptures, cameos, gems, medals, and coins.[10]

In 1780 Stubbs modeled his *Phaeton* composition in relief for his friend and collaborator Josiah Wedgwood as the basis for a Wedgwood plaque (fig. 72). Earlier in the same year he had modeled a relief of his recurrent subject of a horse stalked by a lion; he derived the design from the print *A Horse Affrighted by a Lion*, etched by him from one of his own paintings and published in 1777.[11] For the *Phaeton* plaque, which was to be a companion piece, he used the Benjamin Green mezzotint after his second painting of the subject, published in 1770. The plaque corresponds closely to the print in width but truncates the composition at the top to eliminate sky, presumably because this is difficult to represent well in relief work. Stubbs was staying with Wedgwood at his estate in Etruria, Staffordshire, when he modeled the plaque, and he had an impression of the print sent to him from London. Wedgwood wrote to his partner Thomas Bentley on October 28, 1780: "He . . . wishes to employ some of his evenings in modeling a companion to his frighten'd horse, & has fixed upon one of his Phaetons for that purpose, but cannot proceed till he has the print of this subject which he says may be had at some of the print shops, but he does not know which . . . He desires Mr. Brock will find him this print & send it down by the first coach that he may have time to complete the model whilst he stays here."[12]

Wedgwood was unhappy about Stubbs's choice of subject. "I have objected to this subject as a companion to the frightened horse," he told Bentley, "as that is a piece of natural history, this is a piece of unnatural fiction, & indeed I should prefer something less hackney'd & shall still endeavour to convert him."[13] But Stubbs persevered. The result cannot have worked well as a companion to the plaque of the frightened horse, being considerably larger and rectangular instead of oval, but it was undoubtedly more successful as a translation of painting into relief. Both plaques were in production and advertised in Wedgwood's catalogue by 1783.

Stubbs seems never to have sold the present painting, and it appeared in his posthumous sale in 1807.[14]

Notes

1. Humphry MS, 209.
2. The Morley Collection, Saltram (National Trust); see the entry on the painting by Judy Egerton in Hall 2000, 120–23, no. 25.
3. Lennox-Boyd, Dixon, and Clayton 1989, 68–70, no. 3; Hall 2000, 124–25, no. 26.
4. Addison's translation was presumably the one Stubbs himself used. For the lines in their original form, see Addison 1914, 1:71, 76.
5. The painting is untraced. For the mezzotint, see Lennox-Boyd, Dixon, and Clayton 1989, 84–85, no. 8, and Hall 2000, 130–32, no. 28.
6. Humphry MS, 209.
7. Hall 2000, 123, n. 8.
8. Gilbey 1898, 51.
9. Humphry MS, 209.
10. Hall 2000, 126–28. An anthology of such images was available in Montfaucon 1721–22, 3:pl. 51.
11. Tattersall 1974, 78–79, no. 23; Cormack et al. 1999, 81, no. 62. For the print, see Lennox-Boyd, Dixon, and Clayton 1989, 170–71, no. 59.
12. Tattersall 1974, 115.
13. Tattersall 1974, 115.
14. See Gilbey 1898, 205.

65 (CHRONOLOGY FIG. 4)

65
Sketch for the Self-Portrait in Enamel, 1781

Graphite, squared for transfer
12 × 9 in. (30.5 × 22.9 cm)
Yale Center for British Art, New Haven.
Paul Mellon Collection

Literature: Tattersall 1974, 90–91, no. 29; Egerton 1984a, 28, no. 3

Kimbell only

THIS WAS the preparatory drawing for Stubbs's self-portrait in enamel on Wedgwood earthenware (cat. 66). Like most self-portraitists, he presumably worked from his reflection in a mirror; though right-handed he must have posed with a paintbrush in his left hand, which appears as his right because of the reversal of the image. After completing the drawing, he drew a grid of squares across the sheet and used it to transfer the design exactly to the larger surface of the ceramic, on which he must have drawn a grid of the same number of squares that is no longer visible.

66

Self-Portrait, 1781

Enamel on Wedgwood earthenware
oval, 27 × 20 in. (68.6 × 50.8 cm)
National Portrait Gallery, London

Literature: Humphry MS, 205; Taylor 1965b;
Taylor 1971, 211, pl. 86; Tattersall 1974,
94–95; Egerton 1984a, 28–29, no. 4

OZIAS HUMPHRY mentioned this painting in a discussion of Stubbs's work in enamel: "our author also painted a portrait of himself in Enamel (painting) by a commission from Mr Thorold—this portrait was half the Size of Life."[1] Judy Egerton has identified the man who commissioned the work as Richard Thorold, a London lawyer and, in the words of his obituary, "a very ingenious mechanic."[2] We know little about his connection to Stubbs, but his commissioning a self-portrait rather than a more typical subject suggests a friendship between the two men. Thorold came from near Horkstow, where Stubbs made the equine dissections that were the basis for *The Anatomy of the Horse,* and they may have known each other since that time.

With his interest in technology, perhaps Thorold was especially keen to own one of the artist's ventures into enamel painting on Wedgwood earthenware. From 1777 Stubbs and the master potter Josiah Wedgwood collaborated on ever larger works in this technique. Ambitiously, they hoped to forge a new art form, comparable in scale and purpose to oil painting—enamel was traditionally associated with small-scale decorative work—but without the same vulnerability to damage. In a letter of October 1778 to his partner Thomas Bentley, Wedgwood wrote: "When you see Mr Stubbs pray tell him how hard I have been labouring to furnish him with the means of adding immortality to his excel-

66 (FIG. 116)

lent pencil. I mean only to arrogate to myself the honor of being his *canvas maker.*"[3] Stubbs and Wedgwood had their first success in firing a painting in that year and went on creating works in the technique until Wedgwood's death in 1795 (for further examples, see figs. 63, 111, 114, 117, 119, 128). Most were fired at Wedgwood's London premises on Greek Street. The technique was fraught with difficulties, took some time for even Wedgwood and Stubbs to master, and, despite their hopes, never caught on with other artists.[4]

In 1775, after fourteen years with the Society of Artists, Stubbs had begun to show his works at the annual exhibitions of the Royal Academy. In 1781 he was elected an academician, and in the following year he clearly felt that he should make a strong showing at the exhibition. He sent seven works, five of them enamels, including a self-portrait under the title of *Portrait of an Artist; Enamel.* The submission of a self-portrait, a statement of his identity as an artist, must have seemed especially appropriate to the moment. It was in all likelihood the present work, although it may possibly have been another

enamel self-portrait in which he appears on a white hunter (Chronology fig. 5). Much to the artist's dismay, his paintings were poorly placed in the exhibition and some quotations that he wished to include in the catalogue were never printed. "He felt this treatment with particular sensibility," Ozias Humphry recounted, "as it tended more than any other circumstance could have done, to discredit his enamel pictures and to defeat the purpose of so much labour and study, not to mention his loss of time and great expence."[5] The incident led to a major falling-out with the Royal Academy. Stubbs refused to donate the required "diploma work," and his election as an academician was eventually annulled.

In the present work he shows himself wearing a loose-fitting robe. This may have been his usual painting attire, but it also conferred on him a classical or "timeless" appearance that would have been impossible if he had worn modern dress. When Joshua Reynolds, president of the Royal Academy, painted his self-portrait as a gift to the institution in 1780, he showed himself wearing doctoral robes and cap.[6] Stubbs would certainly have been aware of the Reynolds, although in comparison to the worldly leader of the British art establishment he appears almost ascetic: his robe might be a monk's habit.

Notes

1. Humphry MS, 205.
2. Egerton 1984a, 28–29.
3. Tattersall 1974, 111.
4. For further information on Stubbs's work with Wedgwood, see Tattersall 1974; Cossa 1982; Emmerson 1999; and the essay by Lance Mayer and Gay Myers in the present catalogue.
5. Humphry MS, 207.
6. Royal Academy of Arts, London; Mannings 2000, 1:51, no. 21.

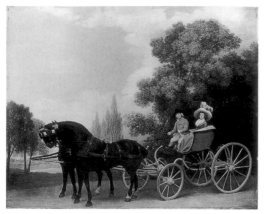

67 (FIG. 121)

67

Gentleman Driving a Lady in a Phaeton, 1787

Oil, wax, and resin on oak panel
32½ × 40 in. (82.5 × 101.6 cm)
The National Gallery, London

Literature: Taylor 1971, 213, pls. 106–7; White et al. 1980; Egerton 1984a, 175, no. 132; Mills and White 1985; Egerton 1998a, 256–59

A PHAETON—named after the reckless youth whom Stubbs painted in some of his main ventures into history painting (cat. 64)—was an expensive type of carriage built for driving at speed. Stubbs painted others in *Phaeton with a Pair of Cream Ponies and a Stable-Lad* (fig. 124) and *The Prince of Wales's Phaeton, with the Coachman Samuel Thomas and a Tiger-Boy* (cat. 74). Here the proud owners of the vehicle are unidentified, but they may be members of the Hope family of bankers in Stubbs's native Liverpool; the portrait passed down in that family and was bequeathed to the National Gallery by Miss S. H. Hope in 1920.

Painted on an oak panel using a medium containing wax and resin as well as oil, the portrait is an example of the technical experimentation that characterizes Stubbs's later work. From about 1769 he made paintings in enamel on copper; from the early 1770s he tried media that were various mixtures of drying oils, non-drying oils, fat, beeswax, and pine resin on panel supports; and from 1777 he developed techniques of enamel painting on ceramic in collaboration with Josiah Wedgwood. His enamels have proved as durable as he hoped, and most are well preserved, but his wax paintings have been much damaged by restorers ignorant of his methods.[1]

Note

1. On Stubbs's painting media, see White et al. 1980; Mills and White 1985; and the essay by Lance Mayer and Gay Myers in the present catalogue.

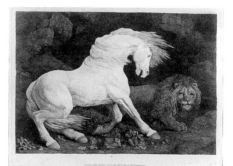

68 (FIG. 112)

68

A Horse Affrighted at a Lion, published 1788

Etching with roulette work, third state
plate: 9¹⁵⁄₁₆ × 13 in. (25.2 × 33 cm)
Yale Center for British Art, New Haven.
Paul Mellon Collection

Literature: Egerton 1984a, 228, no. 174; Lennox-Boyd, Dixon, and Clayton 1989, 186–87, no. 70; Cormack et al. 1999, 48, no. 26

THIS AND the following work (cat. 69) constitute Stubbs's final reprise of the horse-and-lion theme (see also cats. 40, 41, 60, 61, 62), with stalking and attack scenes matched as in earlier pairs of paintings. Both etchings are inscribed "Painted, Engrav'd & Publish'd by Geo. Stubbs," which implies the existence of corresponding paintings. The positions of the animals in the present work are close to those in the painting of the same subject with an extensive landscape setting in the collection of the Walker Art Gallery, Liverpool (cat. 62). Among the several earlier variations on the attack scene, the companion etching most resembles the large Rockingham painting that was probably the first of all the horse-and-lion compositions (fig. 104), the horse's mane and the lion's tail being the telling points of comparison.

As Lennox-Boyd, Dixon, and Clayton point out, however, the more immediate sources seem to have been a pair of untraced enamel paintings on copper that are known through reproductions illustrating articles on Stubbs in the *Sporting Magazine*.[1] The correspondences between the etchings and the enamels (as shown in the reproductions) extend beyond the animals to details of the rocks and trees in the landscape settings. The enamels probably dated from about 1770.

Note

1. See T. N. 1808a, opp. 55; T. N. 1808b, opp. 154; and Lennox-Boyd, Dixon, and Clayton 1989, 186–89, 338, nos. 70–71, 229–30.

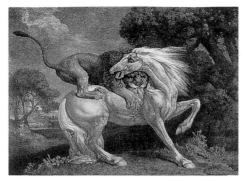

69 (FIG. 113)

69

A Lion Devouring a Horse,
published 1788
Soft-ground etching with roulette work,
 third state
plate: 11 × 13⅞ in. (27.9 × 35.2 cm)
Tobin Foundation for Theatre Arts, courtesy
 of the McNay Art Museum, San Antonio

Literature: Egerton 1984a, 229, no. 175;
 Lennox-Boyd, Dixon, and Clayton 1989,
 188–89, no. 71

FOR A discussion of this print and its
source, see its companion piece (cat. 68).

70

George Townly Stubbs, after George Stubbs
Horses Fighting, published 1788
Mezzotint, second state
plate: 18⅞ × 23⅜ in. (48.3 × 59.5 cm)
Yale Center for British Art, New Haven.
 Paul Mellon Collection

Literature: Lennox-Boyd, Dixon, and Clayton
 1989, 200–201, no. 81; Cormack et al.
 1999, 62, no. 39

STUBBS PAINTED his first version of this
scene in enamel on a Wedgwood plaque
(fig. 114). "This picture in Enamel was
painted immediately from Nature,"
Humphry noted, "without any previous

study as has usually been done for pictures
in this line of the art."[1] According to the
same source, the models were two coach
horses belonging to Stubbs's patron Lord
Grosvenor (see cats. 48, 49). The enamel
was probably the work shown at the Royal
Academy exhibition of 1781 as *Two Horses;
in Enamel.*

In 1787 the artist exhibited a second
version at the Royal Academy as *Fighting
Horses.* This was probably in oil on panel;
it is untraced and known only through the
present reproductive mezzotint. Whereas
the stallions in the first version were both
dark, one of those in the second was a
gray; the backgrounds were also different,
the second version omitting the mare and
foal that in the first version underlined
the origins of the fight in mating rivalry.
At the 1787 exhibition the second version
was shown as the companion to another
painting of animal combat, *Fighting Bulls,*
and the present work and a mezzotint after
the bulls subject, both by George Townly
Stubbs, were published together by Benja-
min Beale Evans on May 1, 1788.[2]

George Townly Stubbs was the artist's
son. He probably worked for his father as
a studio assistant, and made reproductive
mezzotints after his paintings from 1770
onward. The present work and the print
of the bulls subject are the outstanding
examples. He also engraved works by
other artists, and apparently some of his
own satirical designs. In the 1790s he
engraved nineteen plates for *A Review of
the Turf* (see cats. 76–78).[3]

Notes

1. Humphry MS, 204–5.
2. The painting of the bulls is at the Yale Center
 for British Art, Paul Mellon Collection; Egerton
 1984a, 171, no. 128. For the mezzotint, see
 Lennox-Boyd, Dixon, and Clayton 1989, 202–3,
 no. 82.
3. For an account of G. T. Stubbs's life and a list
 of works, see Lennox-Boyd, Dixon, and Clay-
 ton 1989, 373–78.

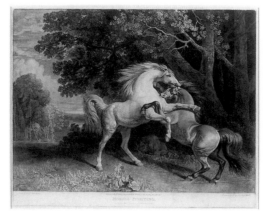

70 (FIG. 12)

71 (FIG. 94)

71

Labourers, published 1789

Etching, stipple, roulette, and rocker work,
 second state

plate: 20⁹/₁₆ × 27³/₈ in. (52.3 × 69.5 cm)

Yale Center for British Art, New Haven.
 Paul Mellon Collection

Literature: Taylor 1971, 213, pls. 108–9; Egerton
 1984a, 237, no. 186; Lennox-Boyd, Dixon,
 and Clayton 1989, 210–11, no. 86;
 Cormack et al. 1999, 58, no. 35

By the time of the present print Stubbs
had painted at least four versions of this
subject, and it is difficult to connect the
print with any of them in particular. The
composition began life as a painting of
some elderly bricklayers in the employ of
the fourth Viscount Torrington at Southill,
Bedfordshire, engaged in a dispute over
the attachment of a tailgate to a cart (cat
54). Here, by omitting a lodge at Southill
that appeared in the original version of the
subject and using the broad title of *Labour-
ers,* Stubbs removed some of the specific
significance of the scene to create an
image of more general appeal. (For a fuller
discussion of the origins of the composi-
tion and the various versions, see cat. 54.)
Despite the inscribed publication date of
January 1, 1789, Stubbs advertised that

the print was available for purchase in
September 1788—as a companion to *The
Farmer's Wife and the Raven,* another gently
comic rustic scene that he had published
earlier that year.[1]

Stubbs was a skilled and highly inno-
vative printmaker. In the large intaglios
of his later career (cats. 71–73), he used
the techniques of etching and stipple in
conjunction with roulettes, punches,
and rockers to achieve a rich variety of
textures.

Note

1. Lennox-Boyd, Dixon, and Clayton 1989,
 184–85, no. 69, and 218, fig. 53. The subject of
 The Farmer's Wife and the Raven was one of the
 animal fables of John Gay.

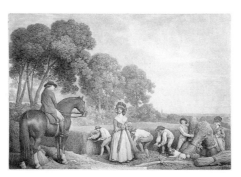

72 (FIG. 92)

72

Reapers, published 1791

Stipple and roulette work, first state

plate: 19 × 26⁷/₈ in. (48.3 × 68.3 cm)

Tobin Foundation for Theatre Arts, courtesy
 of the McNay Art Museum, San Antonio

Literature: Egerton 1984a, 238, no. 187;
 Lennox-Boyd, Dixon, and Clayton 1989,
 219–20, no. 90

Although the *Labourers* that Stubbs
showed at the Royal Academy exhibition of
1779 was an adaptation of a commissioned
portrait of workers on the estate of Lord

Torrington (cat. 54), the more general title
he gave the exhibited painting announced
a fresh line of subject matter in his work,
the rural genre scene. His next composi-
tions of this type, roughly the same size
and in the same technique of oil on panel,
were scenes of reaping and haymaking,
both dated 1783.[1] In 1785 he painted second
versions of these, exhibiting them at the
Royal Academy in the following year as
Reapers and *Haymakers;* the second ver-
sions departed considerably from the
first, with more figures in each case (figs.
118, 91).[2] Catalogue numbers 72 and 73
reproduce the second versions.

Stubbs advertised for subscribers for
the prints as early as September 1788 but
did not publish them until January 1, 1791.
They were obviously intended, like the
paintings, as a pair—and would have
combined naturally as a thematic group
with the earlier prints *Labourers* and *The
Farmer's Wife and the Raven* (see cat. 71),
showing various country characters,
seasonal activities, and—not least—types
of the working horse.

In 1795 Stubbs painted further versions
of the reaping and haymaking scenes in
enamel on Wedgwood earthenware. The
reaping scene is at the Yale Center for
British Art (fig. 117), and the haymaking
scene at the Lady Lever Art Gallery, Port
Sunlight (National Museums Liverpool).[3]

Notes

1. All three works are in the Bearsted Collection,
 Upton House (National Trust), Warwickshire;
 for reproductions of *Reapers* and *Haymakers,*
 see Parker 1971, 131, 126. The "original design"
 for each of the reaping and haymaking scenes
 was in the artist's sale in 1807; see Gilbey 1898,
 197.
2. Tate, London; Egerton 1984a, 166–68, nos.
 124–25.

3. See Egerton 1984a, 169, no. 126, and Kidson 1999, 159–63. An enamel of a different haymaking scene, though including the same female worker with her hand on her hip, is also at Port Sunlight; it is dated 1794.

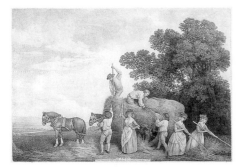

73 (FIG. 93)

73

Hay-Makers, published 1791

Stipple with roulette work, first state, stamped "proof"

plate: 19 × 26⅞ in. (48.3 × 68.3 cm)

Tobin Foundation for Theatre Arts, courtesy of the McNay Art Museum, San Antonio

Literature: Egerton 1984a, 239, no. 188; Lennox-Boyd, Dixon, and Clayton 1989, 216–18, no. 89

THIS PRINT is discussed above in conjunction with its companion, *Reapers* (cat. 72).

74

The Prince of Wales's Phaeton, with the Coachman Samuel Thomas and a Tiger-Boy, 1793

Oil on canvas

40¼ × 50½ in. (102.2 × 128.3 cm)

Commissioned by George, Prince of Wales

The Royal Collection

Literature: Gilbey 1898, 120–22; Millar 1969, 124, no. 1117; Taylor 1971, 214, pl. 120; Egerton 1984a, 178, no. 135

WHILE IN his late sixties, Stubbs enjoyed a spate of patronage from the Prince of Wales (the future George IV), whom he probably met through his friend and fellow painter Richard Cosway. The prince proved even more lavish in his patronage than the artist's earlier aristocratic supporters the Duke of Richmond, Viscount Bolingbroke, the Marquess of Rockingham, and Lord Grosvenor. Between 1790 and 1793 he commissioned no fewer than fourteen paintings, all in oil on canvas and all about the same size. Together they form a considered series celebrating the prince's delight in various pleasures of the outdoors: riding, driving, racing, the park, dogs, and the military. They comprise equestrian portraits of the prince (fig. 125), his friend Lady Lade (cat. 75), and possibly the famous horseman Sir Sidney Medows; two portraits of favorite horses with their grooms (including fig. 130); the present work, which shows the prince's phaeton and coachman; four portraits of racehorses; a painting of deer in a paddock; two portraits of dogs; and a group of soldiers of the Tenth Light Dragoons, the regiment of which the prince was colonel in command (fig. 132). All these remain in the Royal Collection and are in uniform frames.[1] The frame maker Thomas Allwood billed the prince for £110.16s on February 14, 1793, "To Carving and Gilding eight Picture frames of half length size for sundry Pictures painted by Mr Stubbs. All of one pattern."[2] Presumably only eight of the fourteen paintings were finished by that date. Later Stubbs seems also to have painted a large portrait of a sorrel hunter, a chestnut hunter, and a black-and-white dog for the prince; this was at Carlton House in 1816 but has apparently been lost.[3] For a fuller discussion of Stubbs's relations with the prince, see Robin Blake's essay "Stubbs, the Macaroni, and the Prince of Wales" in the present catalogue.

The prince was a driving enthusiast and ordered several new carriages in the early 1790s, taking advice from his sporting friend Sir John Lade (see cat. 75). A phaeton was a carriage built for speed—Stubbs had painted others in the 1780s (cat. 67 and fig. 124)—and the prince's was an especially fast "high-flyer." In the present painting his servants are getting the vehicle and a beautifully matched pair of horses ready for a drive. The choice of this moment of preparation underlines the importance, for drivers at this glamorous level, of maintaining a fine appearance: much of the pleasure and status attached to the sport lay in an impeccable turnout. With characteristic subtlety, Stubbs used the pursuit of order and neatness as an opportunity for gentle humor in the painting: it is as though the coachman and horses were picture-perfect a moment ago but have been a little disturbed by the leaping and barking of the prince's dog Fino—creating an ostensibly accidental and more engaging composition. He used the idea of military precision and unifor-

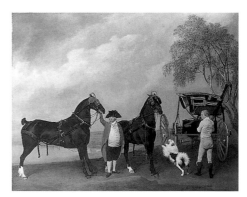

74 (FIG. 131)

mity in a similarly playful way in his painting of soldiers of the Tenth Light Dragoons.

As a portrait of servants, the work takes up a theme Stubbs began in the 1760s in the group of paintings commissioned by Lord Torrington (cats. 54–56). The portly figure near the center of the composition is that of Samuel Thomas (d. 1800 or 1801), who had been appointed post-chaise man in ordinary to the prince's father, George III, in 1767, and body coachman to the prince in 1771. The identity of the tiger-boy (a young liveried servant) is unknown.

Notes

1. For details of the Stubbses in the Royal Collection, see Millar 1969, 122–26, nos. 1109–26, pls. 139–53.
2. Millar 1969, 122.
3. The painting measured five by eight feet; see Millar 1969, 122.

75
Lady Lade, 1793

Oil on canvas
40¼ × 50⅜ in. (102.2 × 127.9 cm)
Commissioned by George, Prince of Wales
The Royal Collection

Literature: Gilbey 1898, 125; Millar 1969, 123, no. 1112; Egerton 1984a, 176–77, no. 134

THIS WAS one of the fourteen paintings commissioned from Stubbs by the Prince of Wales between 1790 and 1793 (see cat. 74). The sitter's husband, Sir John Lade, second Baronet, a member of the Jockey Club and the Four-in-Hand Club, was a racing and driving friend of the prince's. Born Letitia Darby, Lady Lade was an adventuress who had become Sir John's established mistress by 1785 (alias "Mrs. Smith") and his wife in 1787. The prince seems to have enjoyed the Lades' company a great deal and continued his friendship

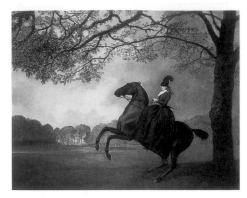

75 (FIG. 129)

with them despite public criticism, fueled in part by Lady Lade's notorious foul language, that they were too far below his station. In spite of the pension he gave them, they were often in financial trouble, and Sir John later spent time in a debtors' prison. They had no children. Lady Lade died in 1825 and Sir John in 1838, at which the baronetcy became extinct.

Lady Lade was taught to ride and drive expertly by her husband, and she shows her horsemanship to advantage in the portrait by controlling what is clearly a difficult horse, its laid-back ears indicating anger, intended mischief, or both. Like the prince in the similar portrait that he commissioned of himself (fig. 125), she seems to be riding in a London park, perhaps St. James's or Kensington Gardens.

76
Dungannon, 1793

Oil on canvas
39⅛ × 49⅝ in. (99 × 126 cm)
The Earl of Halifax

Literature: Gilbey 1898, 134, 186, 199; Taylor 1971, 214, pl. 123; Egerton 1984a, 135, no. 96; Lennox-Boyd, Dixon, and Clayton 1989, 244–45, 341, nos. 106–7, 249–50

"IN 1790," wrote Ozias Humphry, "a gentleman unknown to Mr Stubbs called on him, who must be distinguished by the name of Turf and proposed a scheme to him—of painting in a series of pictures (portraits) from the Godolphin Arabian to the most distinguished Race Horse of the present time, a general chronological History of the Turf, specifying the races & matches with particular anecdotes and properties of each horse, with a view to their being first exhibited & then engraven, & published in numbers . . . it was intimated that for the series of pictures which were to be painted, a sum amounting to 9000 pounds was deposited in the hands of a Banker, and that as the pictures were completed from time to time, Mr Stubbs had the privilege of drawing for their respective amount."[1] Both Tim Clayton and Robin Blake have argued that the anonymous gentleman who proposed and funded the project was in fact the Prince of Wales, and that it was his withdrawal, owing to financial difficulties, that brought about its collapse long before completion.[2]

Stubbs opened his Turf Gallery in Conduit Street, near Hanover Square, on January 20, 1794, and showed sixteen paintings, all about forty by fifty inches, in the inaugural exhibition. The catalogue was dedicated "By Permission" to the Prince of Wales.[3] Prints after the Turf Gallery paintings were to be published in numbers consisting of three large prints (about sixteen by twenty inches), smaller versions of the same (about eight by ten inches), and letterpress giving the histories of the horses; the large prints were intended to be framed, and the smaller prints and letterpress to be bound in book form under the title *A Review of the Turf.* The prints were all to be made by Stubbs's son George Townly Stubbs. A print in the smaller size

of the Godolphin Arabian, most recent of the foundation sires of the thoroughbred (fig. 96), was to be presented free of charge to subscribers with the first number as a frontispiece. The subscription proposal was inconsistent as to figures, but the complete series was apparently to have included some 150 horses.[4] By the time the first number appeared, the plan had changed to include more histories in the letterpress and fewer portraits, perhaps about fifty in all. Still, the completion of the series must have been a tedious prospect for the artist, especially given that most of the paintings would be replicas and versions of existing compositions, not to mention the fact that he would soon be seventy years old. One suspects that the eventual demise of the project may have been as much a relief to him as a disappointment.

Prints of the Godolphin Arabian and three other subjects were published together on February 20, 1794, and three further subjects on May 20—and in June, Stubbs added several new paintings to the gallery.[5] A third trio of subjects was published in December that year, but after this the project clearly began to founder. After a long hiatus a single subject was published on July 30, 1796, and a further two on September 1; the last subject, Eclipse (see cat. 63), may have appeared that year or later. In all, fourteen paintings were engraved and published, that of the Godolphin Arabian in the smaller size only and thirteen in both sizes; all fourteen were paintings that were on show when the Turf Gallery first opened. Apparently only two numbers of letterpress were ever printed, and the dates of issue are unknown.[6] There is no record of any paintings being added to the gallery after June 1794, although Stubbs and his son appear not to have given up the lease on the premises on Conduit Street until March 1798.[7]

On show in the Turf Gallery from January 1794, the present painting was listed in the catalogue as follows:

NO. IV.

DUNGANNON,

ESTEEMED amongst the most famous, if not the very best son of Eclipse, was both bred and trained by the late COL. O'KELLY, and is now a stallion; among the few of his get that have yet appeared, is MR. WILSON'S LURCHER. The great attachment of this horse to a Sheep, which by some accident got into his paddock, is very singular.

Dungannon was foaled in 1780, bred by the colorful Irish gambler and owner-breeder Dennis O'Kelly. One of a number of highly successful sons of the magnificent Eclipse (see cat. 63), he came in second to Saltram in the 1783 Derby and won the King's Plate and the Whip in the October 1786 meeting at Newmarket. It was mainly through Dungannon's prowess as a sire at O'Kelly's stud, getting foals of "uncommon Strength, Symmetry and Size," that the virtues of Eclipse's line were confirmed.[8]

Stubbs seems to have based the portrait on an untraced earlier painting published as a print in 1791, although he changed the setting from a broad landscape to a paddock and added the sheep that was Dungannon's living companion.[9] Posed like the horse and also seen in profile, this unathletic animal makes for a gently humorous study in comparative anatomy; its side is marked with Dennis O'Kelly's initials. Stubbs included the cat to which the Godolphin Arabian was similarly attached in his Turf Gallery painting of him (see fig. 96), derived from a print after David Morier.

George Townly Stubbs's prints after Dungannon were published on May 20, 1794 (see cat. 77).

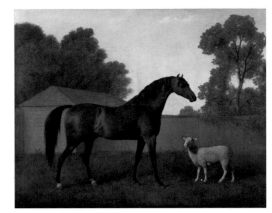

76 (FIG. 134)

Notes

1. Humphry MS, 207.
2. See Lennox-Boyd, Dixon, and Clayton 1989, 51–53, and the present catalogue, 154–56.
3. For a reprint, see Gilbey 1898, 184–89.
4. For the proposal, published in the *Sporting Magazine* in January 1794, see Taylor 1971, 59–61.
5. See Lennox-Boyd, Dixon, and Clayton 1989, 53. The additions included the version of *Gimcrack on Newmarket Heath, with a Trainer, a Stable-Lad, and a Jockey* that is now at the Jockey Club in Newmarket (see cat. 45).
6. The only known copies with prints are at the Keeneland Library, Lexington, Kentucky. They comprise histories of horses from Aaron to Alexia and from Alfred to Astraea. Each contains only a single print, respectively that of the Godolphin Arabian and that of Anvil.
7. For fuller histories of the project, see Tim Clayton's in Lennox-Boyd, Dixon, and Clayton 1989, 49–55, and Robin Blake's in the present catalogue, 149–56; for entries on all the prints, see Lennox-Boyd, Dixon, and Clayton 1989, 235–65, nos. 99–125.
8. See Lennox-Boyd, Dixon, and Clayton 1989, 341, no. 250.
9. For the print of 1791, see Lennox-Boyd, Dixon, and Clayton 1989, 166–68, no. 55.

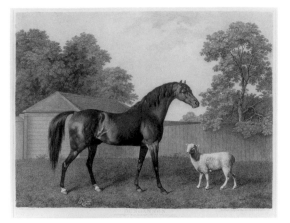

77 (FIG. 135)

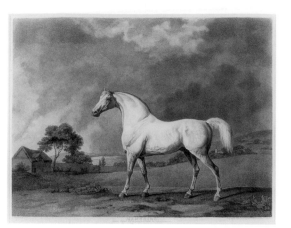

78 (FIG. 136)

77

George Townly Stubbs, after George Stubbs
Dungannon, published 1794
Stipple with etching, first state
plate: 15⅞ × 19⅞ in. (40.4 × 50.5 cm)
Yale Center for British Art, New Haven.
 Paul Mellon Collection

Literature: Lennox-Boyd, Dixon, and Clayton
 1989, 244, no. 106; Cormack et al. 1999, 90,
 no. 71

THIS PRINT after one of Stubbs's Turf
Gallery paintings (cat. 76) was published
on May 20, 1794, as part of the second set
of prints in the series *A Review of the Turf;*
the other horses featured in the set were
Mambrino (see cat. 78) and Sharke. For
more details of the Turf Gallery and *A
Review of the Turf,* see cat. 76.

78

George Townly Stubbs, after George Stubbs
Mambrino, published 1794
Stipple with etching, second state
plate: 16¼ × 20⅙ in. (41.2 × 51 cm)
Yale Center for British Art, New Haven.
 Paul Mellon Collection

Literature: Lennox-Boyd, Dixon, and Clayton
 1989, 246, no. 108; Cormack et al. 1999,
 93, no. 74

FOALED IN 1768, Mambrino was a son of
Engineer and through him a descendant
of the Darley Arabian. He raced well for
his owner, Lord Grosvenor, and won the
Jockey Club Plate and the King's Plate at
Newmarket in 1775. But his fame rested
chiefly on his success as a stallion at
Grosvenor's Oxcroft stud, near Newmar-
ket, where he covered mares from 1777
onward. One of his sons was Messenger,
who came to the United States and was a
foundation sire of the Standardbred.

The present work reproduces the
portrait of Mambrino that Stubbs painted
for his Turf Gallery.[1] The print was pub-
lished on May 20, 1794, along with that of
Dungannon (cat. 77), as part of the second
set of prints in the series *A Review of the
Turf.* For more details of the Turf Gallery
and *A Review of the Turf,* see cat. 76.

Stubbs based his Turf Gallery paint-
ing of Mambrino on a portrait that he had
painted for Lord Grosvenor in 1779, pub-
lished as a mezzotint in 1788.[2] The replica
is larger than the original, conforming to
the standard Turf Gallery canvas size of
forty by fifty inches. Stubbs inscribed the
work not with its actual date of execution,
which must have been between 1790 and
1793, but with the date of the original. He
showed it in the inaugural exhibition of

the gallery in January 1794 with the follow-
ing note in the catalogue:

<div align="center">

NO. VII.
MAMBRINO,

</div>

WAS chosen by Mr. STUBBS, not only as a
capital horse, worthy to be inserted in such
a work, but from his being so beautiful and
animated a subject for the painter.

The painting was identified as one of a
group showing horses belonging to
Grosvenor, the settings of which were
"different views of his Lordship's Farm
at Oxcroft."

Notes

1. Collection of the Earl of Halifax; see Egerton
 1984a, 134, no. 95. In its present state the paint-
 ing is trimmed at the top and on the left, and
 shows ranges of trees and large hills in the
 background that are not in the print and there-
 fore presumably the work of a later hand. The
 changes had been made by 1898 (see Gilbey
 1898, 137).
2. For the painting of 1779, see Taylor 1971, 211,
 pl. 85. For the mezzotint, see Lennox-Boyd,
 Dixon, and Clayton 1989, 206–7, no. 84.

Chronology

1724

AUGUST 25: Birth of George Stubbs, first of four children of John Stubbs and his wife, Mary, of Dale Street, Liverpool. John Stubbs was a member of an established family of curriers (dressers of tanned leather) in Liverpool. GS baptized in Church of St. Nicholas, Liverpool.

1734

Family living in Ormond Street, Liverpool.

1741

AUGUST 16: Death of father. Apprenticed for a short time to the minor artist Hamlet Winstanley, who was working as a copyist for the eleventh Earl of Derby at Knowsley Hall. (?) Birth of future companion Mary Spencer (d. 1817).[1]

1742–44

Works in family currier's shop, meanwhile teaching himself to paint.

1744–45

Paints portraits in Wigan for Captain Blackbourn, then in Leeds for the Wilson family.

1746–52

Living in York, studies and teaches anatomy with the surgeon Charles Atkinson at York Hospital. Associates with Jacobite and Roman Catholic circles centered on the hospital. Teaches drawing and perspective at a school near Wakefield.

1748

FEBRUARY 26: Baptism of son George Townly at Church of St. Helen's, Stonegate, York.[2] George Townly Stubbs was to become an engraver; as a young man he probably assisted in his father's studio (he died c. 1815).[3] The woman—presumably wife—with whom GS had four children between 1748 and 1755 remains a shadowy figure and anonymous, although her maiden name may have been Townly.

1750

JULY 19: Baptism of son Charles Edward at St. Helen's, Stonegate, York.

1751

Publication of John Burton's *Essay Towards a Complete New System of Midwifry*, with etched anatomical illustrations by GS.

1752

Living in Hull. FEBRUARY 8: Baptism of daughter, Mary-Ann, at Holy Trinity Church, Hull. GS paints portraits for the Nelthorpe family of nearby Barton-on-Humber.

1754

APRIL: GS in Rome. Reportedly visits Morocco on homeward journey. Returns to England by September.

1755

Living in Plumb Street, Liverpool, with his mother. MAY 23: Baptism of son John in Church of St. Nicholas, Liverpool.

1756

Death of mother.

1756–58

GS living at Horkstow, near Hull, under patronage of the Nelthorpes; dissects and draws horses for about eighteen months, assisted by Mary Spencer.

1759

SEPTEMBER 18: Burial of daughter, Mary-Ann, at Church of St. Peter's, Liverpool.

1759–60

GS in London with anatomical drawings, attracting the attention of the second Marquess of Rockingham and members of his circle. Carries out commissions for the third Duke of Richmond at Goodwood House, Sussex (cat. 33 and fig. 53), and for Sir Richard Grosvenor at Eaton Hall, Cheshire (fig. 47).

1761

MAY 9: Second annual exhibition of the Society of Artists opens. GS shows one painting, a portrait of the stallion Romulus. He will take part in the society's exhibition every spring for fourteen years.

1762

Four works in the Society of Artists exhibition, including the first version of *Phaeton* (cat. 64), racehorse portraits commissioned by the second Viscount Bolingbroke, and *A Brood of Mares* (probably cat. 35). GS paints large works for Lord Rockingham, including the largest and probably the first of the horse-and-lion compositions (see fig. 104) and *Whistlejacket* (cat. 39).

1763

Four works in the Society of Artists exhibition, including a painting of a zebra (Yale Center for British Art) and, for the first time, a horse-and-lion composition. GS and Mary Spencer move into a newly built house at 24 Somerset Street, near Portman Square (the western end of Selfridges department store now occupies the site).

CHRONOLOGY FIG. 1. George Stubbs, *Self-Portrait,* c. 1765. Oil on copper, 5½ × 4¼ in. (13.9 × 10.8 cm). Private collection, on loan to the Fitzwilliam Museum, Cambridge. Reproduced actual size

1764
Six works in the Society of Artists exhibition, including the second version of *Phaeton, A Lion Seizing a Horse* (probably cat. 41), and paintings commissioned by the third Duke of Grafton.

1765
Three works in the Society of Artists exhibition, including *Portrait of a Hunting Tyger* (probably the painting of a cheetah with Indian attendants, Manchester City Art Gallery) and the portrait of the second Earl of Clanbrassill (cat. 44).

1765–66
Further paintings commissioned by Lord Bolingbroke (cats. 45–46).

1766
MARCH: Publication of *The Anatomy of the Horse* (cats. 30–32). Four works in the Society of Artists exhibition, including *Brood Mares* (possibly cat. 48) and *An Arabian Horse* (possibly cat. 51). MAY 17: Publication of mezzotint of *Gimcrack, with John Pratt Up, at Newmarket* (fig. 81), the first reproductive print after a Stubbs painting. OCTOBER: GS elected a director of the Society of Artists.

1767
Two works in the Society of Artists exhibition: a portrait of the third Duke of Portland at Welbeck Abbey (cat. 53) and the first of four paintings in the *Shooting Series* (Yale Center for British Art). GS paints series of three canvases for the fourth Viscount Torrington showing outdoor servants on his estate, Southill, in Bedfordshire (cats. 54–56). AUGUST 24: Publication of *The Horse and Lion* (cat. 40, fig. 1), first of a series of six mezzotints after various Stubbs paintings by Benjamin Green; the last appeared in 1774.

1768
Three works in the Society of Artists exhibition, including *Brood Mares and Foals* (cat. 57). GS appointed a vestryman of the parish of St. Marylebone, a local government office.

1769
Six works in the Society of Artists exhibition. GS experiments with enamel painting.

1770
Four works in the Society of Artists exhibition, including GS's first exhibited enamel, *A Lion Devouring a Horse* (cat. 60), along with *A Conversation* (probably cat. 59), and *Hercules and Achelous* (untraced). JULY 24: Publication of first print after Stubbs by his son George Townly Stubbs, *The Lion and Stag.*

1771
Four works in the Society of Artists exhibition, including a portrait of Eclipse (cat. 63). GS elected treasurer of the society.

1772

Eight works in the Society of Artists exhibition, including *The Centaur, Nessus, and Dejanira* (untraced). OCTOBER 19: GS elected president of the society. About this time begins experiments with the technique of wax painting on panel.

1773

Eleven works in the Society of Artists exhibition, including a painting of a kangaroo (Parham Park, Sussex). OCTOBER: GS retires as president of the society, though remaining a director.

1774

One work in the Society of Artists exhibition, his last: a portrait of a horse.

1775

Four works in the exhibition of the Royal Academy of Arts: portraits of a horse, two dogs, and a monkey. GS will continue to show his works at the Royal Academy, though not every year. Begins association with master potter Josiah Wedgwood.

1776

Four works in the Royal Academy exhibition.

1777

SEPTEMBER 25: Publication of first print by GS himself after one of his paintings, the etching *A Horse Affrighted by a Lion*. First painting in enamel on Wedgwood earthenware.

1778

Six works in the Royal Academy exhibition.

1779

Four works in the Royal Academy exhibition, including *Labourers* (Upton House, National Trust).

1780

Six works in the Royal Academy exhibition. AUGUST–NOVEMBER: GS stays with Josiah Wedgwood at Etruria, Staffordshire, painting a portrait of the Wedgwood family (Wedgwood Museum, Barlaston) and making models for ceramic relief plaques (fig. 72). NOVEMBER 5: Elected associate of the Royal Academy.

CHRONOLOGY FIG. 4. George Stubbs, *Self-Portrait*, 1781. Graphite, squared for transfer, 12 × 9 in. (30.5 × 22.9 cm). Yale Center for British Art, New Haven. Paul Mellon Collection (cat. 65)

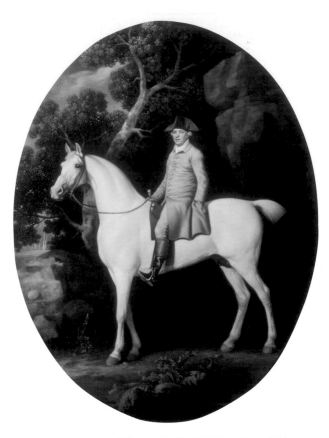

CHRONOLOGY FIG. 5. George Stubbs, *Self-Portrait on a White Hunter*, 1782. Enamel on Wedgwood earthenware, 36½ × 27½ in. (92.7 × 69.9 cm). National Museums Liverpool (Lady Lever Art Gallery)

1781
FEBRUARY 13: Elected royal academician. One work in the Royal Academy exhibition, the first of his enamel paintings on Wedgwood earthenware to be shown: *Two Horses* (probably fig. 114). Birth of son Richard to GS and his companion Mary Spencer; he is named Richard Spencer but changes this to Richard Stubbs when baptized as an adult (d. 1815).[4]

1782
Seven works in the Royal Academy exhibition, five of them in enamel on Wedgwood earthenware, including a self-portrait (probably cat. 66) and *Portrait of a Young Lady in the Character of Una, from Spenser's Faerie Queen* (fig. 111). GS is dismayed by their poor presentation. Shows no further works at the Royal Academy for three years and declines to submit his diploma work as an academician.

1783
FEBRUARY 11: Joshua Reynolds, president of the Royal Academy, announces GS's election as an academician annulled for noncompliance with the academy's laws.[5] First paintings of haymakers and reapers (Upton House, National Trust).

1785
APRIL: George Townly Stubbs declared bankrupt.

1786
Two works in the Royal Academy exhibition, second versions of the haymaking and reaping subjects of three years earlier (figs. 91 and 118).

1787
Three works in the Royal Academy exhibition, including *Horses Fighting* (see cat. 70).

1788
MAY 1: Publication of twelve prints by GS of various animal subjects, mostly after paintings (including cats. 68 and 69).

1789
One work in the Royal Academy exhibition.

CHRONOLOGY FIG. 6. Ozias Humphry, *George Stubbs*, 1794. Pastel, 23 × 19 in. (58.5 × 48.3 cm). National Museums Liverpool (The Walker)

1790

Two works in the Royal Academy exhibition, including *Portrait of the Lincolnshire Ox* (Walker Art Gallery, Liverpool). GS begins Turf Gallery project (cats. 76–78), apparently with the financial backing of the Prince of Wales.

1791

Four works at the Royal Academy exhibition, including a portrait of the Prince of Wales on horseback (fig. 125), one of a series of fourteen canvases commissioned by the prince between 1790 and 1793 (cats. 74, 75, figs. 129–32). GS shows no further works at the Royal Academy until 1799.

1794

JANUARY 20: Turf Gallery opens in Conduit Street, London. FEBRUARY 20: Publication of first prints after Turf Gallery paintings by George Townly Stubbs. GS makes a will, his estate to be divided equally between Mary Spencer and his sons George Townly Stubbs and Richard Spencer.

c. 1795

Relates his life and work to Ozias Humphry, who writes a manuscript memoir. Begins work on an ambitious study in anatomy, comparing the human body to that of the tiger and that of the chicken (fig. 4).

1796

Failure of Turf Gallery. GS receives financial help from wealthy friend Isabella Saltonstall.

1799

Two works at the Royal Academy exhibition.

1800

Two works at the Royal Academy exhibition, including *Hambletonian, Rubbing Down* (fig. 137), commissioned by Sir Henry Vane-Tempest.

1801

MARCH: Successfully sues Sir Henry Vane-Tempest for his fee of three hundred guineas for the painting of Hambletonian. Two works at the Royal Academy exhibition: paintings commissioned by the Earl of Clarendon, including a portrait of Freeman, the earl's gamekeeper (Yale Center for British Art).

1802

Two works in the Royal Academy exhibition.

1803

One work in the Royal Academy exhibition, his last: a portrait of a Newfoundland dog belonging to the Duke of York.

1803–6

Publication of first three parts of the *Comparative Anatomy*; the project is never finished.

1806

JULY 10: Death, at 24 Somerset Street, aged eighty-one.

Notes

1. See Fountain 1984, the source of a number of pieces of biographical and archival information used in this chronology.
2. George Townly Stubbs's birth date has generally been given as considerably later, about 1756. The record of his baptism in the parish register was discovered by David Alexander.
3. For a life of George Townly Stubbs and a checklist of his engravings, see Lennox-Boyd, Dixon, and Clayton 1989, 373–78.
4. See Fountain 1984.
5. For an account of Stubbs's difficult relations with the Royal Academy, see Parker 1971, 115–22.

Bibliography

ACKROYD 1995
Ackroyd, Peter. *Blake*. London, 1995.

ADDISON 1914
Addison, Joseph. *The Miscellaneous Works of Joseph Addison.* Edited by A. C. Guthkelch. 2 vols. London, 1914.

AGHION 2002
Aghion, Irène. "Le Comte de Caylus, historien des techniques." In *Caylus, mécène du roi: collectionner les antiquités au XVIIIe siècle,* 83–89. Paris, 2002.

ALBERTS 1978
Alberts, Robert. *Benjamin West: A Biography.* Boston, 1978.

ARMYTAGE 1956
Armytage, W. H. G. "Charles Watson-Wentworth, Second Marquess of Rockingham, F. R. S.: Some Aspects of His Scientific Interests." *Notes and Records of the Royal Society* 12 (1956), 64–76.

ASPINALL 1963–69
Aspinall, A., ed. *The Correspondence of George, Prince of Wales, 1770–1812.* 6 vols. London, 1963–69.

D'AZARA 1786
d'Azara, M. le Chevalier. "Mémoires sur la vie et sur les ouvrages de M. Mengs." In *Oeuvres complètes d'Antoine-Raphael Mengs.* 2 vols. Paris, 1786.

BARDWELL 1756
Bardwell, Thomas. *The Practice of Painting and Perspective Made Easy.* London, 1756.

BARNETT 1995
Barnett, Gerald. *Richard and Maria Cosway: A Biography.* Tiverton, Devon, 1995.

BARRELL 1980
Barrell, John. *The Dark Side of the Landscape: The Rural Poor in English Painting, 1730–1840.* Cambridge, 1980.

BASKETT 1980
Baskett, John. *The Horse in Art.* With a foreword by Paul Mellon. London, 1980.

BASKETT 1986
Baskett, John. "George Stubbs (1724–1806): *Pumpkin with a Stable-Lad* and the Single Horse Portraits." In *In Honor of Paul Mellon, Collector and Benefactor,* edited by John Wilmerding, 25–36. Washington, D.C., 1986.

BAZIN 1987
Bazin, Germain. *Théodore Géricault: étude critique, documents et catalogue raisonné.* 7 vols. Paris, 1987.

BERENGER 1771
Berenger, Richard. *The History and Art of Horsemanship.* 2 vols. London, 1771.

BEWICK 1807/1970
Bewick, Thomas. *A General History of Quadrupeds: The Figures Engraved on Wood by Thomas Bewick.* 5th ed. Newcastle upon Tyne, 1807. Reprint, London, 1970. First published 1790.

BIRCH MS
Birch, William. *The Life and Anecdotes of William Russell Birch, Enamel Painter.* Manuscript in Historical Society of Pennsylvania, Philadelphia, Archives of American Art, roll P20.

BLAKE 1965
Blake, William. *The Poetry and Prose of William Blake.* Edited by David V. Erdman. Commentary by Harold Bloom. New York, 1965.

BLOY 1986
Bloy, Marjorie. "Rockingham and Yorkshire." Ph.D. thesis, University of Sheffield, 1986.

BLUNDEVILLE 1566
Blundeville, Thomas. *The fower chiefyst offices belongyng to Horsemanshippe. . . .* London, 1566.

BOON ET AL. 1995
Boon, Jaap, Jos Pureveen, David Rainford, and Joyce H. Townsend. "'The Opening of the Walhalla, 1842': Studies on the Molecular Signature of Turner's Paint by Direct Temperature-Resolved Mass Spectrometry." In *Turner's Painting Techniques in Context,* edited by Joyce H. Townsend, 35–45. London, 1995.

BRACEGIRDLE AND CONNOR 2000
Bracegirdle, Hilary, and Patricia Connor, eds. *The Essential Horse.* Exh. cat. National Horseracing Museum, Newmarket, 2000.

BRACKEN 1752
Bracken, Henry. *Farriery Improv'd; or, A Compleat Treatise upon the Art of Farriery: Wherein is fully explain'd The Nature, Structure, and Mechanism of that Noble and Useful Creature, A Horse* 7th ed. 2 vols. London, 1752. First published 1738.

BREWER 1997
Brewer, John. *The Pleasures of the Imagination.* London, 1997.

BRINK AND HORNBOSTEL 1993
Pegasus and the Arts. Edited by Claudia Brink and Wilhelm Hornbostel. With essays by Claudia Brink, Kerstin Bütow, Thomas Ketelsen, David Klemm, Andrea Linnebach, Kristen Lippincott, Dorothea

Schröder, Martin Warnke, Gregor J. M. Weber, and Nikolas Yalouris. Exh. cat. Museum für Kunst und Gewerbe, Hamburg, 1993.

BURKE 1759/1958
Burke, Edmund. *A Philosophical Enquiry into the Origin of our Ideas of the Sublime and Beautiful*. Edited with an introduction and notes by J. T. Boulton. London, 1958. First published 1757; 2d ed., with an introductory discourse concerning taste, 1759.

BURTON 1976
Burton, Anthony. *Josiah Wedgwood, a Biography*. London, 1976.

BURTON 1751
Burton, John. *An Essay towards a Complete New System of Midwifry*. London, 1751.

BURTON 1621/1932
Burton, Robert. *The Anatomy of Melancholy*. Introduction by Holbrook Jackson. 3 vols. London, 1932. First published 1621.

BUTEN 1980
Buten, David. *Eighteenth-Century Wedgwood: A Guide for Collectors and Connoisseurs*. New York, 1980.

CAMINS 1981
Camins, Laura. *Glorious Horsemen: Equestrian Art in Europe, 1500–1800*. Exh. cat. Museum of Fine Arts, Springfield, Mass., 1981.

CAMPER 1806
Camper, Petrus. Letters from Petrus Camper to George Stubbs, July 28, 1771, and July 27, 1772. *Gentleman's Magazine* 76 (October 1806), 895–96.

CARLYLE 2001
Carlyle, Leslie. *The Artist's Assistant: Oil Painting Instruction Manuals and Handbooks in Britain, 1800–1900, with Reference to Selected Eighteenth-Century Sources*. London, 2001.

CARPENTIER 1875
Carpentier, Paul. *Notes sur la peinture à la cire cautérisée; ou, procédé encaustique d'après les laborieuses recherches de paillot de Montabert*. Paris, 1875.

CAYLUS AND MAJAULT 1755/1972
Caylus, Comte de, and M. Majault. *Mémoire sur la peinture à l'encaustique et sur la peinture à la cire*. Geneva, 1755. Reprint, Geneva, 1972.

COLLINS 1902
Collins, G. E. *History of the Brocklesby Hounds*. London, 1902.

CONNOR 2003
Connor, Patricia, ed. *All the Queen's Horses: The Role of the Horse in British History*. Exh. cat. Kentucky Horse Park, Lexington, 2003.

CONSTANTINE 1953
Constantine, H. F. "Lord Rockingham and Stubbs: Some New Documents." *Burlington Magazine* 95 (July 1953), 236–38.

COPLEY AND PELHAM 1970
Copley, John Singleton, and Henry Pelham. *The Letters and Papers of John Singleton Copley and Henry Pelham, 1739–1776*. New York, 1970.

CORMACK 1968–70
Cormack, Malcolm. "The Ledgers of Sir Joshua Reynolds." *Walpole Society* 42 (1968–70), 141–43, 168–69.

CORMACK 2000
Cormack, Malcolm. "Stubbs and Science." In Hall 2000, 37–47.

CORMACK ET AL. 1999
Cormack, Malcolm, Patrick McCaughey, Malcolm Warner, Scott Wilcox, Elisabeth Fairman, Gillian Forrester, and Timothy Barringer. *George Stubbs in the Collection of Paul Mellon*. Exh. cat. Yale Center for British Art, New Haven, 1999.

COSSA 1982
Cossa, Frank. "Josiah Wedgwood: His Role as a Patron of Flaxman, Stubbs and Wright of Derby." Ph.D. diss., Rutgers University, 1982.

COVE 1991
Cove, Sarah. "Constable's Oil Painting Materials and Techniques." In Leslie Parris and Ian Fleming-Williams, *Constable*, 493–529. Exh. cat. Tate Gallery, London, 1991.

DANIEL 1813
Daniel, William B. *Rural Sports*. 4 vols. London, 1813.

DANIELL 1890
Daniell, Frederick B. *A Catalogue Raisonné of the Engraved Works of Richard Cosway, R.A.* London, 1890.

DANIELS 1999
Daniels, Stephen. *Humphrey Repton: Landscape Gardening and the Geography of Georgian England*. New Haven and London, 1999.

DARWIN 1794
Darwin, Erasmus. *Zoonomia*. 2 vols. London, 1794.

DEUCHAR 1982
Deuchar, Stephen. *Noble Exercise: The Sporting Ideal in Eighteenth-Century British Art*. Exh. cat. Yale Center for British Art, New Haven, 1982.

DEUCHAR 1985
Deuchar, Stephen. "George Stubbs, 1724–1806." Review of exh. cat. by Judy Egerton. *Oxford Art Journal* 8, no. 1 (1985), 62–66.

DEUCHAR 1988
Deuchar, Stephen. *Sporting Art in Eighteenth-Century England: A Social and Political History*. New Haven and London, 1988.

DOHERTY 1974
Doherty, Terence. *The Anatomical Works of George Stubbs*. London, 1974.

DORMENT 1986
Dorment, Richard. *British Painting in the Philadelphia Museum of Art: From the Seventeenth through the Nineteenth Century*. Philadelphia, 1986.

DOSSIE 1764
Dossie, Robert. *The Handmaid to the Arts*. 2d ed. 2 vols. London, 1764. First published 1758.

EGERTON 1976
Egerton, Judy. *George Stubbs: Anatomist and Animal Painter*. Exh. cat. Tate Gallery, London, 1976.

EGERTON 1978
Egerton, Judy. *British Sporting and Animal Paintings, 1655–1867*. Sport in Art and Books: The Paul Mellon Collection. London, 1978.

EGERTON 1979
Egerton, Judy. "The Painter and the Peer: Stubbs and the Patronage of the First Lord Grosvenor." *Country Life* 166 (November 22, 1979), 1892–93.

EGERTON 1982
Egerton, Judy. "Racing to Save a Stubbs Masterpiece." *Country Life* 171 (May 13, 1982), 1397–1400.

EGERTON 1984A
Egerton, Judy. *George Stubbs, 1724–1806*. Exh. cat. Tate Gallery, London, 1984.

EGERTON 1984B
Egerton, Judy. "George Stubbs and the Landscape of Creswell Crags." *Burlington Magazine* 126 (December 1984), 738–43.

EGERTON 1985
Egerton, Judy. "A Painter, a Patron and a Horse." *Apollo* 122 (October 1985), 264–69.

EGERTON 1990
Egerton, Judy. *Wright of Derby*. Exh. cat. Tate Gallery, London, 1990.

EGERTON 1998A
Egerton, Judy. *The British Paintings*. National Gallery Catalogues. London, 1998.

EGERTON 1998B
Egerton, Judy. "Lord Rockingham and Stubbs." In *Wentworth: The Property of the Olive, Countess Fitzwilliam Chattels Settlement and of Other Members of the Family*, 84–88. Auction cat. Christie's, London, July 8, 1998.

EGERTON 2000
Egerton, Judy. "Enamel Paintings on Copper and Stubbs." In Hall 2000, 49–52.

EMMERSON 1999
Emmerson, Robin. "Stubbs and Wedgwood: New Evidence from the Oven Books." *Apollo* 150 (August 1999), 50–55.

ERFFA AND STALEY 1986
Erffa, Helmut von, and Allen Staley. *The Paintings of Benjamin West*. New Haven and London, 1986.

EVELYN 1955
Evelyn, John. *The Diary of John Evelyn*. Edited by E. S. de Beer. 6 vols. Oxford, 1955.

FAIRLEY 1984
Fairley, John. *Great Racehorses in Art*. Lexington, Ky., 1984.

FALCONET 1808/1970
Falconet, Etienne-Maurice. "Observations sur la statue de Marc-Aurele." First published 1770. In *Oeuvres complètes*, 3d ed., 3:47–145. Paris, 1808. Reprint, Geneva, 1970.

FARINGTON 1978–84
Farington, Joseph. *The Diary of Joseph Farington*. 16 vols. Vol. 4, *January 1799–July 1801*, edited by Kenneth Garlick and Angus Macintyre. Vol. 13, *January 1814–December 1815*, edited by Kathryn Cave. New Haven and London, 1978–84.

FERRAND 1721/1973
Ferrand, Jacques-Philippe. *L'Art du feu ou de peindre en émail*. Paris, 1721. Reprint, Geneva, 1973.

FIELD 1841
Field, George. *Chromatography; or, A Treatise on Colours and Pigments, and Their Powers in Painting*. New ed. London, 1841.

FIELDING 1742/1999
Fielding, Henry. *Joseph Andrews* and *Shamela*. Edited with an introduction and notes by Judith Hawley. London, 1999. *Joseph Andrews* first published 1742.

FIELDING 1846
Fielding, T. H. *On the Theory and Practice of Painting in Oil and Water Colours*. 4th ed. London, 1846.

FOGELMAN AND FUSCO 2002
Fogelman, Peggy, and Peter Fusco. *Italian and Spanish Sculpture: Catalogue of the J. Paul Getty Museum Collection*. With Marietta Cambareri. Los Angeles, 2002.

FORDHAM 2003
Fordham, Douglas. "The Class Menagerie, 1762–1765." In "Raising Standards: Art and Imperial Politics in London, 1745–1776." Ph.D. diss., Yale University, 2003.

FOREMAN 1998
Foreman, Amanda. *Georgiana, Duchess of Devonshire*. London, 1998.

FOUNTAIN 1984
Fountain, R. B. *Some Speculations on the Private Life of George Stubbs, 1724–1806*. British Sporting Art Trust, essay no. 12. London, 1984.

FOUNTAIN AND GATES 1984
Fountain, Robert, and Alfred Gates. *Stubbs's Dogs: The Hounds and Domestic Dogs of the Eighteenth Century as Seen Through the Paintings of George Stubbs*. London, 1984.

FRATREL 1770
Fratrel, Joseph. *La Cire alliée avec l'huile, ou la peinture à huile-cire; trouvée à Manheim par M. Charles Baron de Taubenheim.* Mannheim, 1770.

GAEHTGENS AND LUGAND 1988
Gaehtgens, Thomas W., and Jacques Lugand. *Joseph-Marie Vien: Peintre du roi.* Paris, 1988.

GAGE 1964
Gage, John. "Magilphs and Mysteries." *Apollo* 80 (July 1964), 38–41.

GAUNT 1977
Gaunt, William. *Stubbs.* Oxford, 1977.

GAY 1974
Gay, John. *John Gay: Poetry and Prose.* Edited by Vinton A. Dearing. With the assistance of Charles E. Beckwith. 2 vols. Oxford, 1974.

GIBSON 1735
Gibson, William. *The Farrier's New Guide: Containing, First, the Anatomy of a Horse . . . Secondly, an Account of All the Diseases Incident to Horses* 8th ed. London, 1735. First published 1720.

GILBEY 1898
Gilbey, Walter. *Life of George Stubbs, R.A.* London, 1898.

GILPIN 1808
Gilpin, William. *Remarks on Forest Scenery. . . .* 3d ed. 2 vols. London, 1808. First published 1791.

GODFREY 2000
Godfrey, Richard. "George Stubbs as a Printmaker." In Hall 2000, 53–54.

GODFREY 1985
Godfrey, Tony. "Stubbs and Laocoon." *Artscribe* 50 (January–February 1985), 36–39.

GRAHAM-DIXON 1996
Graham-Dixon, Andrew. "Standing Alone: The Genius of George Stubbs." In *A History of British Art*, 119–23. London, 1996.

GRANGER 1773
Granger, James. *An Apology for the Brute Creation; or, Abuse of Animals censured.* London, 1773.

GRAVES 1907
Graves, Algernon. *The Society of Artists of Great Britain, 1760–1791, the Free Society of Artists, 1761–1783: A Complete Dictionary of Contributors and Their Work from the Foundation of the Societies to 1791.* London, 1907.

GRIGSON 1948
Grigson, Geoffrey. "George Stubbs, 1724–1806." In *The Harp of Aeolus and Other Essays on Art, Literature and Nature*, 13–23. London, 1948. The essay was first published in *Signature*, no. 13 (January 1940), 15–32.

GRIGSON 1950
Grigson, Geoffrey. *Horse and Rider: Eight Centuries of Equestrian Paintings.* London, 1950.

HALL 2000
Hall, Nicholas H. J. *Fearful Symmetry: George Stubbs, Painter of the English Enlightenment.* Exh. cat. Hall and Knight, New York, 2000.

HARWOOD 1928
Harwood, Dix. *Love for Animals and How It Developed in Great Britain.* New York, 1928.

HASKELL AND PENNY 1981
Haskell, Francis, and Nicholas Penny. *Taste and the Antique: The Lure of Classical Sculpture, 1500–1900.* New Haven and London, 1981.

HAWKESWORTH 1753
Hawkesworth, John. "Happiness properly estimated by its degree in whatever subject; Remarkable instances of cruelty to brutes; Elegy on a blackbird." *Adventurer*, no. 37 (March 13, 1753), 9.

HAYDON 1853
Haydon, Benjamin Robert. *Life of Benjamin Robert Haydon, Historical Painter, from His Autobiography and Journals.* Edited by Tom Taylor. 2d ed. 3 vols. London, 1853.

HAYDON 1963
Haydon, Benjamin Robert. *The Diary of Benjamin Robert Haydon.* Edited by Willard Bissell Pope. 3 vols. Cambridge, Mass., 1963.

HAYES 1992
Hayes, John. *British Paintings of the Sixteenth Through Nineteenth Centuries.* The Collections of the National Gallery of Art: Systematic Catalogue. Washington, D.C., 1992.

HEBER 1766
Heber, Reginald. *A Historical List of Horse-matches Run, and of Plates and Prizes run for in Great Britain and Ireland in the Year 1765.* London, 1766.

HOGARTH 1753/1997
Hogarth, William. *The Analysis of Beauty.* Edited by Ronald Paulson. New Haven and London, 1997. First published 1753.

HOLCROFT AND HAZLITT 1926
Holcroft, Thomas, and William Hazlitt. *The Memoirs of Thomas Holcroft.* London, 1926.

HUGHES AND HUGHES 1967
Hughes, Therle, and Bernard Hughes. *English Painted Enamels.* Feltham, Middlesex, 1967.

HUMPHRY *MEMORANDUM BOOK*
Humphry, Ozias. *Memorandum Book.* British Library, London. Add. MSS. 22949, 22950.

HUMPHRY MS
Humphry, Ozias. "Particulars of the life of Mr Stubbs." Manuscript (c. 1795), Joseph Mayer Papers, Liverpool City Libraries. Transcribed, with notes, by Helen Macintyre. In Hall 2000, 195–212.

HUSSEY 1927/1967
Hussey, Christopher. *The Picturesque: Studies in a Point of View.* With a new preface by the author. London, 1967. First published 1927.

JONES 1990
Jones, Rica. "Wright of Derby's Techniques of Painting." In Egerton 1990, 263–71.

JONES 1999
Jones, Rica. "Sir Joshua Reynolds: George IV When Prince of Wales, 1785." In *Paint and Purpose: A Study of Technique in British Art*, 146–51. London, 1999.

KEAN 1998
Kean, Hilda. *Animal Rights: Political and Social Change in Britain Since 1800*. London, 1998.

KENT 1896
Kent, John. *Records and Reminiscences of . . . the Dukes of Richmond*. London, 1896.

KIDSON 1999
Kidson, Alex. *Earlier British Paintings in the Lady Lever Art Gallery*. Liverpool, 1999.

[LAURIE] 1840
[Laurie, R. H.]. *The Art of Painting in Oil-Colours . . . Extracted from the Works of the Most Eminent Masters, of Italian, Flemish, and English Schools . . . but Principally from Mr. Bardwell*. 15th ed. London, 1840.

LAWRENCE 1796–98
Lawrence, John. *A Philosophical and Practical Treatise on Horses, and on the Moral Duties of Man towards the Brute Creation*. 2 vols. London, 1796–98.

LAWRENCE 1809
Lawrence, John. *The History and Delineation of the Horse, in All His Varieties. . . .* London, 1809.

LEDGARD 1985
Ledgard, Annabel. "Mr. Stubbs' Views of the Passions." *Print Collector's Newsletter* 16, no. 1 (March–April 1985), 1–4.

LENNOX-BOYD, DIXON, AND CLAYTON 1989
Lennox-Boyd, Christopher, Rob Dixon, and Tim Clayton. *George Stubbs: The Complete Engraved Works*. London, 1989.

LIEDTKE 1989
Liedtke, Walter. *The Royal Horse and Rider: Painting, Sculpture, and Horsemanship, 1500–1800*. New York, 1989.

LONGRIGG 1972
Longrigg, Roger. *The History of Horse Racing*. New York, 1972.

LONGRIGG 1975
Longrigg, Roger. *The History of Foxhunting*. New York, 1975.

LONGRIGG 1977
Longrigg, Roger. *The English Squire and His Sport*. New York, 1977.

MCCLURE AND FEATHERSTONE 1984
McClure, Ian, and Rupert Featherstone. "The Cleaning of Stubbs's 'Hambletonian.'" In Egerton 1984a, 22–23.

MANNINGS 2000
Mannings, David. *Sir Joshua Reynolds: A Complete Catalogue of His Paintings*. The subject pictures catalogued by Martin Postle. New Haven and London, 2000.

MARKHAM 1610/1695
Markham, Gervase. *Markham's Maister-peece; Or, What doth a horse-man lack* London, 1695. First published 1610.

MASSING 1993
Massing, Ann. "Arnaud Vincent de Montpetit and Eludoric Painting." *Zeitschrift für Kunsttechnologie und Konservierung* 7 (1993), 359–68.

MAYER 1879
Mayer, Joseph. *Memoirs of Thomas Dodd, William Upcott, and George Stubbs, R.A.* Liverpool, 1879.

MAYER AND MYERS 1996
Mayer, Lance, and Gay Myers. "'The Court of Death' Through Conservators' Eyes." *Bulletin of the Detroit Institute of Arts* 70, nos. 1/2 (1996), 4–13.

METEYARD 1865/1970
Meteyard, Eliza. *The Life of Josiah Wedgwood from His Private Correspondence and Family Papers*. London, 1865. Reprint, London, 1970.

MILLAR 1963
Millar, Oliver. *The Tudor, Stuart and Early Georgian Pictures in the Collection of Her Majesty the Queen*. Catalogue of Pictures in the Collection of Her Majesty the Queen. 2 vols. London, 1963.

MILLAR 1969
Millar, Oliver. *The Later Georgian Pictures in the Collection of Her Majesty the Queen*. Catalogue of Pictures in the Collection of Her Majesty the Queen. 2 vols. London, 1969.

MILLAR 1974
Millar, Oliver, et al. *British Sporting Painting, 1650–1850*. Exh. cat. Arts Council of Great Britain, London, 1974.

MILNER 1987
Milner, Frank. *George Stubbs: Paintings, Ceramics, Prints and Documents in Merseyside Collections*. Liverpool, 1987.

MILLS AND WHITE 1985
Mills, John, and Raymond White. "The Mediums Used by George Stubbs: Some Further Studies." *National Gallery Technical Bulletin* 9 (1985), 60–64.

MINGAY 1963
Mingay, G. E. *English Landed Society in the Eighteenth Century*. London, 1963.

MONTFAUCON 1721–22
Montfaucon, Bernard de. *Antiquity Explained, and Represented in Sculptures*. Translated by David Humphreys. 5 vols. London, 1721–22. Originally published as *L'Antiquité expliquée et représentée en figures*, 1719.

MORRISON 1989
Morrison, Venetia. *The Art of George Stubbs*. London, 1989.

MÜNTZ 1760
Müntz, Johann Heinrich. *Encaustic, or Count Caylus's Method of Painting in the Manner of the Ancients; To which is added a Sure and Easy method for Fixing of Crayons.* London, 1760.

MURRAY 1998
Murray, Venetia. *High Society in the Regency Period, 1788–1830.* London, 1998.

MYRONE 2002
Myrone, Martin. *George Stubbs.* British Artists (Tate). London, 2002.

T. N. 1808A
T. N. "Memoirs of George Stubbs, Esq., the Celebrated Painter of Horses." *Sporting Magazine* 32 (May 1808), 54–57.

T. N. 1808B
T. N. "The Lion and Horse." *Sporting Magazine* 32 (July 1808), 154–57.

T. N. 1809
T. N. "Further Particulars respecting the merits and labours of George Stubbs, Esq., R.A., The celebrated painter of Horses and other Quadrupeds." *Sporting Magazine* 35 (November 1809), 49–52.

NAMIER AND BROOKE 1964
Namier, Lewis, and John Brooke. *The House of Commons, 1754–1790.* 3 vols. New York, 1964.

[NEAGLE] MS
[Neagle, John]. *Hints for a Painter with Regard to his Method of Study* Manuscript notebook, n.d., in American Philosophical Society, Philadelphia.

NEWCASTLE 1667
Newcastle, William Cavendish, Duke of. *A New Method, and Extraordinary Invention, to Dress Horses, and Work Them according to Nature, as also, To Perfect Nature by the Subtilty of Art* London, 1667.

O'GORMAN 1875
O'Gorman, Frank. *The Rise of Party in England: The Rockingham Whigs, 1760–1782.* London, 1875.

ORAM 1810
Oram, William. *Precepts and Observations on the Art of Colouring in Landscape Painting, Arranged from the Author's Original MS. and Published by Charles Clarke.* London, 1810.

ORTON 1844
Orton, John. *Turf Annals of York and Doncaster.* London, 1844.

PAGE 1912
Page, William, ed. *Victoria County History of Yorkshire.* 2 vols. London, 1912.

PARKER 1971
Parker, Constance-Anne. *Mr Stubbs the Horse Painter.* London, 1971.

PAULSON 1975
Paulson, Ronald. "Stubbs: A 'Look into Nature.'" In *Emblem and Expression: Meaning in English Art of the Eighteenth Century*, 159–83. London, 1975.

PAULSON 1985
Paulson, Ronald. "Hambletonian, Rubbing Down: George Stubbs and English Society." *Raritan* 4 (Spring 1985), 22–43.

PEALE 1983–
Peale, Charles Willson. *The Selected Papers of Charles Willson Peale and His Family.* Edited by Lillian B. Miller. 5 vols. New Haven and London, 1983– .

PENNANT 1768–70
Pennant, Thomas. *British Zoology.* 4 vols. London, 1768–70.

PENNY 1991
Penny, Nicholas. "Lord Rockingham's Sculpture Collection and *The Judgment of Paris* by Nollekens." *J. Paul Getty Museum Journal* 19 (1991), 5–34.

PERCIVAL 1776
Percival, Thomas. "Cruelty to Horses, extracted from a Work lately published by Dr. Percival, entitled 'A Father's Instructions to His Children; consisting of Tales, Fables, and Reflections; designed to promote the Love of Virtue, a Taste for Knowledge, and an early Acquaintance with the Works of Nature.'" *Gentleman's Magazine* 46 (March 1776), 109–10. Percival's book was first published in 1775.

PINDAR 1794–1801
Pindar, Peter (pseudonym of John Wolcot). *The Works of Peter Pindar, Esq.* 5 vols. London, 1794–1801.

PIPER 1964
Piper, David. "A Study of Horses Exercising, by Stubbs." *Listener* (April 9, 1964), 594–96.

PIPER 1992
Piper, David. *The English Face.* 2d ed. London, 1992.

PODESCHI 1981
Podeschi, John B. *Books on the Horse and Horsemanship: Riding, Hunting, Breeding and Racing, 1400–1941.* Sport in Art and Books: The Paul Mellon Collection. London, 1981.

POTTS 1990
Potts, Alex. "Natural Order and the Call of the Wild: The Politics of Animal Picturing." *Oxford Art Journal* 13, no. 1 (1990), 12–33.

PRICE 1794
Price, Uvedale. *An Essay on the Picturesque, as Compared with the Sublime and the Beautiful. . . .* London, 1794.

PRIMATT 1776/1992
Primatt, Humphry. *On the Duty of Mercy and the Sin of Cruelty to Brute Animals.* Edited by Richard D. Ryder. Fontwell, Sussex, 1992. First published 1776.

REESE 1987
Reese, Max Meredith. *Goodwood's Oak: The Life and Times of the Third Duke of Richmond, Lennox and D'Aubigny.* London, 1987.

REILLY 1994
Reilly, Robin. *Wedgwood Jasper.* New York, 1994.

REQUENO Y VIVES 1787
Requeno y Vives, Vincenzo. *Saggi sul ristabilimento dell'antica arte de' greci e de' romani*

pittori. 2d ed. Parma, 1787. First published 1784. Modern reprint of 1787 edition published by Elibron Classics, [n.d.].

REYNOLDS 1797/1975
Reynolds, Joshua. *Discourses on Art*. Edited by Robert R. Wark. New Haven and London, 1975. First published 1797.

RICE 1979
Rice, Danielle. "The Fire of the Ancients: The Encaustic Painting Revival, 1755 to 1812." Ph.D. diss., Yale University, 1979.

RICE 1999
Rice, Danielle. "Encaustic Painting Revivals: A History of Discord and Discovery." In Gail Stavitsky, *Waxing Poetic: Encaustic Art in America*, 5–15. Exh. cat. Montclair Art Museum, Montclair, N.J., 1999.

RICE 1879
Rice, James. *The History of the British Turf*. 2 vols. London, 1879.

ROGERSON 2000
Rogerson, Barnaby. "Did Stubbs Go to Morocco?" *Country Life* 194 (March 2, 2000), 60–61.

RUHEMANN 1968
Ruhemann, Helmut. *The Cleaning of Paintings: Problems and Potentialities*. New York, 1968.

RUMP 1983
Rump, Gerhard Charles. *Pferde- und Jagdbilder in der englischen Kunst: Studien zu George Stubbs und dem Genre der "sporting Art" von 1650–1830*. Hildesheim, 1983.

RUSSELL 1980
Russell, Francis. "Lord Torrington and Stubbs, a Footnote." *Burlington Magazine* 122 (April 1980), 250–53.

RUSSELL 2003
Russell, Francis, et al. *Sporting Art in Britain: A Loan Exhibition to Celebrate Twenty-Five Years of the British Sporting Art Trust*. Exh. cat. Christie's, London, 2003.

RYDER 2000
Ryder, Richard D. *Animal Revolution: Changing Attitudes Towards Speciesism*. Rev. ed. Oxford, 2000.

SAVAGE 2002
Savage, Nick. *The Beauties of the Horse: Drawings by George Stubbs and Related Materials for Artists at the Royal Academy of Arts*. With Bryan Kneale and Catherine Rickman. Exh. cat. Royal Academy Library Print Room, London, 2002.

SCHIMMELMAN 1984
Schimmelman, Janice G. "Books on Drawing and Painting Techniques Available in Eighteenth-Century American Libraries and Bookstores." *Winterthur Portfolio* 19, nos. 2/3 (Summer–Autumn 1984), 193–205.

SHEPHERD 1984
Shepherd, Robert. "Stubbs: A Conservator's View." In Egerton 1984a, 20–21.

SNAPE 1683
Snape, Andrew. *The Anatomy of an Horse: Containing An exact and full Description of the Frame, Situation and Connexion of all his Parts* London, 1683.

SNELGROVE 1981
Snelgrove, Dudley. *British Sporting and Animal Prints, 1658–1874*. Sport in Art and Books: The Paul Mellon Collection. London, 1981.

SPARROW 1922
Sparrow, Walter Shaw. *British Sporting Artists: From Barlow to Herring*. London, 1922.

SPARROW 1929
Sparrow, Walter Shaw. *George Stubbs and Ben Marshall*. With an introduction by E. D. Cuming. London, 1929.

STUBBS 1766
Stubbs, George. *The Anatomy of the Horse: Including A particular Description of the Bones, Cartilages, Muscles, Fascias, Ligaments, Nerves, Arteries, Veins, and Glands; In Eighteen Tables, all done from Nature*. London, 1766.

STUBBS 1803–6
Stubbs, George. *A Comparative Anatomical Exposition of the Structure of the Human Body, with that of a Tiger and Common Fowl*. Planned as a series of six numbers, of which only three were published. London, 1803–6.

SULLY MS
Thomas Sully. *Hints for Pictures* (1809–1871). Manuscript at Beinecke Rare Book and Manuscript Library, Yale University.

SWIFT 1726/2001
Swift, Jonathan. *Gulliver's Travels*. Edited with an introduction and notes by Robert Demaria, Jr. London, 2001. Originally published as *Travels into several Remote Nations of the World, In Four Parts: by Lemuel Gulliver*, 1726.

TALLEY 1981
Talley, Mansfield Kirby. *Portrait Painting in England: Studies in the Technical Literature Before 1700*. London, 1981.

TALLEY 1986
Talley, M. Kirby, Jr. "'All Good Pictures Crack': Sir Joshua Reynolds's Practice and Studio." In *Reynolds*, edited by Nicholas Penny, 55–70. Exh. cat. Royal Academy of Arts, London, 1986.

TATTERSALL 1974
Tattersall, Bruce. *Stubbs and Wedgwood: A Unique Alliance Between Artist and Potter*. Exh. cat. Tate Gallery, London, 1974.

TAYLOR 1955
Taylor, Basil. *Animal Painting in England from Barlow to Landseer*. London, 1955.

TAYLOR 1957
Taylor, Basil. *George Stubbs, 1724–1806*. Exh. cat. Whitechapel Art Gallery, London, 1957.

TAYLOR 1960
Taylor, Basil. *Sport and the Horse*. Exh. cat. Virginia Museum of Fine Arts, Richmond, 1960.

TAYLOR 1961
Taylor, Basil. "Josiah Wedgwood and George Stubbs." *Proceedings of the Wedgwood Society* 4 (1961), 209–24.

TAYLOR 1965A
Taylor, Basil. "George Stubbs: 'The Lion and Horse' Theme." *Burlington Magazine* 107 (February 1965), 81–86.

TAYLOR 1965B
Taylor, Basil. "Portraits of George Stubbs." *Apollo* 81 (May 1965), Supplement: Notes on British Art 3, between pp. 422 and 423.

TAYLOR 1969
Taylor, Basil. *The Prints of George Stubbs*. London, 1969.

TAYLOR 1970
Taylor, Basil. *Stubbs in the 1760s*. Exh. cat. Thomas Agnew and Sons. London, 1970.

TAYLOR 1971
Taylor, Basil. *George Stubbs*. London, 1971.

TAYLOR 1974
Taylor, Basil. "Stubbs and the Art of Painted Enamel." In Tattersall 1974, 9–13.

TAYLOR 1976
Taylor, Basil. "Stubbs as Anatomist." In Egerton 1976, 10–19.

TAYLOR 1987
Taylor, Desmond. "George Stubbs at Horkstow." *Antique Collector*, August 1987, 66–67.

TAYLOR 1843
Taylor, William B. Sarsfield. *A Manual of Fresco and Encaustic Painting*. London, 1843.

THEOPHILUS 1963/1979
Theophilus. *On Divers Arts*. Translated by John G. Hawthorne and Cyril Stanley Smith. Chicago, 1963. Reprint, New York, 1979.

THOMAS 1983
Thomas, Keith. *Man and the Natural World: A History of the Modern Sensibility*. New York, 1983.

THOMPSON 2000
Thompson, Laura. *Newmarket: From James I to the Present Day*. London, 2000.

TREASURE 1997
Treasure, Geoffrey. *Who's Who in Late Hanoverian Britain*. London, 1997.

TRUMBULL MS
Trumbull, John. *Inventories*. Manuscript in New-York Historical Society.

[UPCOTT?] 1806
[Upcott, William?]. [Obituary of the artist.] *Gentleman's Magazine* 76 (October 1806), 978–79.

VIAL DE SAINBEL 1797
Vial de Sainbel, Charles. *Elements of the Veterinary Art*. 3d ed. London, 1797.

WALKER 1972
Walker, Stella A. *Sporting Art: England, 1700–1900*. London, 1972.

WALPOLE 1762–80/1937/1969
Walpole, Horace. *Anecdotes of Painting in England* Edited by Frederick W. Hilles and Philip B. Daghlian. 4 vols. New Haven, 1937. Reprint, New York, 1969. First published 1762–80.

WALPOLE 1928
Walpole, Horace. "Horace Walpole's Journals of Visits to Country Seats" Edited by Paget Toynbee. *Walpole Society* 16 (1928), 11–80.

WALPOLE 1937–83
Walpole, Horace. *The Yale Edition of Horace Walpole's Correspondence*. Edited by W. S. Lewis et al. 48 vols. New Haven, 1937–83.

WALPOLE 1939
Walpole, Horace. "Notes by Horace Walpole, Fourth Earl of Orford, on the Exhibitions of the Society of Artists and the Free Society of Artists, 1760–1791." Transcribed and edited by Hugh Gatty. *Walpole Society* 27 (1938–39), 55–88.

WARK 1955
Wark, Robert. "A Horse and Lion Painting by George Stubbs." *Bulletin of the Associates in Fine Arts at Yale University* 22, no. 1 (1955), 1–6.

WATERFIELD ET AL. 2003
Waterfield, Giles, and Anne French, with Matthew Craske. *Below Stairs: Four Hundred Years of Servants' Portraits*. Foreword by Julian Fellowes. Exh. cat. National Portrait Gallery. London, 2003.

WATERHOUSE 1953/1962
Waterhouse, Ellis. *Painting in Britain, 1530 to 1790*. 2d ed. London, 1962. First published 1953.

WATIN 1773
Watin, [Jean-Félix]. *L'Art du peintre, doreur, vernisseur*. 2d ed. Paris, 1773.

WATIN 1808
Watin, [Jean-Félix]. *L'Art du peintre, doreur, vernisseur, et du fabricant de couleurs*. 6th ed. Paris, 1808.

WATTS 1994
Watts, Teresa S. "J. H. Müntz, Horace Walpole and Encaustic Painting: Müntz's Experiments in England, 1755–62." *Apollo* 140 (October 1994), 37–43.

WESLEY 1876
Wesley, John. *Sermons on Several Occasions*. 3 vols. London, 1876.

WHITE 1789/1993
White, Gilbert. *The Natural History of Selborne*. Compiled by Ronald Davidson-Houston, with an introduction by June E. Chatfield. London, 1993. First published 1789.

WHITE ET AL. 1980
White, Raymond, Ashok Roy, John Mills, and Joyce Plesters. "George Stubbs's 'Lady and Gentleman in a Carriage': A Preliminary Note on the Technique." *National Gallery Technical Bulletin* 4 (1980), 64.

WHITLEY 1928
Whitley, William T. *Artists and Their Friends in England, 1700–1799*. 2 vols. London, 1928.

WILSON 1765
Wilson, Benjamin. *A Letter to the Marquess of Rockingham with Some Observations on the Effects of Lightning*. London, 1765.

WINCKELMANN 1764/1968
Winckelmann, Johann Joachim. *History of Ancient Art*. Translated by Alexander Gode [from the 1849–73 edition]. New York, 1968. 4 vols. Originally published as *Geschichte der Kunst des Altertums*, 1764.

YOUNG 1771/1967
Young, Arthur. *A Six Months Tour through the North of England*. 2d ed. 4 vols. London, 1771. Reprint, New York, 1967.

Index

Photograph Credits